30.00

83194

THE TERRACOTTA REVIVAL

This book was supported by a major grant from Ibstock Building Products and a grant towards the cost of illustrations from the Graham Foundation for Advanced Studies in the Fine Arts.

THE TERRACOTTA REVIVAL

Building Innovation and the Image of the Industrial City in Britain and North America

MICHAEL STRATTON

LONDON
VICTOR GOLLANCZ
in association with
PETER CRAWLEY

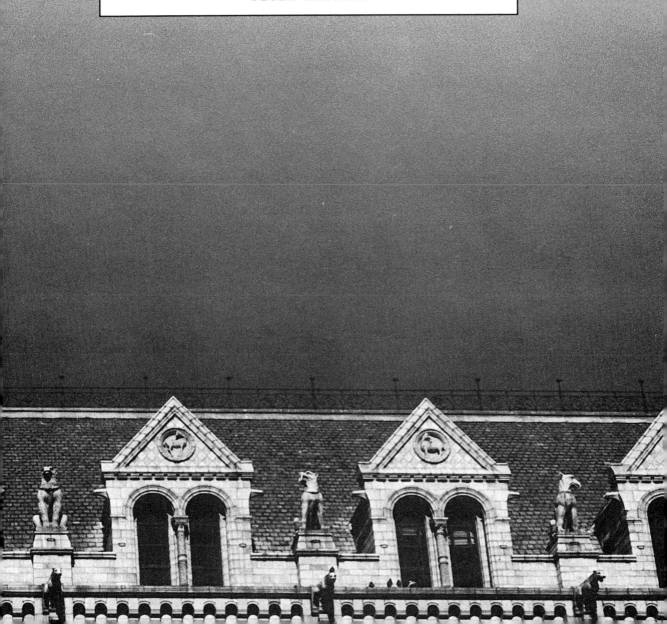

First published in Great Britain 1993
in association with Peter Crawley
by Victor Gollancz,
A Cassell imprint
Villiers House, 41–47 Strand, London WC2N 5JE

A catalogue record for this book is
available from the British Library

ISBN 0 575 05433 6

Designed by Stephen Bray
Photoset by Rowland Phototypesetting Ltd, Bury St Edmunds, Suffolk
and printed in Great Britain by
Butler and Tanner Ltd, Frome, Somerset

CONTENTS

<div style="border:1px solid black; padding:1em; text-align:center;">

COLOUR PLATES

</div>

Between pages 64 and 65:

1 Everard Building, Broad Street, Bristol *(Peter Crawley)*
2 Dalmeny House, Linlithgow, Lothian *(Michael Stratton)*
3 Cliveden, Buckinghamshire *(Ibstock Hathernware)*
4 Certosa di Pavia, Italy *(Michael Stratton)*
5 Sutton Place, Surrey *(Michael Stratton)*
6 Wedgwood Memorial Institute, Burslem, Staffordshire *(Michael Stratton)*
7 Oxburgh Hall, Norfolk *(Michael Stratton)*
8 Natural History Museum, London *(Peter Crawley)*

Between pages 96 and 97:

9 Grosvenor Park Road, Chester *(Michael Stratton)*
10 Spring Hill Library, Birmingham *(Michael Stratton)*
11 Courtyard of Prudential Assurance Head Office, Holborn, London *(Ibstock Hathernware)*
12 Prudential Assurance Head Office, Holborn, London *(Peter Crawley)*
13 St John Evangelist Church, Rhosymedre, near Ruabon, Clwyd *(Michael Stratton)*
14 Lancaster House, Whitworth Street, Manchester *(Michael Stratton)*
15 Central Arcade, Newcastle upon Tyne *(Michael Stratton)*
16 Gunmakers' Arms, Aston, Birmingham *(Michael Stratton)*
17 Savoy Hotel, Strand, London *(Ibstock Hathernware)*
18 The seafront at Blackpool *(Michael Stratton)*
19 Hoover Factory, Western Avenue, London *(Michael Stratton)*
20 Carlton Cinema, Upton Park, London *(Ironbridge Gorge Museum Trust)*
21 Palace Cinema, Southall, London *(Ironbridge Gorge Museum Trust)*

Between pages 160 and 161:

22 Hotel Victoria, Dartmouth Street, Boston, Mass. *(Michael Stratton)*
23 Pension Building, Washington DC *(Michael Stratton)*
24 Furness Building, Walnut Street, Philadelphia, Pa. *(Michael Stratton)*
25 Guaranty Building, Buffalo, NY *(Cervin Robinson)*

PREFACE
AND ACKNOWLEDGEMENTS

Terracotta rouses passionate enthusiasm among manufacturers, architects and historians alike. The greatest pleasure of writing this book has been meeting and working with people who share an appreciation of architectural ceramics on both sides of the Atlantic. My interest in this subject originated in doctoral research supervised by Jennifer Tann.

Information and inspiration has flowed from colleagues at the Ironbridge Institute and the Ironbridge Gorge Museum, and in particular from Barrie Trinder, John Powell and Marilyn Higson. Janet Markland and Carol Sampson provided secretarial assistance while Shelley White produced the drawings. Maurice Glendenning kindly helped with proof-reading.

I am indebted to friends and contacts with interests in this field, including Tony Herbert and Kathryn Huggins, Ruth Harman, Robert Thorne, Francis Celoria, Louise Irvine, John Fidler, Susan Beattie, Colin Cunningham, Alison Kelly, Stefan Muthesius, Clive Wainwright, Gaye Blake-Roberts, Peter Howell and Julia Elton.

Many staff have helped unravel the labyrinthine layout of terracotta factories, in particular Dennis Moffatt, Brian Joines, Peter Ainsworth, Harry North at Ibstock Hathernware; Jon Wilson and the late Branson Knight at Shaws of Darwen; and Leslie Hayward at Poole Pottery Limited.

I am grateful for grants from the United States Embassy, a Hagley Fellowship and a Winston Churchill Fellowship to allow me to study American ceramic architecture. Those who have given me time and hospitality include Susan Tunick in New York, Mary Swisher in Sacramento, Cleota Reed in Syracuse, Tim Samuelson in Chicago, Robert Weis and Margaret Henderson Floyd in Boston. I am grateful for help from the staff of the National Building Museum in Washington, Boston Public Library, Hagley and Winterthur Libraries and the Avery Architectural Library in New York. Bill Wyatt and his colleagues at Gladding McBean laid open their wonderful plant to myself and Annabel, who joined in searching through dusty box files of correspondence in a semi-desert heatwave.

This publication has been made possible by support from Ibstock Building Products and the commitment of Andrew McEwan and John Dunsford. Further thanks are due to the Graham Foundation for assistance with the cost of the illustrations. Peter Crawley has helped mould the project and contributed his photographic skills to the book which was designed by Stephen Bray.

Reference points are marked in the text by a star symbol, which refers, by page and line number, to bibliographical or other supplementary information provided at the end of the book.

The majority of the black and white photographs were taken by the author. Credits for archival or other modern images are as follows: Peter Crawley, **title page**, 3, 47, 59, 62, 65, 78, 79, 89, 93, 94, 192; California State Library 5, 151, 165, 166, 173; Ironbridge Gorge Museum Trust 8, 32, 38, 83, 84, 99, 100, 101, 102, 110, 114, 116, 117, 118, 119, 120, 121, 123, 124, 125, 199, 200; Mary Swisher 9, 17, 24, 194, 201; Ibstock Hathernware 14, 15, 122, 193; Royal Doulton Limited 26, 27, 69, 75, 76, 86, 90, 106, 107, 115, 137; Tamworth Castle Museum 28; F. E. Parshley 29; Savoy Hotel 30; Sheffield Record Office Archive 44; RIBA 57; Leeds City Museums 88; London Transport Museum 104; Poole Pottery Limited 105; CEGB Archive 112; Susan Tunick Collection 126, 197; Boston Library Archive 127; David Taylor Collection 130; Chicago Historical Society 131, 143; New York Historical Society 139; Philadelphia Historical Commission 142; R. T. Fuller 148; Gladding McBean 150, 164; Cervin Robinson 152, 153, 154, 155, 202; National Terracotta Society 167; Tulsa Historical Society 186; Peter Mauss 187; English Heritage 188; Lawrance Hurst 189; Venturi Scott Brown 195; Robert Adam 198.

Michael Stratton

INTRODUCTION
Symbolism and Soot

The revival of architectural terracotta, and in the form of large, intricately moulded blocks of clay drawing on Renaissance precedent (**I**), was remarkably widespread in Britain and the United States. Its adoption progressed, falteringly at first, to culminate in façades of brightly coloured ceramics, erected in the thoroughfares of major industrial cities from the 1880s. Terracotta was promoted as a solution to some of the most pressing problems encountered in urban building – smog, fire and the expense of quality stonework – and to further the development of a decorative architecture for the cities of the industrial age. In the years after 1850 interest in the material was heightened by ideals of art and architecture shaping the morals of the masses and acting as agents of 'self-improvement'. One commentator prophesied that the introduction of terracotta ornaments would 'help to communicate life and picturesqueness to our cities'. ✫ On both sides of the Atlantic the first major experiments with terracotta were on combined museums and art schools.

The use of terracotta on commercial buildings blossomed in the 1880s, when it was worked with a bravura that matched the economic and democratic vitality of emergent industrial communities. Richly decorated red and buff façades gained a particular association with such cities as Birmingham, Leeds, New York and Chicago, dominated by factories and workshops, steam and trams, and by groups committed to a liberal combination of commercial enterprise and freedom.

Terracotta merits study simply on grounds of its extensive use: there are still around 2,600 terracotta buildings in the centre of Chicago. ✫ This book attempts to document and explain the manufacture and use of terracotta, and its glazed counterpart faience, over the last 150 years. The revival offers a means of exploring a neglected strand of architectural history. The clayworkers, architects and clients involved in creating ceramic board schools, theatres, skyscrapers and cinemas shared tastes and aspirations that mark the central ground of building design, between the high art of Edwin Lutyens or Frank Lloyd Wright and utilitarian building. These figures were united in their efforts to create an architecture that was practically suited to industrial towns and cities but at the same time uplifting and progressive, while still appealing to a broad public.

The widespread and vigorous use of decorative ceramics proved highly contentious: in Britain the choice of terracotta in lieu of stone could generate a storm of protest. When it was discovered that Birmingham's new Law Courts were to be housed behind a frontage of terracotta, masons gathered at the town hall to complain to the council and reinforced their objections

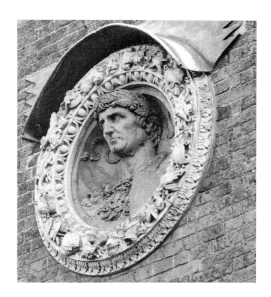

1 Bust of Roman emperor, Hampton Court Palace, by G. de Maiano, c.1520

with a brief strike. Less than twenty years after the lusciously moulded design was completed it was condemned as 'a mess of ineffective ornament' (2).* Terracotta gained a broader, less controversial acceptance in the United States; but the cultural optimism and commitment to ornament that motivated its adoption buckled and eventually collapsed under the trauma of economic crises and the Second World War, and under the pressure applied by new, modernist philosophies of art and architecture.

The reasons why the revival gained sworn advocates and opponents, and why failure and mediocrity so closely paralleled inspired achievements, do not lie in crisp explanations of art history or building economics. Neither a particular architectural style nor precise costs per cubic foot relative to stone brought the material to the fore. Manufacture and use blossomed and waned at the behest of less tractable factors. Following a brief discussion of terracotta terminology, this introductory chapter will identify the major causes and issues in which the material became embroiled.

TERRACOTTA TERMINOLOGY

In Italian, terracotta means baked earth or clay. The term was first applied, in the eighteenth century, to both classical antiquities and contemporary ornaments. During the same period, Coade's Manufactory started moulding plastic clay into sculptural groups and architectural details, but referred to the pale grey or buff ware as 'artificial stone'.

Architectural and sculptural wares made of natural clay had been described as terracotta by 1839 and were itemized as such in the catalogue of the Great Exhibition of 1851.* The word implied that the products were not directly imitative of stone, were decorative in form, and typically

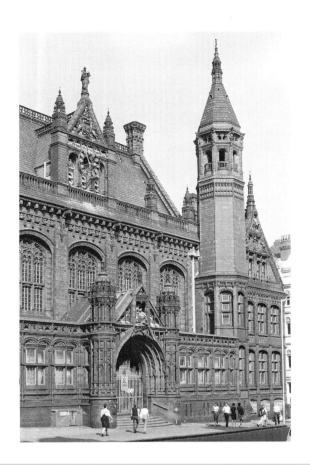

2 Victoria Law Courts, Corporation Street, Birmingham, by A. Webb and I. Bell, 1887–91 (J. C. Edwards)

inspired by the antique. The revival of terracotta as an architectural material reached a climax in 1886, and in that year James Doulton provided a valuable definition of the material: 'That class of ware used in the construction of buildings which is more or less ornamental and of a higher class than ordinary bricks, demanding more care in the choice and manipulation of the clay and much harder firing, and being, consequently, more durable and better fitted for moulded and modelled work.'✫

The distinction between terracotta and faience became a source of confusion as the term faience gained an architectural meaning that differed from its specialist ceramic definition. Most precisely, faience was taken to mean a glazed earthenware, as opposed to majolica, which consisted of a stoneware body coated with a white tin glaze and further coloured glazes. Around the 1880s, the term majolica was dropped in favour of faience to describe any glazed blocks (and later, slabs) intended for architectural use.

Americans sensibly avoided confusion by describing all ware, glazed or unglazed, block or slab, as terracotta. For the purpose of this study, the term 'architectural ceramics' will be used to embrace all the variations of ceramic artificial stone, terracotta and faience. 'Terracotta' will be applied to unglazed ware, 'faience' to glazed ware made in Britain and 'glazed terracotta' to its American equivalent. ✫

APPROPRIATE AND UNDERSTANDABLE ORNAMENT

The marked interest shown in architecture by the educated public in the decades around the turn of the century coincided with a belief that design was not so much a matter of pure style or form, but of conveying the building's purpose and status. After the scaffolding on the Everard Printing Works in Bristol was dismantled in 1901, police had to be on hand for the next two days to control the enormous crowds which gathered to inspect the newly exposed ceramic façade. It was suggested that the frontage designed by W. J. Neatby proved highly popular because it could be 'read like an open book'. Doulton's brightly coloured Carraraware portrayed Gutenberg and Morris pulling their presses and surrounded by their own designs of alphabet (*colour plate 1*). ✦

The Victorians sought an architecture loaded with moral and practical messages. They judged architecture, from town halls to public conveniences, as a barometer of the state of urban society. Books, journals and art training classes created a broad awareness of building styles and materials and of the sister art of sculpture, and most educated people could judge façades and read meanings into them. ✦ They could gauge, as they walked on the opposite pavement or rode on an omnibus, the opulence of apartments in Mayfair by the intricacy of their fenestration, draw inspiration from bas-reliefs on a museum and art school, or be lured by the baroque corner tower of an 'improved' and respectable public house.

Mid-Victorian designers came to regard architectural ceramics as ideal media for introducing 'meaning' into a façade. The simplest approach was to emblazon the name of a business or institution in a pediment or gable-end. Sculptural representations of activities relevant to the building were welcomed as being more subtle and artistic (**3**). The terracotta frieze by Benjamin Creswick on the Cutlers' Hall (1886–7) in London gained warm approval: the scenes of workers forging, grinding and filing 'in such a land as ours must in a sense affect every passer-by, or, we may say, every intelligent observer'. ✦ Narrative decoration was considered particularly desirable on essentially new building types, giving hospitals, public libraries or railway stations a status traditionally afforded to churches, town halls or country houses.

A STYLE FOR THE AGE

The Victorians are regarded as having been preoccupied with the search for an original style of architecture; there was widespread feeling that if architecture was a material reflection of the state of society, then the age of

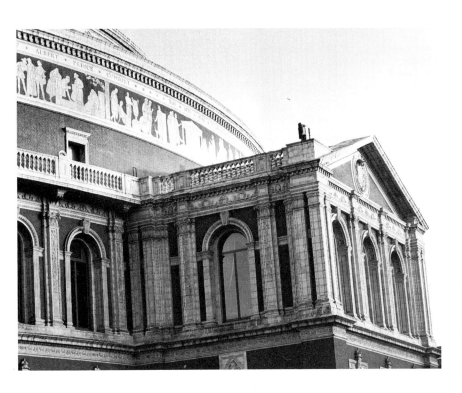

3 Western elevation of
Royal Albert Hall, London,
by H. Scott and
R. Townroe, 1867–71,
showing narrative frieze
(Gibbs and Canning and
Minton Hollins)

industry and the British Empire needed an original form of expression. Many historians regard the quest to break free from the fetters of historicism as a failure. This goal was largely circumvented by the architects who most closely identified with terracotta. Adopting a more pragmatic approach, they considered that their designs needed to relate, if only loosely, to stylistic tradition if they were to be acceptable to a broad public. Originality was cultivated through exploitation of the potential of ceramics for intricate modelling and bold colours, and through the incorporation of narrative decoration.

The arch-pragmatist Matthew Digby Wyatt was convinced that the use of relatively new and highly practical materials such as tiles, terracotta and cast iron was more likely to lead to novelty than 'twisting up old materials into new forms'.☆ Terracotta had the advantage over iron of being a walling material, equatable with stone, and derived from a natural raw material. It had the sanction of historical usage yet was brimming with unexploited potential for contemporary urban architecture.

The Americans initially viewed the dilemma of style in terms of national identity. The greater sense of unity and prosperity that developed after the end of the Civil War in 1865 heightened a concern forcefully expressed by William Potter: 'We have no distinctly American architecture, but rather a free admixture of all sorts and kinds, drawing its inspiration from many fountains . . . our streets might be the streets of the modern part of any European town.'☆

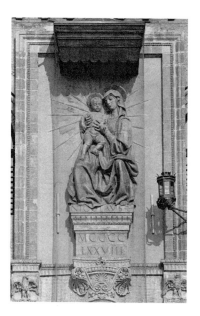

4 Madonna and child in terracotta, by Nicolo dell'Arca, 1478, on Palazzo Communale, Bologna, Italy, 1287, 1425–8, 1444

Colour was accepted as an aid to originality both in Britain and America. In the 1850s Owen Jones had put forward the principle that colour should complement style, assisting 'in the development of form' and 'light and shade'.✫ The discipline of repetition, with large numbers of forms being pressed out of moulds or dies, was seen as another path towards novelty.

POPULARITY AND VULGARITY

The belief that terracotta and faience decoration could be both improving and popular arose out of the South Kensington philosophy that ceramics were an ideal medium for imparting 'correct' principles of design and feelings of deference among the masses. As late as 1894 Walter Crane described productions by the Renaissance-inspired Della Robbia Pottery in Birkenhead as 'a form of art which by its vigorous design, frank colouring and dramatic capacity would be essentially popular in its appeal, while eminently educative and refining'.✫

As its use became more directly commercial, terracotta was perceived as a threat to the integrity of architecture both as an art and as a profession. Gottfried Semper, a progressive German theoretician who lived in Britain during the 1850s, had recognized that one danger of an industrialized society was that the designer would become the slave of the employer and of prevailing fashion. Amidst such fears terracotta appeared rather too pliable and popular, especially to those who revelled in the exalted status afforded to the artist and his labour by the Romantic movement. The élite of the architectural profession mistrusted a material that offered a short cut, enabling even a builder to create richly ornamental designs by collaborating

with a sales representative from such companies as Doulton, Burmantofts or Hathern.

Essentially there were architects who did, and those who did not use terracotta and faience. One described himself as becoming 'a "vert" to terracottaism'. Leonard Stokes bluntly recorded the aversion felt by the most highly regarded figures within the profession: 'Men like Norman Shaw and G. F. Bodley never meddled with the material, or if they tried it, did so only to drop it like a hot potato.'*

The American architectural profession tended to be more youthful, open-minded and willing to come to terms with the commercial origin of most of its commissions. Many leading figureheads made use of terracotta, while two pioneers in the development of the ceramic-clad skyscraper, William Le Baron Jenney and John Wellborn Root, had been trained as engineers rather than architects. Even amidst the swing towards classicism and the pursuit of the formally planned 'City Beautiful', the prevailing optimism and faith in urban economic and social institutions gave a broad acceptability to a manufactured decorative material.

SULPHUROUS SMOGS

The Victorians were haunted by soot and the damage it wrought on their buildings, but belching chimneys were regarded as a sign of economic prosperity and, judging by London's nickname 'the Old Smoke', even with affection. Unwilling to impose a solution through controlling pollution they welcomed a palliative in the form of terracotta and faience. Smog became regarded as a major threat to health at exactly the moment when the revival of terracotta reached its climax. During the great fog of 1886 the mortality rate in London equalled figures for the worst years of cholera during the 1840s.

Ceramics were adopted for their clean and healthy image rather than for any proven ability to resist the effects of smoke pollution. The crispness of the detailing on the Renaissance Certosa di Pavia (*colour plate 4*) and on sculpture in such cities as Bologna (**4**) was quoted as evidence of terracotta's suitability to withstand the effects of sulphurous soot, but without any consideration of the difference in air quality between Lombardy and London. Most ceramic façades were not washed down and within a couple of decades they became stained and engrimed. The streets of Edwardian cities were lined with grubby red buildings which, although perfectly sound, tarnished terracotta's reputation. The enthusiasm of Halsey Ricardo for polychromatic faience was countered by concern at the gaudiness of glazed surfaces, and by a resurgent traditionalism which favoured the streaked patina of traditional stonework. A leading article in the *Daily*

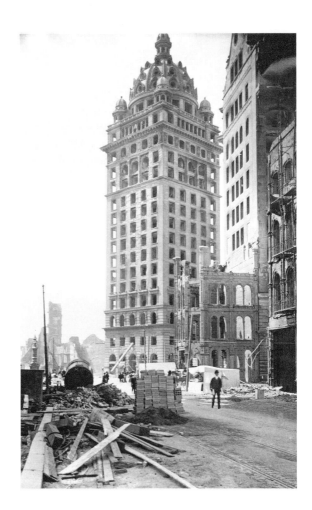

5 The Call Building, with terracotta cornices and dome, standing amidst the ruins of the centre of San Francisco after the earthquake and fire of 1906

Telegraph stated, 'we have no desire to live in London built of glazed ceramics in as many colours as Joseph's coat.'☆

The Americans initially dismissed smog and soot as a British phenomenon; but sanitary surveys of Boston and New York in the 1860s highlighted the medical dangers of bad air, and by the 1880s Chicago had become seriously polluted by smoke from the boilers of industry, railway locomotives and steamers. Pittsburgh suffered the worst pollution and possibly the highest rates of disease in the United States. Willard Glazier wrote in 1883: 'Pittsburgh is a smoky, dismal city, at her best. At her worst, nothing darker, dingier or more dispiriting can be imagined'.☆

FIREPROOFING

If soot concentrated the attention of British architects on the practical attributes of terracotta, the Americans were equally motivated by the danger

of fire. Remarkable strides in the use of iron framing and brick flooring had occurred in England during the late eighteenth century, but most Victorian architects proved unwilling to accept the rigour of full fireproof construction. The most common structural form for the majority of nineteenth-century warehouses, workshops and even textile mills was far from fireproof; timber or cast-iron columns supported heavy wooden beams which in turn carried wooden floorboards. Brick arches resting on iron beams might be specified for larger and more expensive projects.

A fundamental flaw in established tenets of fireproofing became apparent during the 1840s. Iron was incombustible but was not fireproof. A fierce fire would cause exposed tie-rods to expand and columns to crack, if they had not already been destroyed by the heat of the flames. Extreme heat would result in the metal melting, while a sudden drop in temperature produced by jets of water could result in cracking and collapse. It was soon appreciated that structural ironwork was best protected by being encased in ceramic, cement or concrete.

The United States showed a morbid preoccupation with fireproofing owing to the lethal combustibility of its timber-framed and -clad buildings. The American property-owner became satirized as tending 'to burn up his buildings at intervals'.✻ The catastrophic fires in Chicago, Boston and San Francisco encouraged the use of ceramic blocks and slabs as well as light-weight porous terracotta, called lumber, as a key element in the fabric of skyscrapers, stores and warehouses (5).

TERRACOTTA IN ARCHITECTURAL HISTORY

In the Edwardian and inter-war periods the term terracotta was used as a pejorative and condemned by such phrases as 'the raw-meat era' or 'the corned-beef style'. Historians writing in the fifties and sixties tended to be equally dismissive, condemning the output of Ruabon, Accrington or Burmantofts in terms of insensitive monotony, and classing decorative ceramics as rogues – reactionary, indulgent and second-rate.

The terracotta revival must be examined in the context of contemporary desires to improve the appearance of city streets, and the willingness of architects and potters to embrace the mass production of ornamental clay-ware. Their achievements are best analysed by exploring not only the end results but also by examining how designs were developed and detailed, and how the resulting façades were judged, not just by acknowledged critics, but where possible by clients and the general public.

'A CLAYWORKER'S ELDORADO'

Geology, Technology and Entrepreneurship in Britain and America

CLAYWORKERS AND PRACTICAL GEOLOGY

The bright red façades of Waterhouse's Prudential offices gained their colour from the marl clay-banks at Ruabon, while most of the contemporary examples of buff ceramics in New York or Philadelphia were moulded from clays dug around Perth Amboy in New Jersey. The growth of the terracotta industry and the use of its products were closely influenced by the distribution of mud compacted over several millennia to form clay. The transformation of marl and shale into building ornament involved more than just a dry collaboration between managers, modellers and draughtsmen; they were in part inspired by the mystique of a richly coloured and decorative material having remote and earthy origins.

The relationship between geology and industry was dictated by the need for clay bodies used for making terracotta to have very specific properties. They had to be of a fine texture to carry detail and to burn to a smooth surface. They also had to be sufficiently plastic to retain their modelled form until the pressed blocks were dried and fired. Too much moisture would cause heavy shrinkage and twisting in the kiln. The body had to be slightly porous, allowing water to escape during the early stages of burning; however, open bodies were liable to damage by rainwater and atmospheric pollution. With the best clays, the surface was expected to vitrify slightly at full firing, creating a hard, impervious skin.

There was no perfect body, only a variety of compromises: these were largely dictated by the need to control shrinkage and to achieve an even colour. Several ideal compositions for terracotta were proposed, a typical example being 70 per cent silica, 20 per cent alumina, 7 per cent water and 3 per cent iron. Such chemical analyses failed to draw attention to all-important physical properties, which could be altered significantly by each stage of the manufacturing process. Clay preparation was just as important as the proportion of silica in determining plasticity while firing conditions contributed as much as iron oxide towards the creation of a buff or red colour. ✩

The terracotta industry of late-Victorian Britain was dominated by aspiring brickmakers, frustrated by the stigma applied to their rough and mundane trade, and seeking prestige as much as profit through working with architects and sculptors. They often complemented their contribution to the architectural arts by adopting a gentrified life-style. John Coster Edwards, the 'greatest manufacturer of terracotta in the world', started out as a brickmaker, employing a man and two boys. He came to own five

works around Ruabon in Clywd, North Wales, employing nearly a thousand men. Having built a country house, he took up a string of public positions. His obituary described him as having 'the grace and distinguished air of the typical country squire'. ✶

The American industrialists who made terracotta can be categorized as being rather more down-to-earth in their approach to business, forming new companies, rapidly rebuilding after fires, moving from one city to the next and chasing profits rather than knighthoods. Some of the entrepreneurs were first-generation migrants. Others had already made fortunes in different areas of commerce, such as sugar or tobacco, and had been drawn into the terracotta industry at a time of booming demand. A number had come from terracotta works in England, most notably James Taylor and Joseph Joiner from Blashfield's in Stamford. In the twentieth century managerial control was likely to be entrusted to graduates in science or business. Their hobbies were more likely to be driving automobiles than hunting or watercolour painting. ✶

Founding entrepreneurs, whether British or American, had to decide where to site their works and what to manufacture in the light of the known clay reserves. Clayworkers were generally one step ahead of gentlemanly geologists in appreciating the value of particular strata. In most parts of the country, they were boring trial shafts and experimenting with mixing marls and fireclays long before the Geological Survey published its reports, maps and cross-sections. ✶ George Maw, joint owner of the largest decorative tile works in Britain at Jackfield, Shropshire, developed an extensive collection of samples and fired trials for 120 different types of clay. The United States Geological Survey published remarkably comprehensive reports on the clay geology of many American states and did much to promote a more systematic understanding of the nation's reserves. ✶ Such survey work was complemented by increasingly scientific analysis of clay bodies and their properties, several studies being promoted by the National Terra Cotta Society.

SIMPLE AND COMPOUND CLAY BODIES

The nature of the clay bodies used for terracotta was influenced by a vigorous debate that originated in England in the 1860s. The fundamental issue was whether clay bodies should be made up of one type of clay or a carefully chosen mixture. This apparently simple choice marked out different camps in the terracotta trade, all too apparent in the ceramic architecture of London or Chicago, since each approach was supported by groups encompassing both industrialists and architects. John Blashfield and James Taylor, the father of the American industry, claimed that: 'Terracotta should be made by compounded materials, capable of being worked into large pieces of

practically correct lines, delicately finished by hand-work after being taken from the moulds, and of uniform shape and colour.'✶

Taylor, who had worked with Blashfield during the 1860s, summed up with rather less sympathy the opposing stance taken by Gibbs and Canning, J. C. Edwards and a group of major architects including George Gilbert Scott and Alfred Waterhouse. They maintained: 'That terracotta can be made of simple fireclays. That the pieces should be small. That the original models should be good, of low relief, and that the work should be burned as it leaves the mould without any finish or under-cutting by hand; that slight warping and variations of shade and colour is artistic rather than otherwise.'✶

The latter approach prevailed in late-Victorian England and gained a brief sway in the United States. It corresponded to the architectural principle that terracotta should be regarded as a development of brick rather than a substitute for stone. There was also an economic justification, particularly in England, since the use of simple coal-measure clays enabled 'the manufacturer to use more unskilled labour, less expensive machinery, cheaper kilns, reduces the risk of failure and allows economy in the cost of the raw material'.✶

American clayworkers generally subscribed to the compound approach, reflecting the domination of Blashfield's example through the work and writings of Taylor and, most specifically, the decision to import terracotta made by Blashfield rather than Gibbs and Canning for Boston's Museum of Fine Arts. The compound approach ultimately won through, proving to be more appropriate to glazed terracotta, where a precise blending of clays could ensure a compatibility with glazes applied to the surface. The colour of the fired body was no longer of consequence, since it would be obscured. By the early decades of the twentieth century the major British firms had adopted a compromise of mixing material from their own reserves with fireclays and ball clays from Devon or Dorset.

Most manufacturers accepted the value of leaving clays to weather for several months before being worked. Weathering broke down hard lumps into a state suitable for grinding, improved the purity and plasticity of the clays and enhanced the colour of the burnt goods. Some hard shales and fireclays were stored out of doors for up to three years before being used. Mechanical processes of preparation complemented and increasingly offered an alternative to having clay stocks tied up for long periods (fig. 2.1). A typical sequence was for clay to be dry-ground, screened and combined with burnt ceramics, called grog in Britain and grit in the United States. This mixture would be fed into a wet pan-mill to obtain the right degree of plasticity, in a process called tempering. The materials would be fed into a pug-mill whose rotating blades, powered by horse and later steam, thoroughly mixed them into plastic wads ready for pressing. Ibstock

Hathernware prepare fireclays for the manufacture of faience in a pan-mill, while high-grade bodies for fine terracotta work are mixed with water in a blunger and pumped into a filter sieve, before being combined with grog and passed through a pug-mill. Blashfield and his disciples frequently added a range of other materials such as silica and other fusible bodies. The witches in *Macbeth* would have been proud of the way in which he conjured up his clay recipes, adding 'flint, old ware, so much glass and so much China stone'. ✫

James Taylor ensured that Blashfield's eccentric approach was taken up in the United States, initially through his post as Superintendent of the Chicago Terra Cotta Company. In 1876 Taylor was using pit clay combined with calcined flints. Finely decorated statuary would be coated with a boiled slip made of a red or buff clay and coloured as appropriate by metallic oxides. ✫ He became the coast-to-coast trouble-shooter on clay bodies and terracotta, a role that appears to have been increasingly resented by indigenous clayworkers. In 1888 he advised Gladding McBean on a 'semi-glaze', offering further information as long as it was kept 'private for your use

fig. 2.1 Stages in the production of terracotta and faience (*Transactions of the Ceramic Society*, 35, 1935, p.45)

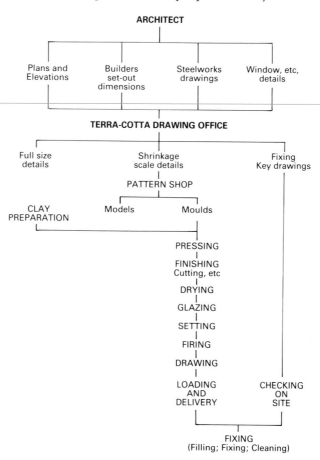

ARCHITECT

Plans and Elevations | Builders set-out dimensions | Steelworks drawings | Window, etc, details

TERRA-COTTA DRAWING OFFICE

Full size details | Shrinkage scale details | Fixing Key drawings

PATTERN SHOP

CLAY PREPARATION | Models | Moulds

PRESSING

FINISHING Cutting, etc

DRYING

GLAZING

SETTING

FIRING

DRAWING

LOADING AND DELIVERY | CHECKING ON SITE

FIXING (Filling; Fixing; Cleaning)

fig. 2.2 (left) Map showing the location of the major manufacturers of terracotta in Britain, *c.*1870

fig. 2.3 (right) Map showing the location of the members of the Terra Cotta Association in Britain, 1929

only'.✶ Such piecemeal advice had little place by the turn of the century. Gladding McBean had appointed a civil engineer with a specialist knowledge of chemistry to supervise the development of their clay bodies. Joseph DeGolyer had no time for Taylor, dismissing his samples of semi-glaze as 'no more than a fine slip' and rejecting his 'white semi-glaze' for turning green.✶

THE GLAZE LABORATORY

Glazed finishes brought new constraints on most stages of terracotta-making: the choice of bodies, modelling, and firing. The bulk of faience made in the nineteenth century was fired twice, first in biscuit form and again at a lower temperature after the glaze had been applied. The cost was prohibitive for large-scale architectural work. A single-fired faience was introduced in England in 1888; glazes were applied as soon as the pressed clay was dry, the body being burnt and the glaze hardened in one firing. The development of a broad palette of glazes required new levels of delicacy. Glazes consisted of a mixture of fluxes and colouring ingredients, very finely ground and mixed to a cream with water. They had to have a comparable shrinkage with the clay body, and the colours had to remain clean and consistent when in contact with kiln gases. The glaze material had to fuse to a glass at a temperature closely approaching that at which the body reached maximum strength in the kiln.

The London firm of Doulton led in the development of glazed ceramics for external architectural use. The American industry quickly followed suit. An expert in glazed-brick production from Tamworth, Staffordshire, had been brought to the works of the Perth Amboy Terra Cotta Company in 1884; T. C. Booth succeeded in pioneering the introduction of a white-glazed terracotta in the United States between 1894 and 1897. His fully glazed terracotta was converted to a matt finish by the rather drastic measure of sand-blasting.✶

For a few years the glaze chemist was the key figure within a terracotta company. He often proved to be a fickle character, examples being quoted at both Leeds Fireclay and Perth Amboy of his departing in high dudgeon, refusing to divulge his formulae. Firms were forced to repeat all their experiments. Gladding McBean spurned the possibility of any useful advice from Taylor on developing a white glaze at a single firing, turning to an academic ceramicist for guidance.✶ Professor Orton had established the first State

Oldhaven, Blackheath, Woolwich & Reading & Thanet Beds Ball Clays Coal Measure Clays

Gibbs & Canning ● Blashfield ●

Pulham ●
Doulton ●
● Blanchard

Leeds
Fireclay
● Shaw
Bispham Hall ●
H Dennis ●
J C Edwards ●
● Hathern
Gibbs & Canning
G King ●
Doulton ●

Carter ●

Ceramic School at the University of Ohio and promoted a more scientific approach to glazes and other aspects of terracotta production. ⁕ One of his first graduates went to work at the American Terra Cotta Company, the firm which executed some of Louis Sullivan's finest ornamental designs.

GEOLOGY AND INDUSTRY IN ENGLAND: THE LONDON BASIN, THE MIDLANDS AND THE NORTH

At almost every stage of the revival, terracotta firms were clustered in different parts of Britain and using different clays. Since there was a regional emphasis in the market of most firms, a loose vernacular relationship between clay geology and terracotta can be identified. In simplest terms the industry progressed from working newer to older deposits; relatively recent Eocene clays in the south of England became supplanted by Keuper marls and Triassic clays from the Midlands and, from the middle of the nineteenth century, by still older coal-measure marls and fireclays (figs. 2.2–3).

Pioneering firms based in London used china and ball clays shipped round from the south coast; by the 1880s Doulton was the only major producer still based in the capital. Narrow outcrops of Eocene clay that circle the

6 The clay-bank at J. C. Edwards
Pen-y-bont Works, Ruabon

7 View from Rhos with terracotta caps
and copings, looking towards the
spoilheap of Hafod colliery and the
works of Dennis Ruabon

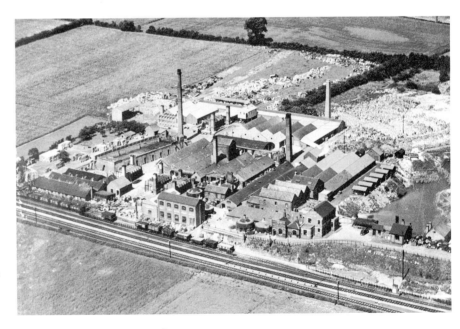

8 Aerial view of the
works of the Hathern
Station Brick and Terra
Cotta Company's works,
now Ibstock
Hathernware, near
Loughborough

London basin attracted Pulham and Blanchard to move out to Broxbourne in Hertfordshire and Bishop's Waltham, Hampshire. The same band was exploited by S. and E. Collier at Reading. Devon and Dorset gained their own works, the most significant being the Watcombe Terracotta Company near Torquay, and George Jennings and Messrs Carter at Poole.

Clays found interspersed with chalk and limestone were, in most areas, only good enough for ordinary bricks. However, John Blashfield took his works from Millwall in London to Stamford in Lincolnshire to exploit a bank of Jurassic clays. Almost at the other end of England's limestone belt, the Stonehouse Brick and Tile Company found both clay and coal on the edge of the Cotswold escarpment. The red clays to be found at Bridgwater in Somerset and on the edge of Nottingham were ideal for finials, plaques and garden ornaments.

The late-Victorian boom in the terracotta industry was entirely dependent on the exploitation of coal-measure shales and fireclays. The same geological sequence that underlies the Staffordshire Potteries re-emerges thirty miles to the west just over the Welsh border, and some of these clays have properties ideal for making terracotta. During the 1880s the small town of Ruabon became synonymous with the indestructible bright red blocks used on public buildings and suburban houses across England and Wales. The reserves at J. C. Edwards's Pen-y-bont works were described as a 'clay-workers' "Eldorado"', and formed the basis of the largest terracotta works in Britain (**6, 7**). ✷

The coalfields of the Midlands present a diverse geology. Clays around Ironbridge in Shropshire were excavated by two major tile-manufacturers, Maw and Craven Dunnill, to make decorative tiles and faience. Stourbridge fireclays, at the southernmost point of the Black Country, were worked into terracotta by Doulton at their Rowley Regis works. The first major works in the coal-measure clays, Gibbs and Canning, was sited at Tamworth. Four miles to the north of Loughborough and just off the coalfield, the Hathern Station Brick and Terracotta Company, founded in 1874, combined clays dug behind their factory with material brought in by rail. Like many of their competitors Hathern started as makers of facing-bricks and progressed to the production of terracotta (**8**). Ibstock Hathernware combine West Country ball clays and Scottish fireclays, mixing in a clay from Cattybrook, near Bristol, if a red colour is required.

Yorkshire and Lancashire's manufacturers proved particularly successful from the turn of the century. Following discovery of a seam of fireclay in a coal-mine at Burmantofts on the eastern edge of Leeds, Wilcock and Company began undertaking architectural contracts from around 1880. Yorkshire's fireclays extend underneath the Pennines to the Lancashire coal-field, where they were exploited for terracotta in the wake of a 'brick fever' during the 1890s. Works in the region of Accrington competed with Shaws

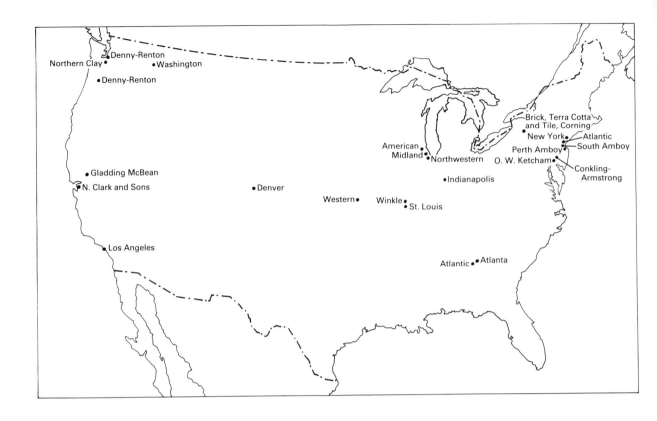

of Darwen, founded in 1897 initially to make glazed bricks and sanitary ware.

Britain's other coalfields only supported a modest level of production. The Cattybrook Brick Company worked the seams of the Bristol coalfield to make dressings for terraced housing. During the 1850s fireclays of the central Scottish lowlands were briefly used to make garden and architectural ornaments. In Northern Ireland, the Lagan Vale Estate Brick and Terracotta Works supplied contracts in Belfast during the Edwardian period.

GEOLOGY AND INDUSTRY IN AMERICA: THE EASTERN SEABOARD, THE MIDWEST AND THE PACIFIC COAST

The American terracotta industry first developed in a stable form in the 1870s, and less as an adjunct to brickmaking than in Britain. The heavy-clay industry was not developed sufficiently to act as a foster-parent, while urban potteries and china works were often dependent on clays imported from England. Pioneering manufacturers overcame their fragmentary knowledge of America's vast clay resources by shipping in proven materials

fig. 2.4 Map showing the location of the works of the
members of the National Terra Cotta Society in the United
States, 1920

or dispatching finished blocks over large distances. The first red terracotta
in New York City was made in Chicago from Ohio clays, while the first
red terracotta building erected in Chicago was made in Perth Amboy from
New Jersey clays.✶

North America's clay geology is particularly rich in young clays, with
the result that the ceramics industry was less directly associated with coal-
mining than in England. Easy-to-work Cretaceous clays abounded in the
eastern-seaboard states of New Jersey and Maryland. Carboniferous clays
were used in Midwestern states such as Missouri and Indiana while younger
clays once again predominated on the Pacific coast (fig. 2.4).

The Cretaceous clays of Massachusetts only occur in pockety deposits of
variable quality. In 1877 the Boston Fire Brick Company started making
terracotta using clays prepared to the required consistency in Chicago. The
Grueby Faience Company was established in Boston in 1897 but shipped
in most of the clays needed for making high-quality tiles and faience
fireplaces.

The New York Architectural Terra Cotta Company, dating from 1886,
combined clays excavated on Long Island and Staten Island with others
shipped in from New Jersey. The Atlantic Terra Cotta Company estab-
lished a works at Tottenville on Staten Island in 1897; by amalgamating
with two other major companies in 1907 Atlantic emerged as the largest
producer of terracotta in the world. Most of the works in New York State
gave up using local clays by the early 1900s to import material from New
Jersey and Pennsylvania. By the mid-eighties 90 per cent of the nation's
terracotta was made with these clays, the Perth Amboy Terra Cotta Com-
pany being one of the leading firms and forming a major constituent of the
Atlantic combine.✶

The high-quality clays of Maryland are closely related to those of New
Jersey, but occur in smaller and more variable deposits. The Burns and
Russell Company progressed from producing face-brick as early as 1790 to
selling terracotta from the mid-1880s, but proved as footloose as a modest
brickyard, relocating once each outcrop of suitable clays had been ex-
hausted. Further south in Georgia, white refractory clays from the
Cretaceous period were mined for shipping to firebrick and terracotta firms
in several east-coast states. They were used by possibly the second oldest
producer in the United States, Pelligrini and Castelberry, founded in 1875
and retitled the Atlanta Company in 1895.

America's most important clayworking state, Ohio, parallels the North
Staffordshire Potteries of England in that the coal-measure fireclays and

older Devonian shales proved less than ideal for architectural terracotta. A firm at Wellsville made terracotta as early as 1867 but only in the form of garden vases. The Rookwood Pottery at Cincinnati, south of the main clayworking region, initially used Ohio clays but came to work raw material from other states by the time it was producing intricately glazed tiles and panels of faience.

The midwestern terracotta firms were largely dependent on Carboniferous clay, although the great ceramic city of Chicago was surrounded by only poor-quality deposits. Manufacturers had to turn to the coal measures of Indiana and Missouri to produce cladding material for the city's skyscrapers. James Taylor, as Superintendent of the Chicago Terra Cotta Company, bought shales and fireclays mined in a region of Indiana aptly named Clay County. In 1877 a group of his workers left to set up in competition. Their works, incorporated in 1888 as the Northwestern Terra Cotta Company, supplied the ceramics for the majority of Chicago's skyscrapers.

The high-quality clays of Brazil County prompted the establishment of the Indianapolis Terra Cotta Company in 1884, while St Louis gained a terracotta works in 1887 when Joseph Winkle leased a small factory from a firm that had been using the local fireclays. Terracotta manufacture was established in other midwestern states relatively late and without upsetting the markets of the major-league firms. The Western Terra Cotta Company set up in Kansas City in 1906, while the Denver Terra Cotta Company was founded in 1911.

Of the American factories, those on the Pacific coast were most likely to be located directly adjacent to clay-banks or -mines. The prime reserves, as on the eastern seaboard, were within recent strata of the Tertiary period, and therefore rarely associated with coal. Alternative fuel sources for boilers

10 (above right) Ernest Kadel's office, Gladding McBean, Sacramento

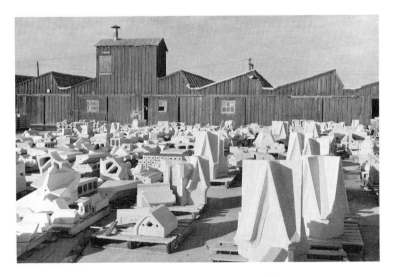

9 Massive terracotta blocks in the courtyard of Gladding McBean's works, Sacramento

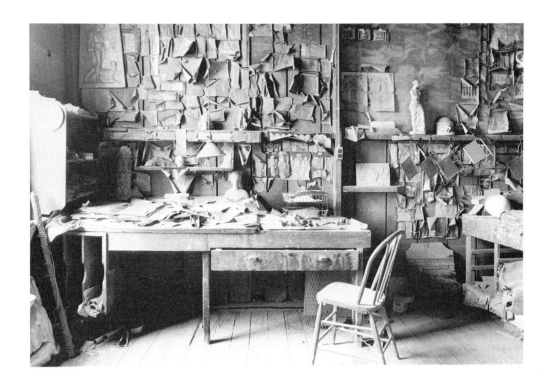

and kilns were to hand in the form of wood or oil. Following the discovery of clay and coal at Lincoln near Sacramento, California, in 1874, the largest producer in the West, Gladding McBean, was established initially to make pipes, the production of terracotta starting in 1883 (**9**, **10**). Other firms were scattered up the length of the coast and also combined terracotta with another product line. The Los Angeles Pressed Brick Company progressed to making terracotta and hollow fireproofing only a year after it had been established in 1887. Nehemiah Clark found valuable clay deposits while prospecting for gold at Sutter's Fort, now Sacramento, but his firm of N. Clark and Son only started producing terracotta once it had relocated to Alameda, also in California.

MODEL, MOULD AND MACHINE

Terracotta was venerated as an art manufacture, but was only economical when forms were replicated by pressing. The scope for mass production hinged on the capabilities and limitations of plaster models and moulds. Full-size drawings, once approved by the architect, had to be produced to oversize scale to allow for shrinkage, and models made up to form the core for moulds into which the clay would be pressed (fig. 2.1). The skills involved were virtually unknown in the brick industry and were more complex than those required in most pottery and china works. Designers

of tableware never had to allow for a shrinkage of several inches, nor for expansion joints or for coursing with brickwork. �ș

One consequence of the need to make models and moulds for terracotta was that the traditional sequence of architectural design had to be reversed. Whereas with stone, decorative details had been among the last elements of a building to be finalized, they had now to be among the first, since the terracotta manufacturer needed around eight weeks before making his first deliveries. A near-standard procedure in the supply of drawings was established by the turn of the century. The architect usually supplied small-scale designs from which the terracotta draughtsman would develop 1:20 scale elevations, and full-size details which in turn were used for the calculation of the slightly oversize plans and sections.

Once approved by the architect, drawings were sent to the plasterer's shop (**11**). Using simple guides and templates, plaster could be worked accurately to create models of the desired forms, and moulds for their manufacture. Complex profiles could be turned on a lathe or run on a 'horse', a wooden block carrying a piece of sheet zinc which was cut to the desired section (fig. 2.5). The zinc profile was run up and down a bench, so shaping a mass of wet plaster (**12, 13**) (figs. 2.6,7). For complex pieces, hand-worked clay details were frequently applied to plaster models. Even one-off sculptural figures were usually first modelled in fine clay, often on large easels, and then re-created via models and moulds in coarser but more durable terracotta (**17**). Completed models of decorative work would be inspected by an architect, either on a visit to the works or increasingly, from the 1890s, through forwarded photographs (**14, 15**). Following any modifications, moulds could be taken. Plaster was poured and built up round the model into a space enclosed by a surrounding wall. Each mould had to be designed so that it could be removed easily after being filled with clay (figs. 2.8,9).

The ingenious use of plaster models and moulds allowed manufacturers

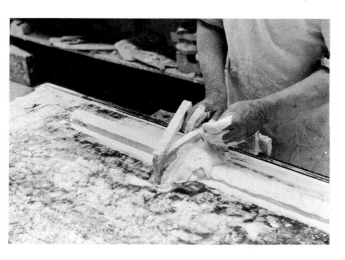

11 (far left) Plaster-modelling shop at Ibstock Hathernware

12 (centre) Over-scale section-drawing and zinc template at Ibstock Hathernware

13 Running a simple plaster moulding using a 'horse', Ibstock Hathernware

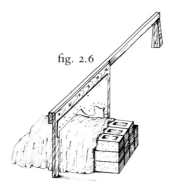

fig. 2.6

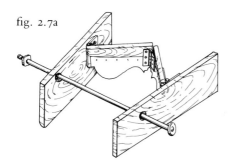

fig. 2.5

fig. 2.5 Cross-section for model, profile of template, and form of zinc template mounted on wood; template and block forming a horse to run along the edge of a slate bench to create models for running decoration

fig. 2.6 Zinc template mounted on a beam to be swung over a brick former covered in wet plaster to build up the model of a curved arch

fig. 2.7a

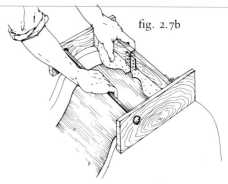

fig. 2.7b

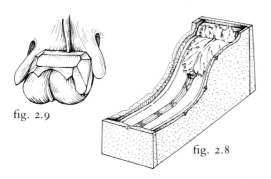

fig. 2.9

fig. 2.8

fig. 2.7 (a) A wooden template with a central hinge, to create the model for a diminishing keystone; and (b) about to be drawn over a mass of wet plaster

fig. 2.8 Four plaster slips forming part of the mould round a model of a keystone; note the tip of the acanthus scroll and the small plaster insert to facilitate replication of the undercut modelling

fig. 2.9 A detail of the acanthus scroll showing the plaster insert set into the undercut

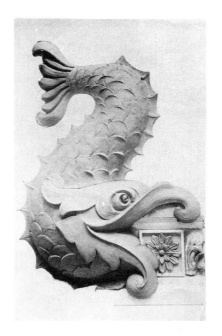

14 (far left) Drawing showing fish detail of the Palace Cinema, Southall

15 Photograph showing modelling of the same fish detail

to produce a bewildering array of architectural details. Coade's collection of models and moulds proved to be a valuable treasure-house of designs for up to half a century. Once terracotta was being made primarily as integral architectural detailing that had to course in with brickwork, the sale of stock forms became less practicable and less acceptable ethically.

16 Terracotta extrusion machine, Gladding McBean

Attempts were made to spare the time and expense involved in using plaster models and moulds. Experiments were undertaken with moulds of gelatine and with extruding simple terracotta sections by machine. Doulton, with their cellular terracotta introduced about 1890, was the only British company to make much use of extrusion. The major American firms, and in particular Gladding McBean, achieved far greater success in extruding simple architectural ashlar and running mouldings from machines developed primarily for the manufacture of sewer-pipe (**16**). Some of the earliest slab faience, in the form of large rectangular tiles, was either extruded or pressed with a back webbing which was knocked out before the goods were dispatched. Most of the slabwork produced in Britain during the late 1930s was cast in banks of moulds produced from simple plaster models. The technique of slip casting is also useful for forming enclosed shapes such as balusters.

In comparison with the precision and artistry required for model- and mould-making, the actual pressing of terracotta blocks was relatively

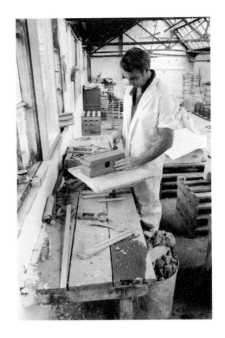

18 Clay pressed into plaster moulds, Ibstock Hathernware

19 Trimming a small block following removal from the mould, Ibstock Hathernware

20 Drying-rooms, showing the use of sacking to control shrinkage, Ibstock Hathernware

21 Glaze-spraying room, Ibstock Hathernware

unskilled and repetitious. In larger works the pressing-shop became organized like a production line, moulds being set in a row with a pressing-table running down the line on tracks. Each mould had its inside surfaces lined with strips of clay about one and a quarter inches thick, which were beaten into the detail of the plasterwork by fist. Cross-pieces called straps were inserted where necessary to provide greater rigidity. The back of the ashlar block, exposed at the open top of the mould, was simply trimmed off with a metal wire tensioned by a bow (18).

The prime advantage of using plaster for the moulds was that it absorbed moisture from the surface of the clay, causing slight shrinkage in the block. This enabled the piece to be removed from the mould, after a few hours if it was a simple block and within the working day if it was more complex.

The rate at which moulds could be refilled was limited by the fact that they retained moisture from the clay. If a mould was damp when used for pressing, clay tended to catch on the plaster. Most moulds were badly worn after they had been used for pressing about fifty to sixty blocks; to make large numbers of a particular block, duplicate moulds had to be used. A considerable amount of manual finishing might be required for each block – cutting holes, inserting struts and scooping out undercuts. Knives and boxwood tools were used to clean up any blemishes and create a smooth surface (**19**).

Model- and mould-making and clay-pressing normally took several days but could be rushed if necessary. The subsequent stages of drying and firing imposed almost inflexible constraints on the rate at which terracotta could be supplied. Control over the initial stages of drying had to be far more precise than for bricks or tiles, which were traditionally left in the sun and fresh air, or exposed to waste heat from the kiln. Water had to be driven off carefully at first, for if the surface dried much faster than the inside, warping and cracking would occur. Such hairline cracks would expand in the kiln, possibly with explosive force.

Two systems of controlled drying were developed. Steam heating was effective in drying large pressings, and most works came to include rooms surrounded by pipes. Blocks and sculptural figures were left there, eerily draped in damp sacking to control the rate of shrinkage, and set on wooden pallets or even rollers to reduce friction as the pieces contracted (**20**). In the twentieth century the tunnel drier satisfied higher standards in drying, but there was some prejudice that an enclosed tunnel could not accommodate terracotta in all its various forms. The ideal solution was the humidity drier, whereby steam-saturated air could, in a day, dry material that would otherwise have needed four days or even a week. Once dry, blocks could be sprayed or dipped to give a glazed finish (**21**).

MUFFLE TO TUNNEL KILNS

Jonathan Harmer was able to burn his terracotta tablets and urns in a domestic bread oven,✶ but architectural work required a kiln that could create a temperature of over 1,000°C with plenty of oxygen, and in which the goods were protected from the flames and smoke. The adoption of coal firing and the exacting standards of china manufactories brought rapid advances in kiln design. Down-draught and muffle kilns enabled both the temperature and the oxygen level to be precisely controlled. An even temperature was ensured by directing the heat up behind the walls and then down through the ware, or by radiating it through the 'muffle' which

fig. 2.10 (left) J. M. Blashfield's patent design for a muffle kiln, 1 March 1860

fig. 2.11 (right) Cross-section of a down-draught kiln with integral chimney, used for burning terracotta at Ruabon (*Building News*, 60, 1891, p.275)

completely lined the kiln and protected the goods from being discoloured by the fire.

The muffle kiln became the industrial hallmark of the continuum of terracotta technology from Coade, through Blashfield, to the first generation of American manufacturers. The larger design of muffle kiln used by Blashfield at Stamford was capable of burning twenty-five tons of terracotta in each firing, but only by the consumption of twenty tons of coal over a period of eight to fourteen days (fig. 2.10). The Taylor brothers, James and Robert, ensured a widespread take-up of muffle-kiln technology in America. In 1871 James Taylor installed two muffle kilns of Blashfield's 'improved' type at the reorganized Chicago Terra Cotta Works. The fire passed completely around the inner muffle and up a pipe-flue in the centre. The ware was set on movable floors made of slabs of fireclay.✶ Taylor subsequently built seven kilns of this type at Boston, and several of the kilns at Perth Amboy were erected to the same design. For the seven kilns that he erected at the New York Architectural Terra Cotta Works the fire grate was set directly under the main chamber. American firms were remarkably slow in moving away from the use of muffle kilns, possibly because wood was cheaply available as a fuel but also owing to fears of buff-coloured ware being discoloured in any other type of oven.

During the early Victorian period the nascent British terracotta industry struggled with the challenge of firing large ornamental blocks in down-draught kilns; they offered greater economy and speed in firing, with the heat being directed down over the ware and out through the gridded floor to a chimney-stack (fig. 2.11). Of the plethora of designs for down-draught kilns, the cupola, so named because of its circular plan and dome-shaped top, was the most widely used for terracotta. It was favoured by the works on the Midlands coalfields, and about twenty-five examples of this design were used at J. C. Edwards's Pen-y-bont works, near Ruabon (**22**), while examples currently in use at Hathern are of rectangular plan (**23**). The Americans belatedly accepted the use of down-draught kilns for firing terracotta, typically once they had adopted oil or gas as a fuel (**24**).

From the late 1920s some faience was fired in tunnel kilns. The goods travelled on trolleys through tightly enclosed heating, firing and cooling sections. The capital cost of tunnel kilns was very high and they allowed little flexibility in production. Both Hathern and Shaw ran small pieces of faience through them during the inter-war period, while several American plants used them for almost all of their production, one of the main advantages being the reduction in firing-time, from between a week and ten days to between three and five days.✶

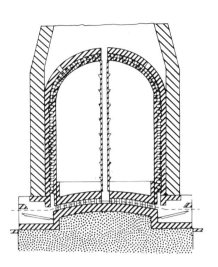

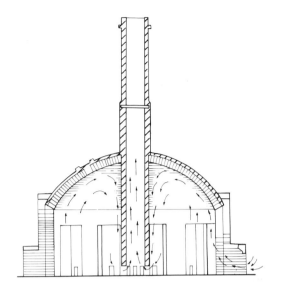

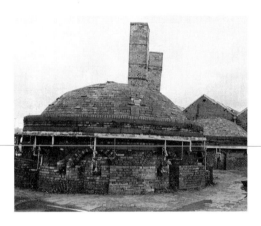

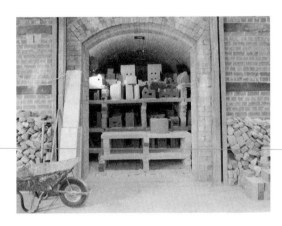

22 (above) Down-draught kilns with external chimneys of the type used for burning terracotta, Dennis Ruabon

23 Terracotta about to be drawn from kiln, Ibstock Hathernware

24 Down-draught kilns at Gladding McBean

26 (right) Doulton showrooms and studios, Lambeth, and 233 feet high chimney in the form of a campanile

27 (far right) Doulton's works, Lambeth, showing kilns, waste mould dump by the Albert Embankment and, to the extreme right, showrooms and studios, by Tarring Son and Wilkinson, 1876–8

The only way to ensure that all the blocks in a contract had been made to dimension was to fabricate the façade at the works, a practice carried out for the Albert Hall at Tamworth, the Coliseum Theatre at Hathern, and for many American buildings.✶ Blocks could be trimmed and touched up in the fitting-shop. This approach was frowned upon by many Victorian architects and most critics. The Americans had few qualms, it being openly admitted that blocks were worked with hammer and chisel at the Chicago Terra Cotta Works in 1876. Since the 1920s firms have often made blocks slightly over size, accepting that virtually all their production would be trimmed with a circular metal saw to achieve a precise length or breadth (**25**).

BRICKYARDS AND MODEL FACTORIES

Many British terracotta works appeared haphazard in layout and untidy in appearance. To an architect wishing to inspect the process for making a product advertised as being clean and colourful, it must have seemed incongruous to be confronted with a maze of sheds and kilns pouring out smoke and soot. None of the Victorian firms, except for Doulton at Lambeth (**26**, **27**), put much emphasis on presenting a public face of order and cleanliness, as exemplified in the model works of Lever Brothers at Port Sunlight, or American food-processing works.

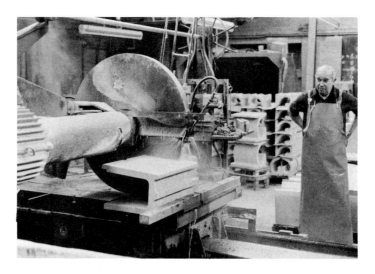

25 Cutting blocks to size, Shaws of Darwen

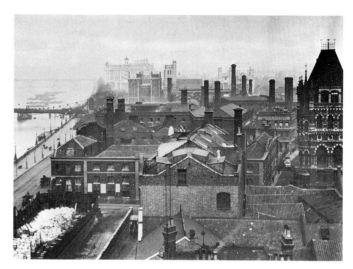

Generally factories were started and developed along the lines of either a pottery or a brickyard, depending on whether the location was urban and the products were primarily in the form of pots or ornamental ware, or whether it was semi-rural and the output consisted largely of bricks. After the middle of the nineteenth century the bulk of British terracotta was made on open sites offering greater space for buildings, storage and the working of clay-banks or -mines. Offices with terracotta decoration fronted sheds which were extended, or relinquished for other uses, as demand justified (**28**).

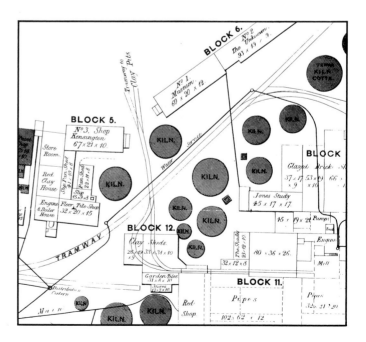

28 Plan showing the terracotta section of the Glascote Works of Gibbs and Canning, Tamworth, 1884

29 (right) The multi-storey factory of the New York Architectural Terra Cotta Company, Long Island City, 1906

fig. 2.12 Cross-section of a 'model' American terracotta factory design by James Taylor (*Clay-Worker*, 10, 1888, p.12)

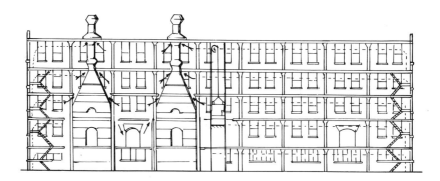

James Taylor promoted a contrasting approach, drawing upon the traditions of the London manufactories of the 1850s. Rejecting the notion that terracotta should be made close to the clay-pit, he urged the advantages of an urban location; clay was cheaper to transport than finished ware and managers needed to liaise closely with architects and builders, both to promote sales and to avoid delay in the completion of a contract. Furthermore it was easier to find and employ skilled draughtsmen and modellers in cities than to attract them to work in relatively remote areas. ✶

Taylor's model factory layouts (fig. 2.12), applied first in Chicago and then in Boston, culminated in his design for the works of the New York Architectural Terra Cotta Company erected in Long Island City, just over the East River from Manhattan, between 1886 and 1892. The main block was five storeys high. Production progressed first up then down through the building: the ground floor was used for clay preparation as well as for fuelling the muffle kilns, and the top storey for the modellers' studio and plasterers' shop (**29**).

ECONOMIC ILLUSIONS

Architects strongly committed to terracotta were more vocal than manufacturers in proclaiming its price advantage over stone. Significant savings over the cost of masonry depended on the intricacy of decorative work and whether the design generated much repetition. Quibbling comparisons of cost per cubic foot did little to promote terracotta, only rousing suspicion that it must be cut-price and second-rate. The more astute clayworkers

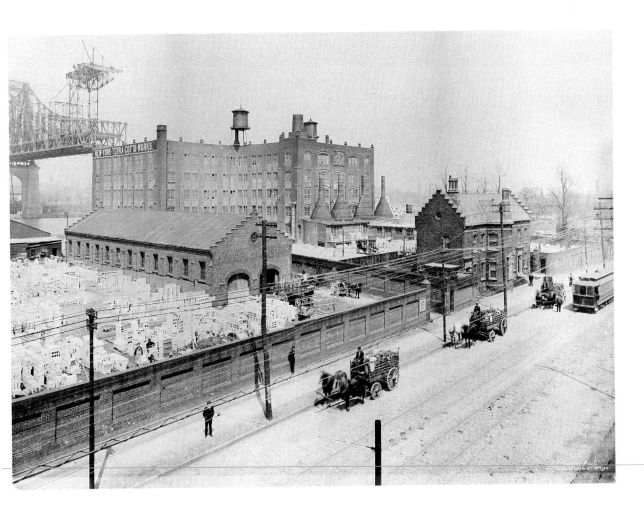

promoted a more elevated status for their product, Henry Doulton for one refusing to cut prices to gain orders. *

When terracotta was first introduced into America as a cheap substitute for stone it met with little approval. It gained acceptance in the 1870s for its practical worth and for the contribution it could make to the structure and the aesthetics of the skyscraper. Nevertheless the shortage and cost of skilled stonemasons gave terracotta a strong price advantage if intricate detailing of a high standard was required. In 1887 terracotta was reported as being 35–40 per cent cheaper than hard stone. Relative costs were influenced by transport, terracotta often gaining the advantage because its light weight made it cheaper to convey over long distances. As in England, artificial stone, cheaply cast in moulds and requiring no firing, undercut any price advantage that terracotta may have held during the nineteenth century. A letter to the New York Architectural Terra Cotta Company from their Boston representative, dated 1913, betrays the prosaic criteria by which terracotta had begun to be judged, chosen or rejected: 'The Boston architect is prejudiced against t.c. to start with, preferring limestone and

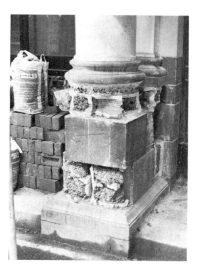

30 Doulton's Carraraware for the Savoy Hotel, London, by T. E. Collcutt, delivered on site ready for erection, c.1904

31 The chambered form of terracotta and faience and type of filling exposed: column base of Gloucester House, Piccadilly, London, by Collcutt and Hamp, 1904 (Doulton)

32 (above right) Installing terracotta for the Bournemouth Pavilion, c.1930 (Hathern)

granite. Now, artificial stone has come in, not because the architect likes it but because the owner can get it for less money.'*

Around 1900 most long-established British manufacturers responded to excessive capacity by launching into a price war with newly emergent competitors such as Hathern, Carter or Shaw. The minimum-rate controls applied by the Terra Cotta Association during the Edwardian and inter-war periods may have ensured a reasonably economic level of pricing, but promoted a backward-looking mentality. Some directors and managers became obsessed with maintaining established markets at the expense of developing more profitable types of architectural ceramic. *

Terracotta was viewed with caution if not hostility by the building trades, who sensed a threat to their traditional status. Builders complained of the

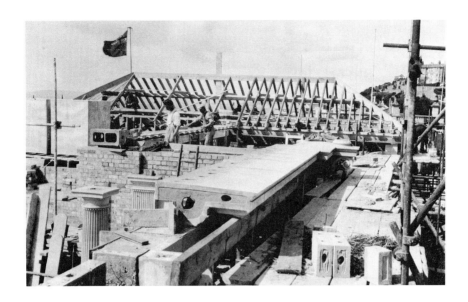

delays caused by the late delivery of blocks or their breakage in transit. It took decades to achieve standardization in the ways that blocks were filled, jointed and set. One of the most unsatisfactory aspects of early architectural schemes was the choice of materials for filling chambered blocks: cement, broken bricks and flints were all used on the Victoria and Albert Museum. By the turn of the century breeze concrete had been adopted as a more consistent alternative, in terms of weight and load-bearing strength. Despite their sometimes vociferous expressions of opposition to the material, stonemasons and plasterers fought bricklayers for the right to fix terracotta (**30, 31, 32**).

American clayworkers, architects and builders had less difficulty in reconciling themselves to terracotta's industrial origins. During the century following independence, the principles of prefabrication and standardization had gained acceptance through the systematized use of lightweight timbers in balloon framing and the erection of cast-iron façades. Despite acceptance of the repetition dictated by the use of models and moulds, enthusiasm for intricate detail typically outweighed the rationality of pressing simple low-relief forms, until new tastes associated with art deco came into play after the First World War.

COADE STONE, SELF-IMPROVEMENT AND SOUTH KENSINGTON

ARTIFICIAL STONE AND GARDEN ORNAMENTS

For almost a century the revival of terracotta was associated with deception and, in terms of Victorian architectural morality, 'dishonesty'. Coade stone, made of a fine-moulded clay body at Lambeth in London from 1769, was valued for its ability to imitate stone and reproduce classical ornament. Confusion between ceramic and non-ceramic artificial stones and over their relative worth was to continue beyond the 1840s, when the Coade works finally closed, until the 1860s when the quadrangle of the Victoria and Albert Museum in South Kensington finally affirmed the true identity of and title for architectural terracotta.

The taste for accurate replicas of Greek and Roman architecture and garden ornaments prompted by neoclassicism demanded a degree of accuracy rare amongst woodcarvers and stonemasons who drew inspiration from out-of-date pattern-books. Owing to the risk of fire, wood had been virtually banished from the façades of London's buildings by the Building Act of 1774, while stone tended to be either expensive or of poor quality. There was a market for a substitute material, one that was durable and that could readily be worked into capitals, keystones or running mouldings as well as free-standing sculpture.

The introduction of plaster models and moulds in the early eighteenth century was a revolution, enabling complex designs to be replicated with absolute correctness whether for internal plasterwork or for making china. The Georgians were tardy in exploiting the potential of moulded terracotta or 'artificial stone' as it became branded. None of the travellers to southern Europe appreciated that clay had been used to form brightly coloured ante-fixes and grotesques on Greek temples, or to produce enormous sculptural groups in Etruscan Italy. The Tudor use of terracotta had been dependent on Italian inspiration and probably French workmanship and did not continue after the Reformation. Legislation forbade or levied fines on the employment of foreign craftsmen and the intense religious and political nationalism of the period would have been intolerant of a material so obviously derived from Italy. ✫

The first glimmer of a revived interest was marked by one of two patents taken out by Richard Holt in 1722, in which clay was referred to as liquid metal. ✫ Although Holt had a factory in Lambeth, possibly a showroom, and published a catalogue, one suspects that there was little demand for his glazed and crudely painted wares. Other rather shadowy figures also attempted to introduce ceramic or non-ceramic artificial stones: Daniel Pin-

33 River god, Ham House, Surrey, as advertised in a catalogue of 1784 (Coade)

cot drew upon renewed public interest in the 1760s to launch a full range of 'near 100 different subjects, such as figures, busts, tablets, friezes . . .'✩

The technological lessons of Pincot's experiments, using ball and china clays to create clay slabs four feet long, may have been passed on to the Coade works and underlain its almost immediate success. Eleanor Coade came to London from Lyme Regis in 1769, establishing her manufactory at King's Arms Stairs, the same location as used by Pincot for the previous two years.✩ The high quality and durability of Coade stone followed from the mixture of china clay with grog, and the firing of the goods in small muffle kilns. In 1771 Coade found an ideal combination of artistic skills in her new superintendent, John Bacon. He had started his career as a modeller of porcelain figures and built up a reputation as a neoclassical sculptor. Bacon probably conceived and modelled the majority of the Coade designs which went into production over the subsequent thirty years, his compositions being reworked by adjusting limbs or changing dress and emblems to suit different customers.✩

Mrs Coade and her cousin, John Sealy, succeeded in engaging not just jobbing modellers, but the best contemporary designers. Their lions, coats of arms, keystones and capitals, and their range of classical statues, monuments and vases all found a ready market (**33**). Plaster models for these and other designs had a long life, as neoclassical forms remained in demand well into the nineteenth century, and architects and builders showed few qualms about integrating one or more stock designs into their work.

When major London architects such as John Nash and Samuel Wyatt used Coade stone they normally provided their own designs. William Wilkins, one of the leaders of the early nineteenth-century Greek revival, worked closely with Coade's manager William Croggon and the designer

Joseph Panzetta in the execution of decorations worth £14,000 for the Tudor-style Dalmeny House, near Edinburgh, over a period of three years from 1815 (*colour plate 2*).✶

The much-publicized success of Coade inevitably encouraged competition. Josiah Wedgwood, epitome of the cultured Georgian entrep· ·neur, failed in his attempts to launch a range of architectural ornament. His bas-relief designs were offered in basalt, common biscuit, terracotta and jasperware bodies.✶ The Adam brothers used some of these plaques on their Adelphi scheme in London (1767–72) but they were not widely adopted, largely on account of their high price. Wedgwood's jasper plaques cost from eight to twelve guineas while Coade had thirty designs for chimney-piece decoration, some priced as low as £1 5s.✶

Other potters managed to establish a modest provincial market for terracotta wares. After a period spent modelling at Derby China Works, William Coffee made a series of busts portraying famous local and national figures. Jonathan Harmer of Heathfield, Sussex, embarked on making terracotta plaques as one strand of a business which encompassed bricklaying, plastering, land-surveying and later iron-casting. He produced only seven types of terracotta ware, mostly rosettes and bas-reliefs, which cost between 8s. and 10s. The designs were either loosely classical or based on more naturalistic subjects such as baskets of flowers. Most were used for decorating headstones and funeral tablets.✶

Two modellers who had left Coade by 1814 presented the strongest challenge to their former employer. James Bubb and John Rossi's venture had a dramatic start in 1818, when they received a contract for reliefs to the value of £5,000 for the façade of the London Custom House. Rossi subsequently modelled the details for St Pancras' Church, London (1818–22). This displays the most completely architectural use of terracotta within neoclassicism, with the running mouldings and sculptural figures being integrated rather than just applied to the building. The architects, H. W. and W. Inwood, took complete casts of the caryatids on the Acropolis, which were then copied by Rossi in terracotta and made to wrap round the cast-iron cores which supported the roof (**34**).

The quality of design and technical proficiency shown in St Pancras' Church was not to be developed. Demand for plaques and sculpture waned in the Regency period, Eleanor Coade had died in 1821, Croggon became bankrupt in 1833, and little ware was produced before the moulds were sold off in 1843.✶ Vases and fountains were now more likely to be made of a non-ceramic artificial stone, cement binding a ground mixture of materials.✶ The quality of such bodies had progressed from the vague claims of Holt's second patent in 1722 to a technical standard rivalling that of terracotta, largely as a result of the experiments with hydraulic and other artificial cements during the intervening century.

34 Caryatids, St Pancras'
Church, London, by H. W. and
W. Inwood, 1818–22 (Rossi)

The brick tax, first introduced in 1784, may have been the key factor in giving artificial stone a commercial edge over terracotta. It was stated in 1834 that the higher tax, applied to all but ordinary bricks, had made ornamental chimney-shafts prohibitively expensive and had led to the adoption of artificial stone.✫ This penalty remained until the tax was finally repealed in 1850, a date which coincided closely with the renewal of interest in terracotta.✫

Two firms, Blashfield and Blanchard, linked the age of Coade stone with the Victorian resurgence of interest in terracotta. The inventive and egocentric John Marriott Blashfield became interested in the material as a sideline to importing marble and manufacturing cement and scagliola. In 1839 he engaged James Bubb on experiments with terracotta at Canford in Dorset.✫ As well as being the London representative of Minton, Blashfield was a partner in the cement firm Wyatt, Parker and Company at Millwall, London. Blashfield took over this works around 1846, and by his own account he turned to making terracotta after seeing Blanchard's prize-winning display in the Great Exhibition of 1851.✫

Blashfield, like Coade, engaged major contemporary sculptors. His most prestigious association was with John Bell. Their collaboration gave full rein to Blashfield's bravura approach to clayworking and the rather sentimental imagination of Bell's modelling. Some of the compositions were massive in scale; an 8 ft. 6 in.-high statue representing Australia was followed by an even larger group supporting a massive tazza. Such ceramic gargantuanism culminated in a 10 ft. 6 in. statue of Diana.✫ The cultivation of publicity was also taken to new extremes. The new works at Stamford had a flamboyant opening in 1859. The local aristocracy attended the drawing of the first kiln and one of the busts of the Queen that had been fired was presented to Her Majesty on the following day.✫

35 (below) Arches to the nave, Christ Church, Welshpool, by T. Penson, 1839–44

36 West front of St Agatha's Church, Llanymynech, by T. Penson, 1845

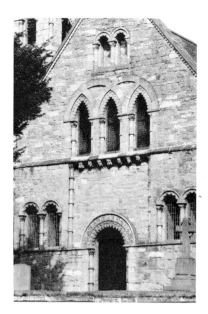

Mark Blanchard worked at Coade during its declining years, probably bought some of the moulds, and established a works in Westminster Road by 1850. He continued to reproduce antique vases and statues in the early 1870s. His emergence as the leading manufacturer of terracotta in Britain was closely tied to the revived use of the material for architecture rather than just for garden ornament. � This transition can be charted through the displays at international exhibitions. In the Great Exhibition of 1851 most of the ware was purely decorative but at the Dublin Exhibition of 1853 three of the four stands displaying terracotta contained architectural items. In the Palace of Art and Industry of 1862 there were twenty exhibitors of terracotta, showing a much more comprehensive range of capitals, trusses and cornices. � During the intervening decade, terracotta balustrades, vases and finials were used to decorate several country houses, such as at Clive-den, Buckinghamshire, by Charles Barry, 1850–1 (*colour plate 3*).

'POT' CHURCHES BY PENSON AND SHARPE

A small group of provincial Gothic architects, who turned to ceramics to achieve originality and rich decoration more cheaply than with carved stone, broke terracotta's association with neoclassicism and gave it a rather ill-fated introduction into the arena of Victorian architectural debate.

Around half a dozen churches built on the Welsh border during the forties incorporated dressings of 'firebrick', large blocks too yellow in colour to be mistaken for stone. Thomas Penson, one of the family of architects from Chester, first combined yellow moulded bricks and terracotta for the arches and apsidal rib-vaulting inside Christ Church, Welshpool (1839–44) (**35**).

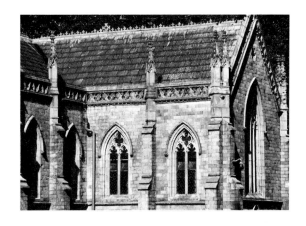

37 South transept of St Stephen's, Lever Bridge, Bolton, Lancashire, by E. Sharpe, 1842–5 (J. Fletcher)

He became more confident in his use of terracotta for St Agatha's at Llanymynech in Shropshire, which was completed a year later. It was now applied on the exterior as well as inside, with a Norman zigzag pattern decorating pointed arches and supplemented by a proliferation of modelled heads (**36**). Such an informal, almost eccentric combination of style and material was still acceptable, at least in the eyes of the *Illustrated London News*, which described the church as being 'pure Norman . . . preserving strict architectural character'. ✲ For Penson's next church, St David's, Newtown, finished in 1847, a combination of brick and terracotta completely replaced the use of stone.

Similar combinations of buff brick and terracotta were used on Holy Trinity, Penrhos (1845) and St Paul's, Dolfor (1851), both in Powys and attributed to Sidney Smirke and T. G. Newenham respectively. The terracotta for these Welsh churches could have been produced by the emergent clayworking industry in Ruabon. Closer to hand, the small mining settlement of Trefonen, between Llanymynech and Oswestry, had a firebrick works that probably produced terracotta, including the headstones once arranged round the village's churchyard. Another source could have been the East Shropshire coalfield, where terracotta was being made and used at mid-century; the most impressive surviving example is the Gothic National School in Broseley designed by Robert Griffiths in 1854.

While Penson adopted moulded 'firebrick' mainly for pragmatic reasons of economy and possibly also to assert a degree of originality, Edmund Sharpe's churches in Lancashire became a widely publicized test of the architectural worth of terracotta. Inspiration for St Stephen's at Lever Bridge, built 1842–5, came from John Fletcher who discovered a fireclay seam at his colliery near Bolton. Sharpe was commissioned to produce designs for a 'pot' church, entirely of terracotta, including even the pulpit and organ-case. Fireclay was worked into flowing tracery for the windows, the parapet and, inside, the chancel arcades and the pew-ends (**37**). The final tour de force was the openwork spire whose blocks were fitted together with ceramic dowels.

To keep the total cost of the building down to £3,000, most of the architectural forms as well as the individual details were repeated wherever practicable. The *Ecclesiologist* commented sarcastically on 'the ingenuity that has made an ambitious church out of so few moulds. One large window, one small window, one large pinnacle, one yard of parapet, one sexfoil-light: behold nearly all that is necessary for the exterior at least of an elaborately cast-clay church.'*

Sharpe refined the use of terracotta for Holy Trinity Church at Platt near Manchester, consecrated in June 1846. The decoration was designed to be worked in smaller pieces partly to ensure that the wall-blocks were more adequately fired.* While St Stephen's has a toy-like appeal comparable to that of eighteenth-century 'Gothick' architecture, the repetition becomes far more dulling at Platt. The *Ecclesiologist* reiterated its opposition to the use of terracotta: it was not regarded as worthy material, lacking the sanctification given to stone by its use on medieval churches and cathedrals. Worse, Sharpe had used terracotta in imitation of ashlar-work; the blocks at Lever Bridge had been given a tooled surface and Sharpe took pride in the fact that most of the visitors had not appreciated that the building material was in fact burnt clay.*

Rejecting terracotta for ecclesiastical use, the driving morality of the Gothic revival reduced it to the status of a second-rate material, better only than the widely condemned stucco. By the middle of the nineteenth century, terracotta was trapped in the strait-jacket imposed by archaeologically inspired revivalism; it could only be used acceptably, without having to imitate other materials, if it was worked in a style with which it was historically associated.

SOUTH KENSINGTON

The architectural development of the Victoria and Albert Museum, the Royal Albert Hall and the Natural History Museum in London brought a new ideology to terracotta. The cultural complex of South Kensington defined an essentially secular, urban and liberal basis for the use of architectural ceramics, not just for the rest of the Victorian period but well into the twentieth century. The principle whereby the Victoria and Albert Museum was designed – decoration of a brick shell by applying a variety of manufactured materials modelled typically in a loose Renaissance style – roused predictable opposition from advocates of the Gothic revival and, subsequently, from the Arts and Crafts movement. The Secretary of the Science and Art Department from 1857 to 1873, Henry Cole, appointed a Royal Engineer as designer for the museum. Captain Fowke's work on the museum may have shown him to be practical and inventive, but he

**38 The Coalbrookdale Literary and
Scientific Institute, Coalbrookdale,
Shropshire, by C. Crookes, 1859
(Coalbrookdale)**

committed, in the eyes of 'artistic' architects, the cardinal sin of largely
abdicating responsibility for the decorative detailing of his buildings.

Cole was part of a reformist crusade, committed to raising standards of
design above the aesthetic indulgence – rococo-style china or carpets woven
in vibrant floral patterns – all too apparent at the Great Exhibition of 1851.
The proponents of reform gave ceramics an elevated status. Clayworking
was not only a long-established and seemingly ubiquitous industry, it
involved, ideally, a combination of science and art, and of utility with a
simple beauty.

Such principles were disseminated by the art schools established from
the 1840s, which came to follow a curriculum defined and controlled from
South Kensington by the Department of Science and Art. While every art
school taught the genteel how to appreciate architectural ornamentation
and the manufactured arts, some also provided a highly didactic training
for architects, designers and decorative artists. Such schools as Lambeth,
Burslem, Sheffield or Coalbrookdale in Shropshire gave close attention to
clay-modelling because they had ties either with ceramic firms or with
companies which had to build up three-dimensional designs for execution
in other materials, such as iron, steel or bronze (**38**).

Lecturers and students drew inspiration from one figure above all others
in their efforts to develop a 'Victorian style' for architectural ornamentation.
The sculptor and painter Alfred Stevens was presented as the Victorian
reincarnation of Michelangelo. Largely as a result of spending nine years
in Italy, Stevens had developed an approach to modelling which combined
the robustness of high-Renaissance sculpture with a typically Victorian mix-
ture of naturalistic detail and abstract patterning.

At Hoole's Green Lane Works in Sheffield Stevens worked up designs
for stoves, fenders and firedogs in plastic clay. He exerted a crucial influence
on the terracotta revival through a group of students whom he taught at
Sheffield School of Art during the 1850s. Godfrey Sykes, Reuben Townroe
and James Gamble studied under Stevens and also worked as his assistants
at Hoole. ✶ Once brought to South Kensington by Cole, they applied and

developed their master's interpretation of the Italian Renaissance in decorative schemes for the Victoria and Albert Museum and the Albert Hall.

ITALY, GERMANY, AUSTRIA AND THE *RUNDBOGENSTIL*

It was one of the most remarkable twists of mid-Victorian culture that two of the prime concerns of the utilitarian reformists – education and the improvement of industrial design – were brought together by the emulation of Renaissance art. The architects and designers who crossed the Alps for artistic inspiration were struck by the vivacious modelling and brilliant red colour of north-Italian terracotta of the fifteenth and sixteenth centuries. Lombardy's architectural ceramics were recommended in moral terms as a model for mid-Victorian design, to create 'elegant exteriors that diffused taste among people'.✶ The broad plain of Lombardy contains the most striking terracotta to be found in Europe. The theory that the masses would be converted to respectability by exposure to Renaissance art and architecture gave a sharpened sense of purpose to those who sped along newly completed railway lines, taking notes, sketches and even plaster casts from the Certosa di Pavia, the church of Santa Maria della Grazie in Milan and civic buildings in Cremona and Bologna (*colour plate 4*, **4**).

Italian example was complemented by English precedent. Cole's interest in terracotta was roused long before his first trip to Lombardy. Around 1840–2, as a young man on holiday, he took special note of some of the earliest manifestations of the Renaissance in Britain: the group of terracotta medallions at Hampton Court portraying rather bullish Roman emperors (**1**).✶ Soon after observing the roundels, Cole designed a box of terracotta bricks to be made by Minton as educational toys.

Over the next two decades Cole visited a group of churches, castles and houses in south-east England that had been given terracotta decorations in the late fifteenth century or during the 1520s and 30s (**39**, *colour plate 7*). His diary of 1864 records a visit to Wymondham Abbey in Norfolk with its terracotta tomb bedecked with cherubs and dolphins and other Renaissance motifs.✶ One of Cole's decorative artists, Richard Redgrave's son Gilbert, referred to the crispness of the sixteenth-century decoration at Sutton Place, Surrey, as evidence for the durability of clayware. The brick walls of Sutton Place were enlivened with thirty-eight winged cherubs (*colour plate 5*); their terrestrial brethren were to become one of the main hallmarks of South Kensington terracotta.✶

Cole and his team of artists also studied contemporary German initiatives, especially in the states of Prussia, Bavaria and Baden, in the use of terracotta and majolica as a means of imbuing civic architecture with an educative

**39 Tomb in Oxburgh Church,
Norfolk, early sixteenth century**

and popular appeal. The German concept of art and architecture came to hold strong sway over the development of South Kensington through the close involvement of Prince Albert of Saxe-Coburg-Gotha, settled in England from 1840 as consort to Queen Victoria. He was aware that numerous German institutions built since the 1830s had frontages of brick and terracotta in a round-arched Italianate style. The *Rundbogenstil*, as it was termed in Germany, was a flexible approach to articulating building façades: wall-surfaces could be subdivided and given projections and recessions by drawing on Lombardic, Romanesque and Byzantine example.

Karl Friedrich Schinkel was probably the first nineteenth-century architect to have appreciated terracotta, when he studied the use of brick during a tour of Italy in 1803. He achieved his most mature use of terracotta on Berlin's architectural school, the Bauakademie, erected around 1831. Dressings of matching red terracotta and glazed violet tiles enlivened the elevations while panels portrayed the evolution of architecture and the balance between art and building technology. ✶

The King of Bavaria, Ludwig I, entrusted a series of commissions to Friedrich von Gärtner, who had acquired an interest in ceramics by a path analogous to that followed by Schinkel, through touring Italy between 1814 and 1817. He used ceramics to dramatic effect in several of his contributions to Munich's new formal boulevard, the Ludwigstrasse. The university, built 1835–40, was set with terracotta medallions portraying academic figures. The industrial associations of the Saltworks Administration Build-

40 and 41 Saltworks Administration Building, with moulded detail around main entrance, Ludwigstrasse, Munich, Germany, by F. von Gärtner, 1838–43

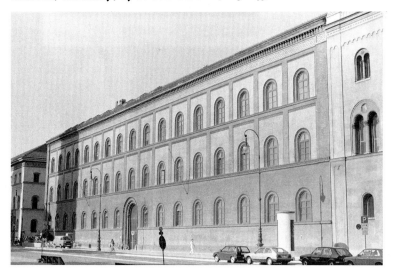

ing (1838–43) justified a bolder use of bright buff and red brick and terracotta, the round-arched doorway and window openings being decorated with repeated low-relief patterns (**40, 41**).

Heinrich Hübsch rejected neoclassicism in favour of more romantic and eclectic compositions. His enthusiasm for ceramics found fullest expression in his design for an arcaded pavilion, the Trinkhalle (1837–40), in the fashionable spa town of Baden-Baden. The cloister formed by the arcade was lined with orange-red tiles and divided by pilasters edged with running mouldings in white terracotta. The end entrances to the Trinkhalle were surmounted by ceramic plaques showing playful cherubs (**43**).

The association of ceramics with civic architecture evolved towards a finely judged maturity in a series of major public buildings erected in Vienna. In the wake of the 1848 revolution, Emperor Franz Joseph sought to give the capital of the Hapsburg empire an expression that reconciled imperial glory with the aspirations of the bourgeoisie. Terracotta and faience were to be applied most freely to a series of buildings erected facing a new grand thoroughfare, the Ringstrasse, and especially onto those devoted to education and the promotion of the arts. Rudolf von Eitelberger had been impressed by the development plans for the Victoria and Albert Museum when he had visited London for the 1862 Exhibition. He returned to become the driving force behind Vienna's Arts and Crafts Museum erected 1868–71; its Florentine renaissance composition by Heinrich Ferstel was studded with majolica plaques naming inventors and with roundels portraying artists. ✩

42 Arts and Crafts Museum, Vienna, Austria, by H. Ferstel, 1868–71

43 Trinkhalle, Baden-Baden, Germany, by H. Hübsch, 1837–40

A TRIUMPHANT COLLABORATION: THE VICTORIA AND ALBERT MUSEUM

Inspired by earlier visits on the part of his associates and by his own studies of English terracotta, Cole spent much of 1858 scrutinizing Romanesque and Renaissance architecture in Italy. After working his way through the cities in the lower valley of the Po, and Turin and Genoa, he went to Rome where he noted of one building: 'The pilasters were of red brick but the Corinthian capital not cut, but moulded before baked. I hope I shall adopt this system in Kensington, rather eschewing the use of stone, except where stone would be decidedly best.'✶

Upon his return, Cole discussed the issue of style for new buildings at the South Kensington Museum, later known as the Victoria and Albert, to be arranged round a formal quadrangle. He also took up the challenge of finding a means for creating the type of ceramic decoration that he had appreciated in Italy. The idea of bringing one or more of Stevens's students with their skills in clay-modelling to South Kensington may have occurred to him as early as January 1857, when he had gone to Sheffield to open the new building for the School of Art and had no doubt met Godfrey Sykes.✶ Cole would have noticed the terracotta medallions set into the Italianate frontage designed by Messrs Manning and Mew. In a rather leaden but pioneering revival of Renaissance ceramics, five roundels containing busts of artistic worthies were set above an arcade of round-headed openings (**44**). In July 1859 Sykes was appointed to make designs for the Department of Science and Art, a post he held until his death in 1866. In bringing a

44 Roundel set into the elevation of Sheffield School of Art, by Messrs Manning and Mew, 1856–7

45 Cherub on the quadrangle elevation of the Official Residences, Victoria and Albert Museum, by F. Fowke and G. Sykes, 1862–3 (Blanchard)

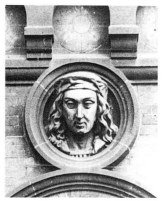

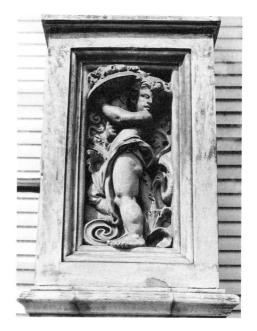

group from Sheffield to South Kensington, Cole gained both their skills in working terracotta and, albeit at second hand, Stevens's progressive interpretation of the Italian Renaissance.

Sykes emerged as an inventive developer of decorative designs. He drew inspiration from Italian precedent, from the work of his master, Alfred Stevens, and from his own imagination. He might adapt his compositions to a particular architectural setting himself, or delegate the task to his assistants. Sykes first went to Italy over the winter of 1861, posting drawings from observation and sketch designs back to Cole. The two assistant designers, James Gamble and Reuben Townroe, drew up Sykes's designs ready for use by the modellers. When Sykes died in February 1866 they turned to using a stockpile of his drawings.

A decorative arts studio was established at South Kensington, but the ideal of developing a forum for practical training seems to have degenerated into a policy of exploiting a free labour-force to execute terracotta, mosaic and fresco work for the museum. Clay and plaster models were made in the studio under the supervision of Sykes and his assistants. As modelling was the most critical stage in the production of terracotta, visual consistency did not depend on all the ceramic blocks across an elevation being supplied by one firm. Blanchard, Doulton, Pulham and Wilson all supplied some portion of the terracotta for the museum building, Blanchard gaining the lion's share of the contracts. Four other firms, Minton Colin Campbell, Minton Hollins, Gibbs and Canning, and Maw won orders for faience. The studio underwrote the cost of the decoration applied to the fabric of the museum, but its drawn-out pace of working and hidden subsidies

engendered attitudes and tastes incompatible with the real world of commercial building, where time was money, and budgets for ornamental work tightly constrained.

The arcades of the Royal Horticultural Society's garden, laid out and built from 1859 to 1861 on the west side of Exhibition Road, served as a prelude for the widespread use of terracotta on the Victoria and Albert Museum. By the summer of 1859 Prince Albert, Cole, Richard Redgrave and Fowke had developed the concept of an anthology of Italian arcades. Sykes gained responsibility for the detailing of all but the northern range. The groups of round arches for the southern arcade, modelled on the cloisters of St John Lateran by Fowke and Sykes, were supported by tall terracotta columns, consisting of two barley-sugar sections divided by a ring and topped with a variety of capitals, of Ionic, Corinthian and even stiff-leaf design. ✩

The brick and terracotta elevation of the Official Residences, commenced in 1862 as the first stage in the establishment of a coherent architectural expression for the museum, arose out of a broad proposal presented by Fowke in 1860. The Residences, which now form the western range of the museum's main quadrangle, achieved a coherency of composition and detailing that would only be matched, among all the subsequent developments undertaken by Cole and his designers, by the Albert Hall (**45**). Smooth plain brickwork was set against intricately modelled terracotta, with no other material or extraneous polychromy being allowed to confuse the contrast.

For the panels forming the square window-mullions, Sykes divided each surface into framed recesses which were filled with a cherub, an animal or vegetation. The cherubs, in four different stances, relate closely to those designed by Stevens more than a decade earlier for porcelain plaques set into an air-stove; their sturdy and active bodies shrug off any tendency towards sentimentality. They, and their neighbouring lions, dolphins and birds, were modelled with a combination of sharply angled edges and rounded surfaces highly expressive of the properties of plastic clay. The imagery was enjoyable and subtle; the studious could analyse the Renaissance references and the use of new materials while the passing visitor could delight in the vitality that characterized both the overall composition and the minutest detail. ✩

The 'Terracotta Building' was widely praised, and Fowke and Sykes developed their joint composition for the north side of the quadrangle, commencing in May 1864. ✩ The central portion of the Lecture Theatre façade exposed the tensions underlying South Kensington's interpretation of Renaissance terracotta. Almost as soon as it had been so laboriously won, the suave restraint apparent in the Official Residences was disrupted in favour of reformist imagery worked in a kaleidoscope of materials and finishes. The 'Ages of Man' columns, installed to support the deep round

arches above the first-floor balcony, were the most impressive elements of the design and proved to be Sykes's ceramic swan-song. Alternating drums were modelled with figures portraying the divisions of life: childhood, manhood and old age. The figures which frolic, strut or stagger round the drums were left in their rough state on leaving the mould, in the manner approved by Stevens (**47**).

In the late 1860s Fowke and Sykes's remarkably fruitful collaboration evolved along two divergent lines: a flamboyant use of tiles and majolica for interiors, and a more homogeneous approach to the external use of terracotta. The adoption of glazed ceramics to line the central Refreshment Room, the West Staircase, and, most appropriately, to encase the columns of the Ceramic Gallery, arose out of Cole and Redgrave's passion for Della Robbia ware and their concern for hygiene. Cole ranked majolica, a fore-runner of architectural faience, as a symbol of progress that equalled photography and the electric telegraph. ✩

During the last months of his life, Sykes produced some initial designs for majolica columns to be installed in the Refreshment Room. Gamble was left to develop detailed designs and to model the columns used both in the Refreshment Room and the Ceramic Gallery. Comparison of the sculptural modelling originating from Sykes with work by his assistants exposes a disintegration of the narrative ideal. Sykes's decorative alphabet was arranged into a frieze with a suitably gastronomic quotation from the Bible. The letters were entwined with figures busily reaping corn, playing harps or occupied in other worthy activities. A frieze by Sykes's former assistant James Gamble was set at dado height and comprised writhing, naked cherubs generally up to no good; their feast appears to be a parody, in rather poor taste, of the Last Supper. Commentators who had welcomed the external terracotta decorations were concerned at the highly florid effect

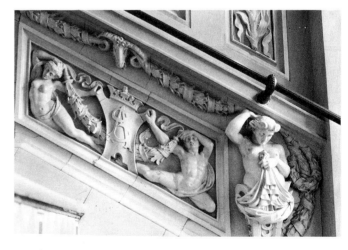

47 (opposite) The balcony and 'Ages of Man' columns on the south façade of the Lecture Theatre block, Victoria and Albert Museum, by F. Fowke and G. Sykes and other decorative artists, 1864–6 (Blanchard, Doulton and Minton Hollins)

46 Dado panels, ceramic staircase, Victoria and Albert Museum, by F. Moody, 1865–71 (Gibbs and Canning, Maw, Minton Hollins)

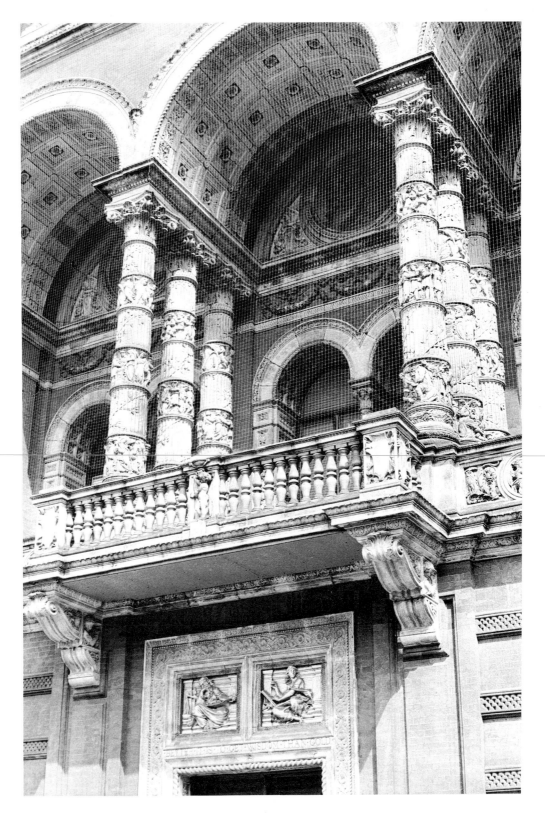

of the Refreshment Room. The *Building News* referred to 'sham columns in a casing of crockery built round a brick core'.✶ The ceramic staircase, finished in 1871, also failed to gain critical acceptance. Modelling work was supervised by the independently minded Frank Moody; the dado frieze consists of naked figures that appear to be swimming frantically up the stairs to avoid drowning (**46**).

Amidst the fragmentation of Sykes's approach to terracotta decoration, a new, broader and more constructional formula emerged. It manifested itself in two projects attributed to Fowke's successor, Lieutenant-Colonel Henry Scott: the Science Schools built just to the west of the Lecture Theatre block (1867–71), and the nearby Albert Hall. The top floor of the Science Schools was entirely clad in terracotta, from the complex network of brackets which encased the supporting iron girders to the floor and the vaulted ceiling. The juxtaposition of brick and terracotta characteristic of Fowke and Sykes's collaboration was replaced by a smooth uniformity: the first example of a complete facing of terracotta being used within the framework of the *Rundbogenstil*.

HISTORICISM SPURNED: THE ROYAL ALBERT HALL

The revival of terracotta was directed towards a sober maturity through the crisp combination of plain red brick and buff dressings used round the circumference of the Royal Albert Hall (1867–71). The project also marked a breakthrough in the way that the material was supplied. Rather than the 80,000 blocks being made through a series of small orders given to small potteries, they were the subject of one contract with Gibbs and Canning, a sanitary-pipe factory on the Midlands coalfield.

Following Fowke's death in December 1865, Scott was given full responsibility for finalizing the design of the hall. In April 1866 Scott and Cole agreed to develop a design in the form of an ornamented amphitheatre. Its detailing would be drawn from Roman or high-Renaissance architecture.✶ The decision carried an implication of fundamental importance: the form of the terracotta facing or dressings would relate most closely to buildings erected in stone rather than Lombardic ceramic. In one bound they had relinquished the historicist justification for the use of terracotta so carefully wrought through travels to Italy and emulation of the German *Rundbogenstil*.

The first imperially scaled design was ultimately abandoned for a more modest but contemporary treatment. This exercise in economy did not lead to a mean starkness but to a remarkable combination of leanness and intricacy. The sheer walls of strawberry-red Fareham bricks formed a metallic-looking background to brightly coloured sandy-buff terracotta, burnt from Staffordshire fireclays. No longer could terracotta fudge its identity as a

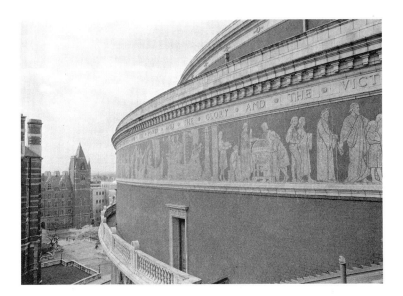

48 Balcony and drum on eastern side of the Royal Albert Hall, London, by H. Scott and R. Townroe, 1867–71 (Gibbs and Canning and Minton Hollins)

derivation from artificial stone or as a substitute for masonry (**3, 48**).

Scott paid meticulous attention to details relating to the use of terracotta. Very little iron was used to support or suspend the terracotta blocks despite the marked overhang of the major cornices. The scale and simplicity of the plan and the boldness of the structure were complemented by the clear-headed and calculated approach to the decoration. The pattern of repetition was ruthlessly efficient. The same square-headed window-surround was repeated no less than sixty-three times at first-floor level, and the round-arched window above fifty-eight times.

The modernity of the warm buff terracotta was matched by a subtle originality in its decorative modelling. Set against plain brickwork, the acanthus scrolls on the second-floor pilasters appear particularly luscious, swirling upwards almost like smoke vapours. Scott and Gilbert Redgrave laid great emphasis on the fact that the blocks were not smoothed over by Gibbs and Canning's finishers, the resultant degree of coarseness ensuring a sense of spontaneity. Scott and Redgrave sent an artist to Tamworth to touch up the blocks and the intricate sculptural detail before they were fired. ☆

The hall was opened in March 1871, having been built for little more than the estimate of £200,000. It was a source of considerable pride to Cole and of some chagrin to his critics that the Albert Hall and the Victoria and Albert Museum were built at such low cost.

SCIENCE AND ART IN THE POTTERIES: THE WEDGWOOD INSTITUTE

The Wedgwood Memorial Institute in Burslem was conceived as a micro-cosm of South Kensington, combining a museum, two libraries and a class-

49 Detail of the Wedgwood Memorial Institute, Burslem, Staffordshire, by R. Edgar, R. J. Morris and W. Wright, 1863–73, showing one of the 'Months' panels (Blanchard) and the 'Process' panels (Blashfield)

room. After discussions with 'the authorities at South Kensington', in 1863 a competition was announced to find a suitable design for its frontage, based on the use of decorative ceramics.✫ The £25 prize was put forward

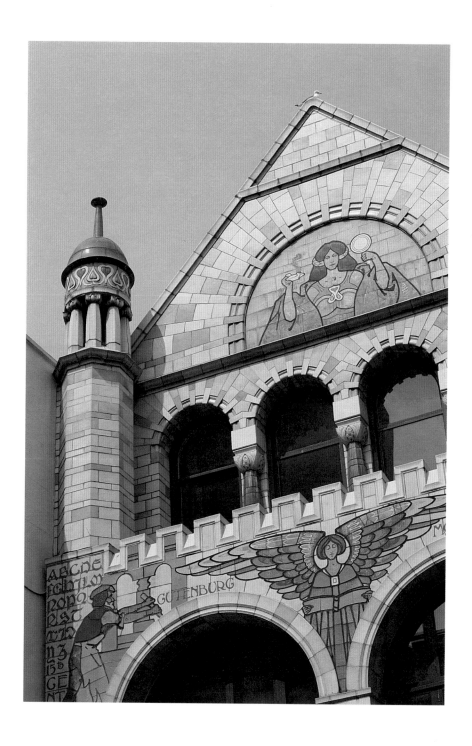

plate 1 **Gutenberg at his press, Everard Building, Broad Street, Bristol, by Essex, Nicol and Goodman with W. J. Neatby, 1901 (Doulton)**

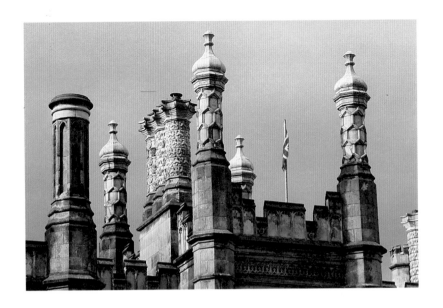

plate 2 **Chimneys, battlements and pinnacles, Dalmeny House, Linlithgow, Lothian, by William Wilkins, junior, 1814–17 (Coade)**

plate 3 **The garden front at Cliveden, Buckinghamshire, with terracotta vases and balustrades, by Sir C. Barry, 1850–1**

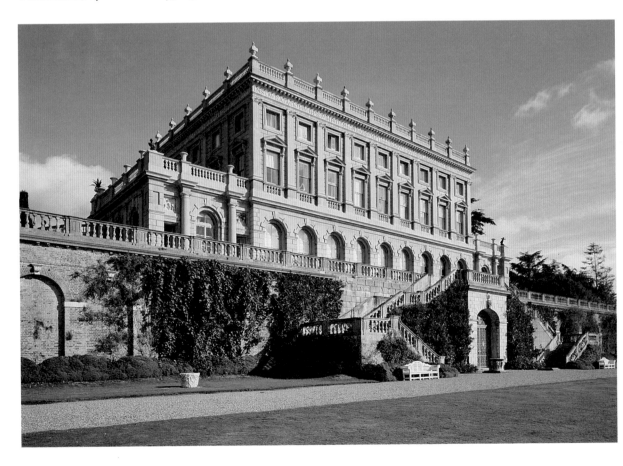

plate 4 **Detail of the arcaded cloisters, Certosa di Pavia, Italy, by R. de Stauris, 1478**

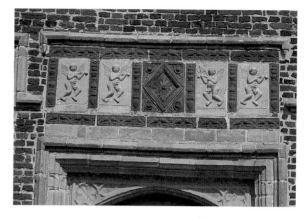

plate 5 **Panels showing winged cherubs, Sutton Place, Surrey, early sixteenth century**

plate 6 **Wedgwood Memorial Institute, Burslem, Staffordshire, by R. Edgar and R. J. Morris and W. Wright, 1863–73 (Blanchard and Blashfield)**

plate 7 **Oxburgh Hall, Norfolk, with Tudor window dressings and corbelling, 1480s, and an oriel window of Victorian terracotta**

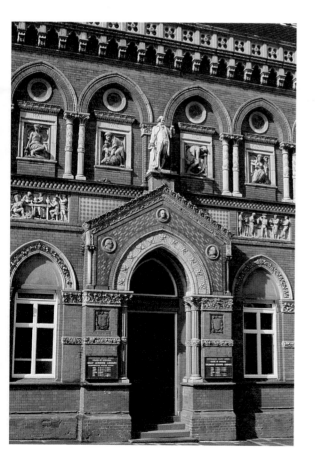

plate 8 **Extinct animal figures on the cornice of the east wing, Natural History Museum, London (Gibbs and Canning)**

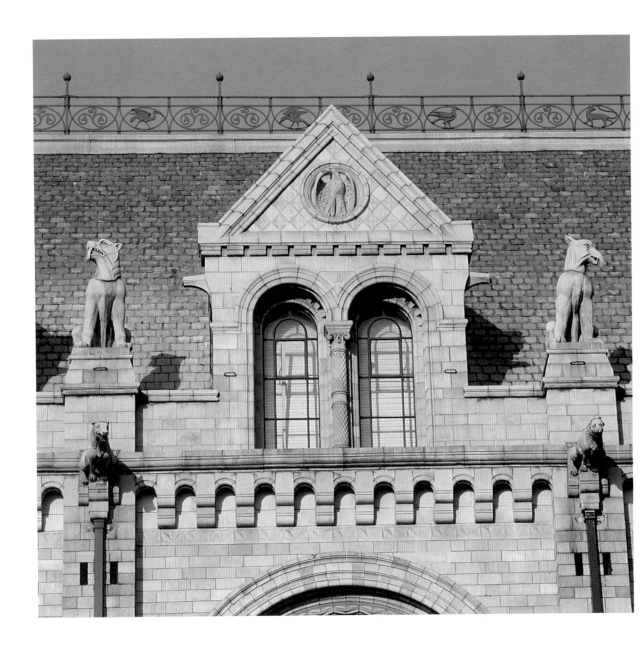

by Alexander Beresford Hope, who had been elected Member of Parliament for Stoke-on-Trent in 1862 and was a leading figure in efforts to promote the architectural arts.

The scheme chosen was by Robert Edgar and John Lockwood Kipling. Father of the novelist Rudyard Kipling, John had been a student at Stoke Art School and gained a scholarship to study at South Kensington. * Edgar and Kipling proposed a polychromatic symphony of decorated brickwork, tiles, terracotta mouldings and panels, mosaic and Della Robbia ware, brought together in a necessarily undisciplined quattrocento style (*colour plate 6*).

Two national scholars from the Potteries School of Art, Rowland James Morris and William Wright, were sent to South Kensington to study the museum's collections and to undertake the modelling work for the institute building. Morris designed and modelled the terracotta panels portraying the Months of the Year. Yet another student, Matthew Elden, from Stoke Art School, was entrusted with designing the panels illustrating the processes of the pottery industry (**49**). The architect, already robbed of most of his artistic responsibilities, was dismissed in the spring of 1866 after falling into dispute with the building committee over the foundations. *

There seemed to be a conscious wish for the technical and artistic challenges involved in creating an outstation of South Kensington fit for the Potteries to be matched by administrative and transport arrangements of comparable complexity. Blanchard, a firm totally imbued with Fowke and Sykes's approach to terracotta, executed the mouldings and the 'Months' panels designed by Rowland Morris. Blashfield, the other major manufacturer of the 1860s, supplied the 'Process' panels. The raw clay for the 'Months' panels was prepared at Stamford, set in a wooden frame with a cover, sent to South Kensington, modelled by Elden, returned to Stamford for firing and then dispatched across country, to Burslem. The building was only finished in 1873, when a terracotta statue of Josiah Wedgwood was fixed above the entrance.

The completed façade contrasted the work of the different manufacturers and modellers as openly as any museum display. While the scenes of pottery-making designed by Elden and fired by Blashfield were rather conventional and static, Morris's and Blanchard's crouched figures representing the Months of the Year filled their frames with the same zest as the cherubs modelled by Sykes for the Official Residences at South Kensington. The Wedgwood Institute was a magnificent provincial riposte to South Kensington, but the delays and wrangling involved in its execution would have confirmed the prejudices of those already critical of such complex combinations of materials and patterns of collaboration. *

4

FITFUL EVOLUTION
Dulwich College to the Natural History Museum

ARCHITECTS IN CONFUSION

Away from the strident ideology and free labour-force of South Kensington, the use of terracotta during the 1860s and early 70s was both sporadic and essentially pragmatic. Only one building stands out from a rather disparate collection of offices and railway stations: Dulwich College, on which Charles Barry, junior, and Blashfield used ceramics in a manner diametrically opposed to the work of Sykes and Blanchard. The differing approaches developed into a controversy that divided the protagonists of the terracotta revival.

In the very simplest terms, Sykes and Blanchard were branded as standing for spontaneous 'Art'; Barry and Blashfield for more contrived 'Science'. While Blanchard and Gibbs and Canning used a homogeneous clay body, Blashfield conjured up a complex mixture of different clays and sand, ground glass, feldspar, flint and mineral colours. The simplicity of the clay body used for the terracotta on the Victoria and Albert Museum was complemented by an equally unlaboured approach to modelling; pressed forms were left untooled, creating an effect of 'less refinement and more artistic "touch"'.* In contrast Blashfield's terracotta was worked into a highly wrought finish. By tooling blocks before they went into the kiln, Blashfield could create surfaces as smooth as marble sculpture, as crisply edged as ashlar or as intricate as carved woodwork.

Patronage for Blashfield's ceramic extravaganzas came from the aristocracy rather than the nouveaux riches. In 1867 Lord Northampton commissioned Matthew Digby Wyatt to design an extensive series of fountains, pedestals and balustrades and a set of ornamental gate-piers for the grounds of Castle Ashby. The yellow terracotta was supplied by Blashfield. An Elizabethan style was chosen in deference to the architecture of the mansion. The angular form of the gate-piers was softened by a riot of undercut and applied detailing including cherubs, fruity festoons and plaques (**51**). The balustrading of the terraces consisted of massive letters spelling out religious and horticultural themes (**50**).*

Terracotta first found a niche in commercial architecture through being specified for buildings closely related to industry, but needing to present some element of urban sophistication. Messrs Hunt and Crombie's combined warehouse and office (1861–2) in Eastcheap, London, was given a cornice incorporating animal heads, columns, and a series of medallions, all moulded in bright red terracotta by Blanchard (**52**). The architects, John Young and Son, failed to rival the artistry of Sykes's cherubs and birds, which Blanchard were also manufacturing during the early 1860s.*

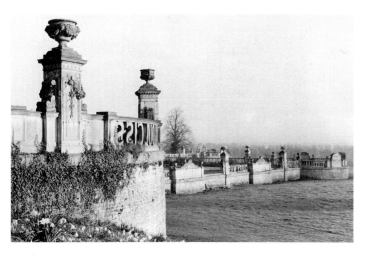

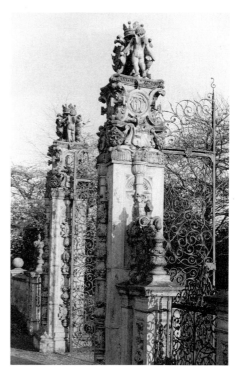

50 Garden walls and vases, Castle Ashby,
Northamptonshire (Blashfield)

51 Ornamental gate-piers, Castle Ashby, by M. Digby
Wyatt, 1867–8 (Blashfield)

A soot-resistant but decorative building material such as terracotta was of especial value for railway-station hotels. The four London termini built between 1864 and 1866, Charing Cross, Broad Street, Cannon Street and Blackfriars, all incorporated terracotta dressings in conjunction with brick and stone. E. M. Barry made rather prosaic use of the material in the hotels he designed for the West End and City stations of the South Eastern Railway at Charing Cross and Cannon Street. He viewed the repetition of moulded details not as a sign of meanness, but as an honest reflection of the scale of the accommodation; a concept which he described as 'the multiplication of small parts essential to the purposes of hotel life'.✶ Blanchard supplied the detailing on the Charing Cross Hotel, all of which was non-structural in form. In 1864 it would almost certainly have represented the most extensive use of terracotta in Britain.

The repetition of decorative detailing was even more extensive in a series of stations built by the London, Chatham and Dover Railway around 1864. Joseph Taylor, junior, used red brick with bands of red and white terracotta for the terminus at Blackfriars and at several smaller stations along the line. A critic invoked the Ruskinian cult of variety in his condemnation of the simple abstract and flower patterns across the arched walls: 'These two designs, one sight of which would surely be sufficient are actually being used over again in the new station at Ludgate Hill. If this be the necessary result of employing terracotta in architecture; the sooner that material is given up the better.'✶

52 **Messrs Hunt and Crombie's premises, Eastcheap, London, by John Young and Son, 1861–2 (Blanchard)**

53 **(centre) Entrance frontage, Dulwich College, London, by C. Barry, junior, 1866–70 (Blashfield)**

54 **(far right) Entrance porch, Dulwich College (Blashfield)**

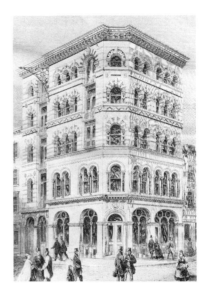

During the 1860s the use of terracotta for the frontages of hotels spread as far as Plymouth and even Cairo. The Oriental Hotel Company shipped arches, cornices and balustrades from Blanchard's works to Egypt where they were set into walls built of local stone.* The intractability of Devon granite provided a justification for terracotta detailing on the Duke of Cornwall Hotel in Plymouth, built opposite the London and South Western Station between 1865 and 1867. The architect, Charles Forster Hayward, collaborated with Blashfield to create massive blocks with sharply angled corners and with deeply undercut detailing.

'THE OLD SPIRIT': DULWICH COLLEGE

The experimental spirit that pervaded the mid-Victorian use of terracotta was given fullest rein in Dulwich College, built 1866–70 in south London (**53**). Blashfield's urge to perform virtuoso feats of clayworking was matched by the delight of Charles Barry, junior, in undertaking his 'maiden essay' in ceramic architecture.

Barry admitted that his aim was not to forge an entirely original and Victorian expression for terracotta but to work in 'the old spirit'.* He managed to accommodate a medley of memories from his trip to Lombardy in 1847–8, but his design relates most directly to buildings faced in stone, marble and mosaic rather than in ceramic. Barry did draw directly upon ceramic example for the tower, which was influenced by that of Santa Maria del Carmine in Pavia, and for the portraits of scientific, literary and philosophical figures executed in a manner that he could have observed on the Ospedale Maggiore in Milan.

Dulwich College was as much a collaborative project as the Victoria and

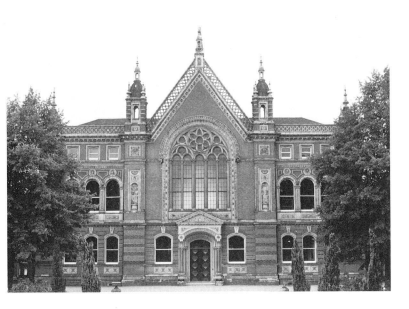
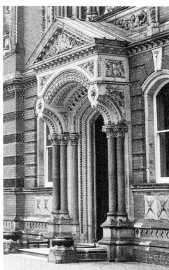

Albert Museum, but the crucial link was not so much between engineer and decorative artist as between architect and manufacturer. Barry made frequent visits to Blashfield's works at Stamford, delegating every stage from the sculptural modelling to the fixing of their ware into the structure of the building.✫ Surviving drawings illustrate how the architect and manufacturer handled what amounted to a systematized kit of parts. Full-size sections defined the pattern of a window surround or decorative panel. Key-plans denoted their use around various parts of the building. Barry appears to have supplied only crude line-drawings for most of the detailing, including portraits, monsters or naturalistic vegetation. These sketches were forwarded to Stamford accompanied by the stipulation that 'ornamental portions are to be submitted to the architect for approval'.✫

Most of the sculptural decoration on the college betrays Blashfield's taste for intricate and grotesque forms (**54**). Details such as the claws of the wyverns and the leaves of the vegetation were applied as plastic clay to blocks and panels, creating an appearance of deep undercutting; an approach that Barry fully supported as offering 'brilliant effects of light and shade'.✫ Barry and Blashfield gained little credit for their efforts at non-historicist originality. The chamfered panels below the ground-floor windows were condemned for looking 'as if casts had been taken in terracotta from boiler plates . . . more original than attractive'.✫

Henry Cole was among those who went to Dulwich to inspect the college. He recorded in his diary: 'Interesting but far less stylish than our own brick and terracotta'.✫ His conceited comment accurately reflects the underlying artistic weakness of an undoubted technical masterpiece. Worst of all, Barry abused the free hand that he was given by the governors of the Dulwich Estate. He had eulogized the economy of terracotta relative to Portland and even Bath stone. When it emerged that the college ended

up costing over double its original estimate, Barry became the subject of vitriolic attacks by the local press.✶

Neither the Victoria and Albert Museum nor Dulwich College exemplified a use of terracotta that could be widely taken up in commercial architecture. Both projects were too dependent on time-consuming collaboration, whether with a team of decorative artists or an eccentrically enthusiastic manufacturer. The terracotta revival was in a state of stagnation in the early 1870s. Whatever the practical questions of cost or resistance to pollution, most architects saw little artistic justification for the material beyond introducing an element of individuality and polychromy. In the second half of the 1870s terracotta might have slipped into mundane insignificance as a building material. Just as in Italy and France, red and buff unglazed ware could have become used for no more than modest decorative detailing in areas where brick predominated as a building material. However, a remarkable combination of historical circumstances abetted by a growing concern over the effects of pollution allowed one architect and, to a large degree, one of his buildings, to point the revival towards its dramatic fruition.

ON A PAR WITH STONE: THE NATURAL HISTORY MUSEUM

The status of the Victoria and Albert Museum as a treasure-house of art was reflected in the varied richness of its terracotta, tile, brick and mosaic decorations. The ceramic facing of the neighbouring Natural History Museum, built 1873–81, reflected a more mature, scientific approach. The design of the museum was entrusted to one architect, Alfred Waterhouse, and evolved round a tightly symmetrical plan and an ordered system of decoration. Great attention was given to exploiting the practical attributes of terracotta in terms of fireproofing and resistance to soot.

A natural history museum seemed to offer the perfect context for narrative ornament. When Fowke produced his first designs for the project in 1864, Professor Richard Owen, its instigator, suggested that the Renaissance design should incorporate decoration portraying beasts and vegetation. Terracotta would not just be symbolic of the purpose and contents of the building, as in the case of the Victoria and Albert Museum, but an education in itself. The principle of architecture directly reflecting the contents of a museum had been pioneered at Oxford. The University Museum, built to a rectangular plan by Deane and Woodward (1855–60), applied ideals repeatedly propounded by Ruskin: external columns were made of different stones to provide a lesson in economic geology while the piers of the gallery were carved to represent different types of plant. The same

combination of architectural symmetry and sculptural variety was to be introduced into South Kensington through the appointment of a disciple of Ruskin to develop Fowke's design.☆

Waterhouse willingly accepted Fowke's specification of terracotta but asserted his own artistic tastes, which leant towards the Gothic, once he had gained the freedom to make his own plans. Adoption of a Romanesque rather than a Renaissance version of the *Rundbogenstil* was accompanied by a decision to face the main elevations entirely with terracotta.

Both Waterhouse and the Department of Science and Art had already experimented with the use of terracotta in the form of ashlar-work. This shift accorded with the way in which terracotta gained a wider usage by other Gothic revivalists, as displayed in a series of churches dating to the 1860s.☆ The Roman Catholic Church of the Holy Name of Jesus, Manchester, presented the most adventurous contemporary use of terracotta as a facing material. The architect, Joseph Aloysius Hansom, had an inventive turn of mind which he could apply to the design of horse cabs or to building materials. The vaults to the nave, chancel and transepts were lined with simply decorated terracotta blocks while the baptistry was given columns decorated with a diamond patterning, comparable to designs subsequently developed by Waterhouse (55). The church was constructed in 1869–71, the same period during which Waterhouse matured his plans and elevations for the Natural History Museum.

Waterhouse had conceived a strong commitment to architectural ceramics in the late sixties. In 1866 he designed his new home in Reading, having moved the head office of his practice to London in the previous year.

55 The nave of the Church of the Holy Name of Jesus, Manchester, by J. A. Hansom, 1869–71 (Gibbs and Canning)

56 Foxhill, Whiteknights, Reading, by A. Waterhouse, 1866

57 (centre) Design for Reading Town Hall, by A. Waterhouse, dated 22 November 1872, completed 1875 (Gunton)

58 (far right) First-floor landing of Manchester Town Hall, by A. Waterhouse, c.1870 (Gibbs and Canning)

Unconstrained by the taste or budget of any client, the design of Foxhill illustrates his enthusiasm for a simple and almost dour brick patterning of a type that he had observed in northern Germany. Lattice panels and moulded window-surrounds of small terracotta blocks blended with the main wall-surfaces of red brickwork (**56**). By the end of 1872 Waterhouse had chosen a combination of red brick and terracotta for other houses in Reading, a school in Erleigh Road, and the Town Hall completed in 1875 (**57**).

The startling combination of buff and blue-grey colours chosen to face the Natural History Museum has a precursor in the prestigious commission entrusted to Waterhouse in 1868: Manchester Town Hall. The walls to the main corridors were lined, from dado level to their groined ceilings, with bands of pale buff and blue-grey terracotta. The terracotta vaulting was comparable to that used inside Hansom's church located a little over a mile away, and was supplied by the same manufacturer, Gibbs and Canning. The stylized ferns on the frieze and the nailheads on the vaulting-ribs were similar to some motifs designed for the Natural History Museum (**58**). ☆

The design that Waterhouse submitted for the museum in 1868 represented a fine balancing-act between South Kensington's commitment to the *Rundbogenstil* and his own preference for the Gothic style. Professor Owen approved of the choice. The Romanesque was a 'Christian' style but characterized, highly appropriately, by the incorporation of animals and plants as decoration. However, all the major examples of the Romanesque in central and southern Europe, such as Worms Cathedral in Germany, had been executed in stone, not ceramic. Through designs in Reading, Manchester and South Kensington, Waterhouse had progressively cast aside the principle by which terracotta had gained acceptability in the 1860s. The justification provided by Lombardic and Tudor precedent was to be abandoned, and terracotta was to be used in an idiom with which it had

ELEVATION TO VASTERN STREET

no historical association. Unlike in the maligned experiments of Edmund Sharpe in the 1840s, clays would not be worked in imitation of stone. They would be exploited for their own artistic potential, along lines already demonstrated by Fowke and Sykes, but not following their stylistic formula.

A major public building with a 680-foot-long façade and two floors of galleries all lined with terracotta represented as much a practical as an artistic challenge. The First Commissioner feared that the arrangement of having a series of contracts for the terracotta would divide the responsibility for completion to time. It was decided that there should be only one tender for the erection of the entire building, the builder choosing the terracotta-supplier. This procedure was to be followed in virtually every subsequent architectural project involving terracotta.

The history of the construction of the museum suggests that the most hard-headed of architects and civil servants were distracted by the vision of clay being transformed into ornamental and imperishable architecture. Efforts to ensure the smooth execution of the terracotta subcontract foundered largely because of Waterhouse's determination to advance the use of terracotta on two fronts at one and the same time: introducing a novel external polychromy, and using blocks and slabs to form a facing material bonded into the building structure. The sophistication of Waterhouse's banding of blue-grey colours was not matched by Gibbs and Canning's skill in firing blocks and slabs coated with cobalt slips. Delays caused by kiln failures at Tamworth, and consequent changes in the balance between

modelled and chromatic decoration, resulted in the timetable for delivery descending into chaos.

Construction stopped when the building contractors went bankrupt in the summer of 1879. The trustees appointed for Baker and Son blamed the firm's collapse on the slow supply of terracotta which in turn was seen as following, in part, from Waterhouse's successive alterations to the design. ☆ Amongst the claims submitted by the trustees for additional costs inflicted upon the contractors was one for sorting the animal figures into their correct categories. Two groups had been designed by Waterhouse. The fronts of the east and west wings were to be decorated, respectively, with portrayals of extinct and living species, to correspond with the internal arrangement of the museum (*colour plate 8*). Somewhere in the process of modelling, manufacture or delivery, pterodactyls and sabre-tooths had become jumbled up with lions and wolves; experts had to be brought in to sort palaeontology from zoology (**59**). ☆

The museum opened in April 1881, five years behind schedule and at a seriously inflated cost of £412,000. A succession of crises, some precipitated by problems with the supply of terracotta, were largely forgotten as the design became the subject of widespread admiration. Its sculptural decoration had already gained saturation coverage in the architectural press. The Natural History Museum was praised for its unique combination of style, material and imagery. The exception that altered the rules of Victorian architecture, it marked the demise of the outmoded Italianate of South Kensington and of the weighty secular Gothic of the 1860s and 70s. At the same time it demonstrated a progressive means of combining eclecticism and the use of terracotta that was to hold sway into the next century. To one of the leading exponents of architectural terracotta, E. Ingress Bell, it was 'a Victorian building, and no other'. ☆

An underlying justification for the use of terracotta was provided by its resistance to both soot and fire. The H-section iron columns in the front ground-floor galleries were encased with terracotta panels which were decorated with low-relief images of swimming fish and eels; the ventilation grilles just below the ceiling were modelled as miniature colonnades.

The nature of the terracotta wall-surface provided the key in Waterhouse's masterful integration of plan, composition and detailing. Courses were varied in height across the façade and made up of blocks and slabs to create a tight bonding between the terracotta facing and the brick structure behind. Diversity in the jointing of the terracotta was reinforced by the changing pattern of the blue bands, sometimes widely spaced, but grouped

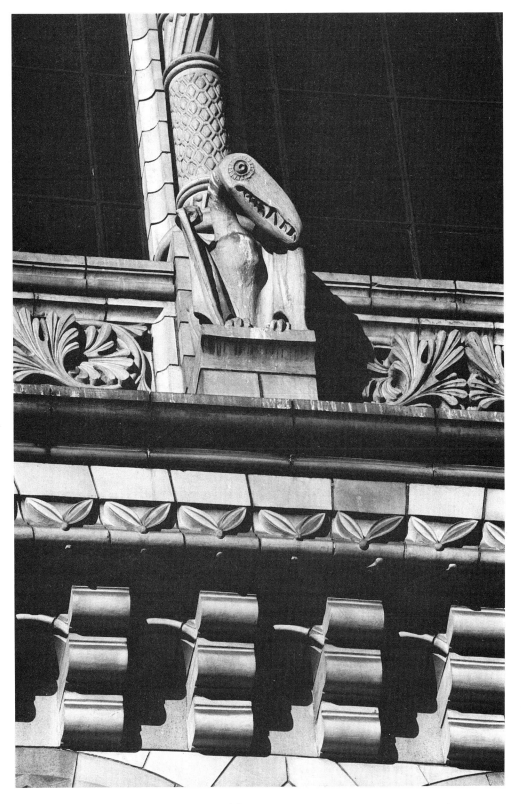

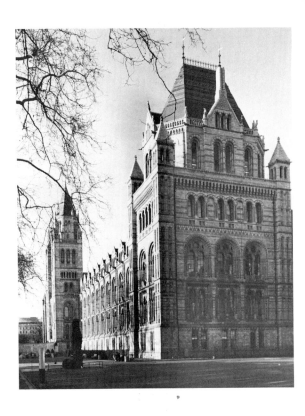

60 Main front of the Natural History Museum, London, by A. Waterhouse, 1873–81 (Gibbs and Canning)

in pairs at ground and first-floor level. Colour variations created in Gibbs and Canning's kilns were welcomed by Waterhouse as 'beautiful accidental tints' that created shimmering surfaces (**60**), just as portrayed in his colour-washed drawings. ☆ The predominant buff colour of the museum met with less approval from the curators, who condemned the colour as too bonelike, detracting from the impact of their collections of skeletons and skulls. ☆

The miracle of the Natural History Museum was Waterhouse's success in developing educational decoration along lines approved by Ruskin, but with figures crisply modelled and made in a factory. The repetition of lions or monkeys does not convey a feeling of mean economy, but the sense of order at the root of Owen's conception of nature. It is only by close observation that the pattern of repetition becomes fully apparent; just eight species of beast form sentinels along the cornice-line and no more than five patterns of column are used on the balustrades in the central hall.

In October 1873 Professor Owen had supplied Waterhouse with fifty or so illustrations of extinct animals. The architect was responsible for the tautness of the figures, the modeller, Dujardin, closely following his exquisite sketches. Although Waterhouse was a Goth, trained by apprenticeship rather than in an art school, his designs represented a startlingly logical development of the South Kensington idiom. The lions séjants, set proudly along the cornice of the Natural History Museum, had the same muscularity and sweeping ruffs as Stevens's designs for the railings of the British

Museum in Bloomsbury. The plant forms for some of the capitals and panels were as crisp as Sykes's panels on the Official Residences of the Victoria and Albert Museum, some of which included foliation and nestling birds. The mixture of contemporary attitudes to nature was reflected in the religious overtones of the central hall, and in portrayals of the fight for survival amongst the different species. Raw aggression was all too apparent in the grotesqueness of the deep-sea stomatic fish and in the angst of the lion caught in the coils of a snake. The magisterial dominance of the wolf was contrasted with the comical banality of the extinct dodo, the cheeky animation of the monkeys and the vulnerable innocence of the pampas deer.

The Natural History Museum marked the major turning-point in the terracotta revival. Terracotta had been released from the restriction of having to be designed in a form with which it was historically associated. Rather than re-create Italian arcades, Waterhouse had demonstrated an approach based on the purpose of the building and on the potential of clay in terms of colour, repetitive decoration and naturalistic sculpture. Terracotta had gained a status on a par with stone, and a practical cause in resistance to soot, damp and fire.

The museum offered no clear way forward; more a carte blanche. It affirmed the ideology that the exploitation of the natural qualities of terracotta could lead to a 'Victorian' style, if the designer adapted and updated one or more historicist styles and presented imagery appropriate to a building's use. If the stylization was suitably progressive and the narrative decoration not too didactic, then these two strands could be entirely complementary. Waterhouse's achievement was a trifle fortuitous. The almost universal appreciation of the terracotta on the Natural History Museum followed in part from the building's purpose. An up-to-date interpretation of the Romanesque style could accommodate botanical and animal sculpture to unified and inspirational effect. It would prove much more difficult to find a comparable sympathy between any style, however thoroughly adapted, and imagery appropriate to libraries, banks or railway stations.

The museum also marked a somewhat hollow victory in advancing the practicalities of the manufacture and installation of terracotta. Gibbs and Canning went into liquidation in 1881, probably being unable to weather the slump after supplying such a massive order. Late-Victorian architects and manufacturers rarely gambled with the innovative colours and forms that Waterhouse introduced in the Natural History Museum. Until glazed faience was adopted for external work at the turn of the century, they played safe with reds and buffs fired from natural clays, and with the use of terracotta primarily for dressings to brickwork rather than as a vibrant overall facing material.

LATE-VICTORIAN TERRACOTTA
Eclecticism and Originality

Interest in terracotta reached a peak in 1886. Two decades of lectures, articles and essays, with even Thomas Hardy writing in favour of the material, culminated in twelve months of obsessive debate and misery for any stonemason or quarry-owner.✶ Papers with titles such as 'Terracotta v. Stone' contrasted the already 'blackened carcass' of Waterhouse's Manchester Town Hall against the 'bright, clear complexion' of his Natural History Museum.✶ Engravings and water-colours of terracotta buildings in Mayfair and Chelsea were interleaved with reports on early-Renaissance ceramics in England or on study tours of Lombardic churches.

The rash of terracotta that broke out along the high streets of industrial towns and cities coincided with a new mood of openness in architectural design, itself spurred on by economic laissez-faire and political liberalism. An enthusiasm for new materials was matched by a fast-paced stylistic eclecticism, drawing in and intermingling motifs from different countries and periods. Late-Victorian eclecticism, often denigrated as 'bric-à-brac',✶ represented an honest attempt to create an architecture that reflected rather than spurned contemporary progress in terms of technology, prosperity and civic pride. The architects who combined and reworked free Gothic, Loire or 'Renaissance' styles varied as much in the sincerity of their intentions as in their end results. Innovative decoration that drew upon one or more established styles could be conceived as a type of shock-absorber to help urbanized society adjust to rapid change, or, at worst, as a cynical exercise in nostalgia, helping clients and developers to profit from the backward-looking tastes of a gullible public.

If decorative forms and styles became treated as antiquarian fodder to be chosen and consumed without any link with underlying art movements or the needs of society, architecture might be reduced to little more than a form of dress. Some outbursts of terracotta, whether wild or mundane, might be regarded as exploiting rather than contributing to contemporary art and culture. The writings and designs of the leading advocates of ceramics – Alfred Waterhouse, J. H. Chamberlain and Ernest George – cannot be dismissed in these terms; they reflect a commitment to develop an appropriate architecture for the building's function and its location, and ultimately for its age.

Most architects and a broad spectrum of the public shared a common way of looking at buildings. They viewed façades and street scenes as if forming the contents of a picture: expecting them to be satisfying as an overall composition and with variety and detail to further engage the eye. According to the 'Theory of the Picturesque', defined in the eighteenth

century and still widely accepted in the late nineteenth, asymmetrical outlines created vigour and variety, while exotic styles and intricate ornament generated further interest. ☆ Young architects, amateur water-colourists and educated clients all revelled in 'picturesqueness', seeing it as a desirable quality in urban buildings as well as country lodges and dairies.

Publications, art schools and opportunities for easier travel all encouraged a broader interest in architecture and the pursuit of novelty. New meanings were infused into accepted historic forms while the range of stylistic options broadened as the buildings of France, the Low Countries and Spain were reproduced in volumes of engravings. Transitional styles, typically on the border between late Gothic or early Renaissance, offered wide potential for originality in design and a freedom from doctrinaire historicism. Similar arguments were presented in favour of terracotta. Ingress Bell, joint architect of the Birmingham Law Courts, argued that because the material had, historically, only been used on a small scale in comparison with brick and stone, there was considerable scope for new forms, especially with modern methods of manufacture and when used on modern building types. ☆

The degree of repetition of forms and motifs that typically accompanied the adoption of terracotta was welcomed rather than spurned: 'a single line of panelling or diaper over a broad expanse of open wall will often have a most piquant effect, doubling the value of the wall as giving mass to the composition'. ☆ By the mid-1880s the repetition encouraged by the use of plaster moulds and exploitation of the plastic nature of unburnt clay to create smoothly curved surfaces were perceived as contributing to a distinctive 'terracotta style'. ☆

Aesthetic considerations were supported by concern over smog and fire. Long-established doubts about the effects of smoke pollution on masonry built up into a major crisis of confidence in the years around 1880: 'all our stone buildings have been more or less failures. The sooty particles find their way into every nook and crevice . . . all relief and contrast disappears in one dingy coating of lugubrious fur'. ☆ Drab, decaying buildings undermined civic pride, cast doubts on the benefits ascribed to industrialization and were associated with diseases that threatened the genteel as much as the slum-dweller.

Alfred Waterhouse was a founder-member of the Smoke Abatement Society but saw a more expedient solution to the problem in terracotta: a material 'made from a clay found in the same pit as the coal which did the mischief'. ☆ The most ironic instance of the triumph of narrow commercial interests over reform is provided by the vain attempt to restrain two manufacturers of architectural ceramics: Doulton and Stiff of Lambeth, whose kilns belched 'noxious vapours' over Lambeth Palace and Westminster (**27**). Even action by the Archbishop of Canterbury could not stop the two firms from adding to the sulphurous smog that was attacking the city's

fig. 5.1 The Doulton–Peto fireproofing system, *c.*1885

stonework, and hence encouraging demand for their tiles and terracotta. ✻

Fireproofing, in contrast, became an increasingly peripheral issue in relation to British terracotta; arched brick and later concrete proved more economical and flexible than the over-complex systems developed by some of the manufacturers. Blanchard's patent fireproof floor could only span 2 ft. 6 ins. Few architects would have taken it seriously after being subjected to a demonstration of its qualities at the company's Bishop's Waltham works. Visitors were made to stand on a roof made of the patent terracotta while straw, wood and tar were burnt underneath. As a finale, Blanchard's workmen jumped up and down on the surviving structure to demonstrate its unimpaired strength. ✻ The Doulton Peto patent floor was a more viable proposition, developed by Basil Peto following a study of American fire-proofing. His floor was first used in the London Pavilion, Coventry Street, London, in 1885. The chambered blocks were wrapped round wrought-iron or steel I-section beams to protect them from fire, but proved too expensive for widespread adoption, even though they allowed spans of up to 8 feet (fig. 5.1). ✻ Messrs Homan and Rogers developed a simpler and more economical approach: extruded fireclay blocks of triangular section were laid at right angles to the main joists forming a bed to be filled with concrete. The cheaply made blocks were used in many public buildings including London's board schools. ✻

Terracotta was judged primarily on its potential for the art rather than the technology of architecture, debates focusing on the appropriate colour, size and modelling for a moulded building material. The long-running conflict over whether terracotta should be regarded as a sophisticated type of brick or as a substitute for stone was accommodated rather than resolved. Given that advocates of the Gothic style such as George Gilbert Scott favoured the former approach, while large hollow blocks related best to styles under the Renaissance umbrella, two strands of usage emerged. The contrast was heightened by the association of the two schools with red and buff terracotta respectively. Since different clay-pits across the country produced raw materials that burnt naturally to different colours, the disposition had a geographical implication. The works at Ruabon were renowned for their red terracotta which became ubiquitous in the Wirral, Chester and Crewe, while Doulton of Lambeth dominated the London market with their buff and pink materials. This scheme, although distorted by the overriding preferences of particular architects and clients, provides the best approach for unravelling the apparent riotous anarchy of late-Victorian terracotta. In very general terms, the free Gothic of Waterhouse or Martin

and Chamberlain was usually realized in small blocks of simply moulded red terracotta. In contrast, maestros of the northern European Renaissance, such as Ernest George and T. E. Collcutt, opted for buff material, worked in larger pieces and with more complex modelling.

WATERHOUSE AND THE PRUDENTIAL

Alfred Waterhouse, doyen of British terracotta architects, was branded as the leading exponent of an assertive Gothic executed in matching red Ruabon brick and terracotta. The 'slaughterhouse style', as it became derisively labelled, was in practice a hallmark only of his work for the Prudential Assurance Company.* His other commissions reflect a finely tuned if somewhat mechanistic response to the plan and purpose of a building as well as to its materials. Waterhouse lauded terracotta as a 'material of the future' on account of its economy and durability, and for the way in which it allied with his philosophy of adapting historical traditions to the requirements of modern commerce.* His predilection for geometric rather than naturalistic ornament suggests that he had few qualms about accepting the repetition that followed logically from the use of moulded clay rather than carved masonry.

As a supporter of the 'simple' rather than the 'compound' school of clayworking, Waterhouse typically used terracotta in small blocks made of the same single coal-measure clay as for the surrounding brickwork.* A hierarchy of types of window, dormer and gable would be developed into a system of decoration related to the overall form and internal function of the building, the elevation being subdivided by a grid of mullions and string courses. Waterhouse did not adopt terracotta as a way of delegating detailed design work to others, but as a means of retaining a tight control over the execution of his designs. By liaising closely with the firm of modellers, Messrs Farmer and Brindley, and with a small number of trusted manufacturers, especially Gibbs and Canning, J. C. Edwards, and Burmantofts, he could avoid seeing his crisply conceived drawings misinterpreted by often unreliable and self-willed stonemasons.

The acclaim given to the Natural History Museum focused attention on other, near-contemporary, terracotta buildings by Waterhouse. The head office of the Prudential Assurance Company in Holborn, completed in 1878 but subsequently rebuilt, and no. 1 Old Bond Street, dating to 1880, both also incorporated buff terracotta supplied by Gibbs and Canning (**61**). The Prudential frontage was given traditional Gothic details such as stiff-leaf capitals and foliated finials. For 1 Old Bond Street, the decoration was based entirely on low-relief patterns, the panels of simplified flowers creating an almost astylar composition. Waterhouse introduced lattice panels as an

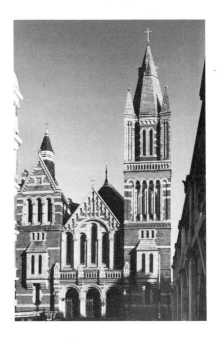

alternative, non-historicist approach to repetitive ornament on Hove Town Hall and his home, Yattendon Court, both completed in 1881.

The supposedly hard-headed and insensitive Waterhouse edged rather than swept his way towards originality, often reworking designs as they progressed from draughting to execution, much to the despair of the managers at Tamworth or Ruabon. The frontage of the Central Institution of the City and Guilds of London Institute, built 1881–4, evolved from *Rundbogenstil* to weighty Queen Anne topped by Dutch-style gables. The arms of principal manufacturing towns were substituted for those of livery companies after James Gamble had already commenced modelling work.* The most notable feature of the institute, situated between the Natural History Museum and the Albert Hall, was its contrasting colour – Gibbs and Canning being instructed to create a deep, strident red. Waterhouse reverted to his Romanesque style for one of his ecclesiastical commissions of the eighties, the King's Weigh House Chapel, built in Mayfair from 1889. Detached shafts distinguished the fenestration of the main front from the windows to the basement and to the upper oval storey of the auditorium, which were given plainer moulded surrounds (**62**).

Amidst this variety of approaches to colour and style, the underlying pattern in Waterhouse's use of terracotta was made abundantly and magnificently clear in the Victoria Building constructed for the University of Liverpool between 1887 and 1892. The corner site at the top of Brownlow Hill allowed his free Gothic style to be worked to the strongest picturesque effect (**63**). Applied decoration was not totally excluded: plaques portrayed the Liver bird and Queen Victoria while floral diaper patterns were set in the wall under the staircase windows. However, the dressings were

61 (far left) No. 1 Old Bond Street, London by A. Waterhouse, 1880 (Gibbs and Canning)

62 (left) King's Weigh House Chapel, Duke Street, London, by A. Waterhouse, 1889–91 (Burmantofts)

63 Victoria Building, University of Liverpool, by A. Waterhouse, 1887–92 (Clark and Rea)

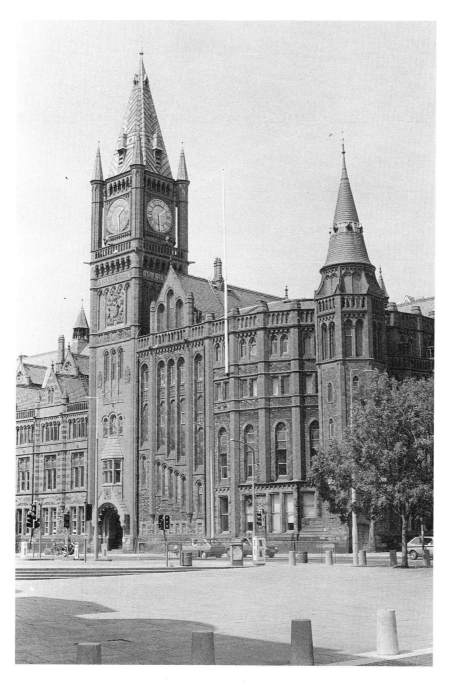

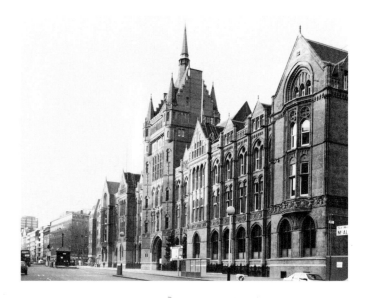

arranged across the frontage primarily to articulate the overall arrangement of the building. Ruabon terracotta and matching red bricks were concentrated in the walls of the entrance tower, the adjacent staircase and the gables and dormers, to contrast with the grey of the common bricks and the roofing-slates. Even the richness of the window tracery and the width of the mouldings in the string courses and buttresses were designed to contribute to this hierarchy, giving an air of controlled logicality to the composition.

Waterhouse's combination of red brick and red terracotta formed the basis of a house style for the branch offices of the Prudential; seventeen were to be faced in ceramic. Apart from a few exceptions, where buff terracotta or stone was used, a bold red colour, possibly with an orange or purple tinge, was adopted from one end of the country to the other. To the managers of the Prudential this strident uniformity betokened dependability and permanence. For the architect it accorded with his disillusionment with polychromatic contrasts, summarized in his pithy caution that 'colour contrasts kill form'. ☆

Even the first Prudential branch, opened in Liverpool in 1885, was viewed by critics as something of a reworking of the established Waterhouse idiom rather than a revolutionary new initiative. ☆ The most striking feature at Liverpool was the corner doorway, surmounted by an oriel stepped out on tiers of corbels. Comparable forms, though enlivened by clustered tourelles, were used in the larger and more symmetrical building at Portsmouth, dating to 1886. Plainer, pointed-headed windows were employed for the smaller office at Bolton (1889) while the design for Huddersfield (1898) showed a more full-blown Gothic flavour (**64**). Waterhouse jibbed at the tight formula that he himself had developed, introducing more variety into the later branches. Leeds (1890) and Sheffield (1895) were less Gothic, more

64 (far left) Prudential Assurance Building, Huddersfield, by A. Waterhouse, 1898

65 Prudential Assurance Head Office, Holborn, London, by A. Waterhouse. Original 1878 block rebuilt in 1930s on left (Hathern) and Furnival's Inn building including tower on right, 1897–1901 (J. C. Edwards)

Queen Anne and French Renaissance, while the crisply conceived gables and round arches of the Bradford office (1893) defy any stylistic labelling.

The Prudential management kept their architect in line with their corporate identity. After he had juxtaposed red brick and buff dressings at Leeds and Leicester (1892), the secretary was instructed 'to remind Mr Waterhouse that the Board preferred red terracotta'.✶ His initial proposal to use buff brick and red terracotta for the extension to the London office in Holborn, designed 1898 and finally completed in 1906, gave way to red Ruabon uniformity, courtesy of J. C. Edwards. Queen Anne detailing was also expunged in favour of nook-shafts and blind arcading, and inside for faience vaulting above the main landings (*colour plates 11 and 12*, **65**). The status of the head office justified high-relief sculpture. Shields portraying the arms of cities in which the Prudential was represented were held by cherubs; in contrast to the taut modelling of most mid-Victorian putti, those arranged across the Furnival's Inn Building look a trifle old and overfed.✶

EXPRESSING BIRMINGHAM'S CIVIC GOSPEL

Red Gothic terracotta became the architectural symbol of Birmingham's Civic Gospel, a movement to improve the political administration and physical fabric of the rapidly growing city. This association was established through the board schools, the first example coinciding in date with the commencement of Joseph Chamberlain's highly productive mayoralty in 1873. Martin and Chamberlain, the unrelated firm of architects, were to design forty-one board schools up to 1898, developing a relatively consistent architectural image across Birmingham's inner suburbs. The schools needed to stand out from the meanness of surrounding houses, and by being progressive and economical in their design and use of materials they could convey a message of educational enlightenment.

The style of the schools was consistently Gothic. John Henry Chamberlain was an avid disciple of Ruskin and had been articled to another Goth, Joseph Goddard of Leicester, who around 1870 made modest use of terracotta himself. Reflecting Ruskin's love of polychromy, the early schools combined brick, tiling and stone – and in the case of Oozells Street School of 1878, naturalistic carving. Seven years later, at Stratford Road School, plant and flower patterns were set in a series of terracotta panels (**66**).✶ Red terracotta dressings were typically concentrated on the main doorways, windows, gables and the soaring ventilation towers. Despite some resist-

ance to the near-monopoly that the practice achieved in designing Birmingham's board schools, Martin and Chamberlain also had the opportunity to use terracotta in most of the free libraries built in the city and at a number of public baths, asylums and pumping-stations. ✫

The School Board had close ties with the School of Arts Committee, which sought to provide art training for the brass, jewellery and other skilled trades. While the City Art Gallery was built in stone to blend with the adjoining Council House, the main façade of the College of Arts and Crafts in Margaret Street shows John Henry Chamberlain's use of terracotta, tiling and mosaic at its most lavish. Dating to 1884–5, it forms a late example of the juxtaposition of several contrasting materials, as recommended by Ruskin. Terracotta was used both for the cornice and the foliate decoration; the *pièce de résistance* was a large blank rose window, 12 feet in diameter, designed by Chamberlain and modelled by S. Barfield of Leicester (**67**). Its subject – a lattice grid overlain by a sweeping lily – evoked the potential of terracotta for both abstract and naturalistic decoration.

Corporation Street became the most dramatic manifestation of Joseph Chamberlain's Civic Gospel. The upper end, towards Aston, displays one of the most striking groups of terracotta buildings in the country, rivalling the museums of South Kensington and the arcades of Leeds. The masterpiece, the Victoria Law Courts, designed by Aston Webb and Ingress Bell and built 1887–91, was sited virtually at the end of Corporation Street (**2, 68**). This building, more fully than any work by Waterhouse, bridged the void between Gothic and Renaissance historicism, to proffer a way in which terracotta could form the basis of a contemporary decorative architecture.

The competition to choose a design for the Law Courts was judged by Waterhouse. Webb and Bell's anonymous entry, cunningly titled 'Terra-

66 (far left) Stratford Road School, Sparkbrook, Birmingham, by Martin and Chamberlain, 1885

67 Rose-window with a lattice overgrown by lilies, modelled by S. Barfield, on the façade of the College of Art, Margaret Street, Birmingham, by Martin and Chamberlain, 1881–5

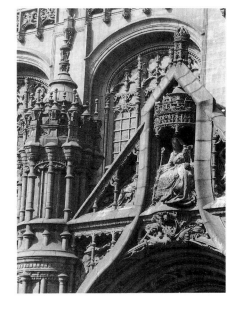

68 Statue of Queen Victoria, by H. Bates, over the entrance of the Law Courts, Corporation Street, Birmingham, by A. Webb and I. Bell, 1887–91 (J. C. Edwards)

cotta' to catch the assessor's eye, was praised in terms of its picturesque composition and its sophisticated detailing.✩ The architects drew inspiration from the early Tudor style of Hampton Court and from sixteenth-century Flemish town houses for a stock of motifs, such as scrolls, dolphins, and cable and egg-and-dart mouldings, to decorate cornices, turrets and arcades. The decoration was designed not so much as part of the structure of the façade as to flow out of it in curves that break away from the line of the walls. Such curving sections could easily be moulded in terracotta but would have been laborious to carve in stone.

The Law Courts were the product of a complex collaboration between architects and decorative artists. The detailing was modelled by William Aumonier, and Webb and Bell's design left spaces for sculptural work to be conceived and modelled by independent artists. Aumonier himself was responsible for the figures representing Art and Craft, set into the gable wings. W. S. Frith undertook the figure of Justice on the central gable and the cherubs supporting the cornices. He also modelled the figures of Truth, Patience and Plenty in the spandrels of the porch, to designs by Walter Crane. Harry Bates, like Frith an innovative London sculptor, designed and modelled the exquisite figure of Queen Victoria in the entrance gable. The strong consistency in sculptural style demonstrated how well new ideas of modesty in scale and natural expression in sculpture related to the eclectic use of terracotta. Aumonier went to great lengths to judge the architectural effect of his work. He modelled his figures at Ruabon on a stage erected above the clay-pit, allowing him to judge the effect from a position 60 to 70 feet below at the equivalent of street level.✩ The deep red terracotta used to face the entire frontage was supplied by J. C. Edwards, but a more local firm, Gibbs and Canning of Tamworth, gained the contract for the

buff lining to the interior. The great hall was lined up to the roof with terracotta, the finest details being the royal coat of arms, flanked by a lion and unicorn, set above a pair of archways.

The terracotta decoration of the Law Courts virtually took on a life of its own, certainly beyond what the Victorians could justify as a direct expression of the structure of the building. Webb and Bell's design was well received, widely emulated and, in Birmingham, almost directly copied. Some critics were apprehensive: the *Builder* commented on the 'waxy-looking texture' and the 'hard and cast-iron effect of the ornaments' and was suspicious that 'the plastic character has betrayed the architect into a somewhat exuberant form of ornamentation in some places'. ☆

The Law Courts became surrounded by other terracotta buildings, the most innovative being the General Hospital, built 1892–7. William Henman's design was also chosen through a competition assessed by Waterhouse, and features such as the elliptical and round arches, projecting cornices and pilasters hark back to the Law Courts on the other side of Steelhouse Lane (**69**). They were repeated, with little variation, from the gateway to the entrance portico, the balconies and the main towers. The entrance to the administrative block was decorated with large female figures representing Medicine, Surgery and Philanthropy. Patients passed by statues symbolizing the more abstract concepts of Air, Purity and Light. Much of the terracotta decoration was worked into curving and interlacing motifs, while columns were grooved with diagonal lines. Such forms provided a Romanesque or Celtic identity but also served to obscure any irregu-

69 Forecourt and entrances with statues by J. W. Rollins, General Hospital, Steelhouse Lane, Birmingham, by W. Henman, 1894–7 (Doulton)

70 Corner tower of the General Hospital, Birmingham (Doulton)

71 Entrance gable, Bell, Edison building, Newhall Street, Birmingham, by E. Martin, 1896 (J. C. Edwards)

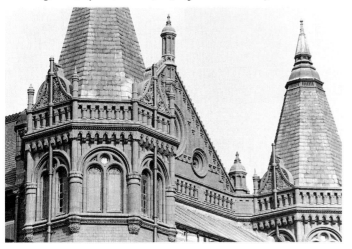

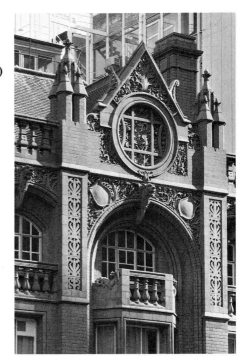

larity in the form of the blocks (**70**). Problems with warpage may have arisen as a result of Henman's decision to use dark red terracotta made by Doulton at Rowley Regis. The firing conditions for this plum-coloured and slightly vitrified material were reported as being particularly critical.

During the 1890s several architectural practices were to develop what was virtually a Birmingham terracotta style. Frederick Martin, of the practice of Martin and Chamberlain, worked to match red brick and terracotta with dramatic originality in two libraries dating to 1893. The Green Lane branch in Small Heath is dominated by a rocket-like tower, while Spring Hill has an entrance archway incorporating the arms of the city and winged beasts perched on corbels (*colour plate 10*). The high point of Martin's free-Gothic use of terracotta is the Bell, Edison Company Building erected on the corner of Newhall Street in 1896. Tall arcades provided a framework for a graduation in decorative effect from simple moulded sections to swirling acanthus leaves in the spandrels, while leopard-like animals projected as keystones or wrapped themselves over balustrades (**71**).

DOUGLAS AND THE DUKE OF WESTMINSTER

Cheshire and Lancashire gained a particularly sensitive use of Ruabon red terracotta, almost as a Victorian vernacular, through a group of architects connected by apprenticeship or partnership. John Douglas had been articled to E. G. Paley in the mid- or late 1840s, at a time when Paley was in

72 St Cross Church, Knutsford, Cheshire, by Paley and Austin, 1880–1

73 (opposite left) The use of extruded solid blocks for window tracery, St Saviour's Church, Folkestone, Kent, by S. Clarke and L. T. Micklethwaite, 1892 (Doulton) (from *Builder*, 63, 1892, p.283)

74 (opposite right) Sculptural detail on Eye, Ear and Throat Hospital, Shrewsbury, by C. O. Ellison, 1879 (J. C. Edwards)

partnership with Edmund Sharpe, designer of the 'pot' churches of the 1840s. Most of Douglas's commissions were for churches, minor country houses and estate cottages; their typically rural location made brick and simple forms of solid terracotta more appropriate than heavily modelled decoration. Douglas achieved a close collaboration with J. C. Edwards, several of his designs for domestic chimney-stacks being incorporated into the company's catalogue.☆ His most lavish use of ceramics emerged out of a commission from that great aficionado of terracotta, the Duke of Westminster: the imposingly Germanic terrace, 6–11 Grosvenor Park Road, Chester (1879–80) combined scrupulously profiled brick mouldings with small decorative panels and corbels (*colour plate 9*).

The hardness and bright red colour of terracotta could be toned down by combining it with other materials. One of Douglas's pupils, E. A. Ould, included decorative brickwork, tile-hanging and half-timbering in Queen's Road School, also in Chester (1882–3); the simple red blocks and the statue of Queen Victoria were manufactured by H. R. Bower of Ruabon. The practice of Paley and Austin became finely attuned to the appropriateness of materials, stone being deemed most fitting for prestigious churches and those in rural settings. Plain brick and then brick and terracotta were used in the Lancashire coal and cotton settlements, as at St James's, Daisy Hill (1879–81). For St Cross, Knutsford (1880–1), small solid blocks were used for running mouldings, for Perpendicular tracery, and to line the interior of the chancel (**72**). Appreciating the demand for small pieces of solid terracotta, Doulton took out a patent for making them by extrusion (**73**).

Another Lancashire architect, C. O. Ellison, integrated terracotta into

the Old English style, characterized by its inclusion of half-timbering. His 'modern Gothic' design for the Eye, Ear and Throat Hospital in Shrewsbury (1879–81) was considered 'eminently suitable to the architecture of the local timber work'.✶ Mouldings and floral panels typical of J. C. Edwards's output were combined with symbolic sculpture: a figure panel illustrated Christ giving sight to the blind while two griffins, set either side of the entrance with beady eyes and pointed, listening ears, appear to denote good eyesight and hearing (74).

TERRACOTTA AND THE NEW SCULPTURE

Animated and narrative decoration gained a central place in the terracotta revival through the New Sculpture movement. An informal group of decorative artists, based primarily in London, drew upon the legacy of Alfred Stevens and contemporary French practice in clay-modelling to break away from the stranglehold of neoclassicism and develop more dynamic and

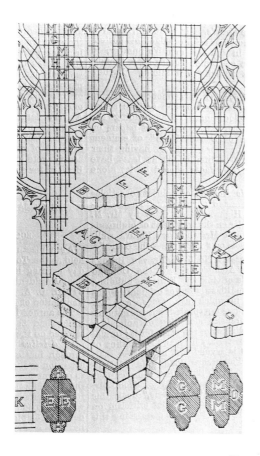

91

seductive approaches to figure sculpture. Their openness to links with industry first emerged in a fruitful collaboration between the Lambeth School of Art and the nearby Doulton works, a tie which was to give terracotta a key role within the movement. Henry Doulton fostered worthy decorative artists over several decades. On the suggestion of the headmaster of the Lambeth School of Art, John Sparkes, he had taken on George Tinworth in 1867. Tinworth, praised by Ruskin as an 'indubitable genius', collaborated with G. E. Street for the first of his large reliefs, the triptych for York Minster designed in 1876. The static, almost naïve, modelling of disciples, Pharisees and thieves aroused fascination; but by the middle of the following decade Tinworth's panels and statues were more likely to be condemned as disjointed and lacking any broad idealism (**75**, **76**). ✩

Sparkes was to prompt a revolution in terracotta sculpture as Superintendent of the South London School of Art, a post he combined with that of Principal of the National Art Training School at South Kensington. He arranged for a French sculptor to teach the evening classes in clay-modelling: Jules Dalou had gained a reputation for combining bold modelling and emotion in his sculpture, largely through a series of terracotta statuettes on genre themes. Two of his students, Harry Bates and W. S. Frith, applied their training at South Kensington to bring a sweeping, confident approach to architectural sculpture, as already noted in the Law Courts in Birmingham. Few major examples of the New Sculpture in terracotta survive. Major losses in London include George Frampton's contribution to R. W. Edis's Constitutional Club (1886) and Bates's four reliefs on Messrs Hill and Sons' bakery of the same year. The figures representing ploughing, sowing, reaping and milling in idyllic rural settings had all the spontaneity and expressiveness of Sykes's work on the Victoria and Albert Museum. The frontage by Thomas Verity, who had trained at South Kensington, demonstrated how the New Sculpture could be related to the string courses and pilasters of loosely Renaissance compositions. ✩

76 George Tinworth modelling a maquette of a monument, c.1890

75 (opposite) The 'Sons of Cydippe' panel by G. Tinworth, c.1884 (Doulton)

MAYFAIR, KENSINGTON AND CHELSEA

The Queen Anne style – drawing ideas from English domestic architecture of the seventeenth century – loosened the moral reins of high-Victorianism that had so constrained the use of terracotta in the mid-Victorian period. Accommodating a medley of Renaissance motifs from northern Europe, Queen Anne provided a framework for an indulgent use of terracotta, often incorporating figures worked with flowing drapes, contemplative expressions and other hallmarks of the New Sculpture movement. The pioneers of Queen Anne, J. J. Stevenson, Richard Norman Shaw and W. E. Nesfield, avoided terracotta, preferring to use rubbed and carved brick to create pediments, pilasters, festoons and sunflowers. Rubbed brick allowed a fastidious architect to modify details as finely as if stonemasons were being employed, but it was expensive and vulnerable to attack by soot and frost.

Other architects were less hidebound about using factory-made ornament. They seem to have revelled in the substitution of materials, their wilful juxtaposition, and other conceits and excesses. A group, a decade younger than Waterhouse, Chamberlain and Douglas, combined the picturesque and asymmetrical principles of Queen Anne with motifs sketched from Jacobean country houses, or during travels to the Loire, Ghent or Lübeck. Decorative forms and plain ashlar were moulded in large blocks, typically of bright buff colour, equatable with but not imitating stonemasonry. They found sympathetic clients for their sketches and plans in the Duke of Westminster and Lord Cadogan, who came to see their Mayfair and Chelsea estates as oases of glistening terracotta amidst streets of drab stock brick or stucco. ✩

77 Nos. 104–8 (right) and nos. 109–11 (left) Mount Street, London, by E. George and Peto, 1885–90 (Doulton (right) and J. C. Edwards (left))

78 (opposite) Detail of window-bay and porch, 52 Cadogan Square, London, by E. George and Peto, 1886 (Doulton)

79 (far top) Gable incorporating a beast modelled by Walter Smith, City Bank, Ludgate Hill, by T. E. Collcutt, 1890 (Doulton)

80 (far foot) Doorway, no. 128 Mount Street, London, by W. H. Powell, 1886–8

The Duke of Westminster was able to bring Mayfair into the vanguard of contemporary architecture by vetting all the designs submitted to the estate office. The richest man in Britain but an avowed liberal and philanthropist, he had been impressed by the quadrangle of the Victoria and Albert Museum.✩ The Duke first saw his taste for red brickwork fulfilled in the china and glass shop, 17–19 South Audley Street, of 1875, designed by Ernest George for Thomas Goode; just the copings on the four gables were of terracotta.✩ In the following decade indigenous Queen Anne gave way to the French- and Flemish-style fantasies erected in adjoining Mount Street. Architects, including A. J. Bolton and Thomas Verity, competed in creating groups of shops, houses and flats with over-scaled porches, bays, gables and chimney-stacks, faced entirely in salmon- or buff-coloured terracotta, for the most part supplied by Doulton. While W. H. Powell indulged in curving archways and consoles in nos. 125–9 (1886–8) (80), J. T. Smith piled on the weightiest detailing possible for nos. 117–21 (1886): pediments were not just decorated with shields and shells but executed in two colours of terracotta, the gaudy contrast placing the design on the borderline between the dramatic and the visually offensive. The possibly contrite Duke described the frontage as being 'overdone and wanting in simplicity'.✩

George and Peto made a relatively tame contribution to Mount Street, nos. 104–11 (1885–90) introducing their hallmark of broad surfaces of buff terracotta, half the elevation being detailed for one client with crockets and pinnacles, and the other with pilasters and pediments (77). They found more verve for the Cadogan estate in Kensington, giving an individual identity to the burghers' houses erected in Collingham Gardens and Harrington Gardens. Ernest George drew upon sketches made in Belgium while Harold Peto could offer ideas gained from travels in Holland. Each individual house was dominated by a broad gable, rising above bays or balconies; those with predominantly brick elevations acted as a foil to

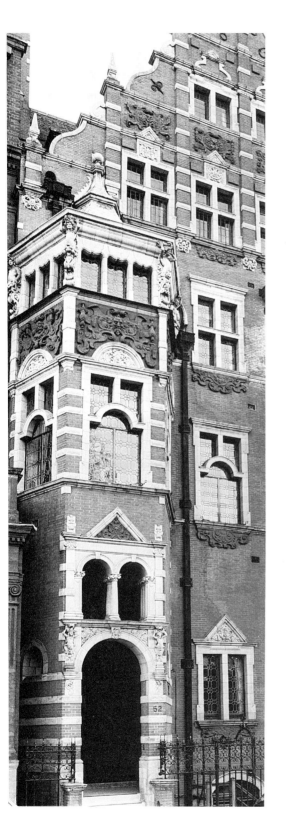

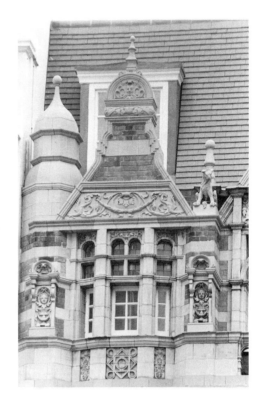

others, such as 12 and 12a Collingham Gardens (1886–8), which were entirely faced with yellow and buff terracotta and gridded by pilasters and string courses, and by transomed and mullioned windows. The partnership achieved a meticulous integration of free-Renaissance composition and New Sculpture at no. 52 Cadogan Square (1886). Jester caryatids and miniature grotesques were modelled in buff Doulton terracotta with sufficiently light-hearted vigour to complement the inventive massing of two bays squeezed under a wide scrolled gable spanning the width of the house (**78**).

Just as George and Peto probably worked with Harry Bates for the sculpture for 52 Cadogan Square, T. E. Collcutt developed a collaboration with Walter Smith, a renowned designer and college instructor.✩ Collcutt's first use of terracotta appears to have been for a sanitary engineer, George Jennings, who commissioned him to design a group of houses in Nightingale Lane, Clapham, *c.*1879; not surprisingly, Jennings's factory near Poole in Dorset supplied the panels of strapwork, masks and cornucopia.

Collcutt's subsequent work with Smith and Doulton shows a relationship between overall composition and ornament as finely controlled as the best designs by Waterhouse. For the City Bank, Ludgate Hill (1890), motifs derived from Loire châteaux were combined with two lean and menacing beasts, one peering down from a corbel, the other perched on the gable-end (**79**). In the same year Smith modelled figures, birds and grotesques to Collcutt's designs for the Palace Theatre, Cambridge Circus. The rest of the dressings were almost entirely plain, such restraint being reflected in the choice of materials: Doulton's pale buff terracotta and mottled brown brickwork. Critics favoured the lack of 'columns or pilasters and "classic" gimcracks'.✩

THE FREE RENAISSANCE IN THE PROVINCES

By the late eighties numerous other London architects, such as R. W. Edis and F. G. Knight, had developed a repertoire based primarily around free-Renaissance terracotta (**81**). Their work was paralleled in other cities, where commercial practices established productive links with one or more manufacturers. Essex, Nicol and Goodman of Birmingham directed orders to Gibbs and Canning and Hathern, while most of William Watkins's buildings in Lincoln were supplied by Hathern or Doulton. Woodhouse and Willoughby and other architects working in the industrial towns of Cheshire and Lancashire tended to collaborate with the Ruabon firms. Meanwhile E. Lainson acquired terracotta for his buildings in Brighton from the distant Tamar Terracotta Company near Plymouth.

Leeds was the only other Victorian city to rival London and Birmingham in the inventiveness of its terracotta. Messrs Chorley and Connon's designs

plate 9 **Terrace, Grosvenor Park Road, Chester, by John Douglas, 1879–80**

plate 10 **Spring Hill Library, Birmingham, by F. Martin, 1893 (J. C. Edwards)**

plate 11 **Courtyard of the Prudential Assurance Head Office, Holborn, by A. Waterhouse, 1895–1901, refurbished by EPR Partnership (Ibstock Hathernware)**

plate 12 **Prudential Assurance Head Office, Holborn, London, by A. Waterhouse, 1897–1901 (Hathern and J. C. Edwards)**

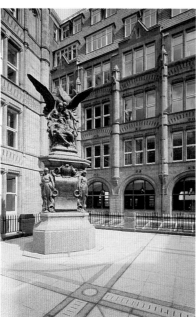

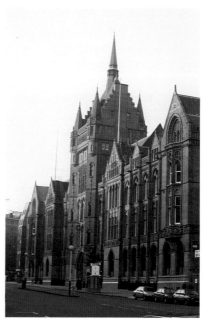

plate 13 **Tiled reredos with faience mouldings, St John Evangelist Church, Rhosymedre, near Ruabon, Clwyd (J. C. Edwards)**

plate 14 (right) **Lancaster House, Whitworth Street, Manchester, by H. S. Fairhurst and Son, 1912–15 (Burmantofts)**

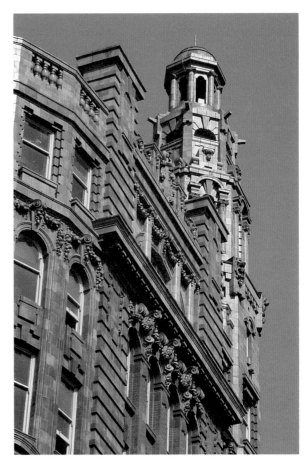

plate 16 **Ceramic bar-front, Gunmakers' Arms, Aston, Birmingham, *c.* 1900 (Craven Dunnill)**

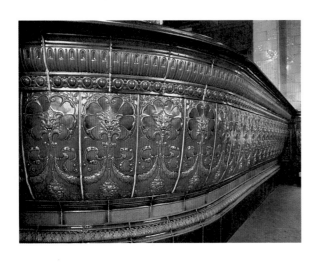

plate 15 **Central Arcade, Newcastle upon Tyne, by J. and H. Oswald, 1906 (Burmantofts)**

plate 17 (opposite) **North elevation and main entrance to Savoy Hotel, Strand, London, by T. E. Collcutt, 1904–5 (Doulton)**

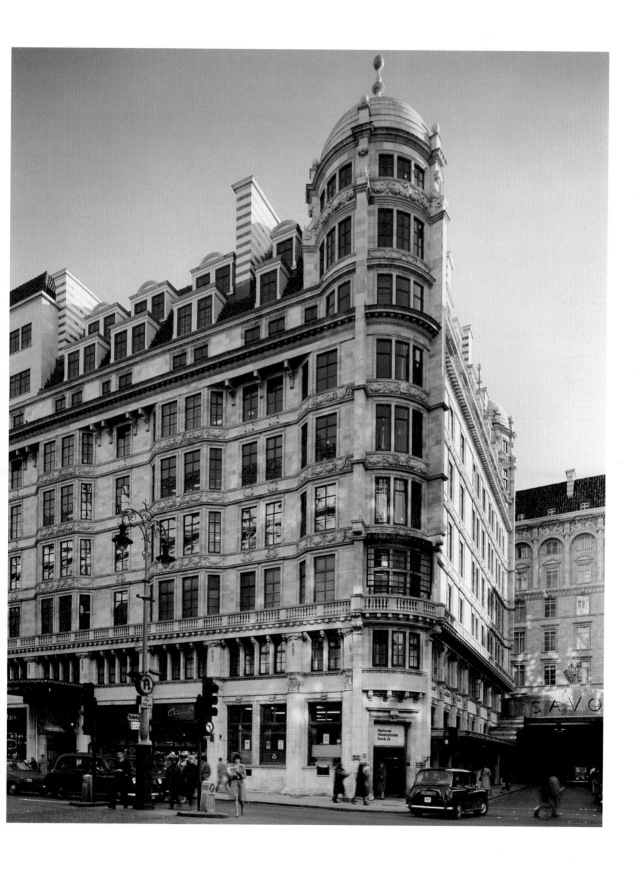

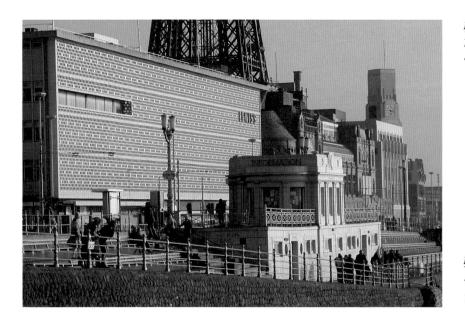

plate 18 **The seafront at Blackpool including the Tower, by Maxwell and Tuke, 1891–4 (Burmantofts)**

plate 19 **Hoover Factory, Western Avenue, London, by Wallis, Gilbert and Partners, 1932 and 1938 (Carter)**

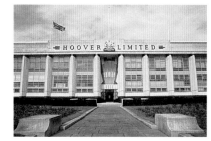

plate 20 **Carlton Cinema, Upton Park, London, by G. Coles, 1928 (Hathern)**

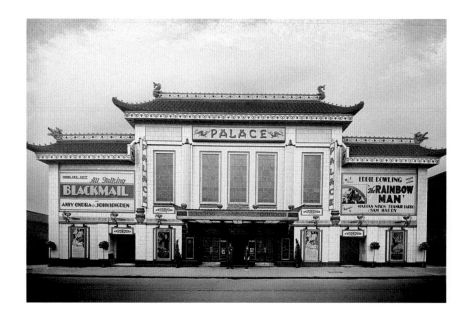

plate 21 **Palace Cinema, South Road, Southall, London, by G. Coles, 1929 (Hathern)**

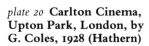

81 Entrance doorway showing integration of terracotta with brickwork, Rifle Volunteer Corps, Duke Street, London, by R. W. Edis, 1888 (from *Builder*, 57, 1889, p.442)

82 Metropole Hotel, King Street, Leeds, by Messrs Chorley and Connon, 1897–9 (J. C. Edwards)

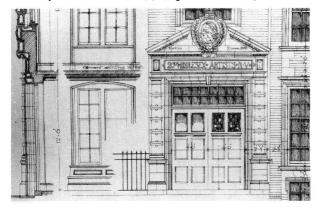

tended to be overloaded with eccentrically scaled Renaissance ornament. For the Metropole Hotel in King Street (1897–9), the oriel bays were supported by brackets extending almost the full height of the ground floor, while the porch was supported by columns covered with flutings and arabesques (**82**). Chorley and Connon relied on the distant firm of J. C. Edwards for their bright red façades. By the time that the city's remarkable network of arcades was being built, the local firm of Wilcock of Burmantofts was able to supply a vivid orange material. The theatre architect, Frank Matcham, worked with Burmantofts to dramatic effect with his County Arcade of 1900, which had turrets flanking the entrance to a palatial interior where Burmantofts faience formed a grey-green frieze of fruit and foliage. ✰

BUILDING BY NUMBERS

It is unlikely that terracotta dressings were chosen from a catalogue even for the most mainstream commercial buildings where pilasters, balustrades, seated lions and vases often look so similar. Most of the major manufacturers produced folio volumes offering such elements as a kit of parts (**83, 84**). Jennings published designs by Collcutt, and Burmantofts designs by Maurice B. Adams, while J. C. Edwards presented a series of schemes drawn up by architects specifically to illustrate the virtuoso use of terracotta. Such catalogues may have caught the eye of architects, but they failed to persuade them to turn their next commission into a numbered list of stock components. It ran completely against the ethics of Victorian design for an architect not to be responsible for the decorative detailing of his work.

Waterhouse, for example, personally inked in the pencil outlines that had been prepared for window tracery, waterspouts and other forms in his buildings. He would not have risked his reputation by reusing detailed forms from one building to the next, let alone ordering them from J. C. Edwards's catalogue.

Even the laziest third-rate architect or builder would encounter the practical problem that terracotta had to course in with brickwork and there was, as yet, no standardization in the size of bricks. Few manufacturers could afford to hold in stock a wide range of architectural forms in different sizes. The most widely sold stock designs would be non-structural elements such as pier-caps or finials. Only a small number of streets of suburban terraces or villas gained ornate architectural terracotta, examples being Manilla Road, Bristol, and Newton Road, Faversham in Kent. Catalogued forms of terracotta are most widely found in towns close to major factories, such as Wrexham, Tamworth and Loughborough, where heavily dressed villas, chapels and shop-fronts suggest that the material was coursed in with local brick of known dimension and was viewed with pride by local residents, congregations and shopkeepers (**85**).

6

THE EDWARDIAN AGE
New Manufacturers, Materials and Attitudes
to Architectural Decoration

The vibrant red colour favoured by Waterhouse and his contemporaries offended the imperial dignity sought by the Edwardians. P. G. Konody, in a letter to the *Daily Mail*, condemned terracotta as 'the bane of modern Birmingham', describing the Municipal Technical School designed by Essex, Nicol and Goodman in 1893–5 as 'an absurd jumble of incompatible styles'.☆ Such criticism was fuelled by the penchant of some architects towards a riotous use of terracotta well into the Edwardian period. Charles Fitzroy Doll's Imperial Hotel, Bloomsbury, of 1900 was extended in 1907 and again in 1911, multiplying the terracotta turrets and flèches soaring over Russell Square and creating internal doorways of an equally over-powering scale (**86**).

Eclecticism, narrative decoration and terracotta flourished together as the architectural expression of liberal individualism, from South Kensington through to Birmingham's Civic Gospel. This association proved to be terra-cotta's undoing. Social and political critics had long criticized the lack of collective spirit in the Victorian age. In the eyes of Edwardian reformers the exuberant opulence of Mayfair mocked those trapped in the East London slums. Waterhouse's enormous offices came to symbolize feverish money-grubbing rather than probity.

83 (opposite, left) Suggested treatments of catalogued ornament, showing the method of incorporating terracotta panels and blocks, Ruabon Brick and Terracotta Company, 1890s

84 (opposite, top right) Catalogued gargoyle designs by Ruabon Brick and Terracotta Company, 1890s

85 (opposite, bottom right) Building ornaments chosen ex-catalogue in Rhos, Ruabon, Clwyd, c.1890

86 Internal doorway of the Imperial Hotel, Southampton Row, London, by C. F. Doll, 1905–11 (Doulton and Shaw)

Terracotta fell from its elevated status to a more prosaic role; as a useful facing for public houses, music-halls and hotels. It gained its most express-ive use where ceramics had made only minor inroads in the late nineteenth century, in cities such as Manchester, Bristol and Norwich, rather than Birmingham or Leeds. In London, faience came to predominate over its unglazed counterpart, and in forms and colours that contrasted markedly with the Renaissance and Gothic terracotta of the 1880s and early 90s.

TILING AND THE DEVELOPMENT OF FAIENCE

The widespread adoption of faience in the years around the turn of the century marked the coming-together of two strands of architectural cer-amics: terracotta and tiling. Apart from the contentious use of 'majolica' at South Kensington during the 1860s and 70s, faience was developed primar-ily as an adjunct to wall-tiling for schemes of interior decoration in public buildings.

Tiles did not suffer from the same prejudices as terracotta; they had an indisputable practical value, strong British precedents from the Middle Ages, and did not challenge the status of other materials. Minton and Maw ensured that their tiles had strong artistic credibility by commissioning designs from such major architects as A. W. N. Pugin and George Edmund Street (**87**). The Victorian tile revival followed the rediscovery of medieval tiled floors; tiling was applied to interior walls in response to tastes for bright colours and abstract patterns, and to practical concerns over hygiene. R. W. Edis recommended glazed tiles as a means of banishing dirt from houses and public buildings.* Tiles with patterns moulded in relief and coloured by glazes became mass-produced from the 1870s. Glazes were run across the moulded tile, the deeper pools in the recesses firing to a darker shade than the thin covering over the raised areas. Other techniques for mass-producing wall decoration were developed. As early as the 1860s Maw were pressing wall-tiles with raised ribs which created cloisons between the areas of different colours, making hand-painting a quick and relatively unskilled process.

The use of relief-moulded wall-tiles and painted tile panels stimulated an associated demand for faience to form frames, corner mouldings and dados (*colour plate 13*). Maw developed an extensive range of faience panels, col-umns and capitals and more mundane plinths, corner sections and key-stones. There was a crucial difference between the workings of the tile and

terracotta industries in that tiles were normally chosen from catalogues distributed to architects, builders and merchants. Only a minority of orders involved one-off runs to designs specially supplied by the architect, which was the approach adopted for most terracotta contracts. The major tile-manufacturers published folio volumes filled with scale drawings of their stock patterns of tiles and faience. They stored their metal dies and their plaster models and moulds, indexed and ready for reuse. Most tiles were 6 inches square; most simple faience mouldings 6 inches long. Such standardization was possible because tiles were used as a superficial facing that did not have to course in with particular sizes of brick. While critics viewed terracotta as a material that should be architect-designed and show evidence of hand-working through variations in colour and detail, tiles were generally expected to be crisply mechanistic in their repetition, creating a perfectly true grid.

The treatment of faience diverged from its roots in tiling, as the major tile firms sought the prestige which came from supplying large, architect-designed contracts. A distinction developed between simple mouldings of standard format and larger blocks and panels. Intricate plaques, portraying classical figures, plants or dolphins, were pressed in plaster moulds; it is most likely that these were made initially for a specific contract and then stored on the off-chance that they could be reused.

Two firms, whose range of products encompassed both tiling and terracotta, spearheaded the production of large forms of faience for commercial contracts. From the early 1880s Wilcock and Company, of Burmantofts in Leeds, and Doulton of Lambeth advertised capitals, arches and other

architectural elements for use in interiors. James Holroyd, manager at Burmantofts from 1879, appreciated that the architectural profession had to be won over to his essentially new product. Maurice B. Adams produced some designs for windows and porches to show off the new material; as a respected architect and the technical editor of the *Building News*, he was ideally placed to provide favourable publicity.✫

Doulton and Burmantofts first found outlets for their wares in the cavernous restaurants built in central London from the 1870s. Ceramics not only presented an aura of bright opulence, but resisted fire and the wear and tear induced by the thousand or more diners who could be served at a sitting.✫ Faience was used to augment tilework and to form imposing cooking-grills; around 1883 Burmantofts supplied a particularly monstrous example, brown, purple and yellow in colour, for the First Avenue Hotel in Holborn (**88**). Alfred Waterhouse led the reaction against such gaudy creations, advising caution in the choice of colours for tiles and faience. The grill that he installed inside the National Liberal Club, London, in 1884 was relatively plain. As with the exteriors of his buildings, Waterhouse preferred to avoid strident colour contrasts. He declared that his own taste in glazed ceramics veered towards combinations of greys and drabs, red or green, with small points of delicate turquoise blue.✫

Burmantofts' early schemes for Waterhouse were characterized by their coffee-brown colours, examples being the Yorkshire College in Leeds (1877–86, 1894) and the Victoria Building at Liverpool University (1887–91). In the latter, the columns for the staircase hall were given a banded effect by allowing the brown glaze to run down each block. By 1890 Waterhouse and his contemporaries had become more innovative in their choice of colours. Blue-green shades were used by H. Barnes and F. E. Coates for the County Council Buildings in Durham (1897–8),

89 Detail of Doultonware and Silicon ware mosaic lining the entrance of the Royal Courts of Justice Restaurant (now Lloyds Bank), Fleet Street, London, by G. Cuthbert and W. Wimble, 1883 (Doulton)

and cream and chocolate for the Central Arcade in Newcastle upon Tyne (1906) designed by J. and H. Oswald (*colour plate 15*). These schemes demonstrated Burmantofts' unique ability to make large flat panels of faience up to 2 feet in length, little more than 1 inch thick, and moulded with an arrangement of shells and scrolls highlighted in luscious glazes. Such panels are among the most accomplished and visually effective products of the late-Victorian revival of architectural ceramics. They were used to widely differing effect on walls and ceilings, and even in Gothic and rococo styles. Just as with terracotta, manufacturers were lured by the technically challenging and the visually grandiose away from the simple forms suggested by the logic of standardization and mass production.

FAIENCE AND ART NOUVEAU

Vulnerability to frost damage inhibited the use of faience on the façades of buildings for almost forty years after architectural majolica had been presented at the Great Exhibition of 1851. The relatively fine earthenware bodies that were hand-pressed, fired, glazed and fired again would have been broken up by freezing moisture. By 1876 Doulton had discovered that their stoneware pottery body was resistant to both frost and soot. Early uses of Doultonware, such as on the company's own offices in Lambeth designed by Tarring Son and Wilkinson (1876), and St Paul's House, Leeds (T. Ambler 1878), betrayed the limitations that prevented the material's widespread adoption. The Venetian Gothic style that provided a framework for combining terracotta with small pieces of glazed ceramic was already rather outmoded, while the stoneware body, unlike a good earthenware, could not carry fine moulded detail, and tended to warp in firing.

Doulton's stoneware was most effective when hand-painted in a rich palette, such as the powdery cream, blue and green of the shimmering entrance of the former Royal Courts of Justice Restaurant in Fleet Street, London, designed by G. Cuthbert and W. Wimble in 1883 (**89**). Tiny hexagonal tiles, jewel-like buttons, barley-sugar columns, and fountains issuing from the mouths of flying fish gave the vestibule an atmosphere of exotic lavishness. Some critics objected to the highly reflective finish of Doultonware; a matt earthenware faience was introduced by Doulton in 1885, and a matt-glazed stoneware called Carraraware in 1888, a crystalline glaze giving the latter an appearance akin to Carrara marble.

Carraraware represented a technological breakthrough, permitting large and complex architectural forms which could resist frost and pollution, and initiating the long-anticipated application of faience to building façades. The problem of finding an appropriate expression for faience was highlighted by the garish polychromy and heavy Renaissance decoration of the first major

experiment in the use of Carraraware, the Birkbeck Bank in Chancery Lane, London, built in 1895 to designs by T. E. Knightley (**90**). The frontage of the bank was brown in its lower stages, pink higher up, and set with peacock-green panels. ✫ Inside, the embossed tiles lining the dome were divided into segments by ribs of Carraraware.

Architectural faience gained a more coherent expression through the brief and somewhat guarded flirtation of the Arts and Crafts movement with art nouveau. In continental Europe a small number of architects embraced ceramic polychromy as a liberating force, to create flat or undulating surfaces of astounding richness. French designers, working in Paris or Nancy, tended to respect the traditional differentiation between wall-surface and window-dressings (**92**). In Vienna Otto Wagner turned the elevation into a canvas for floral decoration (**91**) while in Barcelona Antoni Gaudí created abstract patterns in myriad hues of mosaic and faience. Art nouveau was never fully accepted into British architecture, being stigmatized as superficial, over-indulgent and French. During the 1890s it was cautiously adopted by a group of architects and decorative artists who appreciated that sinuous forms could bring out the natural qualities of freely modelled and richly glazed clay. Their interest in ceramics evolved into a creditable but largely unfulfilled initiative towards employing colour as a means of humanizing urban architecture. The Art Workers' Guild became a focus for the innovative use of terracotta and faience. The materials were praised and used to advantage by several masters of the guild in the half-century from its formation in 1884, in particular by Charles Harrison Townsend, Edward Prior, Halsey Ricardo and Gilbert Bayes. ✫

Charles Harrison Townsend was the first member of the guild to experiment freely with architectural ceramics. His Bishopsgate Institute in London (1892–4) was given a façade of buff terracotta with a decorative frieze portraying densely foliated trees (**93**, **94**). The friezes were modelled in low relief by William Aumonier who had started his career by working with Alfred Stevens. Branches and leaves were given lush, swirling forms closely related to art nouveau. The tight spiral forms in the upper frieze can be compared with the outbursts of terracotta ornament created by Louis Sullivan in the United States.

Mary Watts, the eccentric wife of the artist George F. Watts, took Arts and Crafts philosophy to its logical extreme by making terracotta from clay dug on their estate at Compton near Guildford. She established a village workshop entitled the Potters' Art Guild which produced material for the chapel designed in 1896 as a shrine to her husband. For the sculptural decoration, such as the angels set below the main cornice, the amateur potters worked the clay directly, to the best of their individual abilities. Their tutor was emphatic that the Celtic-derived sculpture should not be repeatedly pressed from plaster moulds. ✫

104

90 Birkbeck Bank, Chancery Lane, London, by
T. E. Knightley with J. Broad, 1895–6 (Doulton)

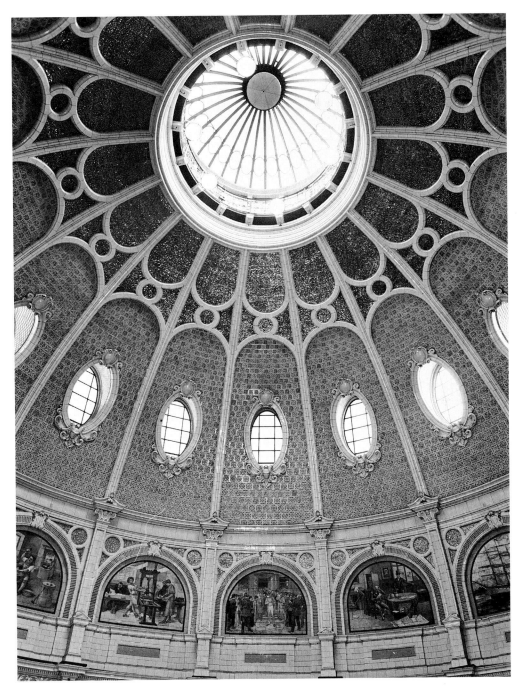

While the reputation of terracotta was tainted by the example of its use in Victorian offices and apartments, faience offered unblemished potential for those committed to tackling the problems of urban architecture. Harold Rathbone and Conrad Dressler displayed a worthy but unpractical idealism in their Della Robbia pottery founded at Birkenhead in 1894. Rathbone was an avid admirer of William Morris, whose firm Morris and Company acted as the London agents for Della Robbia ware. Conrad Dressler, who had studied modelling at South Kensington, took prime responsibility for the architectural department at the pottery; he drew inspiration from the example of Florentine Renaissance sculptures in tin-glazed earthenware to develop colourful plaques and statues to enliven façades and interiors. An early catalogue offered seventy architectural forms, including panels, tiles and overmantels. For special commissions such as the panels in the Memorial Church in Wallasey, undertaken in 1899, or the fountain in the courtyard of the Savoy Hotel, figures were modelled in low relief and coloured with tin glazes (95).

Rathbone and Dressler conceived their pottery as being run on the purest of Arts and Crafts principles. Initially they worked a local clay but it proved too porous and difficult to mould and fire.* Rathbone spurned machinery, condemning the use of mechanical power as 'paralysing artistic development'.* His attempts to allow employees to express their individuality and produce ornaments at modest prices failed. Few architectural decorations were made after 1897 and the pottery went into voluntary liquidation in 1906. Ironically Dressler's greatest contribution to the development of architectural ceramics was his subsequent invention of the tunnel kiln, which transformed the economics of mass-producing tiles and tableware.

92 (opposite, top left) Dormer windows, Ceramic Hotel, Paris, by J. Lavirotte, 1904

91 The Majolica House, Vienna, by Otto Wagner, c.1900

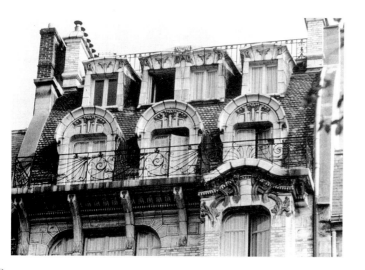

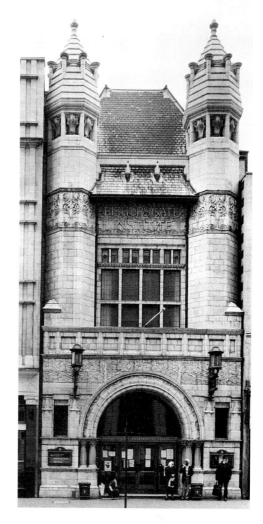

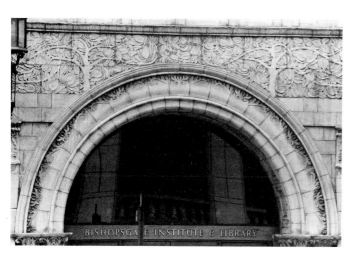

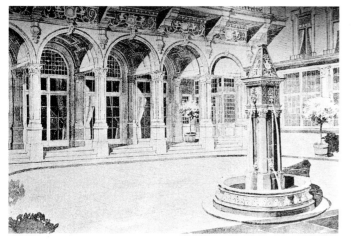

93 and 94 (above) Bishopsgate Institute
and detail of frieze above the entrance,
Bishopsgate, London, by C. H.
Townsend, 1892–4 (Gibbs and Canning)

95 Della Robbia fountain in the
courtyard of the Savoy Hotel, by C. B.
Young and T. E. Collcutt, 1896 (from
Builder, 71, 1896, pp.36–7)

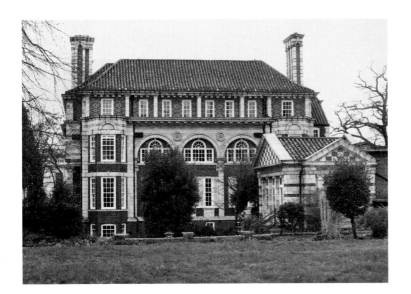

96 The garden front of Debenham's House, Addison Road, London, by H. Ricardo, 1907 (Doulton)

97 and 98 (opposite) Castle Street entrance and interior detail of Royal Arcade, Gentleman's Walk, Norwich, by G. J. Skipper with W. J. Neatby, 1899 (Doulton)

Dressler sought to enliven streets with accents of colour, utilizing plaques and friezes. Halsey Ricardo, another member of the Art Workers' Guild, advocated more of a broad-brush approach. He studied Italian architecture and ceramics at first hand and subsequently gained a strong sympathy with Persian and Hispano-Moresque design. His involvement in the production of lustre and 'Persian' tiles, in partnership with William de Morgan, promoted an obsession with the idea of towns and cities being clad with glazed and washable ceramics. Ricardo believed that urban society had a 'universal hunger for colour' and that polychromy could be used to differentiate between parishes or to highlight particular building types, such as town halls and libraries. ✫

Ricardo designed several offices and houses faced with salt-glazed bricks. The opportunity to realize his architectural vision came with the commission for no. 8 Addison Road, North Kensington. His client, Ernest Debenham, shared Ricardo's tastes for glazed ceramics: his store, Debenham and Freebody in Wigmore Street, was faced with white Carraraware. ✫ The exterior of his house, built in 1905–7, was a remarkable amalgam of a restrained Renaissance style and vibrant colours (96). A round-arched arcade of pink-cream Carraraware projected from the recessed wall surfaces of glazed brick: deep green at ground-storey level and turquoise blue below the cornice and on the chimney-stacks. The basement was faced with blue-grey semi-vitrified brick.

The potential of Carraraware was brought to the fore once Doulton had appointed a decorative artist well versed in Pre-Raphaelite art and art nouveau design. W. J. Neatby had been a designer for Burmantofts of Leeds; his work as head of the architectural department at Doulton from 1890 to 1907 culminated in three experiments in combining art nouveau with architectural polychromy. All arose from collaboration with provincial

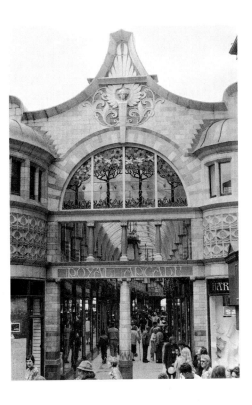
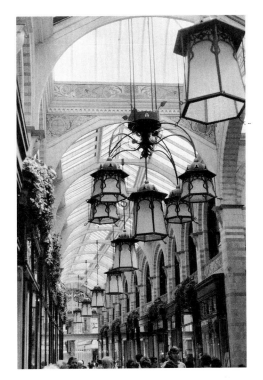

architects who were already convinced of the merits of decorative ceramics.

George Skipper had used terracotta in a Frenchified Queen Anne style for three large hotels built in Cromer, Norfolk, during the 1890s, and in a more Italianate composition for his own office in Norwich, dating from 1896.✵ The Norfolk firm of Gunton had supplied terracotta for these buildings, but Skipper used Doulton's Carraraware and finer Parian ware to face the Royal Arcade in Norwich. Angular chevrons on the column supporting the end screen were contrasted with the flower-bud outlines of tiles set on the bays to either side in a colour scheme based on shades of green and cream (**97**). Panels with a richer decoration of alternating floral and peacock motifs were set over the shop-fronts. At the intersection of the avenues of the arcade spandrels illustrated the four elements: earth, air, fire and water. Other spandrels were filled with 'archaic figures' holding shields bearing the signs of the zodiac (**98**). At the time of its opening in May 1899, the arcade was described as 'a fragment from the Arabian Nights dropped into the heart of the old city'. Neither local press nor national architectural journals could deduce the significance of this jaunty excursion into the exotic east for a medieval city, or the relevance of the signs of the zodiac to a shopping arcade. Skipper reverted to a tamer use of terracotta for most of his subsequent commissions in Norwich, enlivening a baroque style with art nouveau detailing.✵

Neatby achieved a more relevant symbolism in his most celebrated experiment with ceramic polychromy: the Everard Printing Works, erected in Bristol in 1901 (*colour plate 1*). He collaborated with the Birmingham architects Essex, Nicol and Goodman, who made lavish use of terracotta on most of their Midlands commissions. Above the ground floor Edward Everard's name was moulded in a typeface of his own design. The flat wall-surface above the first-floor windows was filled with a mural representing the history of printing: Gutenberg and William Morris pulling at their hand-presses, surrounded by their own alphabets. Two Pre-Raphaelite figures, one set in the centre of the gable, provided allegorical illustrations of the 'spirit of printing' and 'the spirit of light'. Neatby probably conceived his frontage primarily in terms of its mystical imagery, but contemporary interest centred on the way in which narrative illustration had been used to convey the purpose of the building. ☆

In the design of the Turkey Café, Granby Street, Leicester, erected in 1901, Neatby worked with Arthur Wakerley, who had used Doulton's Carraraware for several buildings with polychromatic decoration and Hathern's terracotta for more run-of-the-mill projects. The Turkey Café was designed as a three-dimensional pun on the subject of Turkish coffee. Ottoman architecture formed a setting for three representations of turkeys in full feathered display.

Despite being novel and cheerful, ceramic polychromy did not prove a panacea for the problems of urban architecture. Colour, whether in abstract patterns or pictorial representations, did not overcome the need for style. The symbolism exalted in the teachings of William Lethaby and the astrological imagery used by Neatby at Norwich were dismissed as slightly spooky. There was a parallel reaction against art nouveau. Branded by its association with the Aesthetic movement, it was seen as promoting beauty as an esoteric pursuit, rather than as an element in efforts to advance public taste and social order. The idealistic visions of Ricardo and Neatby, Skipper and Wakerley were to be overrun by a more conventional alliance between the decorative arts and Edwardian architecture, which, nevertheless, allowed ideals of free modelling and colour to filter into the mainstream of resurgent classicism.

ARTS AND CRAFTS AND THE ART SCHOOLS

The Victorian principle that there should be unity between the arts was reinvigorated by reform of the national art curricula, defined by the Department of Science and Art back in the 1850s and followed in virtually every school of art until 1889. As the larger provincial schools developed courses in architecture, so the profession became more receptive to an input from

decorative artists. The Royal College of Art and the Central School of Arts and Crafts taught architectural decoration through students drawing freely and modelling in clay, an approach that was to encourage interest in ceramics and keep Doulton, Carter, and Gibbs and Canning supplied with skilled labour well into the inter-war period.

The restructured teaching programme of the RCA served to perpetuate rather than oust the preoccupation with historic styles, as nurtured by Cole and Richard Redgrave in the mid-Victorian period. Students were still likely to spend much of their time in the Victoria and Albert Museum, drawing pieces of china or architectural fragments. Major provincial art schools reinforced this prolongation of Victorian historicism. The most successful institutions developed links with local industry and with technical schools that taught basic building skills such as bricklaying. By the mid-1890s Birmingham Municipal School of Art offered students not just lectures covering the use of terracotta but practical experience in modelling and firing the material.

The tile- and faience-manufacturer Carter of Poole exemplifies how collaboration between art school and industry reached a new high point in the twentieth century. Two students who had trained together at Sheffield School of Art provided the springboard for Carter to gain a pre-eminence in sculptural ceramics. James Radley Young worked at Carter for forty years from 1893, and William Carter Unwin from 1896 to around 1920, progressing to become head of the sculpture section. Shortly after the First World War, Unwin took up a teaching post in the Sculpture Department at Bournemouth Art School. As the order books for Carter's tiling, faience and mosaic filled, so draughtsmen and sculptors were sent to the smaller but more local Borough School of Art in Poole to be taught by Unwin or Young. The links between Carter and these art schools were so close that the company gained virtually a subsidized in-house training for their staff. ☆

IMITATING MARBLE

During the Edwardian period terracotta was employed less in bright reds and buffs, more in quiet greys; modelled decoration infused some baroque swagger and timid art nouveau detailing into otherwise staid compositions. Meanwhile faience gained a broad acceptability by being moulded and glazed to glisten like newly unveiled Portland stone or marble. Such imitation did not win universal appreciation: Charles Reilly demanded that faience should stop 'aping the attributes of stone and looking like glue'. ☆

Doulton's Carraraware was the first frostproof ceramic that could be sprayed or dipped with a white glaze to cover evenly the sharply angled surfaces and high-relief mouldings characteristic of classical and high-

Renaissance architecture. The body was never sufficiently plastic to be worked into intricate sculptural decoration, but was well suited to the Parisian Beaux-Arts style increasingly in favour. Carraraware won a degree of esteem from its employment to create a suave exterior for the Savoy Hotel in a series of extensions by T. E. Collcutt (*colour plate 17*). For the imposing developments of 1903–4, creating new frontages on the Strand and Savoy Court, decorative modelling was restricted to some name-plaques and simple panels under the main windows. Collcutt and Rupert D'Oyly Carte may have appreciated Doulton's faience as much for its capacity for speedy erection as for its aesthetic qualities. Blocks were delivered from Lambeth in the order required, permitting rapid construction while minimizing disturbance for the guests (**30**). In 1910 steel girders and Carraraware were laid out on a vacant site in New Aldwych for an epic display of the potential of prefabrication. Collcutt's river front for the hotel went up in ten weeks. ✩

The use of Carraraware on the Savoy, with its highly ordered detailing laid over a steel frame, established a precedent for other London hotels. J. Lyons used Carraraware for the Strand Palace, built opposite the Savoy from 1907 to designs by Ancell and Tanner. Lyons' next major hotel, the Regent Palace, was commenced five years later, Sir Henry Tanner using a white faience made by Burmantofts.

While Doulton responded to challenges presented by both innovative and academically traditionalist architects, most manufacturers of terracotta and faience sought a degree of stability by satisfying the conservative tastes of most provincial architects. Doulton and Carter could afford to be adventurous: they gained the bulk of their profits from the mass production of sewer-pipes, tiles and pottery. In contrast, Gibbs and Canning or Hathern had to maintain a healthy market for their terracotta and faience in contracts that were easy to execute and hence profitable. As demand became concentrated around the construction of more mundane buildings such as shops, factories and railway stations, managers realized that commercial security was best promoted through strong ties with the architects or surveyors who won repeated commissions for such building types.

The Victorians had considered terracotta to be particularly appropriate for major commercial and public buildings in the centres of industrial towns and cities. From the Edwardian period, terracotta and faience came to be associated with the inner suburbs and with a series of more specific building types. Four groups of examples – reformed public houses, theatres, warehouses and London's Underground stations – illustrate the rationale and practice of Edwardian ceramic architecture. The buildings reflect the use of architecture as advertising, a continuing concern for the moral fibre of city-dwellers and a desire to reconcile contemporary taste for decoration with modern construction in the form of steel and concrete framing.

THE REFORMED PUBLIC HOUSE IN BIRMINGHAM

The reformed public house exemplifies the wholesome but more workaday image of terracotta at the turn of the century, and the convoluted relationship that the material formed with tiles and faience. Birmingham's pubs traded on the architectural identity given to buildings associated with the city's Civic Gospel. During a spate of building and rebuilding, breweries sought to placate the temperance movement by using terracotta in colours and forms akin to board schools or libraries. ✶

Most of Birmingham's terracotta-fronted pubs were designed by one firm of architects and supplied by one manufacturer. Between 1889 and 1914 twenty-six pubs were built in the city to designs by James and Lister Lea, and faced with terracotta supplied by Hathern. The principal designers within the Lea practice, recorded as Mr Brassington and Mr Roberts, were probably too busy to have qualms about delegating the detailing of their designs to the draughtsmen and modellers at Hathern.

By the end of the century Brassington and Roberts had a carefully worked-out formula for the composition of their terracotta pubs, which was adapted to each site and varied in detail to provide a semblance of individuality. A tower, terminating in a cupola or spire, might be set over the corner entrance. Oversized and steeply sided gables created vigorous skylines that would stand out above the shallow-pitched roofs and dirty chimney-pots of surrounding terraces and workshops. Motifs popularized by the Queen Anne style were mingled with those derived from the Low Countries. Scrolls, keystones and other details were modelled at a grossly inflated scale, giving the pubs a presence that belied their modest size.

Birmingham's terracotta pubs perfectly reflect their date, bridging two centuries. They mark the ultimate debasement of Victorian eclecticism, different strands of Renaissance architecture being plundered more for commercial gain than in pursuit of any aesthetic ideal. On the other hand the use of ceramics to clad structural iron and steel, permitting large areas of glass, and as an encouragement to delegating detailed design to specialist manufacturers, heralds some of the characteristics of twentieth-century construction. There is little evidence that James and Lister Lea tried to advance their use of terracotta from one commission to the next. Nor did they attempt to create a distinctive house style for Holt or Mitchell and Butler breweries.

A brewery might invest in expensive sculptural decoration if the pub was being erected on a busy thoroughfare. Hathern charged around £300 for a small façade and up to £600 for a miniaturized Renaissance palace. At a cost of £353 the Salutation Inn in Snow Hill (1902) was decorated with

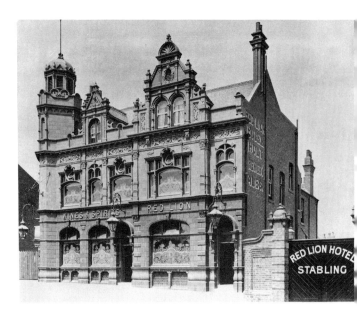

dolphins and festoons redolent of early Tudor architecture, while the £548 paid to Hathern for the Red Lion in Soho Road, Handsworth, of the same year bought more imposing caryatids and 'lions séjants' (**99**, **100**). Similar decorative details recur from one pub to the next but always in a slightly different size or shape. Hathern were not reusing sets of plaster moulds but were respecting the ethics of high architecture by designing a unique series of details for each contract. ☆

A thirsty customer could progress from a cursory appreciation of a pub's terracotta exterior to a more lingering consideration of a bar lined with opulent schemes of ceramic tiles. The design of pub tiling was also a collaborative effort by architect and manufacturer, though the approach differed fundamentally from that used with terracotta. James and Lister Lea and their contemporaries would have worked closely with representatives from Maw, Minton or Craven Dunnill and then left the company's design departments to develop schemes according to the ground-plan of each pub and the money available. Except for the hand-painted murals, tiles would be chosen from those illustrated in company catalogues. James and Lister Lea tended to work with Minton who specialized in producing brightly coloured majolica tiles moulded in relief. The majolica tiles were typically arranged into panels surrounded by large areas of relatively plain tiling. Several other designers of pubs, and especially those involved in refurbishing rather more up-market restaurants and hotels, worked with Maw.

Maw's Shropshire neighbour, Craven Dunnill, created interiors that were more directly Renaissance in style and three-dimensional in their decoration, using faience blocks and panels to form pilasters, capitals and arches. The culmination of Craven Dunnill's policy of producing a restricted range of high-quality ceramics emerged in their three designs of bar-front. The

99 (far left) Salutation Inn, Snow Hill, Birmingham, by J. and L. Lea, 1902 (Hathern)

100 (left) Red Lion, Soho Road, Handsworth, Birmingham, by J. and L. Lea, 1902 (Hathern)

101 Dog and Duck, Aston, Birmingham, by M. J. Butcher, 1900 (terracotta by Hathern; faience and mosaic by Craven Dunnill)

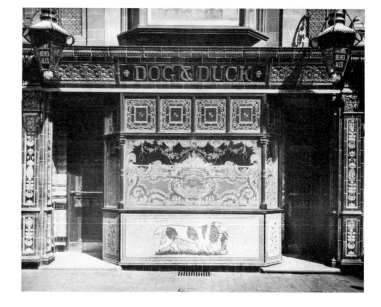

fronts were made up of repeated sections, each being curved in profile and decorated with griffins' heads, deep ribbing or complex floral shapes. The griffin design, with a wonderfully subtle blending of brown and green glazes, was installed in the Gunmakers' Arms at Aston (c.1900) (*colour plate 16*). The floral bar-front, as installed in the Red Lion, Erdington (1899), incorporated moulded flowers, wreaths and ribbons highlighted in pink, mustard, soft grey and two shades of green.✶ Craven Dunnill's most endearing contribution to Birmingham's pub architecture was the ground-floor frontage for the Dog and Duck by M. J. Butcher (1900), faience, tiling and mosaic being surmounted by a simpler scheme of Hathern's terracotta (**101**).

FRANK MATCHAM'S THEATRES

Theatre-going was regarded as a preferable alternative to the ribald singing and dancing that took place in dingy halls and pubs. Entrepreneurs such as Oswald Stoll saw commercial potential in providing fit and proper enter-tainment in London's suburbs. They worked with a group of architects, the pre-eminent figure being Frank Matcham, who grasped both the practical requirements and the flavour of late-Victorian and Edwardian theatre design. Fire was the most pressing practical issue. A series of blazes in London theatres and a major holocaust in Paris in 1897 provided a tragic reminder of the need for fireproofing. Many of Matcham's theatres were given fronts of stone rather than terracotta; but brick, steel girders and fibrous plaster were specified wherever possible and the use of wood was kept to a minimum.

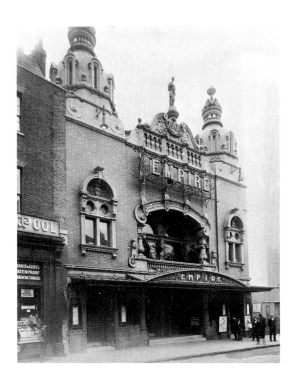

102 **Hackney Empire, Mare Street, London, by F. Matcham, 1901 (Hathern)**

Matcham co-ordinated the supply and fabrication of manufactured materials for his theatre designs with a speed and efficiency that set a model for commercial building. The contract for the Richmond Theatre, won by Hathern in 1898 at £987, stipulated that delivery should commence in six weeks and that the project should be completed after another two months.

The outline of the Richmond frontage, a central gable flanked by two towers, was comparable with Matcham's stone-faced theatres, but the composition was executed in rounded forms, from the shape of the pediments and buttresses to the section of the window-mouldings. By wilfully distorting baroque details and cramming them into a compact frontage, Matcham succeeded in combining excitement and intimacy, an atmosphere further developed in marble and plasterwork for the vestibule and the auditorium.

Matcham's Hackney Empire (1901) was intended primarily for variety shows, so its façade could be more openly frivolous. The theatre's frontage reflected the flavour of comic songs, clowning, acrobatics and other frivolities through a mannerism pushed into skittish eccentricity (**102**). ✭ Matcham's design adopted the tone of most variety acts: gently mocking at convention while showing some respect for propriety. The arch spanning the central balcony was made daringly wide and shallow. It terminated in scrolls resting on bulging columns not more than 5 feet in height. The domed turrets were given slit windows and were surmounted by flambeaux, consisting of crowns set on columns fit for a wedding-cake. The central pediment was surmounted by a figure holding pan-pipes.

Matcham's embryonic 'ceramic style' of bulges and curves came close to matching the freer use of terracotta attained in the United States. Unappreciated by architectural critics, he took this approach no further, reverting to a more traditional classicism for the Marlborough Theatre in Holloway Road (1901). The terracotta for the Coliseum in the West End (1903) was stone-like in its colour and worked into deep-channelled rustication. It cost £3,635, making it Hathern's largest and possibly most profitable contract before the First World War.

INNOVATION IN LANCASHIRE

The designers of public houses and music-halls exploited the potential of iron and steel to create wide window-openings and open sightlines, but did not attempt to give any external expression to structural metalwork through using ceramics as a repetitively moulded cladding material. Several critics demanded that terracotta and faience should be pressed into simple low-relief forms, rather than complex profiles and details.✷ While the late-Edwardian use of white Carraraware went some way down this path in pursuit of an ordered classicism, a far more creative approach developed in Lancashire, drawing upon the clayworking skills of the Burmantofts works located on the other side of the Pennines in Leeds.

Manchester, the archetypal city of the Industrial Revolution, had acquired relatively little terracotta in the Victorian period. The dull brown brick walls of cotton-mills and warehouses, and the equally drab buff or grey sandstone used on public buildings, proved remarkably resistant to the sulphurous smoke emitted by domestic and factory chimneys. Both brick and sandstone, however, became encrusted with layers of soot. The city would have had an even more sombre appearance in the early twentieth century than in the 1830s and 40s, when Dr Kay and Friedrich Engels exposed the squalid and depressing conditions in which Mancunians lived and worked.✷

In the Edwardian period Burmantofts supplied faience for a group of warehouses in Whitworth Street whose design directly revolved round the use of a steel frame. The rear elevations were conceived as simple grids, each bay being filled with a large metal-framed window surrounded by plain brickwork. The more public elevations to Whitworth Street and Dale Street were articulated with classical detailing closely derived from the example of contemporary American tower blocks, themselves executed in matt-glazed faience.

The warehouses designed by Harry Fairhurst and Son were virtually minor skyscrapers: Lancaster House of 1909 had eight storeys above street level, rising to a height of 150 feet and extending into a corner turret (*colour*

plate 14). It was not the modernistic rationalism of these structures that caught the imagination of the local press but the juxtaposition of rusticated classical façades and the soaring towers: 'the rigid utilitarianism of the past defaced Manchester with many a hideous mass of inchoate slate and brick; a little leaning towards beauty cannot injure our business future.'✶ Steel framing brought an increased scale to the use of faience, but there was no absolute rejection of decoration, historicism or even of asymmetry.

The implications of adopting concrete could have been far more revolutionary if it had been used directly as a means of fixing faience. Most architects rejected out of hand the thought of public or commercial buildings having façades of exposed concrete. During the first flurry of interest in concrete, faience was presented as one means whereby it could be given a more attractive public face. Blocks or slabs could in theory simply be used as shuttering, reducing the time and labour demanded by the use of planks of timber. In practice, the adoption of faience as a facing to concrete construction was hampered by the conservatism of most architects, builders and local government surveyors. Local building by-laws negated one of the prime advantages of concrete by demanding that walls should conform to standards of thickness developed for traditional construction.

A concerted effort to relate concrete and faience emerged out of Burmantofts' success in gaining contracts in Manchester. The YMCA had already made repeated use of terracotta across the country, the material suiting the association's reformist philosophy and the urban location of their hostels. The design of the Manchester YMCA by Woodhouse, Corbett and Dean, executed in 1910–11, was based on the use of concrete for both the frame and the walls (**103**). The concrete was fabricated on the Kahn system whereby the beams were reinforced with bars, specially angled projecting wings carrying the thrust created by the weight of floor or wall above. ✶

The architects, or their client, hesitated over a suitable form and colour for the faience cladding. It was originally planned that green and cream Burmantofts Marmo was to be used, but buff and chocolate colours, more in harmony with the nearby Midland Hotel, were substituted. The method of construction was highly innovative, but ultimately as labour-intensive as if traditional brick walls had been specified. The faience was built up as an outer shell, course by course; the concrete was then shovelled into position behind the faience and rammed into dovetailed recesses in the slabs.

The architects made a conscious attempt to create an appropriate external expression for concrete construction.✶ The load-bearing form of the walling was conveyed by broad surfaces of faience ashlar, with windows appearing as small and deeply recessed openings. The elevations paid lip-service to the American-inspired classicism adopted wholesale by Fairhurst and Son and other Manchester architects. The bulk of the decoration was in the

103 YMCA, Peter Street,
Manchester, by Woodhouse,
Corbett and Dean, 1909–11
(Burmantofts)

form of either vertical strips of intricately modelled fruit and vegetation
spiralling down in narrow panels, or in slightly broader panels of flowing
ornament set beneath the windows just below the cornice. These fillets
acknowledge the traditions of naturalistic decoration but, from a distance,
appeared as abstract surface patterns more appropriate to the new century
and modern methods of construction.

THE ACCEPTABLE FACE OF REPETITION

London's Edwardian tube stations mark the most systematic use of faience
ever to be achieved in Britain in terms of standardization, of relating to a
steel structure, and of creating a tight corporate identity. In 1906–7
Burmantofts supplied faience for up to thirty-five stations built by the
Underground Electric Railways of London Limited to designs by Leslie
Green. ☆ They are unique in conveying an utterly consistent house style.
The repetition of forms was far more disciplined than the loose identity
created by Matcham for Stoll's theatres or the broad stylistic continuity
achieved by Fairhurst and Son in their warehouse designs.

The entrances to Underground stations were designed to convey an aura
of cleanliness and efficiency; tube lines with their electric trains had to be
distanced from the smoke-ridden archaism of the steam-operated routes.
Leslie Green, appointed as architect to the Underground Electric Railways

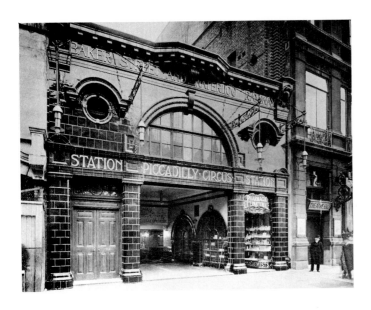

104 Piccadilly Circus Underground Station, London, by L. W. Green, 1906 (Burmantofts)

Company in 1903, had to design more than fifty stations in a period of five years to match the pace with which the tube lines were completed. He used the same composition, whether the entrance was for the Northern, the Bakerloo or the Piccadilly line. The ox-blood colour and the arrangement of an arcade with round-edged pilasters and semicircular arches were repeated from one station to the next, the use of ceramics being justified by their resistance to fire. The steel frame permitted wide entrances and exits, designed to speed the flow of passengers. The mezzanine, with its large glazed arches and flanking circular windows of smaller size, housed the lift machinery. These pavilions were given flat roofs so that extra floors, for offices or apartments, could be set on the steel framing. ☆

The contracts probably generated a healthy profit for Leeds Fireclay's Burmantofts works as it would have been possible to use the same plaster models and moulds for each front. At Leicester Square, Russell Square and Piccadilly Circus, dating to around 1906, the forms were identical, their arrangement being adjusted to suit the length of the frontages and the location of the entrances and exits (**104**).

The group of Underground stations designed by Green and supplied by Burmantofts are the only instance, in the British revival of architectural ceramics, of complete building forms such as window-surrounds and cornices being systematically repeated to achieve a visual consistency and a degree of economy. The same overall composition recurs, but with different detailing, on other Underground stations designed by Green but with faience made by firms other than Burmantofts.

INTER-WAR BRITAIN
A Decorative and Corporate Modernism

The market for faience expanded in fits and starts after the First World War, culminating in a final boom in the late thirties. The material was promoted as an economical adjunct to steel and concrete construction, but the use first of simply moulded blocks and then standardized slabs did not precipitate any fundamental shift in favour of mass production or prefabrication. Faience can hardly be hailed as a revolutionary force in the evolution of either building technology or style. While ceramics became associated with fashionable art deco and streamlined forms, the bulk of inter-war production was moulded into simplified classical forms rather than wildly decorative or futuristic compositions.

The inter-war use of faience related to a middle path in architecture, occupying ground between the embattled traditionalists and the politically inspired Modern movement. It accorded with the philosophy of a more temperate group of progressives, including such proponents of a broadly appealing and eclectic architecture as Howard Robertson. They shared a belief in a gradual evolution towards a modern architecture, without insisting that humanity had to be changed to fit in with any visual ideal. This approach was promoted by Robertson both through his books and by his position as Principal of the Architectural Association School of Architecture. While emphasizing the importance of 'manners' in architecture, he felt that buildings should respond to the aesthetic and moral needs of society. His definition of beauty combined contemporary ideas of abstract physical pleasure with the 'moral' principle exalted by the Victorians, whereby the beholder would be stimulated by associations with history or with other comparable buildings. Though aware of the danger of fussiness, he encouraged the use of ornament to emphasize and accompany the main lines of a building's composition. �

The commercial architects who used faience in the inter-war period, whether trained at the Architectural Association, through apprenticeship or in provincial art schools, saw little conflict between introducing such industrial materials as steel and concrete and retaining elements of stylistic decoration. There was to be no drawing-office revolution as the designers of Co-operative stores or Odeon cinemas adopted steel framing or progressed from simplified classical motifs to streamlined effects. The architect of the Co-operative Wholesale Society, W. A. Johnson, who supervised an office designing shops, factories and dairies, expounded a rational philosophy for his own work, which he regarded as part of a new architecture 'in keeping with the motor car, the aeroplane, and other phases of our time. It must make use of synthetic materials including marble and stone, ceramics, and

mass production articles. It should aim at the building which is the assem-
blage of mass production in the workshop, and put together on the site.'✶

This progressive standpoint did not preclude Johnson from continuing
to incorporate classical elements in his designs until well into the 1930s. His
writings suggest an Arcadian vision, shared with many of his generation,
of pre-industrial and particularly Georgian towns that gave pilasters and
pediments a timeless applicability.

The innumerable architects who shared Johnson's pragmatic acceptance
of modern materials and who preferred traditional detailing enjoyed full
support from the management of most of the terracotta works. G. N.
Hodson, who succeeded his father as managing director at Hathern in 1938,
recognized that plain slab faience was both economical and honestly express-
ive of its mode of manufacture, being cast from a liquid-clay slip. Neverthe-
less he considered it 'doubtful, even in this standardised age, if we shall
ever get a standard box-form architecture since condition of site and pos-
ition varies so much. It is much more likely that a reaction will resurrect
the cherubim and garlands of flowers with which our grandfathers loved
to decorate their buildings.'✶

The gentle transition from classical detailing in colours imitating Portland
stone or marble to rather more exotic art deco or streamlining was facilitated
by the responsiveness of the draughtsmen and decorative artists employed
at Hathern, Shaw or Doulton. Many of the draughtsmen gained their skills
in commercial architectural practices while studying during the evenings at

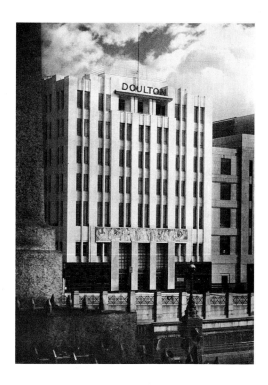

106 Doulton House, Albert
Embankment, London, by T. P. Bennett,
1939 (Doulton), with the 'Pottery
through the Ages' frieze by G. Bayes,
1939

local art schools. The decorative artists may have followed the same classes,
the most able progressing to the Royal College of Art.

Carter of Poole gained most directly from the RCA, Harold and Phoebe
Stabler bringing the firm's production of tiles and faience to the forefront
of inter-war ceramic design. Harold Stabler was appointed Director of
Design in the faience department in 1921. As well as being a teacher at the
Royal College of Art, he was a founder-member of the British Institute of
Industrial Art.✝ Carter cultivated a distinctive combination of art deco
stylization and naturalistic modelling for their figure groups in the years
around the First World War. The most impressive ceramic sculpture under-
taken by the Stablers at Poole was the 21-foot-high statue of Christ sup-
ported by winged angels, which was shipped to Durban in 1925 to form a
war memorial (105). The figure group, glazed in bright blue, yellow and
white, was a dramatic manifestation of revived interest in the reliefs pro-
duced by the della Robbia family in Italy around 1500. The modelling,
with elongated figures and angular sunrays, reflected the contemporary
taste for art deco.

Faience panels and friezes were most likely to draw upon narrative themes
in the manner typical of Renaissance della Robbia plaques and roundels.
Gilbert Bayes designed and modelled polychrome stoneware for Doulton
from 1923 until the outbreak of the Second World War. His culminating
achievement was the fifty-foot frieze depicting 'Pottery through the Ages',
set across the façade of Doulton House, the firm's new head office com-

pleted in 1939 (**106**). Most of the Bayes's panels, roundels and garden ornaments were devoted to the cause of bringing decoration into deprived urban areas. A nursery school in London's East End was given a polychrome stoneware panel illustrating the Madonna and Child in 1925, despite the conviction of Bayes's colleagues that it would soon be vandalized.✶ Frank Dobson worked with Doulton in a more angular, modernist manner to create a series of gilt-finished panels in 1931 for St Olave's House, Hay's Wharf, facing the Thames (**107**).

Shifts in taste towards simple, abstract forms were reinforced by the inflation of building costs during the First World War. Intricate, deeply modelled decoration became too expensive for most commercial architecture. The cost of building multiplied by two and a half times between 1914 and 1920; the price of architectural ceramics rose by a comparable amount. As the differential between terracotta and faience narrowed, it became cheaper to create schemes of decoration dependent on colour rather than on decorative modelling. The major manufacturers responded to these shifts in different ways. While Doulton and Carter encouraged architects to incorporate polychromatic sculpture in their designs, the aspirant Lancashire companies, Bispham and Shaw, concentrated on supplying 'stripped' classical façades in plain grey or cream. Burmantofts turned away from the vibrant glazes and subtle modelling of their turn-of-the-century tiling and faience; the company's inter-war schemes were characterized by creamy-buff colours and simple low-relief mouldings, seen to most impressive effect in the interior columns and arcades of the Basilique du Sacré-Cœur in Brussels by A. van Huffel and P. Rome (1936) (**108**). The most venerable of the terracotta manufacturers, Gibbs and Canning, continued to incorporate wreaths, cornucopias and garlands in their schemes. The Hathern Station Brick and Terracotta Company typified the flexible stance taken by the

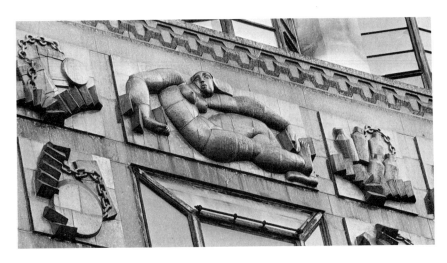

108 **Basilique du Sacré-Cœur, Brussels, by A. van Huffel and P. Rome, 1936 (Burmantofts)**

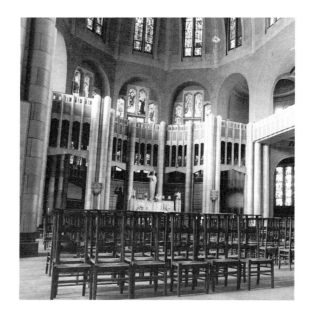

107 **(opposite foot) Reliefs by F. Dobson on St Olave's House, Hay's Wharf, London, by H. S. Goodhart Rendel, 1931 (Doulton)**

twentieth-century industry in wooing clients and collaborating with architects. The management never restricted their work to particular markets, geographical areas or styles. A comment by the managing director, G. A. Hodson, could have served as the company motto: 'The material used had remained the same throughout the centuries. It was the adaptation of the material which had changed and in this matter the move must first be with the architect'. ✫

FAIENCE AT THE SEASIDE

Concerns over health continued to provide the strongest justification for architectural ceramics. Progress in sanitary reform was accompanied by the emergence of a crisp new aesthetic of cleanliness. Efforts to improve the nation's health concentrated on nutrition, preventative medicine and the improvement of urban living-conditions. Architecture could play its part; both external and internal walls could be faced in washable materials designed to appear healthy and hygienic.

The identification of architectural ceramics with health, fresh air and recreation centred on seaside resorts, which depended on their reputation for cleanliness to attract trippers and holidaymakers. Terracotta, and especially tiling and faience, could create a suitably jovial atmosphere and had the practical merit of resisting corrosion by salt-laden air. The councillors of Great Yarmouth, Blackpool and Eastbourne saw ceramics as a means of attracting visitors in growing numbers, against competition from other resorts (**109**). Their efforts suggest a remarkable continuity with the values that had made terracotta a symbol of civic improvement in late-Victorian

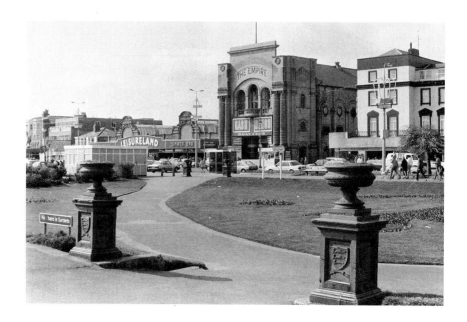

Birmingham or Leeds. Few doubted that impressive architecture encouraged good behaviour, that cleanliness was the highest of virtues and that municipal and commercial investment should closely complement each other.

As Blackpool developed into Britain's premier resort, its seven-mile seafront came to be dominated by red terracotta and creamy faience. The materials were used with a confidence that suggests that ceramics became something of a cult for the borough surveyor and a small group of Lancashire architects. Their vision of a boulevard lined by glistening, jocular frontages was given every encouragement from the managers, draughtsmen and modellers at Shaw, Hathern and Burmantofts, who came to regard Blackpool as an open-air showcase for their wares (*colour plate 18*).

Blackpool developed into an unmistakably working-class resort. The floods of trippers arriving by train from the coal-mining and cotton towns of Lancashire and indulging in the 'demon drink' gave Blackpool a reputation akin to that of a Midwest frontier town. Three immense brick and terracotta entertainment palaces were erected in the 1890s, capitalizing on this influx and providing more worthy attractions than public houses and seedy music-halls. The Tower Building, designed by Maxwell and Tuke and completed in 1894, was faced with red brick and terracotta. Inside, access to the Aquarium, the Ballroom and the lifts to the top of the Tower was provided by a staircase lined in terracotta supplied by J. C. Edwards and set with panels of Burmantofts faience decorated with fishes, birds, cherubs and children.

When the holiday trade revived after the First World War, faience became the norm for hotels, boarding-houses and pubs erected along or near the sea-front. Simplified classical forms predominated, in cream or yellowy

109 (opposite) Terracotta architecture and garden ornaments on the seafront, Great Yarmouth, with the Empire Picture Palace, by A. S. Hewitt, 1911 (Burmantofts)

110 Church of Christ, Scientist, Blackpool, by H. Best, 1928 (Hathern)

colours, and the small number of practices who gained the bulk of the commissions achieved a restrained style that almost amounted to a local vernacular. Hathern collaborated closely with Halstead Best, starting with a subcontract for the Princess Cinema (1921). Whatever the date or building type, Best's designs had square proportions and juxtaposed large areas of plain brickwork with faience dressings. One of his most successful buildings was the First Church of Christ, Scientist, with its remarkable curving arcade of Corinthian columns (1928) (**110**).

During the mid-1920s the corporation invested around £800,000 per year in the resort. A series of stylish tram stations illustrate how provincial engineers and architects gently moved from a classical style to a more streamlined identity. The tram station at Bispham (1931) incorporated groups of classical columns and a pediment.✶ Subsequent stations had rounded corners, plainer wall-surfaces and flat roofs.

The competitive balance between Hathern, who supplied the bulk of the faience used in Blackpool during the 1920s, and Shaw, who predominated in the following decade, was transformed by a single project. In 1929, having previously undertaken only modest contracts in the resort, Shaw beat Hathern and Gibbs and Canning to win the contract for the faience for the rebuilding of the Winter Gardens. The order for 30,000 cubic feet of faience marked the arrival of the Lancashire firm as a major manufacturer of architectural ware, a position confirmed by subsequent contracts as the Winter Gardens underwent further alterations during the 1930s. The consultant architect for the Tower and the Winter Gardens, J. C. Derham, chose white faience for the exterior, with a bright blue glaze accentuating the curved gable over the main entrance and a golden yellow highlighting the lions' heads and other sculptural detailing.

127

111 Woolworth's Store, Blackpool, by
Woolworth Construction Department,
1938 (Shaw)

Blackpool provided the ideal setting for the jazzy brand of modernism
popular in the late thirties. In the store erected from 1938 on a prime
site adjacent to the Tower, the Woolworth Construction Company gave
Blackpool a miniature Manhattan skyscraper (**111**). A steel frame and brick
walls were covered with Shaw's cream faience, forming a series of fin-like
mullions while the corner tower was decorated with wave patterns.

STEEL, CONCRETE AND CERAMICS IN INDUSTRIAL ARCHITECTURE

Industrial architecture was perceived as a logical testing-ground for new
manufactured building materials. Critics expected factories and warehouses
to express the rationale and efficiency of mechanized production through
a functionalist aesthetic, rather than to have their basic operations shrouded
in historicist decoration.✶ Most industrialists were more pragmatic. They
sought a form of construction which would be economical to build and
maintain, could be quickly erected without falling foul of building regu-
lations, and would create a flexible, extendible work-space. Beyond such
'functional' requirements, they might be willing to invest in a frontage that
would encourage commitment amongst their workers and advertise their
firm and its products.

Faience might have been expected to emerge as an adjunct to the use of

128

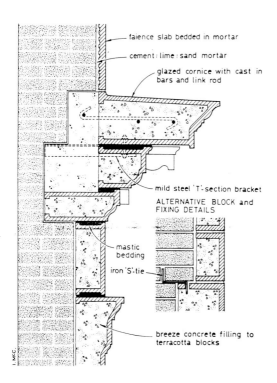

faience slab bedded in mortar

cement:lime:sand mortar

glazed cornice with cast in
bars and link rod

mild steel 'T'-section bracket

ALTERNATIVE BLOCK and
FIXING DETAILS

mastic
bedding

iron 'S'-tie

breeze concrete filling to
terracotta blocks

fig. 7.1 Cross-section of a typical terracotta construction in inter-war Britain (*English Heritage*)

steel and concrete in factories. In return industrial architecture could have provided the impetus for the terracotta industry to mass-produce a cladding material appropriate to modern framed construction. In practice, the methods and implications of steel and concrete construction continued to be shrouded by misunderstanding and controversy well into the inter-war period, doubts working against the much-heralded revolution in the non-structural use of ceramic blocks or slabs.

Steel framing was widely adopted during the twenties as girders became available in a range of stock sizes. Steelwork was most likely to be encased with thin non-load-bearing walls of brick which might be faced with stone or faience. Ceramic blocks would be designed to wrap round stanchions and be pressed with holes for loops of wire (fig. 7.1). Draughtsmen at the major terracotta works regarded steelwork as a complicating factor rather than a path towards greater simplicity and efficiency. They had to work from drawings supplied by the structural engineer as well as by the architect and take care to incorporate air-spaces between beams and stanchions to allow for differential thermal expansion.

The acceptance of concrete was more spasmodic. Floors of reinforced concrete were widely adopted, but a widespread use of full concrete construction, except for bridges, silos, canopies and other structures on the borderline between architecture and engineering, was inhibited by the complexity of the competing systems. Many local architects and builders would have found foreign names such as Hennébique and Mouchel off-putting and the schedules for reinforcing-stirrups and -bars almost incomprehensible. ✩

129

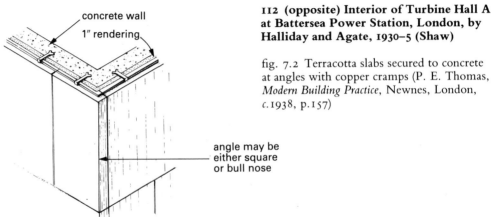

concrete wall

1″ rendering

angle may be
either square
or bull nose

112 (opposite) Interior of Turbine Hall A at Battersea Power Station, London, by Halliday and Agate, 1930–5 (Shaw)

fig. 7.2 Terracotta slabs secured to concrete at angles with copper cramps (P. E. Thomas, *Modern Building Practice*, Newnes, London, *c.*1938, p.157)

In principle concrete could be given an economical facing by being directly bonded with faience slabs to the exclusion of brickwork, as pioneered with the YMCA in Manchester. If faience was used as a shuttering and backed up with poured concrete, the blocks or slabs had to be temporarily propped in place from the front to ensure that they could withstand the pressure of the liquid mix. Alternatively, extreme precision was needed if concrete walls were to have a flat enough surface to be faced directly with tiles. Larger slabs could only be fixed securely if metal ties had been set into the concrete.✳ Partly because of the problems of fixing, slabs were most typically cemented and hooked on to flat walls of cheap Fletton brick (fig. 7.2).

Faience had a clear justification for industrial architecture where an aura of hygiene or bright modernity was sought; obvious instances were food-processing factories, works related to the supply or use of electricity and factories mass-producing consumer goods. Gibbs and Canning and Burmantofts concentrated on supplying orders for workshops and dairies. Hathern, Shaw and Carter, who specialized in producing simple blocks or slabs in a range of bright glazes, gained the most important industrial contracts.

Shaw earned £23,750 in the years around 1930 for producing the faience to line the first of the two turbine halls at Battersea Power Station (**112**). The architects for the interior of Battersea, Halliday and Agate of Manchester, and their clients the London Power Company, lavished meticulous attention on fittings and surface finishes to reflect the record-breaking scale of the turbines and generators. The turbines were painted with a newly developed cellulose, the floor was covered with terrazzo and the brick walls and steel girders were clad in faience in colours complementing the Italian marble used in the adjoining control room. The main glaze-colour was a pale grey, contrasting with black for the dado and the string courses, and light blue for other details. Relief decoration was restricted to a simple ribbing of the square piers supporting the tracks for the overhead gantry.✳

Wallis, Gilbert and Partners sought to project a clean, modern image of

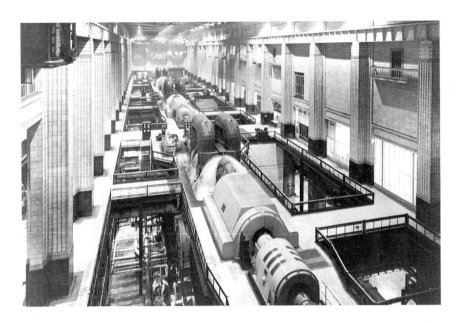

industry through the almost festive appearance given to their bypass factories. Sited in suburbs and powered and lit by electricity, these buildings marked a break from the grime and exploitation associated with Victorian industry. Thomas Wallis justified decorative façades, with simple but colourful forms of faience, in two terms: they provided a more distinguished advertisement for a company than lines of massive lettering, and had a beneficial psychological effect on the worker.✴

The practice developed a long-running collaboration with Carter, the only firm to identify directly with the art deco styles in vogue during the twenties. The link came to dramatic fruition in the Firestone, Pyrene and Hoover factories built on arterial roads in West London. Opened in 1925, the Great West Road attracted growth industries such as processed food, chemicals, car components and electrical goods.✴ The Firestone Tyre Factory (1927) was fronted by a long range of offices finished in a brilliant white render over a reinforced concrete structure. Columns and the central doorway and pediment were highlighted by an American-inspired combination of classical and Egyptian forms executed in faience.

Wallis's passion for the Egyptian style and brightly coloured ceramics culminated in the Hoover Factory, built in 1932 facing the Western Avenue in Perivale. Dashes of orange tiling accentuated the ribs on the main columns in a flickering, spark-like pattern. Thicker bands were combined with painted and gilded metals for the energy-ridden composition of rays that surrounded the entrance and the fan-shaped window above (*colour plate 19*). At the opening ceremony in 1933, Lord Rochdale was moved to surmise that Wallis, Gilbert and Partners had created 'a playground in which the worker could live a life of Utopian felicity, untroubled by, and unconcerned with the rest of the world'.✴

CHAIN-STORE STYLE: ARCHITECTURE AS ADVERTISING

Faience was most widely used on shop-fronts, not surprisingly, since the material was appreciated as being so closely attuned to the needs of advertising. Retail chains developed corporate styles which were executed in blocks and slabs of faience embedded into brickwork supported where necessary by steel joists and beams. Their house styles progressed gently from the classical to the modernistic, while remaining sufficiently distinctive to differentiate the presence of a Co-operative Society, Burton or Times Furnishing store.

The Co-operative movement precipitated a revolution in shop-front design which was taken up by capitalist retailers in the late 1920s. One of the first societies to establish Co-operation on a large scale in London advertised the proliferation of its outlets with strident terracotta façades. For the main emporium of the Royal Arsenal Co-operative Society in Powis Street, Woolwich (1903), F. Bethell created virtually a suburban Harrods, with a central dome and rich Renaissance decorations in a brownish-buff terracotta. A statue set into the main elevation portrayed Alexander McLeod, the first secretary and manager of the society (**113**). *

The Royal Arsenal Committee, in common with many other societies, developed a close collaboration with a single architect whose designs were subjected to the scrutiny of the members. Since the drawings for each store, bakery or dairy had to gain democratic sanction, Co-operative architecture closely reflected public tastes in commercial architecture. The design of Co-operative stores was characterized by a conservatism most typically expressed in the use of a pared-down form of classicism for the street façades. It was stated at the time of the opening of the Woolwich store that 'Your co-operator, as a rule, is averse to anything which smacks of the alien'. *

The Co-operative Wholesale Society and the Union of Retail Societies, both based in Manchester, took up the challenge of ensuring that the movement should not be outshone by commercial retailers: 'No longer are Co-operative stores the Cinderella of shopkeeping . . . co-operators, like the Greeks and Romans, can contribute something of sound and elegant architecture in . . . beautifying the cities in which they dwell.' *

The Union of Retail Societies presented its conception of a model shop-front in 1925, in a store erected by the Manchester and Salford Equitable Co-operative Society and designed by the Co-operative Wholesale Society. The façade was of a simplified classical style, executed in faience and tiles. * This combination of style and materials was to be emulated across the country, whether a local retail society commissioned a local architect for

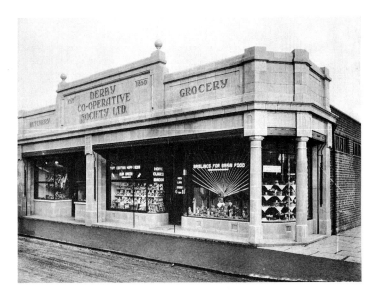

113 Central Store, Royal Arsenal Co-operative Society, Paris Street, Woolwich, by F. Bethell, 1903

114 Shop, Derby Co-operative Society, Balaclava Road, Derby, by L. G. Ekins, 1930 (Hathern)

its new shops or took its designs from one of the architects' departments of the CWS. During the inter-war period, the head architects in Manchester and London, W. A. Johnson and L. G. Ekins, promoted a near-universal use of faience for major shop façades.

Hathern dominated the market for Co-operative stores, producing a total of sixty-seven fronts for the CWS and various retail societies by the end of the 1920s. The schemes supplied by Hathern illustrate the range of variations on the Co-operative house style worked by different societies, and demonstrates how they were repeated from one local branch to the next with minor variations. Ten stores were designed under the supervision of L. G. Ekins for the Derby Co-operative Society. The mottled vitreous faience was kept plain, except for a panel carrying the title of the society and its date of establishment. The designs varied subtly, but enough to have excluded the possibility of reusing any of the moulds made in Hathern's plaster-shop (**114**).

Co-operative architecture steered an untroubled course through the embattled rhetoric of traditionalists and exponents of the Modern movement. One store, dating from 1930, marked W. A. Johnson's most sophisticated marriage of these two architectural ideologies. For a major extension to the central store of the Sheffield and Eccleshall Society, Doulton was given a design that combined classical and art deco forms and incorporated

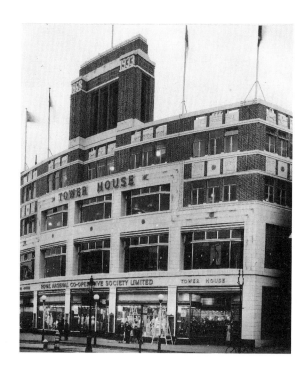

115 Polychrome capital for the extension to the Central Store, Sheffield and Eccleshall Co-operative Society, Eccleshall Road, Sheffield, by W. A. Johnson, 1930 (Doulton)

116 Tower House, Lewisham, by S. W. Ackroyd, 1933 (Hathern)

a variety of glazed effects. Ribbings and zigzag patterns were executed in white Carraraware while the cornice and the capitals, which consisted of bunches of flowers, were brightly coloured with salt-glazes including a lustrous bronze finish (**115**). The staff architect of the Royal Arsenal Co-operative Society had the last word in designing town-centre stores with his façade for the Tower House in Lewisham, which incorporated lorries, railway locomotives and ships (**116**).

Capitalist retailers chose to be far more dogmatic in imposing their chosen house styles across the country. They succeeded in outcompeting the 'Co-ops' by a combination of heavy advertising in newspapers and through erecting lavishly decorated emporia, faience being applied, often as a veneer over existing shop façades, to create tightly controlled and sometimes gaudy identities.

C. J. Eprile created a sleek blend of classical and modernistic detailing for Times Furnishing. Above a black plinth, pure white Hathern faience surrounded large sheets of plate-glass. The branch in the High Road, Ilford (1926), had the company's name set in two large faience panels, the upper one being lit by spotlights (**117**).

Burton used faience as part of a carefully co-ordinated image extending from the firm's typeface to its fleet of 'Black Prince' delivery vans. There were over six hundred Burton stores in the British Isles by 1939. Façades of reflective faience, polished stone and prismatic glass were combined with interiors lined with polished oak to create surroundings 'of masculine dignity'. ☆

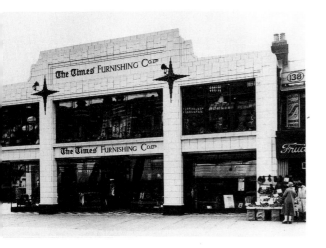

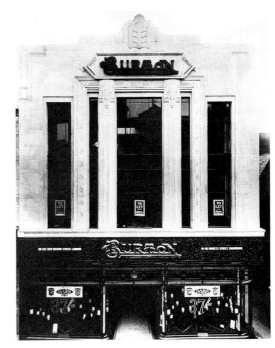

117 Times Furnishing Store, High Street, Ilford, Essex, by C. J. Eprile, 1926 (Hathern)

118 Burton Store, Ann Street, Belfast, by N. Martin, 1932 (Hathern)

The Burton house style was developed by Harry Wilson during the mid-twenties. A surrounding reveal or an entablature incorporated a name-plaque, chevron patterns and bizarrely original capitals. The most distinctive design of capital, as seen in the Belfast branch (1932) and supplied by Hathern, was an elephant's head, designed by E. A. Moore with stylized ears and tusks (**118**).

Burton opened their own architectural office in about 1930 to cope with the pace of building and refurbishment work.☆ The chief architect, N. Martin, appears to have promoted a reversion to classically derived as opposed to overtly art deco motifs. Each façade was drawn in meticulous detail. The decorative forms were defined by full-scale drawings, rather than being sketched in outline for a terracotta draughtsman to develop according to his own whim.

The largest façades showed a deranged juxtaposition of angular capitals and cornices. F. Towndrow lambasted the travesty of classical architecture erected in Glasgow: 'Greece and Rome have a great deal to answer for. Thank goodness Mr Burton doesn't dress his customers as he dresses his buildings.'☆

THE IMAGE OF THE CINEMA

Cinema façades fulfilled the potential vested in faience, not in terms of mass production or systematized construction, but in promoting riotously

intricate and brightly coloured decoration. The material was central to every advance in cinema architecture, which evolved in inventive spurts, from fairground shows and adaptations of the Edwardian theatre to free and indulgent interpretations of Renaissance and other historicist styles, and in the thirties into streamlined and futuristic originality.

There were about 3,000 cinemas in Britain by 1914 and almost 5,000 by 1939. Owing to their proliferation and their strident appearance, cinemas became a *cause célèbre* in the tussle between groups who viewed architecture as an elevated art and those who saw buildings as needing to be in tune with the tastes and aspirations of the public. Proprietors accepted from the outset that the appeal of their cinemas was essentially escapist. They emphasized the value of picture-theatres as a refuge from the dinginess of the cities inherited from the Victorians, but also as centres of education.

Practical factors underlay any enthusiasm for the visual potential of faience. The risk of nitrate film exploding prompted a series of fire regulations which were imposed by the Cinematograph Acts of 1909 and 1923 and by local by-laws. Fireproof terracotta and faience were widely used for facing brick-built cinemas almost as soon as the first Act came into force in January 1909. Hathern gained their first contract for a cinema in 1910, supplying the Electric Theatre in Birmingham, designed by Wall and Ball.

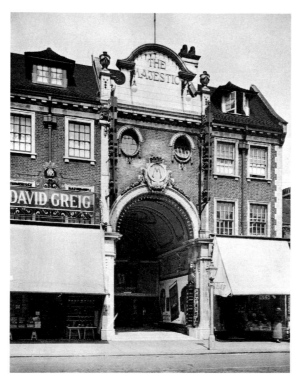

120 (opposite) Cinema House, Rotherham, by Hickton and Farmer, 1912 (Hathern)

119 Majestic Theatre, Clapham, London, by J. Stanley Beard, 1913 (Hathern)

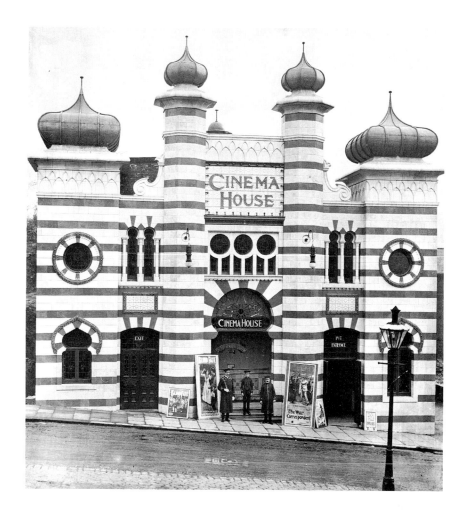

The pioneering bioscope shows, accommodated in canvas booths, wooden sheds or small converted theatres, were dismissed as an unsavoury diversion for the lower classes on account of the combination of over-crowding, sweat and catcalls. A group of three London cinemas, designed by J. Stanley Beard, demonstrated how decorative faience could give a small façade respectability and enable it to stand out from neighbouring shops and offices. The Majestic Theatre in Clapham (1913) was faced with white Hathernware moulded with a variety of French Renaissance decoration that had already found favour in Edwardian theatres (**119**). By the end of 1914, Hathern had undertaken twenty-five orders relating to cinemas.

Cinema design quickly broke free from the traditionalism of theatre archi-tecture. American films, mostly in the form of thrillers and 'hit and near-miss' slapsticks, called for elevations that were equally spellbinding. Faience was worked into eastern styles or wild mannerisms of contemporary classi-cal design. The Electra Palace in Sheffield, built in 1911, was given a front of Burmantofts' faience incorporating Egyptian heads. The local press was enraptured by the fifteenth-century Arabian style: 'The graceful minarets,

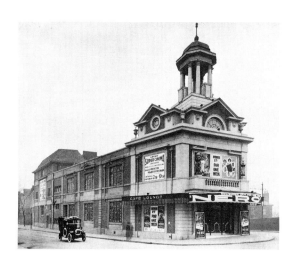
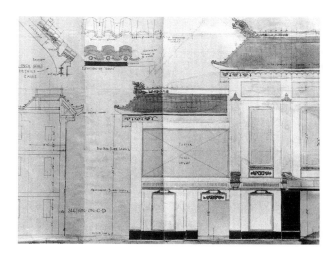

from which, in the original, the call was daily made to the faithful, are in this instance used to call the citizen's attention to a palace of light, to be daily visited by all in search of knowledge and delight.'✶ One year later, the architects of the Electra Palace, Hickton and Farmer, devised a compilation of middle-eastern motifs for the Cinema House in Rotherham. Minarets were combined with onion-shaped windows and a frieze of stylized lotus leaves (**120**).

Cinema façades of the twenties encompass a bewildering variety of styles and materials. W. E. Trent was responsible for some of the first 'super' cinemas containing over 200 seats; the Baroque exterior at Ilford, 1921, enclosed an auditorium designed to create the effect of a Greek theatre with an open roof (**121**). Before the emergence of large chains of Odeons or Regals, many provincial architects designed cinemas as just one aspect of their practice. They might create compositions reflecting their own tastes to the last detail, or develop designs in league with particular terracotta manufacturers. Talkies, pioneered in 1929, prompted an upsurge in audiences and a spate of cinema construction. Proprietors planned a series of super-cinemas with over 2,000 seats and lavish decoration; fibrous plasterwork created interiors evoking Gothic palaces or Mediterranean landscapes, while faience was worked into richly modelled façades, designed to look their most impressive when floodlit at night.

George Coles, Britain's most creative designer of cinemas, openly accepted the need to reconcile architectural and commercial considerations. He created a bewildering variety of Renaissance, Egyptian, Chinese and art deco designs through an almost unwavering collaboration with Hathern. ✶ Coles's commitment was based as much on the firm's reputation as on their prices, the draughtsmen responding to any architectural challenge that his sketches presented. He exerted an absolute control over the detailed form of his cinemas and, through his autocratic personality, established himself

121 **Super Cinema, Ilford, by W. E. Trent, 1921 (Hathern)**

122 **Part of an elevation for the Palace Cinema, Southall, London, by G. Coles, 1929 (Hathern), annotated with the instruction: 'make the dragons as fierce as possible'**

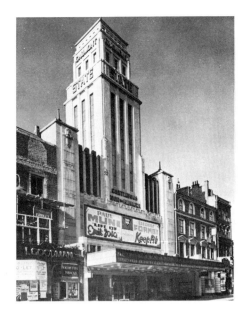

123 **Gaumont State, Kilburn High Road, London, by G. Coles, 1936 (Hathern)**

as the directing half of the partnership with Hathern, whose staff were always on their mettle to satisfy his meticulous standards.

A brief Egyptian revival was stimulated by the discovery of Tutankhamen's tomb in 1922. Coles created pylons – monumental gateways – for the Carlton cinemas in Upton Park (1928) (*colour plate 20*) and Islington (1930). Hathern's faience was moulded into bulbous ribbed columns, coved cornices, and, at Islington, sloping window-reveals and a frieze of papyrus leaves. Underglaze enamels produced bright colours but incurred considerable expense, since they had to be hand-painted. Hathern also created the only British cinema in the Chinese style: the Palace at Southall (1929) (*colour plate 21*). Coles could draw inspiration from Grauman's Egyptian and Chinese cinemas in Hollywood, dating from 1922 and 1927; he justified such stylistic indulgence as being permissible in working-class suburbs where a cinema needed to establish a strident presence amidst garish hoardings and glittering lights. Referring to the Palace at Southall, the Chinese style, he suggested, 'invests the building with definite character, which is always effective, and besides stimulating interest through its sheer novelty, should inspire the mind with the romance that is associated with an ancient culture of far-distant lands'. ✶

The Palace gained its impact primarily through complex polychromy, the relatively flat wall-surface being glazed in seven colours on an ivory background. The cornice and ridge-tiles were hand-painted, while finials of dragons and fishes completed the far-eastern flavour (**14, 15**). Coles's assistant architect, Arthur Roberts, made visits to the British Museum, paying particular attention to the style and form of Chinese dragons. An instruction on an elevation supplied to Hathern exhorted the modellers to make them 'as fierce as possible' (**122**).

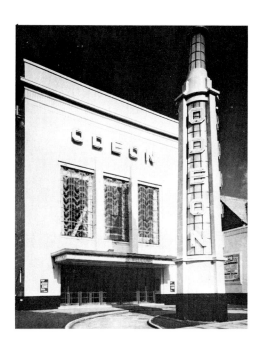

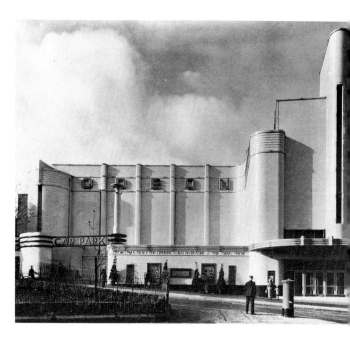

Coles turned to America to find a more contemporary image for the cinema. His grandest design, the 4,000-seat Gaumont State (1936), had a skyscraping tower that loomed over the Kilburn High Road as if it was Fifth Avenue in Manhattan (**123**). American example and the merits of neon lighting were combined to create a flexible but up-to-date house style for the rapidly growing Odeon circuit. Oscar Deutsch and his architects saw streamlining as an appropriate form for cinemas in newly built suburbs. If neo-Tudor expressed the inter-war image of the home, then streamlining encapsulated the escapist and slightly light-headed application of modern technology in the cinema.

Faience slabs were applied as a veneer to brickwork which was itself non-load-bearing. The walls were backed by a steel frame, strong enough to support the fireproof projection box and the projecting balcony. In theory the completion of a cinema could have been speeded up by rapidly erecting the brick shell and then applying the faience veneer at the same time as the interior was being fitted out. This time-saving approach was compromised by the continued use of blocks for corners and for curved sections that had to course in with brickwork. Most architects specified that slabs should be tied individually into the brickwork, typically by metal clamps linking their edges into mortar courses between the layers of brick. ✫

Coles designed fourteen Odeons which incorporated Hathern's faience. Those dating from 1934–5 sometimes show a restrained classicism. He later adopted a more futuristic aesthetic, aided by Hathern's ability to produce full-gloss finishes in a variety of colours, and to cast thin slabs and mould blocks with curved surfaces. His adoption of slabs of faience with unbroken surfaces and in standard sizes occurred as late as 1936.

124 (far left) Odeon, Horsham, Sussex, by G. Coles, 1936 (Hathern)

125 Odeon, Woolwich, London, by G. Coles, 1936 (Hathern)

The forecourt of the Horsham Odeon (1936) was given a cylindrical beacon, executed in concrete but finished to match the faience of the cinema itself. By night it would have shone like a space rocket amid the town's narrow streets and picturesque mixture of Wealden vernacular and modest classicism. The sheer façade of the cinema, completely clad in Hathernware, had sufficient classical references, in terms of windows being divided by slab pilasters and the top of the frontage being surmounted by a cornice, for the local press to report that 'the general lines of the building are designed to harmonise with the character of the town' (**124**).☆ Coles appears to have found the right balance, at least in local eyes, between startling and alluring originality and civic respectability.

An even more daring balance between futurism and traditionalism was presented in the Odeon at Woolwich (1936), which shows Coles's most indulgent use of curved forms and slab faience (**125**). The buff blocks and slabs swept round the end staircase, over some vertical fins arranged along the wall of the auditorium and round the entrance front which was surmounted by a tall central fin. Coles's inspiration probably came from contemporary product design in America, such as the streamlined railway locomotives developed by Raymond Loewy or the curvaceous lines of car designs like the 1936 Lincoln Zephyr. The futurist vigour of the composition was tempered by restrained references to Egyptian art, the torchères by the entrance to the car-park being modelled in the form of slender palm shafts.

Harry Weedon, another architect who designed cinemas for Deutsch, found an economical means of achieving a striking architectural impact at very modest cost. His first Odeon was built in 1935 in Kingstanding, Birmingham. The bulk of the cinema was faced in brick. A gently bowed section of plain faience above the entrance was topped by tall fins soaring above the surrounding shopping parade. Weedon typically worked with Shaw, who were able to undertake a complete Odeon contract, from receiving sketch drawings to final delivery, in about eight weeks.☆ Some critics objected to the assertiveness of thirties' cinema design. Robert Cromie described the use of 'sickly faience' as abusing the layman's right to that 'decency and order which it is a privilege to inspire and a duty to uphold'.☆ Despite their blatant use of architecture for commercial ends, the Odeons designed by Coles and Weedon demonstrated a popular approach to non-historicist design. The client, architect, local figure-heads and press had no doubt of their merit, or of the value of faience both in attracting custom and in conveying a worthy image for film entertainment.

THE ADOPTION OF TERRACOTTA IN NORTH AMERICA

Importing Skilled Labour and an Architectural Ideology

The introduction of terracotta into the United States, as in Britain, experienced a false start in the years around 1850. Interest revived following completion of the Boston Museum of Fine Arts in 1876 and culminated, again as in Britain, in the middle of the following decade. From the outset its adoption was motivated at least as much by a practical concern for fireproofing as by the search for a new form of 'indigenous' architecture, attention being focused by a series of fires, especially the holocaust that destroyed Chicago in 1871.

IMMIGRANT CLAYWORKERS AND IMITATIVE EXPERIMENTS

The earliest terracotta blocks made in America imitated the appearance of stone or even iron. In 1840, a works at Worcester, Massachusetts, started to make buff-coloured decorative details, ready for painting to any desired finish. Lintels and pediments were supplied for several houses, and other detailing was supplied for two prestigious contracts in Boston: capitals for the columns of the State Capitol and windows for the Pine Street Church.

Initial attempts to introduce terracotta into New York were just as imitative, and short-lived. In 1853 James Renwick, one of the best-educated and most-travelled of America's mid-nineteenth-century architects, embarked on a collaboration with a Mr Young who owned a sewer-pipe factory in 40th Street, New York. Renwick not only designed terracotta for some of his commissions but also supervised its manufacture at the pipe works. Young was tempted by Renwick's promise of large profits once clients were convinced of the superior durability of his terracotta in comparison to friable brownstone, which the ceramic blocks were painted to match. Dressings were supplied for three houses in 9th Street, the Tontine Building, and two buildings on Broadway: La Farge House and the six-storey St Denis Hotel. The hotel was a four-square block with classical window-surrounds, looking not unlike a mid-Victorian London public house (**126**).

Far from making his fortune, Mr Young lost money on these contracts. Renwick claimed subsequently that stonemasons and builders in New York had conspired to persuade clients not to accept terracotta. Any opposition within the building industry must have been reinforced by the disaster experienced by another leading New York architect, the senior Richard Upjohn. Material supplied by the firm of Messrs Winter and Company of

Newark, New Jersey, for his Corn Exchange Building disintegrated after just one season of winter frosts. ☆

During the next twenty years problems associated with the use of stone, such as transport costs, a shortage of skilled stonemasons and inconsistent durability, continued to vex American architects. A few resorted to the drastic and expensive solution of importing terracotta: columns, billet mouldings and dog-tooth forms were shipped in for the Westminster Presbyterian Church in Columbus, Ohio, designed by Mr Hamilton of Cincinnati (1856–7). During the same decade J. E. Mitchell of Philadelphia was advertising chimney-pots, vases and fountains imported from the Garnkirk works in Scotland 'at a quarter of the cost' of those carved in stone. ☆

JOHN BLASHFIELD AND THE BOSTON MUSEUM
OF FINE ARTS

British terracotta was durable and provided a means whereby high-quality modelling by European artists could be introduced into American architecture. This double potential was realized in just one major building, the Museum of Fine Arts in Boston, completed in 1876 with terracotta imported from Blashfield's works in Stamford, Lincolnshire (**127**). This impressive Gothic building paralleled the influence of the Victoria and Albert Museum in turning aesthetic taste in favour of the material. The Boston Museum achieved even greater significance, since the immigration of potters involved in the contract, or at least employed by Blashfield, provided the expertise for the large-scale manufacture and use of terracotta not just in Boston but also in Chicago and later New York.

John Hubbard Sturgis and Charles Brigham won the architectural commission through a competition, but had to adapt their design in response to the wishes of the local cultural élite. Martin Brimmer, the chairman of the building committee, and Walter Smith, Professor of Art Education, were among those who attested to the appropriateness of architectural ceramics for a museum embracing science and art and housing an art school. Walter Smith, one of the group of British design reformers, had been invited, on the recommendation of Henry Cole, to apply his experience in organizing art education in Leeds and the West Riding to developing a comparable system for the state of Massachusetts.✶ Almost paraphrasing the words of Cole or Redgrave, Smith extolled the merits of terracotta for fireproofing and its indestructibility, and as 'the noblest of all materials for the expression of art', especially when worked into 'sculptured enrichments'.✶

Sturgis was instructed by the trustees of the new museum to study current British practice in terracotta. A distant if not sleeping member of the partnership with Brigham, Sturgis had lived in England since 1866, working with the English architect J. K. Colling and establishing a collaboration with Blashfield. The Stamford works had already made the parapets and decorative panels for Pinebank, a house erected in Boston to Sturgis's designs in 1868–9.✶ Colling, who designed some of the carved stonework on Pinebank, was commissioned to prepare detailed drawings of the ceramic decoration for the museum, forwarding drawings to Stamford. He also inspected all the models and many of the finished pieces. Having a strong enthusiasm for naturalistic foliage, he probably influenced Sturgis towards evolving a Gothic expression out of round-arched Renaissance design.✶ The museum, until demolished in 1906, presented a virtuoso display reflecting Blashfield's penchant for deeply undercut foliate decoration.

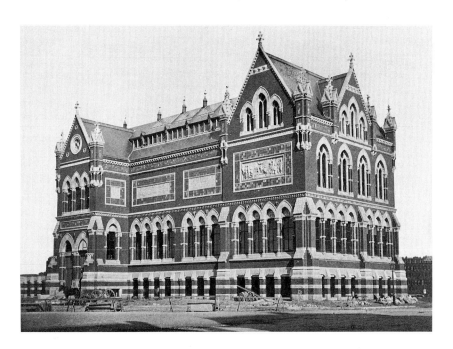

127 The part-completed
Museum of Fine Arts,
Boston, by Sturgis and
Brigham, 1870–6 (Blashfield)

The enthusiasm shown by Boston's cultural grandees was matched by Blashfield's rather wayward zeal for the challenge of shipping consignments of fragile blocks across the Atlantic Ocean. The Boston contract would have offered some compensation for his exclusion from supplying material for the Victoria and Albert Museum or the Albert Hall. He may also have been spurred on by a wish for revenge against a group of his work-force who had already taken their skills to the United States in the hope of developing an indigenous terracotta industry. ☆ Blashfield worked with suppressed excitement during the months before the contract was confirmed by an agreement of 3 July 1872. He took Sturgis to inspect the terracotta at Dulwich and forwarded photographs of other schemes and sketches of pieces made to designs by Owen Jones. The problems of shipping crates of fragile blocks to America were glossed over by reference to another long-distance export contract: an entrance gateway and dressings for a clock tower for the Victoria Gardens in Bombay supplied during the mid-1860s (128, 129). ☆

This confidence was first shaken by the time it took for money to come from Boston. The Stamford Terracotta Company started to incur serious debts as delivery of one consignment of blocks was delayed by a ship having to turn back to England. Other payments were held up when the building contractors were unable to relate the pieces supplied to the spaces across the façade. ☆ By the summer of 1874 Blashfield's relationship with the building committee and with Sturgis, who was trying to act as intermediary from his English home in Leatherhead, were worse than strained.

Blashfield became a martyr to the cause of introducing terracotta into the United States. Before half the shipments had been dispatched, he real-

145

ized that he had accepted an uneconomic contract. He was castigated by his shareholders for taking the work at too low a price and from the beginning of 1873 was requesting payments from America with increasing desperation. His fears that the project would 'end very disastrous to me both in health and pocket' were to be tragically fulfilled.* Writing shakily on out-of-date letterheads his tone became increasingly frantic. By December 1874 the Stamford works, including models, moulds and machinery, were being offered for sale. In the following month Blashfield announced that the firm was being wound up, and Sturgis snapped up the spare pieces of terracotta made for the Boston Museum at a knock-down price of £150.* Blashfield's personal finances had become entangled with those of the company. Two and a half years after the Stamford Terracotta Company went into liquidation John Marriott Blashfield, 'modeller and potter' of London and Stamford, by now a sick man, was declared bankrupt.*

Before his final downfall, Blashfield had been tempted by prospects in the United States. As early as 1871 he had received letters inviting him to emigrate or to send out models and moulds.* Aware of the destruction occurring through fire in America, Blashfield saw the potential market for ceramics as a cladding for structural ironwork. One of his letters included a series of rough diagrams of columns and beams encased with terracotta.* Even at the height of the crisis precipitated by lost moulds, broken blocks and mounting debts, he was considering how to mass-produce and export blocks for fireproof construction.*

Blashfield's failure indirectly helped to surmount two major shortcomings within the nascent terracotta industry of the United States: the dearth of stock ornamental designs on offer to architects and builders, and

146

128 and 129 Archway, Victoria Park, Bombay, and detail of the archway, showing portraits of Queen Victoria and Prince Albert and cherubs supporting a flagpole, *c.*1865 (Blashfield)

130 Portrait of James Taylor, *c.*1885

of managers and workers capable of undertaking complex contracts. The purchase of second-hand models and moulds was a valuable short cut towards producing a catalogue of architectural components and statues and vases. The demise of Coade's Manufactory in the 1830s had resulted in several aspiring manufacturers purchasing moulds, among them Blashfield. In turn, the closure of his own works, just as the industry was becoming established in America, offered a valuable opportunity for the more enterprising 'Yankee' potter. In 1888 the proprietor of the Market Street Pottery in Philadelphia, William Galloway, was recorded as having a set of what must have been rather worn moulds used at Blashfield's during the 1860s. ✩

Blashfield knew that he was too old and infirm to make a new start in America, but a group of his employees did emigrate to benefit from the interest in terracotta created by the example of the Boston Museum. At least one employee was sent out to ease the problems of sorting and fixing the blocks as they were delivered, but did not return. Others emigrated after Blashfield's business had collapsed.

JAMES TAYLOR AND THE INTRODUCTION OF TERRACOTTA TO CHICAGO

The dominant figure in the introduction of terracotta into America was James Taylor (**130**). After fourteen years' experience as a builder he worked for Blashfield for at least five years, becoming the chief foreman at Stamford. Much of this period was spent in supervising the execution of the contract for Dulwich College.

Taylor was just as obsessed with terracotta as was Blashfield, and no less

convinced of his own capabilities. It could have been a personal rivalry with Blashfield that made him decide in 1870 to emigrate, apparently without any clear plans. While Taylor was planning his departure from Stamford, a letter arrived from Chicago seeking guidance on techniques of manufacturing terracotta. The request was from Sanford Loring, director of the Chicago Terra Cotta Works. It was too good an opportunity to pass by: in July 1870 Taylor was established in Chicago as the firm's superintendent. ✩

The plant at Chicago was founded by a builder of Louisville, Kentucky, who started making terracotta in 1861. J. N. Glover's aim was to produce a fireproof and non-rusting alternative to iron. His moulds were in fact taken from cast-iron models. These forms, dismissed by Taylor as 'a clay imitation of an iron imitation of a cut stone' were well appreciated by builders. Loring and a Signor G. Meli introduced new stock designs with simple incised patterns, broadly in accordance with the Eastlake style. Taylor saw the future in terms of supplying not just vases and window-heads but whole façades. He distributed a circular emphasizing the capabilities of the works and declaring that the material would be supplied to 'any required design'. ✩

By 1870 terracotta had been adopted by several architects working in Chicago, such as W. W. Boyington and William Le Baron Jenney. Their choice was partially dictated by the fire-resistant qualities of ceramics, which had been officially recognized by the Chicago Board of Underwriters in 1868. Such practical concern over fire and consequent interest in terracotta was given an urgency by the blaze that raged through Chicago for twenty hours in October 1871, destroying 18,000 buildings, almost a third of the city's property. Granite walling had crumbled and disintegrated; limestone walls simply calcined away (**131**).

The architects, developers and owners who picked their way through the ruins of the city on the morning of Tuesday 11 October were aghast that buildings with brick walls should have been reduced to rubble. The explanation lay in the typical form of construction in Chicago: wooden frames clad with a four-inch shell of brickwork. ✩ The timbers were tied into the outside wall so that an internal fire resulted in collapsing joists levering over the thin brick façades. The loss of major commercial and governmental buildings that were supposedly of fireproof iron construction was even more of a shock. Unprotected cast-iron columns had cracked or melted in the searing heat and the molten metal served only to intensify the fire. Amidst the acres of destruction, terracotta detailing hung on to some of the burnt-out shells as a stark lesson in its fire-resisting qualities. During the reconstruction of the city that extended over the rest of the decade, terracotta was adopted as the most effective means of protecting iron framing and of creating façades that would withstand fire.

One of those surveying the ruins of Chicago on 12 October was George

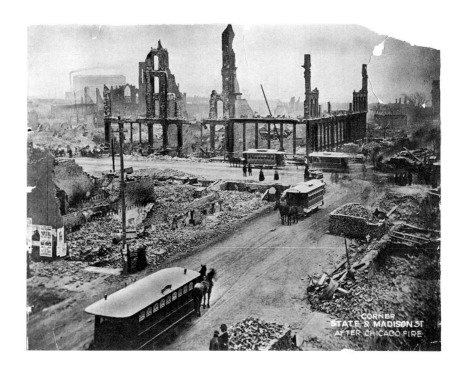

131 Ruined buildings from the Chicago fire of 1871

H. Johnson, who had taken out his first patent for fireproof hollow tiles in 1870. He was probably the original inventor of hollow-tile construction for flooring and partitions. This innovation drew upon his experience of the problems of cast-iron construction, gained through working as a designer in Daniel Badger's Architectural Iron Works in New York.

In 1872 Johnson won the contract for producing a fireproof structure for the Kendall Building, designed by John M. Van Osdel. The building demonstrated the three prime uses of ceramics in fireproofing: for hollow floor-arches between wrought-iron joists, as cladding for cast-iron columns, and for interior partitions. Johnson was also responsible for the terracotta fireproofing used in other structures such as the Cook County Gaol and Court House. His son Ernest V. Johnson was a partner in one of the most important firms to specialize in making terracotta for internal use, the Pioneer Fireproof Construction Company. ✫

Another firm specializing in this branch of terracotta work was the Wight Fireproofing Company. Peter B. Wight was an architect whose earlier attempts to introduce terracotta in New York reflected a personal interest in polychromy shared with his associate during the 1860s, Russell Sturgis. Much of Wight's career was devoted to promoting fireproof construction. His observations after inspecting the ruins of Chicago included a recommendation that the under-side of iron floor-beams should be protected with terracotta. In the autumn of 1874 Wight was propounding the protection of iron columns with hardwood. Only a month later, in October of that year, a porous terracotta was patented by Sanford Loring, and Wight

149

132 Patent design for a fireproof column by Drake and Wight, 1874

immediately went over to using this lightweight ceramic material rather than red oak (**132**). ✩ However, it was not until the early 1880s, with Wight working as general manager of the Wight Fireproofing Company, that his patent column with its ceramic cladding became widely used.

The factory of the Chicago Terra Cotta Company survived the 1871 fire to profit from the demand created by rebuilding work (**133**). Until business could justify more staff, Sanford Loring combined the posts of treasurer and designer, drafting both catalogued forms and complete buildings which incorporated terracotta. In the case of one group of houses in North La Salle Street, he was the owner and the architect, as well as the supplier of the decorative pediments above the doors and windows. One of the earliest major buildings to be erected after the fire was designed by Loring in collaboration with William Le Baron Jenney. The simply worked mouldings, bases, capitals and cornice of the Smith Building were all of a buff

terracotta that contrasted with the dark red brickwork.✲ There was no shortage of red burning clays but Taylor had inherited Blashfield's preference for a buff colour. Some of the architects working in Chicago criticized Taylor's material for looking so much like stone, Wight complaining that 'it loses its own individuality'.✲

SOPHISTICATION IN BOSTON

Up to 1880, 95 per cent of American architectural terracotta was made in Chicago. Massachusetts had a number of small potteries that produced architectural ware, Henry Tolman managing several firms in or near Worcester, Mass., before 1868. No major terracotta works was operating in the eastern states for most of the seventies, so it was not surprising that several buildings in Boston and New York incorporated terracotta made by the Chicago Terra Cotta Company or the breakaway firm of True, Brunkhorst and Company. The first use of American-made terracotta in Boston was on H. H. Richardson's Trinity Church, built 1872–7. The Chicago Terra Cotta Company supplied the hip-rolls and the enormous crockets that run up the squat central spire (**134**).✲ Unlike most of the firm's output, the ridge details were bright red in colour.

Meanwhile, just to the north of Trinity Church in Boston, far more extensive schemes of terracotta decoration were being introduced on the

133 (opposite) Fitting- and shipping-room of the Chicago Terra Cotta Works showing cornices, vases and statues, depicted in 1876 (from *American Architect and Building News*, 1, 1876, unpaged plate)

134 Roof and tower of Trinity Church, Copley Square, Boston, by H. H. Richardson, 1872–77 (Chicago)

135 Boston Art Club, 270 Dartmouth Street, Boston, by W. R. Emerson, 1881

136 Porch to one of a pair of houses, on the corner of Commonwealth Avenue and Gloucester Street, Boston, by J. P. Putnam, 1877 (Boston)

houses of the Back Bay. Many parallels can be drawn between the Back Bay and developments in Kensington and Chelsea, but American architects placed greater emphasis on achieving effects by exploiting the decorative qualities of brick through abstract patterns, rather than by reliance on particular styles and their motifs. In the late sixties a simple articulation of façades had been achieved by projecting and recessing areas of plain brickwork. The use of brick in this 'panel style' also had a practical justification: stone was becoming prohibitively expensive because of the prices charged by quarry-owners and the wages demanded by masons. ☆

Bostonians soon aspired to more lavish decoration. W. Whitney Lewis, an emigrant from England, was responsible for the first significant use of American terracotta in Boston. His designs for a pair of houses on the corner of Commonwealth Avenue and Gloucester Street, dating to around 1877, combined red Philadelphia brick with richly modelled buff terracotta. He had no option but to turn to the Chicago Terra Cotta Company and their modellers, James Legg and Isaac Scott, for the decorative frieze, corbels and arches.

The terracotta made in Chicago for the houses designed by Whitney Lewis compared favourably with Blashfield's material on the nearby Boston Museum of Fine Arts. It was at this moment of new confidence in home-manufactured ceramics that the architect of the new English High and Latin School in Boston, George Clough, was instructed to execute his design with terracotta decorations.

Having gained this contract in 1877, Sanford Loring realized the potential for greater business in Boston. He arranged for clay, prepared to the required consistency and quality in Chicago, to be transported to the works of the Boston Fire Brick Company for pressing and firing under the supervision of James Taylor, his ex-superintendent. ☆ There being no time to wait for pug-mills to be set up, the first batch of clay to arrive from Chicago was tempered by foot. The overall composition of the school was reminiscent of Blashfield's work on Dulwich College; there was the same colour combination of red brick and grey terracotta, but the decoration was far simpler than that used by the younger Charles Barry a decade earlier.

By the early 1880s Boston had two major works. Both shipped their products through the eastern and middle states, in addition to supplying orders for houses in the Back Bay. On the corner of Exeter Street and Commonwealth Avenue, no. 197, a house with Lewis's terracotta designed by Rotch and Tilden is adjoined by no. 195, designed by J. P. Putnam and incorporating moulded bricks and terracotta made by Taylor's Boston

152

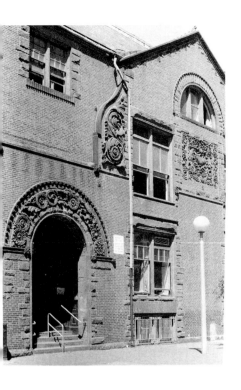
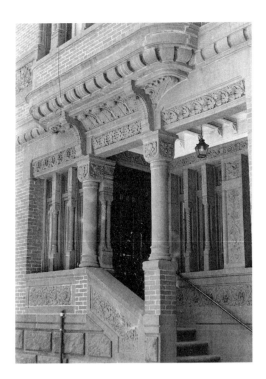

Terra Cotta Company. Both houses date to 1881. The decorative modelling in Putnam's design was entrusted to Boston's leading firm of architectural carvers, Messrs Evans and Tombs. Their skills and Taylor's bravura in the structural handling of terracotta emerge in the use of blocks 7 feet long, supported by a ceramic column only 9 inches in diameter, to form the lintels over the porch (**136**). Just as in Britain, terracotta soon came to be seen as a justification for exotic styles and bright colours, a Venetian Gothic being chosen by J. L. Faxon for the Victoria Hotel of 1886 (*colour plate 22*).

Beyond such extrovert displays, the use of terracotta in Boston around 1880 shows the emergence of a type of clay-modelling that was to be applied widely in both Chicago and New York. William Ralph Emerson had set large rectangular panels of swirling forms of vegetation into the main façade of the Boston Art Club, 270 Dartmouth Street, in 1881 (**135**). The panels were of moulded brick rather than terracotta. The same material and stylization were used by H. H. Richardson in the panels supplied by the Boston Terra Cotta Company for Sever Hall at Harvard University, built 1879–80. On the eastern elevation, panels above the main entrance, beneath the second-floor windows and within the pedimented gable were given intricate patterns of flowers and strongly pinnate leaves. The modelling was taut and slightly mechanistic; it marked a rejection of the florid undercutting introduced into America by Blashfield and Colling and initiated the approach of repeating motifs to create a field of decoration.

Having devised a form of decoration with few debts to historicism,

Richardson concentrated in his subsequent commissions on developing more massive effects using carved and rubble stone. In the hands of other architects, the contrast of plain brick surfaces with panels of crisp, stylized foliate decoration was to be one of the most notable characteristics of American terracotta dating from the 1880s. It emerges in contracts which the Boston Terra Cotta Company undertook in New York and, through Taylor's personal involvement, in the output of the newly established firms in New Jersey. By the late 1880s the ceramic variation of the Richardsonian manner was almost *de rigueur* for terracotta architecture, extending even to the commercial buildings of Chicago. Its emphasis on restraint, repetition of low-relief forms and freedom from stylistic eclecticism was in marked contrast to the assemblages of Gothic or Renaissance columns, arches and mouldings being fabricated in England.

NEW JERSEY AND NEW YORK

Two important factors dominate the extension of the manufacture and use of terracotta down the eastern seaboard from the late 1870s, and in particular the establishment of Perth Amboy in New Jersey as the main centre for supplying cities from New Haven to Washington DC. While American interest in architectural ceramics was disseminated through the art-school movement and various exhibitions, the heavy clay industry was expanding through exploitation of clay reserves in the states of New Jersey, New York and Maryland.

Taylor, Loring and others responsible for the introduction of terracotta into Chicago and Boston tended to be preoccupied with the material's constructional attributes rather than with promoting its use within the decorative arts. The lack of attention given to ceramic sculpture reflects the overriding concern with fireproofing and the dearth of suitably skilled sculptors and modellers throughout America.

Most of the major cities were able to offer some type of art training by the second half of the nineteenth century, but ceramics only gained a central position in teaching curricula after the Centennial Exhibition held in Philadelphia in 1876. It was a national arousal similar to that achieved by the displays of 1851 and 1862 in London. Reports expressed concern at the poor showing of the embryonic American industry. Only one firm, Galloway and Graff, gained an award for terracotta, and their display was mostly made up of decorative wares.☆ The foreign stands at the Centennial, such as the display by Doulton (**137**), proved more inspirational: their example

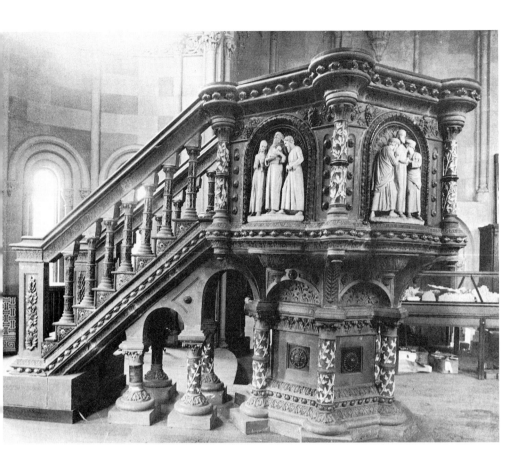

led to the founding of several new works, one of the most significant being the Rookwood Pottery established at Cincinnati in 1880.

The exhibition gave a strong impetus to the introduction of new art courses, most of which devoted considerable attention to ceramics. In Philadelphia itself, the Centennial resulted in the establishment of a department at the Pennsylvania Academy of Fine Arts to teach modelling; students worked from life and copied antique and other casts. A School of Industrial Art was given its charter in 1876 and a clayworking department opened in 1880. The students were given a more comprehensive industrial training than that available in most British art schools. In 1896, Professor H. Plasschaert of the School of Industrial Art could be found with nine assistants in the modelling shop of Stephens, Conkling and Armstrong's terracotta works in Philadelphia, making cupids, capitals and wreaths. ☆

In 1877, Edward Spring, the rather grandly titled Professor of Sculpture at a children's school, invited his friend, the peripatetic James Taylor, to join him in setting up the Eagleswood Art Pottery on an estate near Perth Amboy. The professor and his pupils specialized in making sculptural plaques and medallions. Before moving on to Boston, Taylor was able to find a position for his brother and 'pupil', Robert, within the work-force and to contribute to the setting-up of the first major terracotta works in

New Jersey. Alfred Hall, joint owner of a near-idle pottery in Perth Amboy, asked him if it could be converted to produce architectural ceramics. Taylor's recommendations resulted in the kilns being converted for Blashfield's method of muffle firing and his brother was appointed foreman in the summer of 1877.* Reconstituted as the Perth Amboy Terra Cotta Company in June 1879, the works expanded dramatically on the strength of a growing market in nearby New York.

There had been no significant use of terracotta in New York since the 1850s. Its reintroduction was pioneered by the city's leading architect, George Post, in 1877. He designed a large house in East 36th Street, Manhattan, to incorporate decorative panels and other details made at the Illinois factory of the Chicago Terra Cotta Company. The design was far less progressive than Emerson's or Putnam's houses in Boston, the frontage being broken up by a projecting porch, a large bay and jutting cornices.

Post's design of 1878 for the Long Island Historical Society in Brooklyn presented a far more inspired use of terracotta, while the building's constructional history marks the emergence of Perth Amboy as a source of terracotta supply. The first stage of the order was supplied by the Boston branch of the Chicago Terra Cotta Company; the rest of the contract went, on the recommendation of Taylor, to his brother's works, A. Hall and Sons at Perth Amboy. The patchwork of red and brown hues across the façades reflects the variety of clays employed. The work made in Boston used clays from Akron, Ohio. The early output from Hall and Sons was made with clays from Baltimore, subsequent consignments with a mixture of Baltimore and New Jersey clays, and the final portions entirely from pits in New Jersey. The building's blotchy elevations bear fictile witness to the principle of transporting and combining clays as propounded by Blashfield and Taylor.

The use of terracotta by George B. Post shows an allegiance to the brand of Italian Renaissance architecture that was so much a hallmark of the Victoria and Albert Museum and related developments in South Kensington, this combination of material and style being considered highly appropriate for an edifice accommodating a library and museum. The Long Island Historical Society building marks the maturity of terracotta's acceptance into the New World, the ornamental approaches developed in Chicago and Boston being applied with a new assertiveness of scale and detailing. The rich high-relief decoration was concentrated into the spandrels of the arches and a series of medallions, leaving the elevations to be dominated by sheer brick pilasters and heavily projecting cornices moulded in massive blocks. Busts of Beethoven and other cultural figures glower down from medallions with none of the benignity of those on the walls of Dulwich College in England. The almost life-size Viking and Indian above the main entrance amplify the nationalist overtones of Post's design and stress his commitment

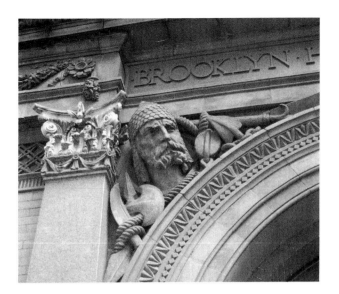

138 Spandrel sculpture, Long Island Historical Society, Brooklyn, by G. B. Post, 1878 (Boston, A. Hall)

to exploring the sculptural potential of his relatively new material (138).

Much of the decoration was in the Blashfield and Colling tradition of naturalistic representation in high relief, achieved by undercutting or applying separately modelled details. In contrast, the cornice above the ground floor was worked with two low-relief patterns more akin to the work of Richardson and other designers of houses in Boston's Back Bay. Some were based on highly stylized and angular leaves and others were given interweaving patterns in a Celtic style. The re-emergence of these forms on a building located virtually in New York City may be explained by the involvement of the Boston sculptor Truman H. Bartlett. It was a condition of both the original contract with Loring and the later one with A. Hall

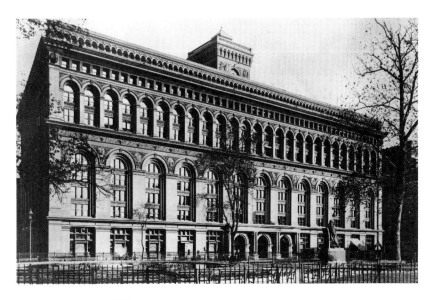

139 Produce Exchange, New York, by G. B. Post, 1881–5 (A. Hall)

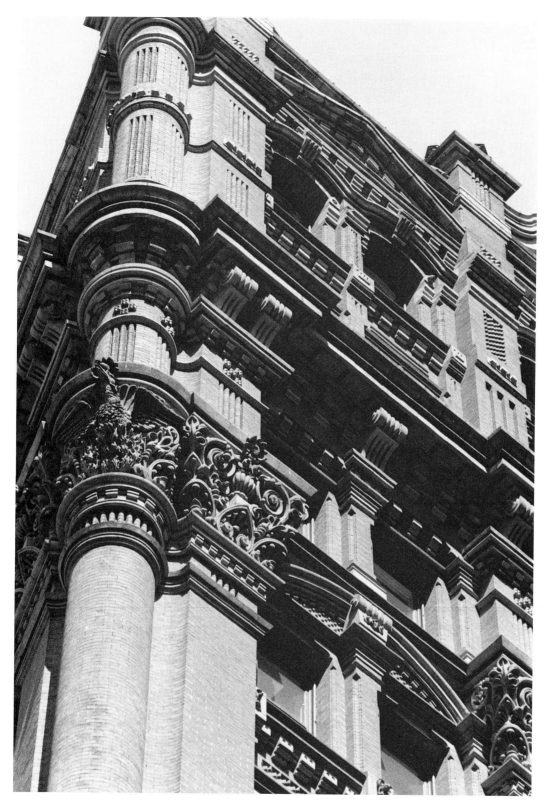

140 **Capital and cornice detail of the Potter Building (Boston)**

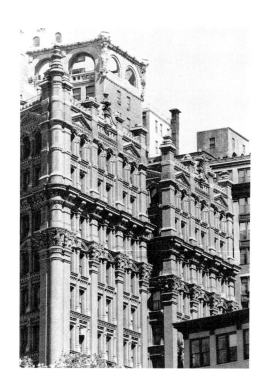

141 **Potter Building, Park Row, New York, by N. G. Starkweather, 1883–4 (Boston)**

and Sons that Bartlett should undertake the modelling, partnered by his associate Olin D. Warner who practised in New York. Both artists had to spend several months at Perth Amboy, assisted by a modeller newly employed at the works, John Noble Pierson. The boldness of their sculptural decoration derived in part from the clay's being worked directly rather than being pressed by moulds taken from models. ✶

The association of terracotta with strident and narrative ornament was reinforced by some of Post's subsequent designs in New York. Essentially a traditionalist in terms of style, he continued to draw on the Renaissance far more directly than did his contemporaries in Chicago. The nine-storey Mills Building, built 1881–5, the largest office block of its date in New York, was given rectangular spandrels of terracotta between the upper floors. ✶ The New York Produce Exchange, also commenced in 1881, was of a 'stupendous scale' incorporating 2,000 tons of terracotta (**139**). More a palazzo than a tower block in its proportions, the Produce Exchange was given an almost complete metal frame to satisfy the need for a vast trading-room and for resistance to fire. The four façades, all of which faced thoroughfares, created the opportunity for a highly economical use of terracotta. Some variety in the long arcades of identical windows was introduced by means of sculpture on nationalistic and carnivorous themes. The spandrels of the four-storey-high arcades portrayed the emblems of the American states, Domingo Mora being paid $100 for each seal. Pierson, the modeller employed at Perth Amboy, undertook the surrounding vegeta-

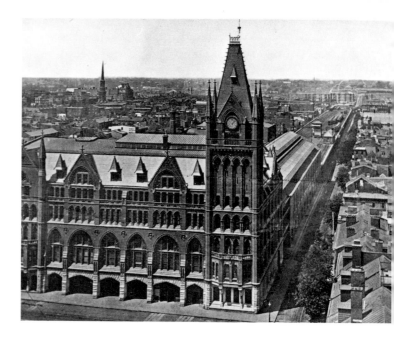

142 Pennsylvania Railroad Station, Broad Street, Philadelphia, by Wilson and Company, 1880–5 (Perth Amboy)

tion and the spandrels of the upper arcades. A notable sculptor, Edward Kerneys, was commissioned to model the buffalo and the animals representing beef, mutton and pork that were repeated across the building.

The Produce Exchange incorporated so much terracotta that the Perth Amboy Terra Cotta Company had to double its capacity. Some change or conflict had led to the resignation of Robert Taylor just when the firm gained this massive order. Into the latter's shoes stepped Joseph Joiner, nephew of John Blashfield. Joiner had worked in his uncle's works at Stamford, and alongside James Taylor, from 1864 to 1870. He had been closely involved in the contract for Dulwich College as a quantity clerk and assistant draughtsman.☆

A property developer, Orlando B. Potter, was instrumental in the establishment of terracotta manufacture in New York. He became committed to fireproof construction in the early 1880s after one of his buildings had been gutted by fire.☆ In 1883–4 he erected two large buildings of brick, with terracotta dressings supplied by the Boston Terra Cotta Company. The design of the Potter Building on Park Row, by N. G. Starkweather, incorporated massive Renaissance forms that almost engulfed the areas of brickwork, while ceramics were also used to protect the structural stone and ironwork (**140**, **141**). The cost of freighting 500 tons of terracotta from Boston for this structure convinced Potter of the need for a works within New York. Taylor claimed that it was the property developer who decided to finance the establishment of a local factory and who then 'induced' him to superintend the New York Architectural Terra Cotta Company, which was incorporated in 1886.

Potter was fully aware of the combination of high technical prowess and

plate 22 **Window-detail of the Hotel Victoria, Dartmouth Street, Boston, by J. L. Faxon, 1886**

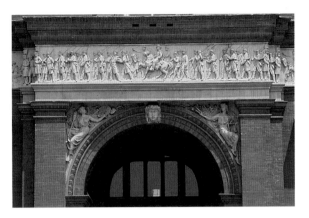

plate 23 **Entrance to the Pension Building, Washington DC, by M. Meigs, 1882–5, showing frieze and spandrel panels (Boston)**

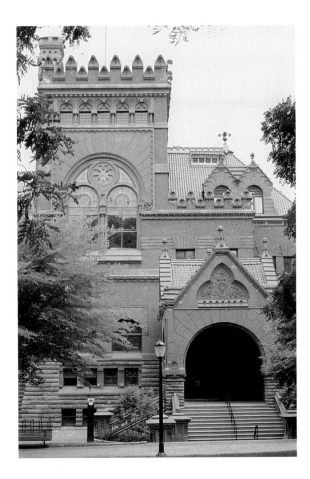

plate 24 **Furness Building, 34th and Walnut Streets, Philadelphia, by F. Furness, 1888–90**

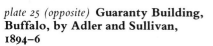
plate 26 **National Farmers' Bank,
Owatonna, Minnesota, by
L. Sullivan, 1906–8**

plate 25 (opposite) **Guaranty Building,
Buffalo, by Adler and Sullivan,
1894–6**

plate 27 **Spandrel panels, Farmers' and
Merchants' Union Bank, Columbus,
Wisconsin, by L. Sullivan, 1919–20**

plate 28 **Sculpture in pediment of north wing, Philadelphia Museum of Art, Benjamin Franklin Parkway, Philadelphia, by H. Trumbauer, C. C. Zantzinger and C. Borie, junior, 1916–28**

plate 29 **Arctic Club, 306 Cherry Street, Seattle, by W. Gould, 1914**

plate 30 **W. C. Reebie Warehouse, 2325 North Clark Street, Chicago, modelled by Fritz Albert, 1923 (Northwestern)**

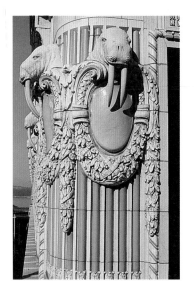

commercial weakness that characterized Blashfield's protégés. Taylor was given the task of designing and managing the new plant on the layout that he had adopted at Boston, with several muffle kilns being incorporated into one multi-storey fireproof building. The control of the model- and mould-making section was entrusted to George Westlake, who had come to America from Stamford to oversee the fixing of Blashfield's terracotta on the Boston Museum of Fine Arts. A Yankee businessman with no previous experience in clayworking was appointed president of the new company. Walter Geer had previously sold mowing- and reaping-machines in Chicago. He brought a new commercial acumen to advertising and selling the wares of the New York Terra Cotta Company during a directorship that lasted until just after the First World War.

COLLABORATION AND CHAOS

By 1890 several east-coast firms could publish long lists of contracts undertaken in New York, Philadelphia and Baltimore. One factor promoting the exploitation of new clay reserves was a growing preference for red terracotta, in part inspired by the example of George Post's designs in New York and Brooklyn. *

Philadelphia was sufficiently close to New Jersey for finished blocks of raw materials to be freighted into the city without prohibitive expense. The station for the Pennsylvania Railroad in Broad Street initiated the widespread use of terracotta in the city (142). Its architects, Messrs Wilson and Company, were attracted towards the material by the example of Post's Long Island Historical Society, and sufficiently impressed to follow his choice of manufacturer and colour. The order for the red terracotta on the terminus building was given to the Perth Amboy Terra Cotta Company in December 1880.

The design of the station is the nearest parallel in America to the contemporary use of terracotta in Britain by Alfred Waterhouse. Drawing on the Gothic of northern Germany, the terminus building was faced with red brick and terracotta above a granite ground floor. The main elevation was divided into a grid of pointed windows of differing sizes and with mouldings and decorative detail of graduated richness. The individual blocks were of a smaller size than those found in most contemporary American uses of terracotta. The only sculptural decoration was a series of small roundels containing 'finely modelled heads typical of the races of humanity'. * When the station was extended in 1895 the additional terracotta was made in Philadelphia by the Conkling–Armstrong Company, a descendant of the first large-scale manufacturer in the city, Stephens, Armstrong and Conkling.

Washington DC never gained its own terracotta industry, and in consequence the adoption of the material in the city was relatively late and modest in extent. One public building in Washington presents a grand finale to the formative years of American terracotta. The design and construction of the Pension Building highlights the inconsistency of early efforts at fireproofing and the well-intentioned but rather naïve efforts of architects, decorative artists and manufacturers to collaborate in creating narrative sculpture (*colour plate 23*).

The Pension Building was built between 1882 and 1885 for the bureau that dispensed payments to war veterans and widows. Its designer, General Montgomery Meigs, drew upon his long experience as an engineer in realizing his conception of the ideal office building. Anxious to reduce the risk of fire, he decided to employ the currently fashionable combination of red brick and red terracotta. In places his commitment to fireproofing was rather cursory: the cornice incorporated a highly flammable trough of wood, on to which Meigs attempted unsuccessfully to attach a series of lion masks made in terracotta. ✶

The lower, terracotta section of the cornice was decorated with cannon and exploding shot. The main area of illustrative decoration was above the ground floor, in a frieze almost a quarter of a mile long that completely circumscribed the building. Infantry, cavalry, supply wagons and sailors march or row across a repeated series of panels modelled in high relief in buff terracotta. Few schemes of narrative terracotta sculpture can match this frieze in complexity, intricacy of detailing, and the effort expended by Meigs and the sculptor responsible, Caspar Buberl.

The design of the frieze permitted the repetition of a restricted number of panels, with ingenious alterations being made to the pressings to increase the variety. The navy was represented by seven men rowing a boat. This subject was repeated seven times but some slabs were also given a lighthouse or clumps of reeds while others were left with a plain background. Buberl developed his designs with pedestrian thoroughness. He took the trouble to sketch an appropriate boat in the Hudson River, but his first model had the oarsmen facing the bow rather than the stern. The driver of the baggage wagon proved to be an intractable problem: Buberl worked from photographs supplied by Meigs and eventually decided to dress the figure in 'an overcoat and perhaps a soft hat for to make him somewhat picturesk and fit for Uncle Sam's service'. ✶

Buberl dithered over the detailed form and arrangement of the frieze, to the frustration of James Taylor, who was supervising its manufacture at the Boston Terra Cotta Company. Taylor, for his part, added further difficulties by losing a batch of models in a fire at the Boston works. To ease some of the problems of manufacture he tried to dissuade the sculptor from creating the figures in such high relief, an initiative rejected by Meigs: 'Mr

Taylor is not the Architect, not the Director of the sculpture. He has no authority to give you [Buberl] directions in regard to the frieze.'*

The frieze was complemented by allegorical sculpture over the four main entrances. Figures representing Justice, Truth, Mars and Minerva filled the spandrels above the arched entrances. These draped classical figures were supplied by Alfred Hall and Sons who undercut the price quoted from Boston.*

THE WANING OF ENGLISH INFLUENCE

The early stages of the American terracotta revival had been characterized by a remarkable degree of interaction between Chicago and New York, necessitated by the paucity of skills and manufacturing plant. The most remarkable evidence of these links is that the first red terracotta to be used in New York was made in Chicago from Ohio clays while the first important building of red terracotta in Chicago was made in Perth Amboy from New Jersey clays.* By the middle of the 1880s the industry was sufficiently well developed for such long-distance freighting to be unnecessary. Increasingly, the major architectural practices in the two cities sought to develop and maintain a collaboration with one or more local manufacturers.

While this period saw marked changes in the geography of the terracotta industry, the manufacturing technology absorbed from Blashfield's Stamford works was to be adhered to by most firms for at least another decade. The typical use of complex mixtures of clays, of high-relief modelling and of muffle kilns followed from James Taylor's involvement in setting up factories in Chicago, Boston, Perth Amboy and New York, and from the responsibilities given to his brother and nephew, and workers such as George Eastlake. It was only in the 1890s that the Americans started to react against this remarkable transfer of English technology, enthusiasm and commercial immaturity. In 1893 a newly established works in Boston was credited with being entirely 'a Yankee enterprise'. 'No Englishman "who knows it all" has had anything to do with it.'*

Joiner and Taylor died within a year of each other, in the last two years of the nineteenth century. Walter Geer, who employed James Taylor as the first superintendent of the New York Architectural Terra Cotta Company, regarded him as 'a man of great energy, of much practical ability, full of confidence in himself and his work, and a most persuasive talker'. He appreciated that James Taylor had been more interested in the challenge of working clay than in securing consistent profits and that he had failed to adapt to a changing commercial and architectural climate. However, the 'In Memoriam' to Taylor simply and rightly described him as 'the Father of Terracotta in America'.*

AMERICA'S GILDED AGE
An Era of Clay and Steel

Speaking in Chicago in 1894, William Le Baron Jenney, architect and engineer, announced that 'we are entering upon a new building era – an era of clay and steel . . . an age of science'.✶ Over the previous two decades terracotta had gained a pivotal role in the development of metal-skeleton construction, seen to most dramatic effect in the skyscrapers of America's rapidly growing cities. Chicago may have been the focus of development of the ceramic-clad skyscraper, but this new building type also transformed downtown areas from Boston to Seattle; and there were coteries of potters, architects and engineers moving between major cities, transferring technologies and ideas from the east coast to the Mid and Far West and back again.

BOOSTERS AND PROGRESSIVES

Many writers expressed awe at the spectacle of the American city and its bustling crowds. Chicago was described as 'this Florence of the West . . . this rude, raw Titan'.✶ During the 'Gilded Age' of the late nineteenth century, enthusiasm for building larger and more impressive cities was rarely undermined by intellectual doubts over the cultural and moral worth of urbanism and economic progress. Most American patrons and architects were too engrossed in the drama and frenetic pace of urban growth to become diverted into any romantic longing for the wide open spaces of the frontier or for the puritanical community spirit of the early settlers.

Boosters – political and commercial figure-heads armed with an unyielding optimism about the future, especially in relation to their own town or city – promoted architecture that was dramatically assertive and rapidly erected. They viewed fires, smog, riots and lack of sewerage provision not as an indictment of their civilization but as a challenge demanding action from themselves. Rapid rises in rental value introduced a further sense of urgency into urban development. The blunt dynamism and the frustration with drawn-out traditional building techniques that prevailed, especially in Chicago, was encapsulated by Jenney:

> When a Chicago capitalist or a Chicago syndicate decide to erect a big skyscraper, they do not brag about it for months . . . Chicago is always short on time. We cannot afford to put a lot of stone-cutters at work pecking away at big blocks of granite, and spending two or three years in the erection of a building . . . We must have materials that can be manufactured by machinery; great quantities in a very short time. Clay and steel adapt themselves most admirably to these requirements.✶

Comparable attitudes predominated during building booms in other cities and through the explosive growth of the 'instant cities' of San Francisco, Seattle and Los Angeles. Swashbuckling property speculation and worsening pollution in industrial centres such as Pittsburgh prompted a broader concern over the state of cities, channelled in the new century through the Progressive movement. The Progressives, embracing both Democrats and Republicans, never doubted the virtues of free-enterprise capitalism, but sought to create a social democracy upholding traditional values. They developed and backed civic improvement schemes, and the provision of schools and other public facilities which were often given ornamental and washable façades of white-glazed terracotta. The architectural critic Herbert Croly pronounced the aesthetic creed of Progressivism to be the elevation of 'propriety' above rampant individualism and shoddy popular taste. *

PROTECTING AND CLADDING THE SKYSCRAPER

The Americans were appalled by the waste represented by the conflagrations in Chicago, Baltimore and San Francisco, yet they were also spurred to creative action by the spectacle of burnt-out tower blocks. Fireproofing became a long-running saga akin to British concern over pollution and sanitation. The use of terracotta was presented as the perfect solution, but hideous losses even of supposedly fireproof buildings continued into the twentieth century.

Terracotta was ardently promoted as the ideal fireproofing material by a group of engineers and architects, especially William Le Baron Jenney, George and Ernest Johnson and Peter B. Wight. They differed in the precise type of clayware that they championed, but shared a disillusionment with dense traditional terracotta as a cladding for structural iron and steelwork. Not only was it too heavy and expensive, but it could crack and disintegrate under severe heat and pressure. Hollow blocks with two or more interior air-spaces could have their outer webs destroyed by the combined effect of heat and subsequent cooling by fire-hoses.

The solution was porous terracotta. Some advocated a semi-porous body: fireclay pressed with 20 per cent ground coal which burnt out in the kiln, creating blocks that could be heated to high temperatures without cracking. An even lighter and more porous body could be created by mixing sawdust with the clay in the ratio of six parts to four. The main doubt over this sponge-like material was that it absorbed more moisture when used for floors and ceilings.

The use of porous terracotta played a crucial role in the advancement of skyscraper design, partly prompted by a Chicago building regulation introduced in 1886 which insisted that new tower blocks should be fully

fireproof. The material's lighter weight was also a major advantage in Chicago, where foundations had to be floated on an unstable muddy sub-soil. Hollow-tile floors weighed only a quarter as much as those constructed with arches of solid brick, just as facing-terracotta weighed half as much as stone ashlar. Once the electric elevator had proved its worth, the main limit on the height of Chicago's buildings was the carrying capacity of the underlying clay geology, and hence the weight of the proposed structure. Possibly the most fundamental implication of steel and terracotta construction was that, being three times lighter than traditional brick or stone, it permitted office blocks to be three times as high without sinking into the muddy shore of Lake Michigan.✫ Once the technology was proven, the same combination of steel framing and terracotta fireproofing was applied in other cities and for other building types as spiralling land prices justified taller buildings and as fires, especially those in Boston, Buffalo and Baltimore, reinforced the lessons painfully learnt in Chicago.

Best practice in fireproofing involved the creation of an impregnable armour against flames and heat. Column casings had to be able to withstand high temperatures for some hours and to be of low heat conductivity. Thermal insulation was best achieved through the provision of voids; by the late 1890s, Chicago building law insisted that there should be two air-spaces around all columns. Both the Pioneer Fireproof Construction Company and the Illinois Terra Cotta Lumber Company offered a system with a ring of segments of hollow porous terracotta designed to wrap round an iron or steel column.✫ W. L. B. Jenney, revered as a structural engineer of high principle, recommended a double cladding of hollow tile to ensure adequate protection.✫

143 Advertisement for end-construction arches, Pioneer Fire-Proof Construction Company, *c.*1893

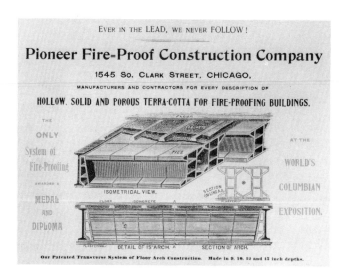

side

end

While relative unanimity was achieved as regards column protection, debate concerning fireproof floors became increasingly vociferous. Large commercial buildings were built with a grid made up of parallel girders crossed by smaller beams which supported the actual floors. A vast number of patent systems were introduced to protect girders and I-beams, early examples using brick-arch floors, until specially shaped fireclay blocks, such as those patented by Wight in 1883, were introduced to encase the beams. *

Fireproof flooring systems dating to the eighties had blocks arranged with their channels running parallel to the I-beams, a layout termed side-construction. The alternative end-construction system had cells running at right angles to the beams, arch pressure being against the end of the blocks, rather than against the sides, thus providing about 50 per cent more strength (**143**, fig. 9.1). This disposition of interior air-spaces permitted tie-rods to be fixed without cutting any of the blocks. * Thomas A. Lee first used the end-pressure system successfully, following tests in 1890, on the Government Building in Denver.

Tile and terracotta fireproofing was also used for party walls and exposed rear elevations, to avoid catastrophic loss if fire broke out in an adjoining property. Around the turn of the century more highly finished blocks were introduced, to line, without any facing, the interiors of railroad stations or public buildings. *

fig. 9.2 Terracotta arch used in Montauk Building, Chicago, 1881

The use of fireproofing for high-rise construction burgeoned in Chicago during the 1880s. Wight supplied Burnham and Root's Montauk block (1881–2), arguably the first 'skyscraper' and certainly the first to be completely fireproofed. The floors were built with 6-inch flat hollow-tile arches between I-beams, and the partitions with 3½-inch hollow tiles (fig. 9.2). The columns and girders were protected by solid blocks of porous terracotta. The effectiveness of this first fully comprehensive exercise in fire-

proofing was to be tested only a year after the completion of the building. In December 1883 a severe fire occurred in an adjoining paper warehouse. Wind drew the flames against the Montauk block above the fourth storey. The furniture and inside woodwork of one room was burnt out, but the fire did not spread beyond this apartment, where only the plaster was damaged. ✶

Wight introduced soffit tiles to protect the underside of joists for the first time on the Mutual Life Assurance Building, New York, by C. W. Clinton (1883–4). This system was itself proven in 1884 on the first skyscraper of fully framed or skeleton construction, the Home Insurance Building in Chicago by William Le Baron Jenney. A wooden shed on the ground floor containing a hoisting engine was destroyed by fire while the building was being fitted out. The ceiling above, of 9-inch flat hollow-tile arches, made by Wight, caught the full heat of the blaze. The bottoms of a few of the tiles fell off, probably when water was applied, but all the upper air-spaces survived intact. ✶

A questionnaire, albeit a biased one, undertaken by the *Brick-Builder*, confirmed that the major Chicago architects had adopted porous or semi-porous terracotta by the end of the century. Sullivan lauded ceramic fire-proofing for aiding rapid construction. Daniel Burnham was particularly emphatic in declaring his use of burnt clay for walls, both outside and inside, and for partitions; he also appreciated the value of arched floors as a form of bracing to a steel frame. The east-coast architects contacted by the *Brick-Builder* were rather more cautious about fireproofed steel construction; George B. Post used porous terracotta on all his large buildings but was clearly wary of skeleton construction; he feared that in a major fire the frame would be so affected by unequal expansion as to render demolition necessary. Francis Kimball, also based in New York, used porous terracotta but was not entirely at ease with arched construction, claiming that the filling over the arches, composed of a low grade of concrete, was apt to settle and cause cracks in the terracotta. Their concerns and conservatism were reflected in a New York building law demanding that even non-bearing walls had to be of great thickness in the case of a tall building, diluting one of the major advantages of skeleton construction over the cage principle whereby an internal iron or steel frame was tied to self-sustaining outer walls. ✶

Best practice in fireproofing was not universally advanced or even main-tained in the 1890s. Once his own company had gone out of business, Wight became a staunch though rather crabby publicist for ceramic fire-proofing. As editor of the magazine *Fireproof*, he reported the loss of any burnt-out concrete buildings in every ghoulish detail. He also railed against any betrayal of the 'fireproof' principle, exposing instances of fireproof ceilings being broken or tampered with, or the illicit use of timber. Sullivan

criticized the quality of hollow tile made in the East as being rough and uneven.* His engineer partner Dankmar Adler complained that many buildings in New York were twenty years out of date in their fireproofing, hollow-tile arches being used but pillars, girders and beams being left exposed.* The poorer standards of fireproofing in New York may be reflected in a section of the city's building code which imposed an excessive depth of blocks in relation to the span, and hence additional expense.*

By the early years of the new century Chicago's architectural practices, such as Holabird and Roche, had standardized the use of porous terracotta with end-pressure floors composed of flat hollow-tile arches; the same approach, though sometimes with denser, semi-porous flooring, was used by D. H. Burnham and Company.* In Baltimore, San Francisco and other cities less progressive in their adoption of fireproofing, major fires acted as the spur for a tightening of building codes, while creating a massive demand for new fireproof buildings.

Confidence in terracotta fireproofing was shattered by the fire that followed the San Francisco earthquake of 18 April 1906. Virtually all the buildings in the downtown area were gutted. Observers studied the burnt-out shells of many terracotta-clad 'fireproof' buildings standing amidst piles of stone rubble, including the completely ruined City Hall (5). On first inspection it seemed as though many could be quickly refurbished. Detailed surveys came as a rude awakening; the carcasses were in practice almost worthless. Brick walls and terracotta trim had to be completely replaced. The report of the National Fire Protection Association recorded: 'of the terracotta fronts, most were destroyed . . . many fronts, apparently in good order must be removed. In the Mills Building [by Burnham and Root] there was hardly a window opening in which the terracotta sills, jambs and heads were not badly cracked. From the street they had the appearance of being in good order.' Damage resulted from a combination of flame action, shattering due to sudden changes in temperature, and expansion of steel members. Highly ornamental terracotta proved most vulnerable.*

The reputation of concrete advanced as terracotta proved less than exemplary in fiery practice. Several systems had been introduced during the 1890s, though their use was restricted by their relative weight and by the fact that concrete could not be set during periods of hard frost. Adler had turned to an arrangement of concrete arches with a suspended ceiling of burnt tile for the Wainwright Building, St Louis (1890–1).* By 1910 concrete had become more widely used, both to protect steelwork and as a form of construction in its own right. Terracotta was losing its status as the only material capable of resisting the ravages of fire; and during these same years more sophisticated central heating systems, the provision of sprinklers and the clearance of timber buildings served to reduce the hazard in downtown areas and weaken interest in the whole issue of fireproofing.

ROMANESQUE VIGOUR IN CHICAGO

The rise of the steel-framed and terracotta-clad skyscraper was acclaimed by contemporary commentators as much as it has since been by architectural historians, but for the most part in different terms. Historical studies have tended to downplay, if not ignore, the strongly ornamental image given to the tall office block well into the inter-war period. Rather than rejecting ornament as countering the logic of modernism, the majority of architects, clients and the press saw innovative decoration as an appropriate means of transforming a blunt cubic form into a monument to commercial prosperity. The Romanesque round-arched style, closely related to the more Italianate *Rundbogenstil*, had already evolved into a tougher and more abstract formula, hailed by many as America's first own national style. Richardson's application of the Romanesque to commercial blocks offered a key example. His Marshall Field Wholesale Store of 1885–7 demonstrated how this strand of eclecticism could be developed 'out of its condition of mere archaeological correctness into one elastic to all the new and strange conditions of structure, material and occupation', in what the most authoritative contemporary text on Chicago's architecture described as the 'great Americo-Romanesque experiment'. ✫

While not denying the value of ornament for its own sake, architects and modellers saw the extensive repetition of forms across a façade as a logical expression for large skyscrapers or warehouses. Metal framing, rectangular lots and gridiron street plans all promoted regularity, symmetry and repetitively moulded detail. Root believed, in the words of his contemporary biographer, that 'the art which is to vitalise this age must not be at war with science and commercialism; it must sympathise with them'. Terracotta could 'express exuberantly our young, crude, buoyant civilisation, and strike our note in the world's art'. ✫

The most progressive exponents of terracotta came to combine the repetition of near-abstract forms with outbursts of lush ornamentation on such features as doorways, quoins and cornices. Most had been trained to conventionalize acanthus, thistle and other plant forms in the manner approved by Ruskin. Possibly inspired by the writings of Owen Jones, they took the process of abstraction further, creating bold swirl and whiplash shapes and drawing upon patterns associated with Celtic or Saracenic ornament. Modellers, from New York and Perth Amboy to Chicago and Gladding McBean in California, all became adept in the Americo-Romanesque style; company catalogues and surviving sketches frequently illustrated panels of spiralling, stylized vegetation. James Taylor may have been an agent in spreading this characteristic style from one works to

another; his skills as a modeller can be noted in the panel he worked for the offices of the New York Architectural Terra Cotta Company in 1892.

The other distinctive feature of Americo-Romanesque terracotta was the deep purplish colour adopted in varying hues by Burnham and Root, Furness and Sullivan alike. Manufacturers frequently used slips to coat their coarse buff clay bodies, achieving a colour and texture akin to uncooked liver.

During the highly creative period of 1880–95, terracotta gained dramatically increased use in Chicago in terms of the number of buildings, their scale and, with several architects, the richness of ornamentation. The Chicago skyscraper did not evolve in isolation, designers often furthering their use of ceramics in other cities and on other building types. Jenney made his first significant use of terracotta on the Natural History Museum of 1869 at Ann Arbor. Having arrived in Chicago in 1872 John Wellborn Root developed his approach of framing plain walls with mouldings in a series of domestic commissions, a landmark being the house built for Sidney Kent in 1882–3, with its flat surfaces of brick divided by string courses and ornamental panels of matching terracotta.✶ One of the most influential examples of terracotta in Chicago was neither a skyscraper nor designed by a midwesterner. Dearborn Street Station by Cyrus L. Eidlitz of New York was built in 1885 with a full red terracotta made by the Perth Amboy Terra Cotta Company of New Jersey. The extensive repetition, the weighty, rounded forms, the tendril-like detailing and the tooling of the ceramic ashlar display many analogies with Root's evolving amour with terracotta (**144**).

The Grannis Block of 1880 heralded Burnham and Root's use of red brick and terracotta in downtown Chicago. As Burnham noted: 'It was a wonder. Everybody went to see it.'✶ Wellborn Root, as the creative artist in the partnership with Daniel Burnham, sought to break away from strict historicism, providing an architecture both immediately impressive to the client and capable of striking 'our note at last in the world's art'.✶ Their Montauk Building (1881–2) initiated the association between the use of terracotta for internal fireproofing and its deployment as exterior ornament, with simple bands of decoration dividing up the ten storeys and providing some relief of the warehouse-like austerity demanded by the puritanical client, Peter Brooks. The Montauk Building reputedly had a great influence extending to other cities, but it was a more florid approach to terracotta that came to dominate during the mid-eighties.

Burnham and Root's handling of terracotta evolved from the ornamental spandrels of the Calumet Building (1882–4) and the foliation and tourelles on the Insurance Exchange Building (1884–5) to the startling combination of smooth brick and eclectic decoration on the Rookery dating to 1885–8. The purple brick and terracotta, matching in colour and shiny texture, were

144 Tower of Dearborn Street Station,
Chicago, by C. L. Eidlitz, 1885 (Perth Amboy)

145 Rookery Building, 209 South La Salle
Street, Chicago, by Burnham and Root, 1885–8
(Northwestern)

146 Detail of the top storey of Rookery
Building (Northwestern)

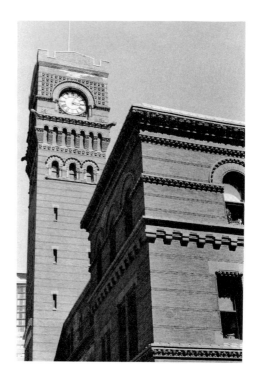

linked by 'clasps', a motif apparent on earlier buildings in Boston and
New York. Low-relief fields of decoration represented pier capitals but the
modelling became deeper and bolder towards the crown of the building,
with tourelles moulded in the form of beehives (**145**, **146**). Elements have
been abstracted from Moorish, Islamic, Venetian and Romanesque styles
to betoken the rugged and yet culturally alert sensibility of midwestern
business. The Rookery has remarkable analogies with the directly contem-
porary Victoria Law Courts in Birmingham in its colour and in its exploi-
tation of the qualities of terracotta to carve a path from revivalism to
originality (**2**).

Burnham and Root worked with the Northwestern Terra Cotta Com-
pany, who held a virtual monopoly over the market for ceramic skyscrapers
in Chicago, to advance the use of terracotta along lines paralleling develop-
ments in Britain. The Rand McNally Building of 1888–90, the first com-
pletely steel-framed skyscraper, was faced with terracotta to the exclusion
of brick; both the mouldings and the swirling foliation above the main
doorways grew out of the smooth wall-surface in sweeping curves. The
structural role of the steel frame was reflected in the way that the terracotta
was no more than a thin sheath, clinging 'round the column and the beam
as the flesh covers the body'. ✫ The Rand McNally was to be the finale to
Root's efforts to interpret the purpose and poetic qualities of business struc-
tures through terracotta; his highly productive career was terminated by
pneumonia in 1891.

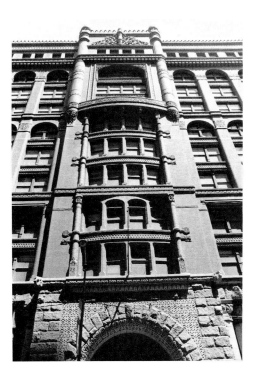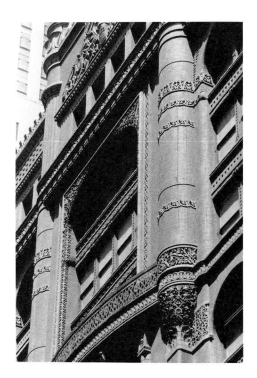

The logic of viewing terracotta as a skin to structural steelwork had been followed more soberly and rigorously by Jenney. Engineer more than artist, Jenney believed that ornament should be used in moderation and must be strictly appropriate to the building and the client. He believed that terracotta firms represented a potential threat to the autonomy of the designer through the temptation to delegate to draughtsmen and modellers who were more than willing to develop 'the roughly expressed ideas of the architect', with the result that he 'is relieved of all study and designing work, if he will but indicate his intention to use terracotta or brick from any one manufacturer'.✩ Jenney introduced decorative spandrels to break the monotony of floors stacked one above the other on the Home Insurance Building (1883– 5) and the Manhattan Building (1889–91). On the Manhattan, the impact of such ornament was diluted by the dominance of the bay and bow windows, and the adoption of a less assertive buff colour.

Holabird and Roche presented the most clear-headed use, though a dry one, of terracotta in skyscraper design. Large, broad windows reduced wall-surfaces to slim moulded courses and cornices. For their Tacoma Building, completed in 1889, brick and porous terracotta provided an intimate protection to the iron frame, while narrow bands of Romanesque ornament and an acanthus-pattern cornice articulated the two street elevations without detracting from the verticality established by the stacks of bay windows.✩ A comparable use of sharply modelled ornament in match-

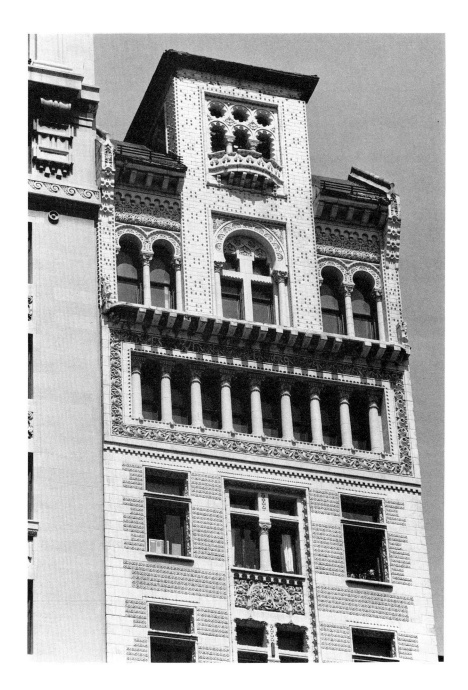

ing purple brick and terracotta is apparent on the Pontiac Building (1891). The rusticated piers and Renaissance detailing set in panels below the cornice of the Marquette Building (1893–4) betray a measured shift towards a more classical expression while the Old Colony Building of the same years has only the most meagre decoration in a quiet, pale colour, to match the surrounding Roman brick and the limestone of the ground and first floors.

NEW YORK, SEATTLE AND SAN FRANCISCO

New York lacked the hothouse atmosphere of its major urban rival, Chicago, in the adoption of terracotta – less rigour being shown in the application of ceramic fireproofing to iron and steel-framed buildings. The proliferation of terracotta, extending the length of Manhattan and to Brooklyn and other heavily built-up areas, and the diversity of its use was arguably more central to the mainstream development of terracotta across America into the twentieth century: period styles and, from the nineties, cream and white colours, were to typify terracotta architecture up to the years both before and after the First World War.

George Post's commitment to the arcaded and tripartite elevation, with string courses defining lower, middle and upper sections, was adopted by many other New York architects, often with highly distinctive results. The warehouse district of Manhattan acquired a series of monolithic blocks with broad areas of plain brick wall divided by mouldings and other terracotta trim. Babb and Cook's quattrocento style, apparent in 173 Duane Street (1879–80), evolved into a sparer idiom with their De Vinne Building (1885–6), terracotta being set with the greatest restraint into the almost flat façade for roundels, narrow quoins and thin courses set with conventionalized Renaissance motifs. ✰

Other architects, working on less austere building types, pursued more florid approaches to decorative ceramics. C. L. W. Eidlitz, already noted for his Dearborn Street Station in Chicago, devised inventive detailing on his drawing-board and then generated added textural interest by instructing finishers to apply random saw-cuts or other patterns across the pressed but unburnt blocks. Eidlitz's later commissions in his home city were characterized by a colonnaded attic relieved by capitals and spandrels that bore dense foliation set against a tooled background. ✰ H. J. Hardenburgh, Francis Kimball and William Schickel opted for more rugged and individualistic uses of terracotta. R. H. Robertson, who had spent part of his early career with Post, worked a weighty Richardsonian Romanesque, blocks of undressed stone being offset by curvaceous terracotta detail which can be seen to best effect on the corner tower of his Macintyre Building on Broadway (1892). This part of Manhattan, focusing on Union Square, also retains the most original example of Alfred Zucker's use of ceramics. His Union Building (1893) has an impact well beyond its three-bay width, the wall-surface being broken up by fields of specially patterned brick, a colonnade, and Moorish arches and balconies (**147**). Such exoticism reflects the input

148 Savannah Cotton Exchange,
Savannah, Georgia, by W. Preston,
1886

149 Pioneer Building, 606 First
Avenue, Seattle, by E. Fisher,
1889–92

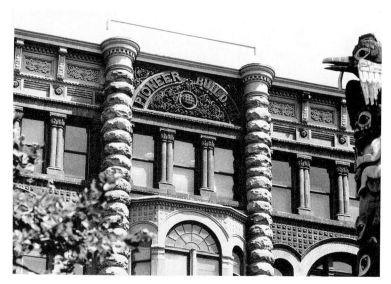

of John Edelmann, who had worked with Sullivan in Chicago before moving to New York and employment in Zucker's office. The east-coast approach to terracotta also emerged in some southern cities. Savannah's Cotton Exchange was designed by the Bostonian architect, William Preston, in his own somewhat hybrid version of the Queen Anne style (**148**).

The rapid growth of the west-coast 'instant cities' occurred through the replication on the other side of the Rockies of many strands of eastern and midwestern technological and stylistic development; terracotta was adopted as a means of gaining up-to-date ornamentation and circumventing the shortage of well-trained stonemasons. A major fire in June 1889 prompted a spate of building in Seattle, several commercial blocks being designed in a rough-and-ready Romanesque by Elmer Fisher. His Pioneer Building of 1889–92 is a somewhat lumpy variation on themes defined by the Rookery in Chicago, its terracotta panels having both prickly acanthus and Celtic motifs (**149**). Elmer Fisher experimented in several styles; a Gothic emerged in the Austin A. Bell Building of 1889.

Gladding McBean found a ready market for Romanesque terracotta detailing in San Francisco, their draughtsmen readily producing sketch designs with foliate capitals and corbels (**150**). Burnham and Root gave California a lesson in the sophisticated use of terracotta when they collaborated with Gladding McBean to execute the Mills Building in San Francisco

150 Elevation for Washington Territory
Investment Company Building, Seattle, by
C. M. Saunders and E. W. Stoughton
(Gladding McBean), 1889

151 Mills Building, 220 Montgomery Street,
San Francisco, by Burnham and Root, 1892

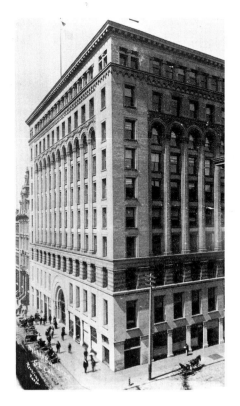

during 1892. Their design effectively combined naturalistic and abstract
motifs in a highly formal composition of the kind that was soon to prevail
up and down the Pacific coast. A base of marble and a rusticated intermedi-
ate storey were surmounted by a tall arcade rising through six storeys, its
spandrels having sharply modelled vegetation (**151**).

SULLIVAN AND ORGANIC ORNAMENTATION

Louis Sullivan brought the American adoption of terracotta to its zenith.
Though he has been cast as the architect who pioneered a rationalist
expression for the skyscraper and offered a foretaste of functional modern-
ism, an objective viewing of his mature work and a perusal of his tortuous
writings show ornamentation to be central to his philosophy, and terracotta
to be the material in which he sought to realize his vision of an organic
architecture. Sullivan's late skyscrapers and his series of midwestern banks
took the decorative potential of ceramics to an innovative extreme, but
they represent a logical evolution from efforts by his contemporaries to
develop an appropriate identity for the forceful commercial and democratic
spirit of the Midwest.

The salient feature of Sullivan's approach to ornament – the conjuring
of decorative forms from botanical example – emerged during his first
architectural post, held with Frank Furness for a few months in 1873. Fur-

ness was a talented ornamentalist who made free and idiosyncratic use of ideas drawn from Richardson and from American and British gurus of design reform. He proved to be a forceful advocate of the design principles of Owen Jones, inviting Walter Smith to Philadelphia and collaborating in the foundation of the city's Museum and School of Industrial Art. Furness applied the principles of stylized motifs and of fields of decoration to terracotta in the late eighties. His university library, now named the Furness Building (1888–90), is one of the most wilfully eccentric examples of ceramic architecture ever created (*colour plate 24*). *Rundbogenstil* and Gothic elements are not so much integrated as juxtaposed within an assertively asymmetrical composition. Every element from the arch voussoirs to the ridge-copings and crenellations was exaggerated in scale. Every projection and curve was emphasized by the monochrome of muddy red brick, terracotta and roof-tile that makes the stocky round arches and details appear almost wet, as if just moulded and carved rather than dried, burnt and exposed to a century of polluted air. ✶

Back in Chicago, Sullivan was to reinterpret the Victorian principle, propounded by John Ruskin, Henry Cole and Walter Smith, that designers needed to help society rebuild ties with nature, and that natural forms represented a universally appropriate language of ornament. While working in the practice of William Le Baron Jenney, Sullivan had the chance to nurture these ideas through discussions with John Edelmann, and ponder their application to the hard logic of commercial real estate and high-rise construction.

A juxtaposition rather than a synthesis first emerges around 1880. Furness's commitment to stylized ornament, bold architectural forms and vibrant colours re-emerged in Sullivan's use of buds and rosettes and of scrolling, scalloped and radiating leaves in panels, doorways and cornices to ornament otherwise bland elevations. The Borden Block (1880), designed when Sullivan was first working for Dankmar Adler, was given spandrel panels and lunettes of rich moulded terracotta, set within a tight grid of piers and string courses. The patterns became bolder, more curvilinear and dynamic in later commissions. ✶ Adler and Sullivan used red and orange terracotta, made by Northwestern, to decorate a series of commercial buildings and houses; tendrils were set in lunettes on the Hammond Library of 1882–3 and the Scoville Building of 1885, and more abstract spiralling forms and stylized lily leaves on the Troescher Building of 1884–5.

Though spurning stylistic historicism, Sullivan still conceived decoration as being subservient to a Renaissance-inspired framework of string courses,

153 Cornice of Guaranty Building,
Buffalo, by Adler and Sullivan, 1894–6
(Northwestern)

bays and cornices. This layered, latticed approach to composition, also used
by Burnham and Root and George Post, was to be rejected as a prelude to
the creation of a new, radical approach to ornamentation. The Wainwright
Building of 1890–1 in St Louis has a near-plain base beneath seven sheer
storeys of brick pilasters, with no mouldings to interrupt the soaring verti-
cality. Terracotta was given a tightly constrained but highly effective role
(152). It was worked in low relief to decorate the bases and capitals of the
piers, for the spandrel panels – a different intricate pattern for each storey
– and to draw the eye up to the attic storey where interlacing swirls of
vegetation sweep round a series of ocular windows. The bright mono-
chrome of brick, stone and terracotta, and the use of ceramics moulded in
low relief to emphasize particular parts of the façades, marks not so much
a revolution as a dramatic and highly rational development of the approach
of other Chicagoan architects and of contemporary work by Alfred Water-
house and Frederick Martin in Britain (71).

A true revolution is apparent in the elevations of the Guaranty Building
in Buffalo, completed five years later in 1896. Sullivan emphasizes rather
than denies the role of the wall-surface, supplanted in its structural role by
the steel skeleton, by creating a taut skin of decorative terracotta (*colour
plate* 25). The windows are recessed to allow the eye to pass from the ground-
floor columns and the entrance pediment up to surfaces of apparently un-
fathomable intricacy. The Guaranty appears as an ornamental casket –
completely faced in bright orange-red terracotta – that glows like gold in
mellow sunlight. The slender piers, decorated from bottom to top, sweep
into a coved attic storey covered with mouldings like interlacing vapour
trails and curve out to the shallow cornice (153).

Sullivan had rejected the high-Victorian principle that ornamentation should be handled with restraint, primarily to reinforce the importance of a building's key elements in terms of structure and function. Whereas almost every other architect and critic urged caution in exploiting the decorative potential of terracotta, Sullivan threw such mutterings aside. He stated, in the years between the Wainwright and Guaranty Buildings, that terracotta 'which will record the impress of a thumb, has still further capabilities of refinement . . . looking forward to the time when even the plain terracotta blocks shall be hand modelled'.✷ The implication was that it was more logical to work so plastic a material into ornamentation than to smooth it to a plain surface and hence deny its decorative potential.

Furthermore, and perhaps most significantly, Sullivan overturned the principle that decoration had to be subservient to the form or function of the building. While such an aesthetic morality had constrained most ceramic architecture of the nineteenth century, with architects using spurious symbolism or arguments of 'fitness' to justify their designs, Sullivan ascribed a more universal relevance to terracotta:

> It is the most plastic of materials in its raw state, suffering itself to be shaped, with marvellous readiness, into every conceivable delicacy and variety of form and movement, yet, when once fired, these forms and delicacies become everlasting; these movements and rhythms of the ornamentation preserve with the persistence every poetic and airy nothing that the creative imagination has imparted to them.✷

What appears to be a recipe for architectural anarchy is in fact rooted in the then widely accepted idea of empathy: the artist should perceive the needs of clients and society, and interpret them by animating building materials so powerfully that the passing public would respond to the design and its detailing through a direct emotional response, rather than through any over-contrived process of association.

Sullivan spurned Renaissance forms as having been developed for the European aristocracy. Instead he elevated nature and organic forms as representing freedom, individuality and moral virtue, and prompting an immediate response from people who were surrounded by drab, soot-laden buildings and divorced from fields, trees and hills. Starting with interior schemes of decoration, as in the Chicago Auditorium of 1887–9, Sullivan reversed his adoption of simple ornamental forms in the pursuit of a bountiful richness. He adopted a combination of botanical motifs, such as seedpods, set against or within a geometric frame of lattices or stretched diamonds. The contrast heightened the feeling of energy and tension, and could be interpreted as representing the union of such opposites as female

and male, emotional and rational, art and science: all potent images within a turbulent economy and culture. Sullivan, together with his draughtsmen and modellers, developed their own botanical encyclopaedia of leaves, stems, buds and tendrils. Established motifs such as a sharply edged acanthus or a vine throwing out tendrils were combined with bursting seed-pods, energetic interlaces characteristic of Celtic ornament and more geometric forms derived from Islamic art. This eclectic pot-pourri was wrought into harmonic unity by being sketched into compositions suffused with a sprouting, lithe energy but modelled with minimal relief.☆

The use of terracotta to express the soaring nature of the skyscraper emerged in more indulgent form in the cream-coloured and relatively small Bayard Building erected in New York in 1897–8; piers in the form of moulded columns lead directly up to surmounting arches and, most disturbingly for any modernists, six angels whose wings are spread to give an added upward thrust to the elevation (**156**).

Lacking further commissions for major commercial buildings, apart from the Schlesinger and Mayer Store, Chicago (1903), where white-glazed terracotta acted as a foil to a riot of decorative cast ironwork, Sullivan continued to indulge his ardour for terracotta in a series of banks. They were built in small towns, where the banking firms sought to ally with local booster mentality and respond to concern over farmers' needs for credit. Sullivan's designs were seen as valuable tools in attracting extra business, but proved just as bemusing to the local community as had the Royal Arcade in Norwich; the local press described a newly opened example by analogy to the

154 Sculptural detail, National Farmers'
Bank, Owatonna, Minnesota, by L.
Sullivan, 1906–8 (American)

155 Merchants' National Bank, Grinnell,
by L. Sullivan, 1914

156 Cornice set with angels,
Bayard Building, 65 Bleecker
Street, New York, by L.
Sullivan with L. P. Smith,
1897–8 (Perth Amboy)

atmosphere of the Arabian Nights, but also implied that the architect must
have been designing under the influence of drugs. ☆

Sullivan decorated plain walls of multi-coloured 'tapestry' brick with
concentrated outbursts of ornament. For the National Farmers' Bank in
Owatonna, Minnesota, of 1906–8, the 'cash-box' or 'safe' of brickwork
was framed by a border of leafy-green terracotta, shot with faint yellows
and oranges (*colour plate 26*). The medallions were highlighted by golden
clusters of fruit and representations of locally grown crops (**154**). The four-
square front of the Merchants' National Bank, Grinnell, Iowa (1913–14),
was dominated by a tense, exploding pattern – composed of overlapping
squares, circles and a curved hexagon – that formed the surround to a
circular stained-glass window (**155**). One of Sullivan's last designs, the
Farmers' and Merchants' Union Bank, Columbus, Wisconsin (1919–20),
illustrates the architect's increasing, and to some critics retrogressive, inter-
est in high-relief ornament and animate sculpture: caskets flank the main
arched openings, and heraldic lions mount guard over the entrance while
a spread-winged eagle crowns the cornice (*colour plate 27*).

Frank Lloyd Wright, pupil of Sullivan and inheritor of his mantle as the
leading architect of the Prairie School, saw Sullivan as having broken free
of all stylistic traditions, using terracotta as the 'ideal medium for his genius
. . . In it this master created a grammar of ornament all of his own . . . The
Sullivan motif was efflorescent, exvolute, supported by tracery of geometric
motives [*sic*] – bringing up the clay in forms so delicate and varied and
lively that no parallel in these respects exists.' ☆

Wright made only modest use of terracotta. However, other Prairie architects who had worked with Sullivan on the Chicago Auditorium and subsequent projects continued to identify closely with his approach to the material, even after the collapse of the practice had driven them into new partnerships or collaborations. The chief figures were Sullivan's draughtsman George Elmslie and his modeller Kristian Schneider. Elmslie left Sullivan to go into partnership with William Purcell. For several commissions, such as the Merchants' National Bank, Winona, Minnesota (1911–12), they set richly modelled panels of terracotta into bold masses of plain brick.

Both Sullivan and Elmslie depended on Schneider's remarkable modelling skills, possibly derived in part from traditions of folk art in his native Norway, to turn their drawings into three-dimensional ceramic. Schneider worked from 1893 with the Northwestern Terra Cotta Company that supplied Sullivan's midwestern skyscrapers. From 1906 he was based in the more idyllic setting of the Crystal Lake works of the American Terra Cotta Company, where two of his sons were also on the payroll, and where the sculptural ornament for the small-town banks was undertaken. This symbiosis between architect and modeller was particularly remarkable in that only Schneider had the ability to realize the imaginative vigour of Sullivan's sketches, while without Sullivan's or Purcell and Elmslie's designs as inspiration, Schneider could lapse into a competent but almost sentimental Renaissance idiom. The extent to which the Northwestern and American companies identified with the Prairie School architects matches the cultural commitment of Henry Doulton or Cyril Carter to terracotta and faience in England. Sullivan frequently took the train out to Crystal Lake to discuss designs with Schneider almost as an equal, and often through a shared alcoholic haze. ✶

TRADITIONALISM IN THE NINETIES

The Prairie School architects became increasingly at odds with the historicism that gained renewed ascendency from the 1890s through to the inter-war period. The idea of grafting classical forms on to modern construction was sarcastically parodied by Purcell and Elmslie: 'ram a steel post down the vitals of as good a copy of the erechtheum columns as terracotta manufacturers can make and let's get on with this play scenery.'✶

Despite the admonitions of Montgomery Schuyler and other critics, most architects had little compunction in using forms associated with masonry for terracotta-clad skyscrapers. American society related more easily to images culled from the Renaissance than to the rhapsodic swirls of the Sullivanesque. Under the impact of growing concern over pollution, the use of deep red terracotta gave way to buff and then glazed material. The vision

157 Judson Memorial Church, 54–7 Washington Square South, New York, by McKim, Mead and White, 1893 (Atlantic)

158 Winthrop Building, Boston, by C. Blackall, 1893

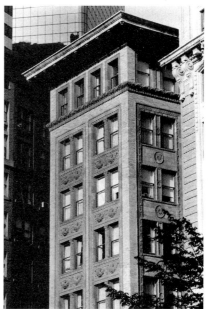

of a shimmering white city presented in the Chicago World's Fair of 1893 first emerged within the city's downtown area in the same year when scaffolding was removed to expose the rusticated grey-white terracotta of Burnham and Company's Marshall Field Annex.

McKim, Mead and White, who worked alongside Burnham in designing buildings for the fair, were in the vanguard of the return to historicism, generating a 'Renaissance craze' in their home city, New York.✱ Their Judson Memorial Church, also dating to 1893, had an Italianate campanile in tawny brick and terracotta supplied by Atlantic (**157**).✱ The fashion for the Italian and French Renaissance progressively changed the colour and style of many downtown areas. In the year of the Chicago Fair, Boston gained its first steel-framed skyscraper, the Winthrop Building. Clarence Blackall, a Chicago architect, neatly dressed the structure within a Renaissance style of brick and pale orange terracotta (**158**).

Amidst this traditionalist contagion, rapidly spreading to most American cities, a single Chicago skyscraper stands out as marking two major innovations: one in the form and one in the style of architectural ceramics. Burnham and Company's Reliance Building of 1894–5 marked the introduction of a fully glazed cream-white terracotta, by Northwestern. It was used in the form of a Gothic sheathing far too scant to simulate a masonry semi-structural wall (**159**). The thirteen storeys above the ground floor are dominated by deep glass bays, the spandrels being separated by slender moulded mullions (fig. 9.3,4). Charles Atwood, the most creative of Burnham's architects, gave each floor only the shallowest section of wall, only 4 ft. 6 ins. deep, the brick backing, rather than the terracotta facing, being bedded into the main girders. He obscured the presence of steel

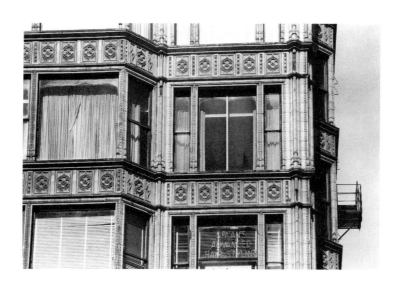

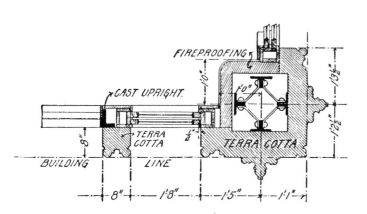

fig. 9.3 Detail of corner pier and column, Reliance Building, Chicago, by D. H. Burnham and Company, 1894 (Northwestern) (J. K. Freitag, *Architectural Engineering*, J. Wiley and Sons, New York, 1901, p.157)

fig. 9.4 (left and right below) Spandrel sections, Reliance Building, Chicago, by D. H. Burnham and Company, 1894 (Northwestern) (J. K. Freitag, *Architectural Engineering*, J. Wiley and Sons, New York, 1901, pp.168 and 183)

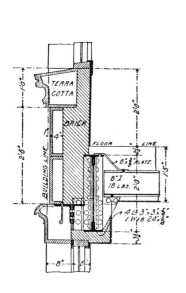

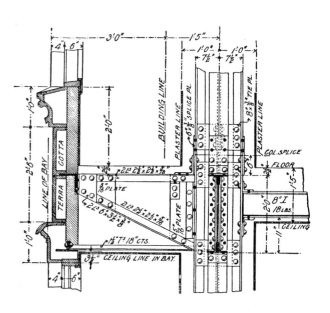

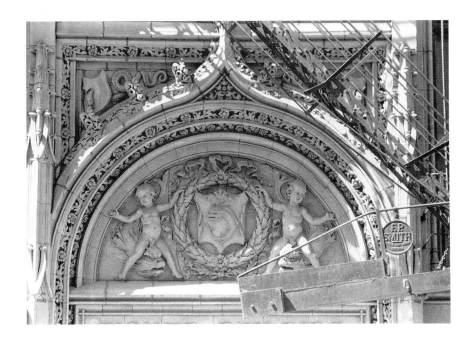

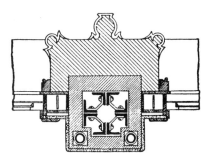

fig. 9.5 Detail of columns in
exterior walls, Fisher Building,
Chicago, by Burnham and
Company, 1896 (Northwestern)
(J. K. Freitag, *Architectural
Engineering*, J. Wiley and Sons, New
York, 1901, p.157)

columns by setting them back from the projecting bays, the terracotta
window-mullions being stiffened by small cast-iron uprights.

Contemporary critics recognized the glistening wall-surface of the
Reliance as a major innovation: 'It is indestructible and as hard and as
smooth as any porcelain ware, it will be washed by every rainstorm and
may if necessary be scrubbed like a dinner plate.'✶ The skyscraper also
gained accolades as a constructional feat: the 200-foot-high building was
erected over an existing store, terracotta and fireproof tile being hoisted up
in huge boxes at night to avoid any hazard to the shoppers along State
Street.✶

Burnham and Company's next major Chicago commission, the Fisher
Building of 1896, was given full Gothic dress (**160**, fig. 9.5). Ogee window-
heads were surrounded by fish, eagles and dragons, modelled in high relief
with a buff-slipped terracotta, a combination of which Blashfield would
have been proud. Subsequent work by Burnham and Company shows a
shift towards a quieter and more urbane classicism, whether the commission

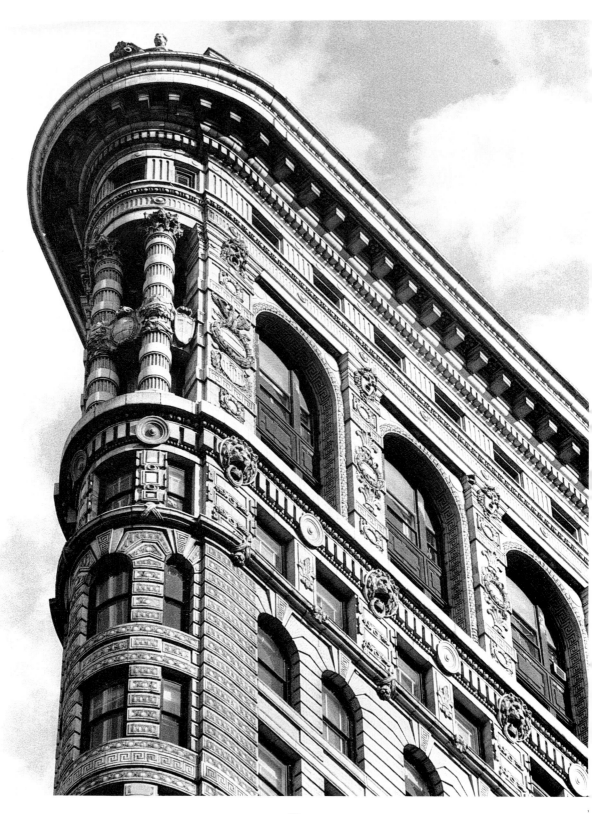

was in Chicago, New York, Atlanta or Cincinnati. Their ordered but rather dry approach to terracotta emerged at its most impressive in the dramatic wedge form of the Flat-Iron Building, New York (1901), with lions and youthful faces set in heavily rusticated walls (**161**). The Atlantic Terra Cotta Company's terracotta was coloured a warm yellowy-grey to match the limestone base.

Holabird and Roche retained a broader arsenal of styles for their terracotta elevations in Chicago, from a rusticated classicism first seen in the Marquette Building of 1893–4 to the sparer cladding of the Cable Building and the McClurg Building of 1899. Away from Chicago's commercial district, Holabird and Roche turned to Dutch and Jacobean motifs for hotels, stores, colleges and houses.

Glazed ceramics and pale grey, cream or white finishes had been widely adopted by the end of the century even in the less-polluted west-coast cities. The wet climate of the north-west favoured highly glazed finishes over unglazed terracotta and Portland and Seattle each gained central districts dominated by white tower blocks, banks and cinemas.

Terracotta became the rule rather than the exception in downtown areas. The major contractors, such as George A. Fuller and Company, who undertook the lion's share of building work in Chicago or Manhattan found that it was a crucial factor in reducing the time needed for on-site erection. Fuller built the Rookery, the Reliance, the Flat-Iron and a host of other show-piece terracotta skyscrapers, developing systems of subcontracting that circumvented most of the problems of delay, damage and incompatibility with structural metalwork apparent in early terracotta projects. The need for speed had been urged by Jenney:

> We must have a style of construction that can be erected rapidly, and so arranged that if the terracotta of the lower stories is not ready, which is usually the case on account of the excess of work in these stories in the shape of columns and other ornamentation, the setting of the terracotta can commence in the second or third stories without waiting for those below.✫

The terracotta firms typically needed ten weeks from receiving an order before they could commence deliveries, but could manage five to six weeks if pushed. Some remarkable records of rapid construction were established, Atlantic advertising that a twenty-storey skyscraper in Cleveland had been clad in just seven weeks.✫

As the terracotta industry reached maturity, so architects and building contractors could, in principle, choose a supplier according to price and delivery schedule, unfettered by doubts about the quality of the body, its modelling or glazing. As in England, firms prided themselves on being able to work in any style and reproduce almost any finish, typically to match granite, limestone or marble. In practice the major firms retained distinctive reputations reflecting the skills of their modellers or glaze chemists. In the early years of the twentieth century, American was pre-eminent for Sullivanesque decoration, New York for high-relief figurework and Perth Amboy for polychromy, their glazes having been developed in collaboration with McKim, Mead and White.

Virtually all terracotta made after 1890 was made to order, although New York Architectural Terra Cotta Company did occasionally offer their stock design of cornice as a means of reducing tendered prices. ✫ The Midland Terra Cotta Company, established in Chicago in 1910, specialized in offering stock panels of foliate ornament in the Prairie School style for dime stores, garages and other minor commercial buildings.

COLOUR AND COMMERCIALISM

Colour only became a major element in American architecture in the interwar period. The announcement by the *New York Times* in 1907 that a 'New decorative movement employing colored glazed terracotta and faience, promises to make Manhattan blaze with the loveliness of azure and ruby, topaz and gold' was somewhat premature, since at this stage it was primarily smaller potteries that were undertaking richly polychromatic schemes – not so much for building façades as for lining restaurants and subway stations. ✫

Rookwood of Cincinnati, Ohio, branched out from producing art pottery to undertake richly coloured interior schemes in 1903. One of their early orders was for number-plaques for the New York Subway. ✫ Twenty-three stations were to be decorated with faience panels and string courses by Rookwood and other firms, some decorated with images such as paddle-steamers and beavers. Rookwood's catalogue offered stock designs of tiles and mantels, but all the most impressive schemes such as the predominantly blackcurrant-coloured Gidding–Jenney Store front in Cincinnati, by Frank M. Andrews (1908), were made to order (**162**).

The Grueby Faience Company emerged out of a link between Fiske, Holmes and Company and the Boston Terra Cotta Company, in the early 1890s. William Grueby pioneered a matt-green glaze; his works, founded in 1897, was to combine the production of architectural ware with vases at first produced simply to take up spare space in the kilns. ✫ Other firms,

162 Gidding-Jenney Store, 18 West 4th Street, Cincinnati, by Frank M. Andrews, 1908 (Rookwood)

163 (right) Woolworth Building, 233 Broadway, New York, by Cass Gilbert, 1913 (Atlantic)

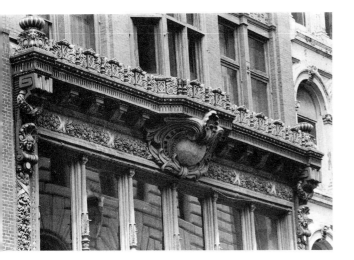

such as Pewabic of Detroit and the American Terra Cotta Company with their Teco range, also embraced the fashion for matt-glazed ceramics. They found that their art pottery, tiles and faience gained the approbation of leading figures within the American Arts and Crafts who would have been equivocal if not antagonistic towards the more obviously commercial white or granite finishes of Altantic's or Northwestern's architectural terracotta.

Rookwood and other potteries gained little profit from their architectural orders, partly because their ware needed two or more firings. Within a few years polychromy re-emerged in the work of the mainstream terracotta firms. Advances in glaze technology and links between different branches of the clayworking industry were furthered by progress within the art and technical schools. The courses in ceramics provided in art schools at Boston, Philadelphia, Trenton and Cleveland were to be complemented by the more technical training offered by the universities of Ohio and Illinois. The key figure in spreading a more advanced understanding of glazes and linking the world of art pottery to industrial ceramics was Charles Binns, former superintendent of the Royal Worcester Porcelain Works, who directed the New York School of Clayworking and Ceramics at Alfred from its establishment in 1900 into the thirties. While his personal work focused on studio ceramics, his teaching curricula included 'the colouring of clays for terracotta' and he established working links with the National Terra Cotta Society and the architecturally orientated *Clay-Worker* journal. ✩

Ralph Adams Cram urged development of an alternative to 'The cheap,

red, mushy stuff . . . and the flaming white Renaissance products consecrated to hotels and clubhouses'.✫ Such eastern architects tended to believe that the artistic use of terracotta was restricted to New York and Boston, but it was a Minnesotan architect who was to give New York and the United States its greatest symbol of the Gilded Age in the form of the subtly polychromatic Woolworth Building (**163**).

Cass Gilbert had introduced colour into some of his earlier buildings in St Paul. The soaring 750-foot spire of Gilbert's Woolworth Building (1913) not only made it the tallest building in the world but also justified a riot of tracery, pinnacles and gargoyles, and the use of blue, yellow and green glazes to throw the white mouldings into greater relief. F. W. Woolworth openly admitted the worth of his skyscraper as a signboard to advertise around the world his spreading chain of five- and ten-cent stores.✫ In contrast, Montgomery Schuyler, in his rhapsodic text for a commemorative booklet, emphasized how Atlantic's 'baked clay' Gothic decorations and the tapering Gothic outline helped generate philanthropic and cultured overtones lacking in a blunt, rent-maximizing block.✫ Both saw the Woolworth Building as an 'architectural triumph' for the United States. Little did they appreciate the extent to which the upper fifty-three storeys were a monument to British clayworking skills: at Atlantic's Perth Amboy plant, not just the superintendent, his assistant, the heads of construction and draughting departments, but also numerous modellers and moulders and twenty-one members of the draughting department had all emigrated from England.✫

THE DECORATIVE SWAN-SONG IN
INTER-WAR AMERICA

The resurgence of terracotta in inter-war America was brief but highly creative; a buoyant economy created a halcyon decade for the ceramic industry until the onset of the Depression, while architects had the option of working traditional or art deco styles in white or more inventive glazed finishes. In the east the material was already in partial retreat, its most typical use on skyscrapers being less as an overall cladding and more as an adjunct to brick. In the south and west, designers and clients came to share an unbridled enthusiasm for exploiting the sculptural and polychromatic potential of terracotta as an all-over cladding. One firm, Gladding McBean of Lincoln, California, dominated the Pacific market, and the remarkable survival of documentary records provides a unique insight into the pragmatics of liaising with architects and building contractors. Established in 1875 and making terracotta from 1884, Gladding McBean developed a working arrangement whereby liaison with architects occurred primarily through Atholl McBean, the rather pedantic secretary and later president, based in the company's San Francisco office. He communicated with the Lincoln plant via a stream of memoranda and drawings. Joseph DeGolyer, head of the architectural department, had to respond to every whim of the architect, the builder or his own employer and motivate his draughtsmen and modellers to respond within tight and sometimes impossible time-scales.

MARKETS AND ARCHITECTS

The American industry successfully rode the roller-coaster of demand set in motion by the First World War. National sales dropped from a peak of over $8 million in 1912 to around half this level in 1915, a rise in the spring of 1920 dipping again in the recession of the following year.* A rapid rise in demand in the West helped drive the national upturn to sales of $16 million for the top thirty manufacturers in 1923. This resurgence and further modest growth was cut short by the stock-market crash of 1929.*

Firms had markets extending over broad regions several thousand miles across. They competed most aggressively in cities that were half-way between major plants, Atlantic and Northwestern locking horns to win orders in Cleveland and Detroit. Concern that the eastern manufacturers were operating in combination was one factor that had prompted the foundation of the National Terra Cotta Society in 1911. The society avoided becoming embroiled in unworkable schemes of price regulation, and

proved far more active than the Terra Cotta Association of England in generating advertising campaigns and in commissioning research into the optimum composition of bodies and glazes. ✩

The market broadened in terms of building type as well as of geography, to embrace railroad and gas stations, schools, libraries and swimming-pools. Manufacturers remained highly protective of their links with prolific architects. Atlantic retained the allegiance of the major practices in New York; meanwhile, Northwestern nurtured their ties with the largest Chicago practices such as D. H. Burnham, and Graham, Anderson, Probst and White. It was a matter of intense pride, just as with J. C. Edwards or Hathern in England, to win key contracts in the local town or city. Gladding McBean lobbied the building committee for the Sacramento Elks Club during the autumn of 1924 to fend off any risk that a competitor or an artificial-stone firm might win the impending contract. ✩

Atholl McBean and DeGolyer had an ambivalent attitude towards architects: revering them as creative masters in the design process and for their power to influence the allocation of contracts, but objecting to prevarication and to any disparagement of their draughtsmen and modellers. Architects and assistants who permitted Gladding McBean to finalize details concerning the size of blocks and their jointing were favoured above prima donnas who often demanded changes to sculptural detail or glaze combinations, even after blocks had been pressed and were on their way to the kiln. Some clients merited particular attention, especially if the order-book was looking empty. Atholl McBean was 'particularly sore' when an error over the cornice of the Firestone Building in Los Angeles, by Morgan and Walls (1910), risked alienating the owner, Mrs Nan Nuys, just as she was about to commission one of the largest office buildings in the city. ✩ Architects, builders and clients in turn could become tetchy if they sensed that competitors, particularly those working in the same city, had received preferential treatment. The contractor for the Hunter Dulin Building in San Francisco threatened that he would cease 'to be a Gladding McBean booster' unless they gave his projects higher priority. ✩

Architects still considered modelled detail the critical issue. Most were happy to delegate the task of creating capitals, friezes and sculptural groups to the modellers at Gladding McBean, but demanded the right to inspect their work and request minute alterations or even major reworking. An architect could only be absolutely confident about each piece of ornament if he travelled to the works at Lincoln, typically taking the overnight paddle-steamer or train up from San Francisco. In most cases it was impossible to develop all the sculptural detailing, from the entrance to the top of the tower, at the same time, so several visits might be required. Timothy Pflueger, for one, balked at these repeated journeys then relented, only to arrive and find that a group of key sections of his Pacific Telephone and

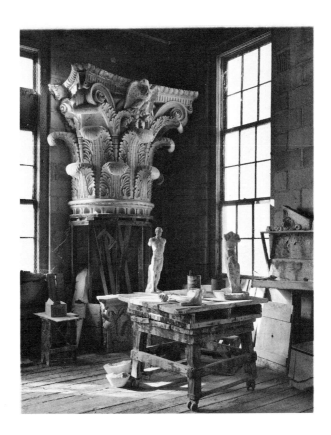

164 Plaster model of capital for the Fireman's Fund Insurance Building, San Francisco, by L. Hobart, 1914 (Gladding McBean)

Telegraph Building was already being fired.✶ Much time was saved by wax models or photographs of less critical elements being forwarded for approval, negatives often being printed on matt paper to allow the architect to sketch in any alterations.

Comments on modelled details ranged from outright praise to the libellous.✶ Suggestions ranged from vague advice to specific recommendations. Lewis Hobart urged that a group of cherubs should be remodelled so that their 'age should be as the other kiddies, much younger'.✶ When O. Speir complained that on one sculptural group the drapery 'was too thin and flexible', he suggested that the head modeller Pio Oscar Tognelli should refer to his collection of French plates for further inspiration.✶

Such dialogue between architect and modeller depended on a shared appreciation of both naturalistic form and Beaux-Arts Renaissance architecture. Gladding McBean's head modeller during the early twentieth century, Pio Oscar Tognelli, had enhanced his versatility in modelling friezes, cartouches and pediments through an expanding library of Renaissance decoration. His collection was frequently augmented in response to outside advice. Hobart forwarded a list of plates that would help inspire the modellers while working on his Fireman's Fund Insurance Building in San Francisco (1914) (**164**). He recommended that one plate should be used in developing column-caps, while a head should be worked up from one

165 Shields for the Spreckels Building, San Diego, by J. and D. Parkinson, 1925–6 (Gladding McBean)

166 (below) Lunette panel for the Hunter-Dulin Building, 111 Sutter Street, San Francisco, by Schultze and Weaver, 1926 (Gladding McBean)

illustrated in Caproni's *Special Catalogue of Subjects for the Decoration of Schools, Libraries and Homes.* ✩ J. and D. Parkinson, architects for the Spreckels Building in San Diego (1925–6), were more helpful, offering to photograph and forward plates from their own library to help DeGolyer and Tognelli develop detailed designs for the string courses and the balcony railings and brackets (**165**). ✩ Architects and clients who lacked such resources or a broad knowledge of European architecture might request that a specific element of an earlier Gladding McBean project in their home town or city should be replicated or reworked for their own commission.

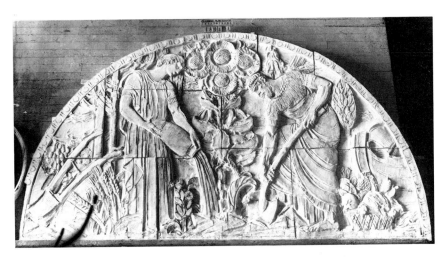

Patterns of collaboration became more complex if part of the modelling was to be undertaken by independent sculptors: their contribution had to be made compatible in terms of both size and style with work undertaken at Lincoln, and tensions often arose within the three-way dialogue between architect, sculptor and manufacturer. In the case of Schulze and Weaver's Hunter Dulin Building (1926) in San Francisco, the lunette panel was modelled by a Mr Lentelli in New York, who ended up lending a sympathetic ear to Atholl McBean's complaints about the architects (**166**).*

JOINTING AND SHUTTERING

The constructional use of terracotta, a somewhat cloudy issue in the early decades of the American skyscraper, was analysed and rationalized during the twenties. Manufacturers provided precise schedules for anchors, to avoid such disasters as when a cornice collapsed on to a sidewalk exposing the use of ties of telegraph wire rather than steel hangers.* The three-dimensional jigsaw of complex block-shapes was simplified wherever possible. Simpler cornices could be made up of just two courses: the lower was embedded into the brick or concrete wall and formed a corbel to support an upper tier, unfilled and therefore lighter and requiring only a simple tie in the form of a flat angle-bracket. Publications and articles contrasted worst and best practice in jointing (**167**): how joints could be arranged to conceal any irregularities in drums or domes, or to accommodate wind movement and thermal expansion through the use of elastic cement.* The National Terra Cotta Society publicized the merits of relatively small blocks that could be more easily adjusted when being fitted, of non-ferrous supports, and of incorporating weep-holes to encourage any moisture to drain away.*

Concrete, having been spurned in favour of structural steelwork, made a come-back. It was used in hybrid constructional systems that came on to the market around 1904 and then later to form a reinforced frame, but the implications for the design and supply of terracotta were initially modest. Few changes were made to the form of the terracotta when, in the autumn of 1913 and just before work commenced, it was decided to erect the St Charles Hotel in Atlantic City with a concrete as opposed to a steel frame.* Reinforced concrete had gained an ascendancy by the inter-war period, since it could resist fire without further protection. Patent systems of encasing steel with porous terracotta had become increasingly bulky and complex: a new building code introduced after the San Francisco earthquake and fire of April 1906 demanded that terracotta sheathing for columns had to be 4 inches thick. Meanwhile, Californian experts suggested that closely bonded concrete and terracotta offered better seismic resistance than steel framed and brick encased construction.

167 Section of a cornice showing the use of
metal supports, *c.*1914 (from National
Terracotta Society, *Architectural Terracotta:
Standard Construction* (1914), plate 26)

168 Palace Hotel, 633–65 Market
Street, San Francisco, by Livingston
and Trowbridge, 1909

169 (far right) Goldberg Bowen
Building, San Francisco, by Meyers
and Ward, 1909

Terracotta was only rarely used as shuttering, when it would be directly bonded to concrete; just as in Britain it was more likely to be attached to hooks and bolts that had been set into the wall. Great precision was needed to ensure that any shelf angle was accurately located so that its lower flange lined up with the horizontal joint of the block or slab. Architects were advised to allow for a void of at least 1 inch between the face of the concrete and the back of the terracotta.✫ Such factors were usually taken into account, but mismatches could occur. There proved to be inadequate space round the structural concrete for the terracotta that Gladding McBean had made for the Pantages Theatre, Los Angeles (1919), with the result that the ceramic blocks would not fit round the metal reinforcement, while other miscalculations meant that the window-voids created by the terracotta cut across the concrete landings.

SAN FRANCISCO AFTER THE EARTHQUAKE

Demand for Gladding McBean's terracotta burgeoned as San Francisco was rebuilt from the ash and rubble of 1906. Damaged buildings were patched where possible, while the Palace Hotel was rebuilt by Trowbridge and Livingston in 1909, in a (by then) highly traditional Beaux-Arts style (**168**). Gladding McBean's order-book remained full throughout 1908, despite the depression affecting much of the country.✫ For a couple of years Pacific-coast architects tended to parody styles and even particular buildings in

199

170 The Smith Tower, Seattle, by Gaggin and
Gaggin, 1912 (Gladding McBean)

171 Wrigley Building, Michigan Avenue,
Chicago, by Graham, Anderson, Probst and
White, 1920–4 (Northwestern)

172 (far right) Jewellers' Building, 35 East
Wacker Drive, Chicago, by Thielbar and
Fugar, 1924–5 (Northwestern)

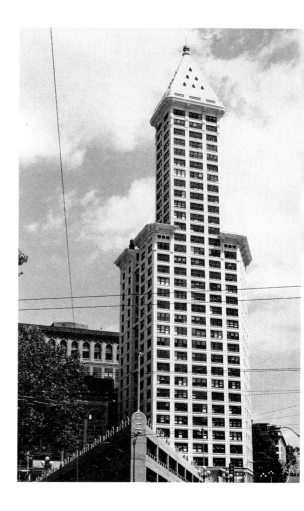

New York or Chicago: Charles Paff presented a miniature version of the
Flat-Iron in his Old Fugazi Bank Building, Columbus Avenue (1907), while
C. F. Whittlesey concocted a rather disjointed Sullivanesque with Moorish
overtones for the Pacific Building, Market Street (1907–8). They soon
developed their own more distinctive idiom, characterized by using white
terracotta, often as a complete cladding. A group of relatively compact
blocks in and adjoining Sutter Street show finely articulated pier and span-
drel compositions, the Goldberg Bowen Building, by Meyers and Ward
(1909), culminating in outbursts of flowers and leaves linking the piers and
the cornice (169).

Architects monitored each other's use of ceramics. George Kelham was
determined that his Sharon Building in Jesse Street (1913) should have 'the
best terracotta modelling in San Francisco', stating that he wanted such
details as the plaques, shields and wreaths handled in the same manner as
worked by Gladding McBean's modellers at Lincoln for designs by Messrs
Bliss and Faville, but with 'more character . . . sections a trifle more defined
and sharper'. After vacillating over his choice of colour, and even deliberat-

ing whether to change the round-arched openings to Gothic, Kelham eventually achieved a finely controlled and logical use of ribbed terracotta, brick and stone. ✫

Gladding McBean became imbued with this ceramic fervour, encouraging architects including Willis Polk to use terracotta as an ashlar rather than just a dressing to brick. Their persuasion was successful in the case of Polk's Hobart Building in Market Street (1914), but at the cost of their having to accept a contract that denied them virtually any profit. Their collaboration over this striking oval skyscraper turned somewhat sour as the terracotta, 'put through as cheaply as possible', came out with serious irregularities. Polk would only accept the material if he was allowed some gold highlighting at no extra charge. ✫

Gladding McBean's first foray into true skyscraper architecture was in Seattle rather than San Francisco. During 1912–14 the Smith Tower rose through forty-two storeys to become the tallest building west of New York (**170**). Gladding McBean's pride at winning this prestigious contract in a city where there was strong competition from more local firms was tempered

by further complaints about colour variation. The developer wanted the terracotta for the thin pilasters and spandrels to be as white as possible. As this western riposte to the Woolworth Building neared completion, the architects, Gaggin and Gaggin, condemned seven boxcars of terracotta, complaining that some blocks were pink and others crazed or covered in iron-spots. Already incensed at having to execute some 'ridiculous' forms of jointing, Atholl McBean suggested patching any faults with 'best bath tub enamel' when the architects' representative was not on site. ☆

Most of the contemporary office blocks in Seattle and Portland were more traditional in style, with classical details in white terracotta surrounded by pale grey brick. ☆ Architects sometimes introduced originality through sculpture evoking the spirit of the western frontier. Modellers at Gladding McBean, Washington Brick, Lime and Sewer Pipe Company or N. Clark and Son became well versed in modelling Indians and buffaloes; their most original and yet appropriate scheme was the line-up of walrus heads complete with tusks for the Arctic Club, Cherry Street, Seattle, by A. Warren Gould (1914–17) (*colour plate 29*).

THE SETBACK SKYSCRAPERS

Traditional ornament retained its credibility into the mid-twenties on both sides of the Rockies. The most fundamental innovation was prompted by legislation rather than by architects and aesthetics: a zoning resolution of 1916, introduced in response to concerns that the streets of Manhattan were becoming nothing more than gloomy chasms, stated that the upper storeys of tall buildings had to be recessed in graduated steps. In some districts, cornices and other projections beyond the building line were also prohibited. Architects responded by developing tower and turret designs with sheer walls rising up in receding sections to Gothic or Renaissance gables, finials and pinnacles. Manufacturers embraced the potential of the setback skyscraper for repeated and hence profitable mouldings, while the National Terra Cotta Society issued a leaflet welcoming such terminations as preventing monotony and giving a design 'emotional appeal'. ☆

A group of skyscrapers in Chicago demonstrates how successfully the white all-terracotta wall-surface of the Woolworth and Smith Buildings could be adapted to conform to the setback principle. The Wrigley Building, North Michigan Boulevard, Chicago, by Graham, Anderson, Probst and White (1919–21 and 1923–4), was hailed as 'the Alpine peak in burned clay' (**171**). The snowy-white walls, graduated in five shades of whiteness, became the city's great architectural show-piece of the twenties, and a subtle advert both for Wrigley's chewing-gum and Northwestern's terracotta. The French and Spanish Renaissance decoration was modelled mostly in

low relief, but with more formal and heavily sculpted spread-winged eagles and vases mounted at cornice level to draw the eye up to the crowning colonnaded turret.✫

For the Pittsfield Building, East Washington (1927), Graham, Anderson, Probst and White updated the Gothic idiom with neatly incised zigzag decoration set into narrow pilasters. The central and four corner towers of the Jewellers' Building, East Wacker, by Thielbar and Fugard (1924–6), was encrusted with baroque decoration (**172**). Such traditionalist use of terracotta worked itself out in another skyscraper located close to the Chicago River. The Lincoln (formerly the Mather) Tower, East Wacker, by Herbert Riddle (1928), soared in pearl-white octagonal stages, diminishing like a telescopic aerial and terminating in Gothic tracery.

SOLON AND HISTORICIST POLYCHROMY

Colour remained a complement to, rather than a substitute for, modelled decoration for most of the twenties. The Italian Renaissance, and the works of the della Robbia family in particular, were presented as a flexible formula for introducing polychromy into American streets, while brochures demonstrated how classical banks, French Renaissance theatres and Tudor and Jacobean schools could all be enlivened with enamelled decoration.✫ A booklet on bank design was published by Léon Solon, an immigrant from the English Potteries who became a major advocate of polychromatic architecture. Trained by his father, Marc Solon, chief decorator at Minton China Works in Stoke-on-Trent, he was to become the company's art director, designing tiles and tableware in an art nouveau style. He resigned in 1909 and emigrated to the United States for a second career as a ceramic designer and interior decorator. He also wrote for the *Architectural Record*, in whose pages he expressed a vision, even as late as 1926, of traditional styles, sculptural modelling and polychromy advancing hand in hand.✫

Solon took a revivalist approach to colour, quoting the precedent of classical and Renaissance use and railing against strident schemes conjured up 'on skittish impulse'. He was able to realize his academically justifiable ideal through his post as 'polychromist' for the new Philadelphia Museum of Art. The architect, Charles Borie, inspired by recent discoveries of the Greek use of colour, convinced the Fairmont Park Commission to create a museum building in the form of a temple with mouldings and pediment sculpture of glazed terracotta (*colour plate 28*). A one-third scale model of the west wing allowed the sculptor, Paul Jennewein, to judge the effect of his Grecian figures and Solon to advise on the use of colour not only for the sculpture but also for the capitals, portico ceilings and other architectural details. Atlantic's Perth Amboy plant, which had led the introduction of

173 Detail for the Orpheum Theatre, 630 South Broadway, Los Angeles, by G. A. Landsburgh, 1911 (Gladding McBean)

glazed finishes during the 1890s, developed the gold, scarlet and vermilion colours used in the pediment and the turquoise-blue terracotta tiles for the roof. The 70-foot-long pediment, with thirteen figures symbolizing 'the Influence which has Produced Western Art', was painted in intricate detail and roused enormous interest: a crowd of over ten thousand visited the works on an open day when the pediment was on show before being shipped to Philadelphia.✩ For the rest of the building, Solon highlighted decorative features with rich glazes. His principle of using 'colour elaboration in inverse relation to structural significance' neatly overturned the Victorian principle of 'appropriateness' or 'fitness' whereby key elements of the building's structure were most likely to be ornamented.✩

Colour brought terracotta manufacturers on opposite sides of the United States into friendly rivalry and, in the open and growing market of the deep South, direct competition. Gladding McBean had monitored the glazed work of other firms for over a decade, crediting Atlantic with achieving better colours than even Rookwood.✩ The Perth Amboy works of Atlantic tended to concentrate on the yellow, green and blue colours associated with Luca della Robbia and his *bambino* figures. DeGolyer used his skills as a chemist to develop a broader palette of finishes, both in terms of hue and special effects. Greys, creams and greens were supplemented by red, midnight blue and, in the twenties, silver and gold. Mottled finishes under the brand-name 'Pulsichrome' were augmented by 'Granitex', a glaze imitating stone and created with the aid of a 'sputterer' spraying-machine.

Though welcomed by both architect and manufacturer, colour proved to be a complicating issue in the already convoluted pattern of works visits and exchanges of memoranda, drawings and photographs. Gladding McBean usually had to ensure that blocks and even diminutive details matched colour samples. Architects varied in their willingness to accept variation; the architect of the Orpheum Theatre, Los Angeles (1910), G. Albert Lansburgh, was understandably distraught to find that the green specified for the robes of the figures turned out as Rockingham yellow (**173**).✩ While some architects defined their colour scheme merely through

coloured sketches or photographs, others took no risks. Kirby, Petit and Green shipped a scale model of the Hearst Building, Market Street, San Francisco (1910), fully painted in buttery colours with brightly coloured swags and other details, from their New York office to Mrs Hearst and hence to Lincoln. *

ARCHITECTS, ARTISTS AND ART DECO

Brightly coloured glazes became an integral element of the modernistic styles that spread across the United States during the late twenties. Architects and sculptors could choose between, or interweave, a series of design strands: art deco from France, Mayan from Mexico and indigenous Indian. Whatever the precise stylistic label, American art deco was well suited to the technology of terracotta: easily pressed low-relief patterns could be highlighted in bright colours and repeated extensively over broad sections of an elevation. Bright, often abstract, forms reflected a country sufficiently confident to break away from European historicism and the moral overtones of the Progressive movement. The juxtaposition of plain brick wall-surfaces and sections of brightly coloured ornament perpetuated, albeit at a more superficial level, some of the aesthetic principles of Sullivan and the Prairie School.

Regional variations emerged. French art deco infiltrated from the eastern states while architects in the West and South identified more with Indian and Meso-American art. The Paris Exposition of 1925 illustrated the potential for working ceramics into chevrons and zigzags, and into stylized fountains, clouds, sunbursts and clumps of flowers. * Items from the Exposition were purchased by the Metropolitan Museum, and it was in New York that art deco first took a firm hold, partly on account of its eminent suitability for the setback ceramic skyscraper.

There was wide variety in the types of ornament and polychromy chosen by different architects. Having studied Moorish architecture while based in Paris at the École des Beaux-Arts and having also visited the 1925 Exposition, Ely Jacques Kahn developed a highly geometric use of terracotta, arranging simply modelled and coloured blocks to accentuate setbacks. His colour scheme for 2 Park Avenue Building (1927) was developed with help from Léon Solon, using the primary colours of Greek architecture: magenta red, black, ochre and a blue with a green cast. * Abstract forms in bold black-and-white patterns were used by Walker and Gillette for the cresting of the Fuller Building (1929) (**175**). Sloan and Robertson introduced lush sculpture, again supplied by Atlantic, on to two slab-type skyscrapers of the late twenties. The water-tank enclosure at the top of the French Building, Fifth Avenue (1927), was given faience panels emblazoned with images considered appropriate by the construction company that built and occupied

174 French Building, 551 Fifth Avenue, New York, by Sloan and Robertson, 1927 (Atlantic)

175 (right) Fuller Building, 41 East 57th Street, New York, by Walker and Gillette, 1929 (Atlantic)

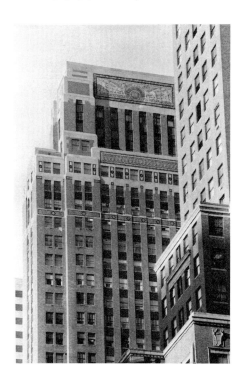

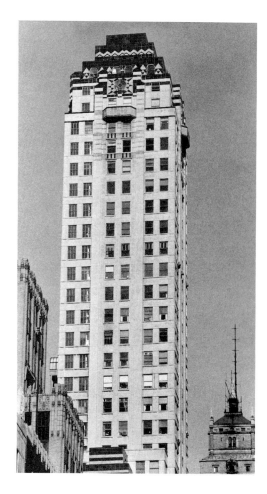

the block: a rising sun for progress, griffins for integrity and watchfulness, beehives for thrift and industry (**174**). A rival construction firm responded with the Chanin Building, Lexington Avenue (1926–9). Apart from the ornamental terracotta brackets near the top of the tower, designed to house floodlighting projectors, the use of terracotta was concentrated at fourth-storey level, panels with a dense pattern of tendrils and fleshy leaves being designed in collaboration with the avant-garde sculptor René-Paul Chambellan. ✩

Other eastern and midwestern cities acquired a token number of art deco skyscrapers. The Union Trust Building in Detroit, by Smith, Hinchman and Grylls (1929), illustrates how polychromy eventually came to override modelled decoration. Geometric patterns on the exterior – in twelve colours of Atlantic terracotta – were outshone by the brilliant octagonal arrangement of Rookwood tiles, again representing a beehive, set in the main lobby. Just as Atlantic continued to dominate the market in New York, Northwestern supplied the key art deco buildings in Chicago. The Carbide and Carbon Building, North Michigan, by Burnham Brothers (1928–9),

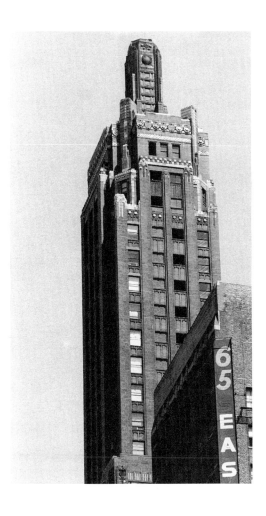

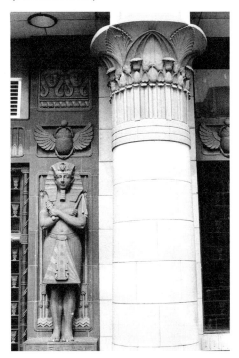

176 Carbide and Carbon Building, 230 North Michigan, Chicago, by Burnham Bros., 1929 (Northwestern)

177 Detail of column and pharaoh, W. C. Reebie Warehouse, 2325 North Clark Street, Chicago, 1923 (Northwestern)

was clad in heavily textured terracotta of a deep olive-green colour and had a campanile trimmed with gold leaf (**176**). Northwestern found that their main market for 'moderne' and polychromatic terracotta was on smaller contracts where ornament could be finely attuned to the building's function. The Reebie Warehouse, North Clark Street, Chicago (1923), was given, at the request of the owners, a façade fit for an Egyptian tomb, with papyrus- and lotus-decorated columns set in front of statues of pharaohs (*colour plate 30*, **177**). The delighted Reebie brothers promptly adopted a new sales slogan: 'If old King Tut were alive today, he'd store his goods the Reebie way.'✩ Growing demand for art deco ornament by the managers of garages, stores and banks encouraged Northwestern to import six French sculptors in 1927 for their skills in modelling flowers, birds and other images in low relief.

Northwestern also included Mayan motifs in their ever-broadening stylistic vocabulary. Pre-Columbian cultures offered the architect a truly American art, readily reproducible in low-relief ceramic. Squat, expressive gods could be combined with stepped and zigzag patterns more typical of Mixtec

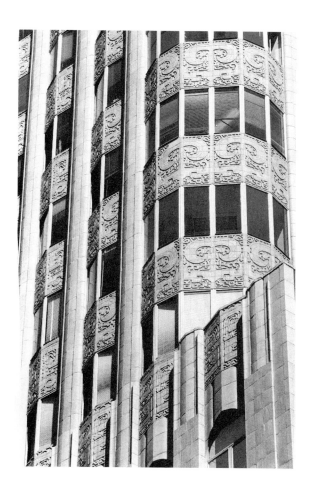

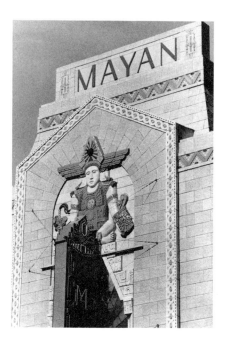

178 **Medical–Dental Office Building, 450 Sutter Street, San Francisco, by T. Pflueger, 1930**

179 **Mayan Theatre, Denver, Colorado, by M. Fallis, 1930**

art. Timothy Pflueger designed America's one and only Mayan skyscraper: the Medical Building, Sutter Street, San Francisco (1930). Rippled wall-surfaces were covered with a tapestry of low-relief Mayan motifs, the piers being reduced to no more than slender window-mullions (**178**). Several cinemas were fronted with pre-Columbian motifs, the most impressive of those executed in terracotta being the Mayan Theatre, Denver, by Montana Fallis (1930). The terracotta sculptor and modeller Julius Ambrusch wove Aztec detailing into the frontage, which was dominated by a cross-legged figure wearing a feathered head-dress highlighted in gold (**179**). ✶

Post-conquest Mexico offered a more direct precedent for American architectural ceramics in the tiles made at Puebla from the late eighteenth century. Dozens of churches in the city were given domes and even complete frontages covered in primary colours and chevron, chequer or star patterns, harking back to the ceramics of Seville and Talavera. A few, such as San Francisco at nearby Acatepec (*c.*1800), show tiles set like jewels into Spanish-inspired Churrigueresque frontages, each yellow, white, red or blue facet sparkling in the sun (*colour plate 31*). ✶ The Spanish baroque, whether derived from Mexico or the Spanish missions, was widely used

for terracotta buildings in the southern states, perhaps to most dramatic effect in offices supplied for Southwestern Bell by Atlantic.

Spanish, Mexican and indigenous Indian motifs could be intermingled to create an indulgent atmosphere for the most escapist of building types: the cinema. Terracotta was almost *de rigueur* for the American movie-palace but most eschewed polychromy in favour of rich, deep modelling. Two major firms of cinema architects, Thomas Lamb and Rapp and Rapp, competed by creating ever more lavish frontages. Lamb's efforts culminated in Loew's 175th Street Theatre (1930) in New York, with a cacophony of classical, Islamic, Mayan, Indian and oriental decoration aimed, in the words of the architect, at creating 'an atmosphere in which the mind is free to frolic and becomes receptive to entertainment'.✩

In Chicago, their home city, Rapp and Rapp created frontages through a formula of a large round-headed window surrounded by panels and swags of intricate decoration; a relatively early example was the Chicago Theatre, North State Street (1921), with creamy-yellow terracotta supplied by Northwestern (**180**). The Midland Terra Cotta Company also profited from the cinema boom, perpetrating probably the most extensive example of duplication by reusing the plaster moulds made for the Granada Theatre (1926) for the Marbro which was completed in the following year.✩

Downtown Los Angeles, only a few miles from the capital of the film industry, Hollywood, gained a startling group of cinemas, each striving to outdo the others in the overblown modelling of its external terracotta as a

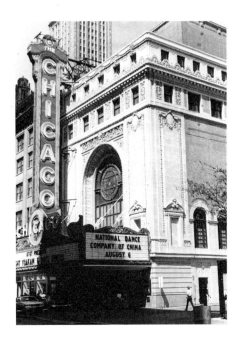

180 Chicago Theatre, 175 North State Street, Chicago, by Rapp and Rapp, 1921 (Northwestern)

181 Million Dollar Theatre, South Broadway,
Los Angeles, by A. Martin and W. Woollett, 1918

182 Tower Theatre, South Broadway and West 7th
Street, Los Angeles, by S. C. Lee, 1925–6

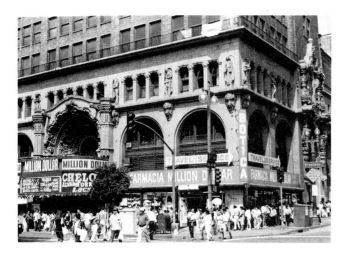

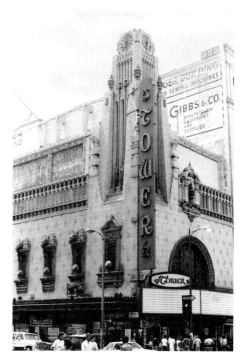

taster for the gilt, drapes and mirrors of the foyer and auditorium. The
Million Dollar Theatre, South Broadway, by Albert Martin and William
Woollett (1918) combined a Churrigueresque entrance arch with oversized
statuary portraying theatrical figures and buffaloes (**181**). S. Charles Lee,
who had trained with Rapp and Rapp, came to dominate cinema architec-
ture in the western cities; the Tower Theatre, also in Broadway (1925–6),
Los Angeles, exemplified his free-ranging approach to terracotta ornament,
with Moorish arcades set over a lattice-patterned wall-surface and beside a
Spanish Renaissance corner tower (**182**).

EXOTIC SHOP-FRONTS

While cinemas retained weighty high-relief decoration long after it had
been banished from skyscrapers, chain-stores and even small corner shops,
erected in huge numbers across America in the inter-war period, show a
more rapid adoption of low-relief forms and unrestrained polychromy.
Atlantic traded on the competitive spirit of retailers, urging the merits of
terracotta in providing 'a front above the ordinary chaos of weather beaten
and discolored building materials'. ✳

In the west-coast city of Oakland, Gladding McBean and N. Clark and
Sons of Alameda used their skills in producing orange, green, deep blue
and low-fired silver and gold glazes to compete in supplying the most
remarkable concentration of art deco shop-fronts in north America, all the

183 Robert Howden and Sons Building,
17th Street and Webster Street, Oakland,
California, by McWithy and Greenleaf, 1923

184 Tower of the Oakland Floral Depot
Building, Telegraph Avenue and 19th Street,
Oakland, California, by A. Evers, 1931

more effective for the simple crispness and modest scale of their façades. Oakland had benefited economically from the disaster that befell neighbouring San Francisco in 1906, and its booster-spirited mayor, John Davie, sought to give his city an architectural expression to match its dynamic growth. The new City Hall was faced with terracotta in a Beaux-Arts style, and the authority worked with 'uptown' investors to create a uniquely ceramic retail district. Modest sewing-machine or dress shops were to be given bright art deco façades, commencing even before New Yorkers had started to assimilate displays at the Paris Exposition. By the end of 1925 Robert Howden and Sons in Webster Street were trading behind a startling black and gold front, designed by McWithy and Greenleaf with slender Moorish columns flanking the entrance (183).

The range of colours and decorative forms became increasingly exotic, culminating in two buildings dating to 1931, both built of reinforced concrete and entirely clad in terracotta. The Oakland Floral Depot, Telegraph Avenue, has a dramatic presence despite its modest two-storey height. The corner tower and the flanking wings are glazed midnight-blue with zigzag, floral and Aztec-derived trim, including a cactus-like spirelet, highlighted in silver (184).

The Breuner Store in Broadway, by Albert Roller, was coated in a sea-green glaze. The company title, images of furniture-making and a frieze of leaves and tendrils were incised into the almost flush wall-surface, which was most notable for Gladding McBean as an early experiment in setting machine-made terracotta into reinforced concrete (185). The bulk of the

185 Breuner Store, Broadway, Oakland, California, by A. Roller, 1931 (Gladding McBean)

terracotta was extruded, so could only carry moulded decoration in one direction. Gladding McBean supplied the terracotta strictly in pace with construction of the building-carcass, grooves being cast into the concrete to provide a stronger bond at critical locations, such as above the window-openings. Anchors set into the concrete carried vertical pencil-rods, the terracotta being initially held in position with wooden bars until a lean concrete grout fixed it to the concrete structure.☆ As with many contracts, it was the small proportion of ornamental work that generated most discussion and occasional rancour. While the clients were apparently satisfied with the machine-made ashlar, Gladding McBean found it disproportionately expensive to make: the clay body had to be very fine, a large amount had to be remade and the metal dies alone cost over $1,000 to fabricate.

Gladding McBean returned a loss in 1931, owing partly to the cost of investing in the production of machine-made ashlar and wall-units.☆ Manufacturers located far distant from the oil and gas boom towns of the Southwest fared even worse. American of Crystal Lake, Illinois, and its subsidiaries had averaged 450–500 orders per year during the mid-twenties but only won fifty-one contracts in 1933.☆ Skyscraper construction came to an almost complete halt, while the Renaissance, Gothic and art deco ornament that had been lavished on them and on cinemas seemed decadent as well as unjustifiably expensive. Taste had already shifted to quieter materials. The building that came to symbolize the inter-war skyscraper, the Empire State Building (1929–31), was clad in stone, which could often be obtained as economically as ceramic ashlar. The streamlined styles that were to be so widely executed in slab faience in Britain were more likely to be executed in concrete and render in the drier and less polluted climate of the American South and West.

The Works Progress Administration, a national relief programme established as part of Roosevelt's New Deal, generated some orders for terracotta, most notably for murals on public buildings and in parks. Peter

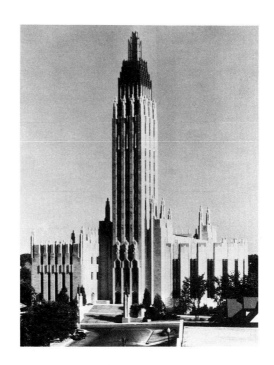

186 Methodist Church, Boston Avenue, Tulsa, Oklahoma, by A. Robinson and/or B. Goff, 1929

Ambrusch executed a series of sculptural projects for the Denver Terra Cotta Company, including the entrance to the library building at Western State College by Temple H. Buell (1939), sculptural work for Natrona County Courthouse (1939) and a massive statue of Christ.

Multiple retailers, especially those expanding in southern states, remained a relatively buoyant source of business. The Samuel H. Kress Company extended its chain of cut-price department stores from its flagship in Fifth Avenue, New York, to the Mexican border. Kress stores of the twenties were often fronted in a Renaissance style with della Robbia details. Gladding McBean found them the ideal client: malleable and likely to offer repeat business. For the Oakland store (1926), their architect allowed the modelling and glazing departments freedom to adjust the disposition of the seven different glazes: 'architect's representative is very liberal minded and will undoubtedly OK without change any recommendations we make'. ✩ He duly approved all the photographs of modelling work without demanding any alterations.

Edward Sibbert, the Kress Company architect from 1929, developed a design formula based on the diverse strands of art deco. Cream terracotta might be moulded into Spanish mission gables or Mayan hieroglyphs or to represent items sold in the store, while the company name was high-lighted in gold enamel. Sibbert achieved his boldest Spanish extravaganza at El Paso, Texas (1937). Motifs derived from the Alhambra were modelled and glazed by Gladding McBean in brilliant red, orange and blue against a beige background, gold being used to embellish the mirador dome and the gable finials (*colour plate 32*). ✩

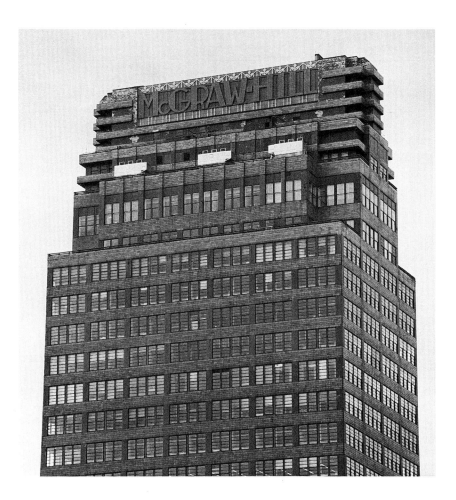

The relatively unfettered use of terracotta in the South emerged at its most dramatic in Tulsa, Oklahoma, a town which grew rapidly during the thirties to fulfil its self-proclaimed title as 'oil capital of the world'. The Boston Avenue Methodist Church was described, following its completion in 1935, as America's only modernist church of cathedral proportions. The designer, Miss Adah Robinson of Tulsa, working in collaboration with local architects Rush, Endicott and Goff, created a jagged skyscraper outline with terracotta worked to a thorough symbolic programme: seven-pointed stars stood for the seven virtues and motifs above the windows represented divine illumination upon mortal ideas (**186**). ✳

SLAB MODERNISM

Symbolism and even more direct narrative decoration had long passed out of favour for commercial buildings. Manufacturers sought economic salvation in slab ceramics, whether extruded as chambered units or cast as slabs, and used to clad exteriors or internal partitions. Each firm had its

own brand-name, single-sheet flyers promoting 'Atlantic Wall Units' or 'American Wall Block' in a bewildering range of glazes including scarlet and lavender. Gladding McBean offered 'Unit Ceramic Veneer' to be mounted on to metal grids and hence on to brick or concrete walls. None gained a very enthusiastic following, machine-made veneer earning the epithet 'terrible cotta'.⁜ The management at Lincoln virtually gave up trying to promote decorative terracotta by 1938, and the competition also drifted into concentrating on tile, sanitary ware or other products. The National Terra Cotta Society folded in 1934.⁜

Only one firm seemed to profit from the shift to plain blocks and slabs. Federal Seaboard was a late arrival in the terracotta trade, emerging as a major New Jersey firm through the amalgamation of three plants in 1928. Their extruded ashlar did not suffer from warpage as it had a solid back. Federal won some major orders, including the first skyscraper to be clad in machine-made terracotta. The McGraw-Hill Building, 42nd Street, New York (1930–1), was faced with ashlar 'laid with the economy of brick' and held together by interlocking clenched joints. Horizontal bands of windows and wall were emphasized, while the main impact of the slab tower came from its blue-green glaze (**187**). The architect, Raymond Hood, had already used deep colours on a New York skyscraper, the American Standard Building in 40th Street (1924). For the McGraw-Hill he developed an aquatic scheme of Dutch blue at the base, with sea-green window-bands – the blue gradually shading off into azure. His client, James McGraw, was initially enthusiastic about a glazing scheme that harked back to his Irish ancestry, but when the building was only half erected he rued the meeting when he chose such assertive colours: 'Perfectly awful. I must have been sick that day.'⁜ From the early thirties most entrepreneurs and architects played safe with a tame, if not bland, use of terracotta, closely associated with the use of plain white or cream tiling for internal stairways and corridors.

II

CONSERVATION AND CONTEMPORARY WORK

The last decade has seen a second revival in terracotta, with the manufacturers that survived the lean years of the sixties blossoming into more optimistic and creative mood. Demand has increased for both conservation and new-build projects, reflecting a consensus in favour of the retention and repair of Victorian and early-twentieth-century buildings, and a growing taste for pattern and colour in modern design.

Ignorance of the nature and qualities of terracotta had led to damage and demolition, symbolized by the grit-blasting of the Albert Hall in London and by the hacking-back of cornices on some of America's finest skyscrapers. Pressure groups such as the Tiles and Architectural Ceramics Society in Britain and the Friends of Terra Cotta in the United States, both founded in 1981, have worked to reverse entrenched prejudice and promote a broader appreciation of ceramics in their varied guises. Terracotta never passed so heavily out of favour in America as in Britain, but, partly on account of weaker conservation legislation, the record of loss is more severe. Several of Sullivan's finest ceramic skyscrapers have been demolished while seminal examples of the Chicago style, such as Burnham's Reliance Building, have been shorn of their projecting cornices. Probably the finest surviving interior scheme of tiling and faience in the country, Atlantic's murals of ships at sea, lining the basement restaurant of the McAlpin Hotel by F. M. Andrews (1915), were cut out as part of an insensitive refurbishment programme as recently as 1990.

Conferences, experimentation, and conflict at a public inquiry concerning the Hackney Empire Theatre in London have helped to define an ethical standpoint for the conservation of terracotta architecture in Britain. The inquiry, of 1983, considered whether terracotta or cheaper substitute materials should be used in the reconstruction of the domes supplied by Hathern for one of Britain's finest variety theatres. The ruling, in favour of ceramics as being integral to Matcham's 1900 design, and the successful completion of the new domes and central statue in 1988 created an example applicable to other conservation cases involving terracotta (**188**). ✩

The saga of the domes of the Hackney Empire and other less positive case histories have helped to define broad principles of best practice in the cleaning and repair of terracotta: the integrity of the original material should be protected, cleaning should be as mild as is compatible with the need to brighten the appearance of the building, as much as possible of the terracotta should be retained, and any replacement pieces should preferably be made in ceramic rather than substitute materials. Coatings, harsh acidic cleaners

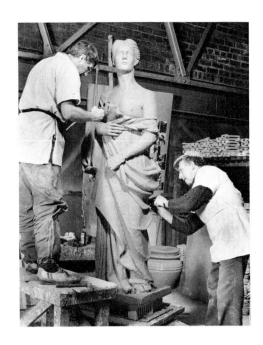

188 Modelling the statue to be set on the
gable of the Hackney Empire, London,
1987 (Shaw)

and glass-reinforced plastic replacement blocks are widely regarded as second-best or even unacceptable.

No comparable consensus has emerged in America, partly owing to the daunting number and size of the buildings involved, and to the geographical separation of specialists working in New York, Chicago or San Francisco. The most fundamental factor is the nature of the material itself. In Britain the bulk of Victorian and Edwardian terracotta is unglazed, presenting the natural surface of burnt and slightly vitrified clay. Most conservationists accept that such red or buff surfaces cannot be replicated by other material, and this principle has been accepted for the most impressive schemes of faience, especially those involving complex polychromy.

In contrast, the vast bulk of American terracotta is of glazed finish, with a wide variety of colours, textures and special effects produced by different manufacturers, but with anonymous white and cream finishes predominating in most downtown areas. Substitute materials and coatings seem more plausible in the American context, especially for balconies and cornices set way above street level, when any saving in weight can dramatically reduce costs of installation.

CAUSES OF FAILURE

Terracotta, like any other material, may develop faults which can culminate in failure, the result being catastrophic if a cornice falls over twenty storeys on to a sidewalk. The faults may have their origin in mistakes in manufacture or installation or may arise through lack of maintenance, though the

189 Blocks damaged by water ingress cut away from the cornice of the Royal Albert Hall, London

190 Spalling on Macy's Store, O'Farrel Street, San Francisco, by L. Hobart, 1928 and 1948

precise cause may be difficult to isolate. Temperature fluctuations can lead to glaze-crazing if the glaze and the clay body have different thermal coefficients of expansion. Small random cracks may develop as the body expands more than the glaze, allowing water to enter the clay body. Subsequent frosts may result in spalling. Of the British variants of terracotta, only buff and pink ware of the 1870s and 80s are likely to suffer from spalling, usually as a result of being underfired. Water ingress appears to have been one factor behind the cracking of part of the balcony of the Albert Hall in London, with the consequence that the offending blocks had to be either consolidated with epoxy resin or cut away and replaced (**189**). Dozens of early-twentieth-century buildings in the Pacific cities of San Francisco, Portland and Seattle have experienced a particularly serious form of exfoliation, with the face of the blocks peeling away like rind. There appears to be no single cause, glazes having disguised a wide variety of clay bodies that deteriorate in different ways. Many of San Francisco's terracotta buildings have blocks with a very coarse porous body, which may make them more susceptible to water-absorption (**190**).

Moisture is the prime agent of destruction; once absorbed into the fabric of a wall it can cause supports to rust, and clay bodies to expand and hence buckle or split. Moisture that enters terracotta from its face or that runs behind the blocks may corrode supporting metal anchors. The pressure created by the rust will, in turn, crack the blocks. Water can also wreak havoc by carrying airborne chemicals, transporting salts and encouraging biological growth in joints and crazing-lines. Only from the 1920s were terracotta schemes likely to be designed with weep-holes to drain away any water that had penetrated the wall-surface, or with expansion joints to absorb compressive stresses generated by expansion of the blocks.

Poor repairs can compound these problems. The indiscriminate use of sealants may trap moisture, unsuitable cleaning agents can attack mortar, and abrasive cleaning will damage the fireskin or the glaze and hence encourage water penetration. Epoxy paints also act as traps and may result in both the paint finish and the underlying glaze spalling away.

ANALYSIS

Analysis has emerged as a vital prelude to any remedial or refurbishment work. While in Britain conservation architects and planners liaise closely with manufacturers, consulting engineers have emerged as important intermediaries in several American cities. Whatever the pattern of collaboration, the fabric – its style, composition and condition – must be carefully studied, a task aided by the archives of drawings, photographs and order-books held by manufacturers or entrusted to museums. Remarkable collections survive for buildings by Hathern, Shaw and Carter in Britain, and for Northwestern, New York and Gladding McBean in the United States. Professionals increasingly emphasize the merits of a systematic examination of walls, using binoculars or ideally a suspended swing-stage, to reduce the need for the destructive cutting-away of blocks. Signs of spalling, cracks and any other deterioration are plotted on large-scale elevation drawings and analysed to deduce patterns of stress or water penetration.

Several more sophisticated techniques have been developed for field and laboratory testing of the material, to provide a more precise measure of deterioration. Internal cracks and delaminations may be detected through radio, pulse radar, or more typically optical microscopes. Infra-red scans or photographs may detect sources of heat-loss in the building façade, caused by internal cracks in the terracotta or voids in the adjoining brickwork, and can be used to locate metal anchors, steel having a higher thermal conductivity than ceramic.

Rust is one of the most frequent causes of problems with terracotta; determining the location of embedded girders and hooks is usually a vital prelude to any conservation work. Archives may provide crucial information on the nature of a steel frame and more intricate support systems. In the absence of such documentation, a metal detector can be used. The scale of corrosion may be determined by inserting a probe into a small drilled hole to make contact with suspect steelwork while a lead is moved across the wall-surface; changes in the electric reading can indicate the presence of rust. ✶

Many skyscrapers are subject to physical movement, and cracks in wall-surfaces may indicate the internal cause of deterioration. Fissures may be monitored by glass telltales and gauges, and the level of stress measured by the use of resistance gauges. American engineers increasingly favour

laboratory testing of samples of terracotta, blocks being taken from different sections of the building, to provide a balanced view of its condition. Different tests can determine the original firing temperature, the absorption and saturation coefficient, shear strength, glaze adhesion and elemental composition, and the degree of likely moisture expansion.

CLEANING TECHNOLOGY

Terracotta used to be promoted as a self-cleaning building material, soot being washed away by each shower. In the damp climate of the American Northwest, where there is little pollution or frost, this claim might be justifiable, but elsewhere a periodic wash and occasional scrub proved necessary to prevent a build-up of grime. Owners and contractors have too often responded to blackened red terracotta or streaked faience with drastic measures, seeking to return buildings to their original or even a mythical sheen by one over-zealous cleaning. In Britain the terracotta of the Albert Hall proved to be the necessary sacrifice; the grit-blasting of 1971 ripped away much of the detailing, but has become a *cause célèbre* and an oft-quoted lesson. Abrasive methods, ranging from sanding-discs to a 'microparticle' system used on the Natural History Museum, are now largely distrusted for cleaning terracotta. American conservationists, meanwhile, still have to battle not only against grit-blasting but against the 'quick-fix' practice of simply painting over glazes in an appropriate colour. Paint forms a water-barrier, trapping moisture inside the block and eventually causing the terracotta to deteriorate.

The initial enthusiasm for abrasive techniques gave way, during the late seventies, to acid cleaning. The most widely used agent, hydrofluoric acid, is highly effective as a cleaner, but, as can be seen on the front of the Natural History Museum in London, may etch into the fireskin, attacking silicates and causing streaking. Over the last few years, conservationists have used weak concentrations of hydrofluoric acid in conjunction with alkali gels or poultices to achieve comparable results with less danger of irretrievable damage.✶ The main risk in specifying acidic or caustic solutions is that contractors might 'spike' fluids, increasing the concentration to transform the elevation to a sparkling cleanliness in the shortest possible time.✶

Neutral detergents are another option, currently in favour for being less likely to damage glazes or fireskins, but with the drawback that they may not remove every trace of soiling. Conservation architects have not committed themselves to one particular type of chemical or procedure but prefer to test and then choose between neutral or mildly alkaline detergents, or mild hydrofluoric acids followed by a neutralizing wash. They usually

191 Hunter-Dulin Building, 111 Sutter Street, San Francisco, by Schultze and Weaver, 1926, with blocks repaired with BMC showing problems with efflorescence

specify that surfaces should be pre-wetted and finally well rinsed. Care must be taken to avoid excessive washing, which could trigger efflorescence. Some experts recommend cleaning with nothing other than water, allowing a sprinkler hose to run for 24 to 100 hours. However, cleaning with water alone will not shift the layers of grime that will have accumulated in industrial cities. A well-researched, complex and carefully controlled programme of cleaning may be necessary if dirt is to be removed without damaging the terracotta.

SUBSTITUTION OR REMANUFACTURE

The current philosophy of terracotta repair has close analogies to dentistry: halt deterioration, ensure that the fixing is secure and repair wherever possible using consolidants, replacement being the expensive final option.

Small areas of spalling may be repaired by cleaning away loose material with hand-tools. The damaged area is then painted with an acrylic-based paint. Any patches used to fill cavities must have the same thermal coefficient of expansion as the terracotta body and must be carefully keyed into the ceramic fabric. In America intricately moulded surfaces have been built up with BMC (breathable masonry coating) and repointed to prevent further water ingress (**191**). Such repairs are relatively economical as they can be carried out from a suspended stage, avoiding the need for highly expensive scaffolding. Where justified by the artistic quality of the design, high standards of patching can be achieved using fillers developed for precision conservation work.

Fibreglass is one of the cheapest substitutes for damaged terracotta, and is light and economical to install. Since plastic resins deteriorate when exposed to light, fibreglass needs to be protected by a light-resistant gel coat, but these themselves discolour over a period of around ten years.

Fibreglass cannot be used to reproduce intricate high-relief ornament because of its laminated form: it is best suited to ornament with flat planes or large curves. In America, extremely simple forms such as plain cornices are sometimes reproduced even more economically in sheet metal.✩

Pre-cast concrete is a tempting alternative, its negligible shrinkage permitting moulds to be taken directly from existing ornament. The most visible disadvantage is its tendency to change colour when wet and hence stand out from surrounding ceramic surfaces. A composite concrete, Micro-cotta, has aroused considerable controversy in Chicago, where it has been used on the Santa Fe and Wrigley Buildings (171). This polymer-based composite concrete is lighter than terracotta, and surface coatings can replicate the texture of a glaze finish. Unfortunately such finishes have not proved to be light-fast, white turning to a buttery cream colour.

Terracotta is acknowledged to be the logical and most acceptable replacement for broken or damaged blocks whenever budgets allow. Remanufacture, whether of just a few sections of cornice or a complete gable, helped to revive the fortunes of the surviving terracotta manufacturers just before many draughtsmen or modellers would have taken their skills into retirement. Ibstock Hathernware and Shaws of Darwen in Britain and Gladding McBean in America have developed a well-organized but flexible approach to handling conservation projects. Photographs, both archival and contemporary, and any key-drawings are studied in conjunction with fragments of terracotta blocks brought back to the factory, with the aim of developing full-size and then shrinkage-scale drawings. The firm can refer to its archives of architects' and shop drawings, covering many of its thousands of past contracts, which may provide detailed designs for missing features that need to be remanufactured. Standards of modelling, colour-matching and fixing have advanced rapidly, and computer-aided design, already used in developing schedules for decorative bricks, can speed up the generation of full-size and then shrinkage-scale drawings.

The extent of replacement varies according to the condition of the original work, the budget available, and the desirability of retaining as much of the original fabric as possible. Detective work in the form of historical and archaeological research may be necessary to gain a full understanding of the fabric and the intentions of the original architect or builder. At Cliveden, Buckinghamshire, the conservation architect, Julian Harrap, had to unravel a complex combination of stone, render and terracotta, Ibstock Hathernware replacing severely damaged balusters, basket vases and finials during 1985–8 (colour plate 3). The availability of grant aid may dictate the pace of refurbishment work, a phased programme having been followed from 1981–9 at Castle Ashby, Northamptonshire, for the remanufacture of some of the garden ornaments (50).

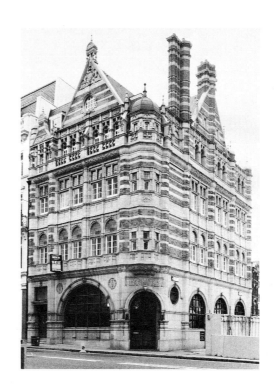

192 City Bank, Ludgate Hill, London, by T. E. Collcutt, 1890 (Doulton) refurbished by Archer Boxer Partners (Hathern)

A truly conservationist approach has been developed for the Tudor masterpiece Sutton Place. The architect responsible, Julian Harrap, had to contend with irregular block-sizes and colours, and coarsely mixed clay bodies pierced by air-holes. Some blocks on the building are themselves replacements and others have been painted over or even relocated. A very fine non-silica abrasive cleaning created a clean surface for injecting ethyl silicone consolidants while leaving the fireskin intact. Replacement blocks supplied by Hathern were given a rough texture and appropriate colour variations to blend in with original material and earlier repair work (*colour plate 5*).

MODERN DESIGN

Refurbishment programmes frequently involve some wholly new work, designed in a style sympathetic to though not directly imitative of the original. During 1989, some of the pink Doulton blocks on the City Bank, Ludgate Hill, London, by T. E. Collcutt, were consolidated or replaced, while Archer Boxer Partners designed a gabled extension wing in matching colours of brick and terracotta dressings (**192**). Commencing in the same year, Ibstock Hathernware have been involved in a major conservation and redevelopment programme at the Prudential head office in London. Over 500 blocks have been supplied to repair existing façades and courtyards, while new gables, plinths and copings have been designed by the EPR

223

193 Tesco Supermarket, behind the Hoover
Building, Western Avenue, London, by Lyons,
Sleeman and Hoare, 1992
(Ibstock Hathernware)

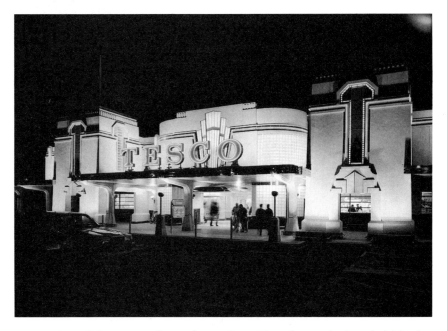

Partnership, following, where appropriate, Waterhouse designs held in the Prudential archives (*colour plate 11*). A more assertive combination of historic and contemporary design was achieved in 1992 at the Hoover Building in West London. While the thirties office block has been meticulously repaired (*colour plate 19*), the associated factory has been cleared for a supermarket, designed by Lyons, Sleeman and Hoare in a complementary art deco style. Bands of orange and black glazed tiling, stainless steel and glass bricks highlight the entrance and counter the anonymous image of most super-stores (**193**).

Gladding McBean must be credited with the most dramatic example of 'in-keeping' extension: no fewer than twenty-two storeys of terracotta were added in a matching Gothic style to the Continent Tower in Tulsa, Oklahoma, in 1982–3. The 5 million dollars' worth of terracotta made by Gladding McBean was set in glass-reinforced concrete, these large panels being attached, in turn, to the metal frame by loops, in a form of system building.

Most new buildings incorporating terracotta in Britain have been given simple detailing, partly owing to economic constraints but also on account of timidity in handling such an intrinsically decorative material. The cost of new-build projects can be reduced by using computer-aided design, especially if the scheme involves extensive repetition. In the case of the Barnard's Inn development, in Holborn, London, by Green Lloyd Associates, 1991–2, installation costs were reduced by designing the terracotta to be hung on steel hangers, rather than integrated into the building structure

plate 31 **Faience polychromy on San Francisco, Acatapec, near Puebla, Mexico,** *c.* **1800**

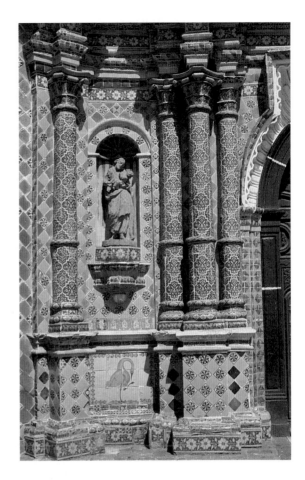

plate 32 **S. H. Kress Store, Oregon Street and Mills Street, El Paso, Texas, by E. F. Sibbert, 1937**

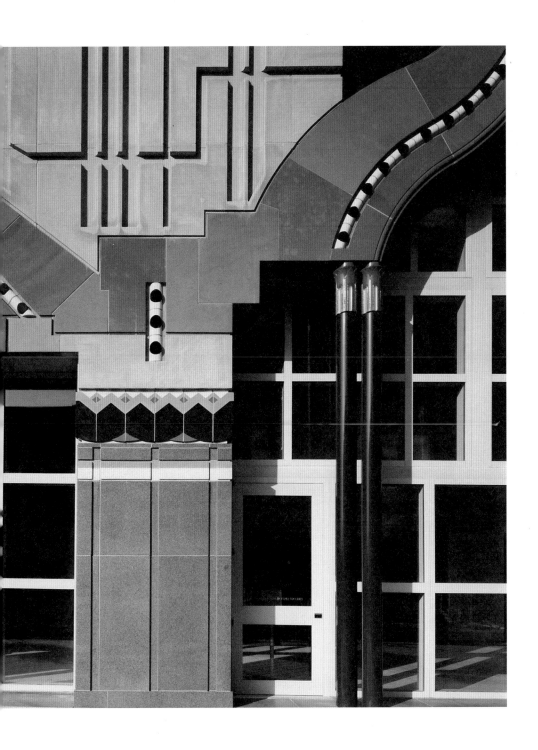

plate 35 **Barnard's Inn, Fetter Lane, London,
with terracotta half-columns and window
arches, by Green Lloyd Associates, 1991–2
(Ibstock Hathernware)**

plate 37 **Atrium, 23 Austin Friars, London, by
Rolfe Judd, 1991 (Hathern)**

plate 36 **Cavern Walks, Liverpool, by
Backhouse Design Consultants (Hathern)**

plate 38 **Nordoff Robbins Musical Therapy
School, Lissenden Gardens, London, by
Douglas Binnie of Sampson Associates, 1990
(Hathern)**

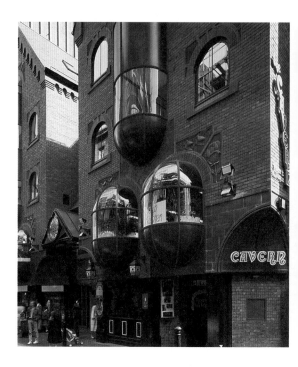

(*colour plate 35*). Further economies can be achieved if designs allow for blocks or slabs to be extruded rather than hand-pressed. During late 1992 Ibstock Hathernware laid out a production line for the extrusion of 30,000 slabs, 70 mm thick and 300 mm wide, and for glazing them to a sea-green colour. They will form a dramatic curved roof for the Mercury Communications Training College in Coventry, designed by MacCormac, Jamieson, Prichard. David Backhouse is one of the few architects to explore terracotta's potential with zest, opting for polychromy with his Gardens Developments in St Anne's Square, Manchester, where consoles are coated in a rich blue glaze, and sculpture in the form of red Lancashire roses and Liver birds for Cavern Walks in Liverpool (*colour plate 36*). One of the more impressive recent schemes is hidden from public appreciation in the internal courtyard of 23 Austin Friars in the City of London. Banded brown terracotta and cream faience and brown piers take their cue from a façade by Aston Webb dating to 1888; the scheme by Rolfe Judd Architects extends with moulded pilasters of brown faience up to fifth-floor level, creating a dramatically original atrium (*colour plate 37*).

The renaissance of ceramic figure sculpture over the past couple of decades has focused more on carved brick than on terracotta, especially through the low-relief murals executed by Walter Ritchie. However, several sculptors are now undertaking outdoor commissions in stoneware. Kate Malone undertakes large-scale projects in the form of plaques, fountains and 'lake sculpture' inspired by deep-sea images. The kiln in her London studio permits huge jugs or fishes up to 4 feet high to be moulded and fired in one piece. Meanwhile terracotta manufacturers are welcoming opportunities for collaboration with art schools and decorative artists. A successful example of such collaboration is presented in the main elevation of the Nordoff–Robbins Music Therapy Centre in Lissenden Gardens, London. A statue of a boy reaching up to play a drum is integrated into the façade designed by Sampson Associates, Douglas Binnie acting as both sculptor and project architect (*colour plate 38*).

The use of terracotta for contemporary design has been more adventurous in the United States, where architects are probably encouraged by the material's historic association with such American icons as the Woolworth and Wrigley Buildings. One of the most important projects that helped bring terracotta back into the limelight was the cool, elegant Los Angeles County Museum of Art designed by Hardy Holzman Pfeiffer: the façade has banded mouldings in an olive-green-glazed terracotta, while profiled columns of a matching finish attract visitors to the main entrance. More recently, John Burgee has produced a skyscraper design clad in cream terracotta for 343 Sansome Street, San Francisco (*colour plate 33*). Venturi Scott Brown have taken a bolder stance in favour of ceramic polychromy. The Medical Research Building for the University College of Los Angeles has

194 (left) Two Rodeo Drive, Beverly Hills
under construction, by Kaplin, McLaughlin,
Diaz, Brand and Allan, 1990 (Gladding McBean)

195 Medical Research Laboratories, UCLA,
Los Angeles, by Venturi Scott Brown

walls with arcaded openings, to relate to several Romanesque buildings on
the campus, and is decorated in a startling scatter of colours executed in
red brick, cast stone, limestone and granite as well as in glazed and natural
terracotta (**195**). At Seattle Art Museum Venturi Scott Brown have used
ceramics to create jazzy capitals and beadings in yellow, white and black
glazes, arranged to compensate for the lack of windows in the upper floors
(*colour plate 34*).

Ceramics have gained high credibility in American architecture without
being too tightly tied to a particular brand of post-modernism. The major
manufacturers are working on an ever-expanding range of new-build and
conservation projects. Over the summer of 1988 Gladding McBean were
producing terracotta for new buildings in Disneyland and for Two Rodeo
Drive, Los Angeles, a prestigious street development lined with ritzy bou-
tiques designed by Kaplin, McLaughlin, Diaz, Brand and Allan (**194**). The
cost of terracotta for such new-build schemes is generally much lower per
cubic foot than for conservation work, and the profits potentially larger.
Forms are simpler and a high degree of repetition can normally be achieved.
Gladding McBean hold a trump card for new work through their remark-
able capability, unmatched by most British firms, to extrude terracotta, thus
avoiding the time and expense of laborious hand-pressing and trimming.

Americans have proved more adventurous in promoting a wider appreci-
ation of the potential of terracotta within modern architecture. The National

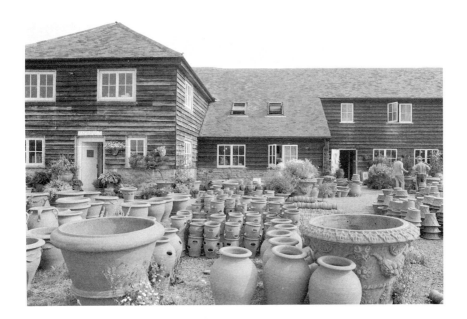

**196 The Whichford Pottery, Warwickshire,
with terracotta vases ready for delivery**

Building Museum's contemporary Terra Cotta Competition of 1985 may
not have generated the profoundest of designs but it did further links
between artists and manufacturers, in particular with the firm of Ludowici
Celadon, who agreed to reproduce and market the winning ideas. Most of
the competitors submitted drawings for tiles with decorative surface-
patterns; the most appealing was for tiles shaped like the profile of a pigeon,
which interlocked to generate more complex and abstract patterns.

Some of the themes of the Washington competition were developed in
an exhibition entitled *Firing the Imagination: Artists and Architects Use Clay*,
shown in New York during 1988. Six artist/architect teams explored the
potential for using clay in contemporary architectural settings. Ideas
included simple terracotta units in the form of large slabs, an 18-foot-high
canted wall for vacant urban lots and a monumental sculpture for a street
corner. ✩

British potters and architects have also been collaborating to explore the
artistic and commercial potential of large moulded clayware. Jim Keeling
has applied his personal interest in Italian hand-thrown ceramics to the
production of a range of terracotta vases at his Whichford Pottery in the
Cotswolds (**196**). Another potter strongly enamoured of terracotta, David
Birch, has developed a working collaboration with the architect Robert
Adam to create designs and models for ornaments that can be mass-
produced for the building trade and for domestic work in particular. Birch

197 'Blue Cross Octagon': tile shard by
Susan Tunick

and Adam have produced designs for simple rosettes and mouldings which
are ideal for repeated use in domestic contexts. As an initial experiment
Adam incorporated them into window-surrounds on his own home near
Winchester in Hampshire, along with a more individualistic terracotta flue
and finial whose spiral form is topped by a gold and red ball (198).

The increasingly dramatic use of tile in subways and other public places,
especially in America, offers a lead for a more innovative approach to
terracotta. Among the artists who produced designs for the Buffalo subway
system, one, Farley Tobin, executed Islamic patterns in bright colours.
Elsewhere decorative artists are working in a less architectural and more
fully sculptural manner creating panels, friezes or columned forms in excit-
ing shapes and complex schemes of glaze and acrylic pigment.✶ American
artists now evince open enthusiasm for exploring the potential of tile and
terracotta (197). The spirit of creative collaboration, nurtured by Henry
Cole and Walter Smith and apparent in the quadrangle of the Victoria and
Albert Museum or the modelling work of Kristian Schneider, remains alive
on both sides of the Atlantic.

198 Terracotta capital, architect's house,
Winchester, Hampshire, by R. Adam

The Major Manufacturers of Terracotta and Faience in Great Britain

The dates embrace the period when terracotta was likely to have been made, or are indicated by references to the material's production.

Accrington Brick and Tile Company
1890–1939 Accrington, Lancashire

This firm, one of the pioneers in exploiting the Lancashire shales for ceramics, produced decorative plaques and other components for use in houses. After it was reconstituted c.1925 its main output became facing and engineering bricks.

Bispham Hall Colliery Company
1906–33 Wigan, Lancashire

Established around 1901, Bispham specialized in making grey terracotta, and faience with white- and cream-glazed finishes.

Mark Henry Blanchard
1839–c.1880 London
Mark Henry Blanchard and Company
c.1883 Bishop's Waltham, Hampshire

Having worked at Coade, Mark Blanchard set up on his own account, initially to undertake plasterwork. His most important early contracts were for the Victoria and Albert Museum. During the 1870s he moved to Bishop's Waltham, but his works came to concentrate on producing bricks and roofing and paving tiles.

John Blashfield
1851–8 London
1859–75 Stamford, Lincolnshire

Blashfield was among the purchasers of Coade moulds. By the end of 1851 he was making terracotta at Millwall. Production was transferred to Stamford to be nearer clay-beds, and a range of wares from classical ornaments to architectural dressings was made both to order and to be sold ex-catalogue.

Burmantofts
see **Leeds Fireclay Company**

Candy and Company
1886–1914 Heathfield, Devon

Candy were founded around 1880 to exploit white ball clays suitable for both bricks and buff terracotta. In the twentieth century the major growth was in the manufacture of tiles and glazed bricks for fireplaces.

Carter and Company
1886–1939 Poole, Dorset

Jesse Carter's firm became established as a clayworks in Poole in 1873. By the start of the twentieth century Carter had become one of the country's leading firms making tiles, faience and pottery. Most of the larger architectural schemes used a single-fired faience, often glazed in strikingly original colours.

Cattybrook Brick Company
1886–90 Aldmondsbury, near Bristol, Avon

Having primarily produced engineering bricks, the firm broadened its output to include terracotta, to be found mostly on suburban houses in the Bristol area.

Clark and Rea
1890–8 Wrexham, Clwyd

This firm supplied a large number of major contracts in Lancashire, the Midlands and London, most of them executed in red, pink or orange terracotta.

Joseph Cliff and Sons
1849–67 Leeds, West Yorkshire

Cliff was one of the earliest firms to use the Leeds fireclay for making firebricks. They developed a strong reputation for their glazed ware, but in 1889 the business became part of Leeds Fireclay.

Coade's Artificial Stone Manufactory
1769–1838 London

The most important of the artificial stone manufacturers, whose works was established by Eleanor Coade when she came up from Dorset. The manufactory was at its peak when John Bacon was among the sculptors working for Coade.

Coalbrookdale Company
c.1861–7 Coalbrookdale, Shropshire

This firm of ironfounders established several commercial brickworks; in 1861 a terracotta works was established and ornamental products were displayed at the 1862 International Exhibition.

S. and E. Collier
1886–1929 Reading, Berkshire

This was the only firm to use Reading clays for making terracotta on a large scale. It was founded in 1848 and produced bricks, roofing tiles, finials and a variety of terracotta decorations. Some constructional forms of terracotta were made at the end of the nineteenth century.

Craven Dunnill and Company
1898–1906 Jackfield, Shropshire

A tileworks established in the early 1870s. Having manufactured encaustic and printed-enamel tiles, Craven Dunnill supplied faience during the 1890s. By the inter-war period they had reverted to concentrating on tile production.

William Cubitt and Company
1850–66 London
These building contractors had a kiln at their depot which was used for making terracotta.

Della Robbia Pottery
1894–1906 Birkenhead, Wirral
This pottery was founded in 1895 by Basil Rathbone and Conrad Dressler. Glazed panels, tiles, figures, and fountains were produced in an Arts and Crafts idiom.

Henry Dennis
1890–1933 Ruabon, Clwyd
Henry Dennis was a Cornish engineer who first pursued a career in building railways and investing in coal and lead mines. One of his companies, which traded under the title of 'Dennis Ruabon', undertook several large contracts for terracotta around the turn of the century, but output became concentrated on red quarry tiles.

Doulton and Watts
1820s–c.1846 London
Doulton and Company
c.1846–1939 London
1883–1910 Rowley Regis, West Midlands
Doulton's production of terracotta and faience continued for well over a century. The firm was responsible for a unique variety of ceramic compositions, and collaborated closely with sculptors and decorative artists. John Doulton began producing terracotta building components in the 1820s, but it was his son Henry who introduced sculptural work and attracted several decorative artists to the factory at Lambeth. A new works was established at Rowley

Regis in 1889 to supply the Midlands and the north of England.

J. C. Edwards
1870s–c.1930 Ruabon, Clwyd
This firm became renowned in the late nineteenth century as the largest manufacturer of terracotta in Britain. The Pen-y-bont works was established around 1870 and used for making roofing tiles, red facing-bricks, and the red terracotta for which the firm became famous.

Messrs Ferguson, Miller and Company
1851–3 Heathfield, Strathclyde
This works was one of the earliest manufacturers of terracotta in Scotland, producing large vases and fountains in the early 1850s.

Colonel John Fletcher
1842–51 Bolton, Lancashire
Having discovered seams of fireclay in his colliery, Fletcher promoted the construction of a terracotta church at nearby Lever Bridge. By the late forties the Ladyshore works was advertising a range of decorative products.

Garnkirk Coal Company
1833–53 Heathfield, Strathclyde
This company was probably the first to produce terracotta in Scotland, an extensive range of products being advertised in 1833, including firebricks, paving- and ridge-tiles, and ornamental chimney-pots and vases.

Gibbs and Canning
1867–1940 Tamworth, Staffordshire
Gibbs and Canning pioneered the transformation of terracotta manufacture from being largely of ornamental ware, made in potteries, to the undertaking of large architectural contracts by works located in coalfields. The works was established in 1847 and

was possibly the first to make glazed socket-pipes in England. Three main groups of products were developed: glazed pipes and sanitary ware, bricks and tiles, and terracotta. The firm's buff-coloured terracotta was widely used in South Kensington and for a series of major contracts in the Midlands during the 1880s.

Gunton Brothers
c.1870–1914 Costessey, Norfolk
By 1851 George Gunton was offering ornamental chimneys, Tudor-style window-frames, turrets, cornices and copings. During the 1870s Costessey brickwork and terracotta was being used throughout East Anglia, especially for window-tracery.

Hathern Station Brick and Terra Cotta Company
1883–1939 Hathern, Leicestershire
Hathernware Limited
1934–79
Hathernware Ceramics Limited
1979–90
Ibstock Hathernware
1990 to date
This firm became one of the most successful of British terracotta manufacturers during the inter-war period, and is now one of only two still making architectural ceramics in Britain. Their works was founded in 1874 by George Hodson, the sanitary inspector for Loughborough Board of Health, when he discovered good beds of clay at Sutton Bonnington. Designs for architectural forms, such as window-surrounds, were published in 1883. The terracotta section developed rapidly from 1896. During the First World War chemical stoneware was introduced to compensate for the slump in demand for architectural work.

Huncoat Brick and Terra Cotta Company
1898–1933 Accrington, Lancashire

This company was formed in 1894 initially to supply facing- and engineering bricks.

George Jennings

c.1860–1910 Poole, Dorset

Pale grey or yellow terracotta made by Jennings was used extensively in Poole, on the nearby Canford estate and in south London, where Jennings was involved in property development.

Lagan Vale Estate Brick and Terra Cotta Works

1898–1920 Belfast, Northern Ireland

This was the only clayworks in Ulster to make terracotta on any scale. It was established by H. R. Vaughan in conjunction with a building contractor from Belfast.

Messrs Wilcock and Company

1858–89 Burmantofts, Leeds, West Yorkshire

Leeds Fireclay Company

1889–c.1946

This firm developed into the largest clay-working business in the north of England, having works at Leeds, Halifax, Hipperholme and Huddersfield. The first terracotta to be produced was a range of stock architectural details, but by the late 1880s the firm was producing large blocks and slabs of architectural faience, under the brand name of Burmantofts. The name was to be widely used by Alfred Waterhouse.

Leeds Pottery and Middleton Fireclay Works

1909–c.1914 Leeds, Yorkshire

Middleton Fireclay Company

1925–39

Founded as an offshoot of the Leeds Fireclay Company, this firm became a significant competitor in the inter-war period.

Maw and Company

1862–83 Benthall, Shropshire
1883–1910 Jackfield, Shropshire

In the late nineteenth century Maw was possibly the largest manufacturer of decorative tiles in the world. During this period the firm supplied some dramatic schemes incorporating faience.

Messrs Minton, Hollins and Company

c.1865–c.1905 Stoke-on-Trent, Staffordshire

Minton Hollins produced impressive forms of majolica which were displayed at exhibitions and used within the Victoria and Albert Museum. By the turn of the century they were making fountains in both majolica and faience.

James Pulham and Son

c.1846–c.1880 Broxbourne, Hertfordshire

James Pulham made terracotta from the 1840s. Ultimately the firm gave up architectural decoration to concentrate on garden and landscape work.

Ruabon Brick and Terra Cotta Company Limited

1890–1939 Ruabon, Clwyd

This works was established in 1883. The bulk of the production was in the form of bricks and tiles.

Shaw's Glazed Brick Company

1909–35 Darwen, Lancashire

Shaws of Darwen

1935 to date

Shaws' works was established in 1897 through the reorganization of an established firm in the firebrick trade. Arthur Gerald Shaw moved the factory to a new works at Whitebirk in 1908, the manufacture of architectural ceramics developing from this date. Shaw became particularly successful in the 1930s in producing slab faience. Fireplaces and grave ornaments were also made during the thirties, while chemical stoneware and porcelain insulators were introduced during the Second World War.

Stanley Brothers

1881–1920 Nuneaton, Warwickshire

Reginald Stanley became involved in brick and tile manufacture in Nuneaton after spending ten years in North America. His terracotta was mostly in the form of simple architectural details and garden ornaments, the firm being best known for its engineering bricks.

James Stiff and Sons

1876–1910 London

Buff terracotta was worked into vases, statuary, coats of arms and architectural details by a firm better known for its stoneware pots and jugs.

Watcombe Terra Cotta Company

1872–90 Torquay, Devon

This was a relatively late firm to be established specifically to produce decorative rather than architectural terracotta. Classical-style vases and hand-painted plates were made in large numbers and some small-scale architectural contracts were undertaken.

Messrs Wilcock and Company

see **Leeds Fireclay Company**

George Woolliscroft and Son

1894–1909 Hanley, Staffordshire

Success in tile manufacture led to the introduction of a single-fired faience, which was used for several architectural contracts during the Edwardian period.

Appendix 2

The Major Manufacturers of Terracotta in the United States

American Terra Cotta and Ceramic Company

1888–1931 Terra Cotta, Illinois
This firm evolved from the Spring Valley Tile Works, founded by William D. Gates in 1881 and based in a redundant sawmill at Spring Valley forty-five miles north-west of Chicago. Gates increasingly concentrated on pottery and terracotta. A farmhouse was converted into a pottery to make vases; the most distinctive had a matt, waxy-looking glaze and were branded as Teco Ware around 1900. Supplied buildings in Chicago, St Paul and Minneapolis.

Atlanta Terra Cotta Company

1895–1908 East Point, Atlanta, Georgia
This company succeeded Pelligrini and Castelberry, founded in 1875. The Atlantic Terra Cotta Company gained control of the works in 1908.

Atlantic Terra Cotta Company

1897–1943 Tottenville, Staten Island; Perth Amboy, New Jersey; Rocky Hill, New Jersey; West Point, Atlanta, Georgia
Atlantic was first established in 1897 with a works at Tottenville, several of the staff having been trained at Perth Amboy. In 1907 Perth Amboy, Excelsior and Atlantic amalgamated. Soon afterwards Atlantic gained control of the Standard Terra Cotta Works and the Atlanta Company in rapid succession, to emerge as reputedly the largest manufacturer in the world and supplying the bulk of New York's terracotta skyscrapers.

Boston Terra Cotta Company

1880–93 Boston, Massachusetts
Evolved from the Boston Fire Brick Company, with George Fiske as treasurer and James Taylor as superintendent. The company was sold to the Perth Amboy and New York companies in 1893 and liquidated.

Burns–Russell Company

1885–1905 Baltimore, Maryland
A major manufacturer of facing-brick which made some terracotta under the title of the Baltimore Terra Cotta Company. In 1905 the firm sold this side of their business to Maryland.

Celadon Terra Cotta Company

1889–1909 Alfred, New York
The company made architectural terracotta and chimney-pots as well as brick and roofing tile. It was reformed in 1906, as Ludowici Celadon and relocated in Ohio following a fire in 1909. This firm, which concentrated on making roofing-tiles, briefly made terracotta for both conservation and new-build commissions.

Chicago Terra Cotta Company

1868–79 Chicago, Illinois
Established to produce horticultural and architectural terracotta by two Chicago florists and seed-dealers, H. Hovey and J. F. Nichols, who bought Joseph Glover's pottery in Indianapolis in 1868. Production was transferred to Chicago soon afterwards. The treasurer, Sanford Loring, acquired the services of James Taylor, who was appointed supervisor of the works in 1870. A branch factory was opened in Boston. Financial wranglings resulted in the closure of the Boston works and in 1879 the Chicago Terra Cotta Company passed into liquidation.

N. Clark and Sons

1889–1950 Sacramento and West Alameda, California
This company succeeded a business established in 1864 by Nehemiah Clark. His Sacramento works was supplemented by a new works at West Alameda in 1887. The former was burnt out soon afterwards, and the latter in 1917.

Conkling–Armstrong Terra Cotta Company

1895–c.1915 Philadelphia, Pennsylvania
This firm was established by Ira L. Conkling and Thomas F. Armstrong, formerly of Stephens, Armstrong and Conkling. They adopted the roles of president and treasurer. The majority of the firm's contracts were in Philadelphia or New York.

Corning Brick, Terracotta and Supply Company

1893–6 Corning, New York

Brick, Terra Cotta and Tile Company

1896–c.1928
This works traded under a number of titles including the Corning Brick Works, Corning Terra Cotta Works and, after being purchased by Morris E. Gregory in 1896, the Brick, Terra Cotta and Tile Company. It developed rapidly in the last years of the century, making pressed and paving brick as well as terracotta. Its market spread through the north-eastern states from Maine to Illinois.

Denny Clay Company

c.1900–1905 Van Asselt, Seattle, Washington

Denny–Renton Clay and Coal Company

1905–c.1912
The company had its origins in the Puget Sound Fire Clay Company, established in 1882 and succeeded by the Denny Clay Company. The

firm had four plants, the Van Asselt making silica and magnesite brick as well as terracotta. Supplied the Arctic Club and other major buildings in Seattle. Came to concentrate on paving-brick.

Denver Terra Cotta Company
1912–c.1950 Denver, Colorado
The company was founded by John and George Fackt and Carl Schwalb in 1911. It undertook some dramatic sculptural schemes in the thirties.

Federal Terra Cotta Company
1910–28 Woodbridge, New Jersey
Established by De Forest Grant who acted as president. Became the Federal Seaboard Company in 1928 through a merger with New Jersey and South Amboy.

Federal Seaboard Terra Cotta Company
1928–68 Perth Amboy, New Jersey
The last east-coast manufacturer to be founded and the most successful at supplying machine-made veneer in the thirties.

William Galloway
1886 Philadelphia, Pennsylvania
A pottery which made small quantities of terracotta.

Gladding McBean
1886 to date Lincoln, California
Established by Charles Gladding, George Chambers and Peter McGill McBean at Lincoln near Sacramento, and located adjacent to clay-banks and the main line to Portland and Seattle. The firm progressed from the mass production of sewer-pipes to making enamelled brick, firebrick and roofing-tiles as well as terracotta. By the turn of the century Gladding McBean was the most successful producer on the Pacific Coast.

Grueby Faience Company
1894–1919 Boston, Massachusetts
A pioneering manufacturer of tiles, glazed and enamelled terracotta and faience mantels.

A. Hall and Sons Fire Brick Works
c.1877 Perth Amboy, New Jersey

Perth Amboy Terra Cotta Company
1879–1907 Perth Amboy, New Jersey
The leading late-nineteenth-century manufacturers of terracotta on the eastern seaboard, fronting an estuary, and established initially through James Taylor's involvement. They undertook numerous contracts in New York and Philadelphia until merged into the Atlantic Company in 1907.

A. Hall Terra Cotta Company
1883–7 Perth Amboy, New Jersey
Alfred Hall founded the company two years after retiring from Perth Amboy. He appointed Robert Taylor as superintendent. Hall died in 1887 and production ceased.

Indianapolis Terra Cotta Company
1893–c.1930 Brightwood, Indianapolis, Indiana
The firm was successor to Stilz, Joiner and Company. After the company's president died in 1916, the firm became controlled by William D. Gates of the American Terra Cotta Company.

O. W. Ketcham Terra Cotta Works
1906–c.1960 Crum Lynne, near Chester, Pennsylvania
The firm may have been in operation from 1895. O. W. Ketcham had been involved with the Boston Terra Cotta Company and acted as Philadelphia agent for the small Excelsior Company of New Jersey.

B. Kreischer and Sons
c.1875–99 Kreischerville, Staten Island, New York
Balthaser Kreischer reputedly started making firebricks in 1845, and established a new works on Staten Island in 1852. He took his three sons into partnership and developed a range of products including facing-brick.

H. A. Lewis Architectural Terra Cotta Works
1879–87 Boston, Massachusetts
Established as Lewis and Wood in 1879, traded for a period as Lewis and Lane, and from 1883 as H. A. Lewis. The concern was bought by Perth Amboy in 1887.

Los Angeles Pressed Brick and Terra Cotta Company
1887–1903 Santa Monica, California

Los Angeles Pressed Brick Company
1903–c.1910
The Pressed Brick Company succeeded the Los Angeles Pressed Brick and Terra Cotta Company established by Charles H. Frost in 1887. It made a wide variety of clay products at four plants.

Ludowici Celadon Company *see* **Celadon Terra Cotta Company**

Maryland Terra Cotta Company
1905–15 Baltimore, Maryland
Acquired the terracotta business of Burns–Russell, located in the suburbs of Baltimore. Most of its contracts were for buildings in Baltimore, Washington, DC, or cities in Georgia and South Carolina.

Midland Terra Cotta Company
1910–c.1939 Cicero, Illinois
Established by William G. Krieg, former city architect, with Alfred Brunkhorst, son of one of the founders of Northwestern. Midland specialized in its range of

stock decorations, used on banks, shops and garages throughout the Midwest.

New Jersey Terra Cotta Company

1893–1928 Perth Amboy, New
 Jersey

This firm was successor to Mathiasen and Hansen, formed in 1888, with Karl Mathiasen taking the post of president. During the late 1890s the firm was operating plants at both Perth Amboy and Matawan in New Jersey. In 1928 it merged with the Federal Terra Cotta Company.

New York Architectural Terra Cotta Company

1886–1932 Long Island City,
 New York

Run by James Taylor as superintendent, this firm gained a strong reputation for its sculptural work and traditional modelling.

Northern Clay Products Company

1903–8 Auburn, Washington

Northern Clay Company

1908–c.1925

This firm purchased the Auburn Pottery in 1903 and was retitled in 1908. It prospered in the twenties, supplying a variety of buildings in Seattle.

Northwestern Terra Cotta Company

see **True, Brunkhorst and Company**

Perth Amboy Terra Cotta Company

see **A. Hall and Sons Fire Brick Works**

Rookwood

c.1904–36 Mount Adams,
 Cincinnati, Ohio

Established by Mrs Maria Longworth Storer in 1880 following experiments by a group of women in decorating ceramics. The business passed to the control of William Watts Taylor. A large extension to the works was built in 1904 to accommodate the architectural faience department. Many of the decorators were drawn from the Art Academy of Cincinnati, which was endowed by Joseph Longworth, the father of Mrs Storer.

St Louis Terra Cotta Company

1898–c.1930 St Louis, Missouri

Established by R. J. Macdonald and Robert F. Grady. Their factory dated back to 1894, being located adjacent to the Winkle Company's works. Most of the orders originated in their home city.

South Amboy Terra Cotta Company

1903–28 South Amboy, New
 Jersey

In 1903 this company leased the Swan Hill Pottery at South Amboy. The firm merged with the Federal Terra Cotta Company in 1928.

Steiger Terra Cotta and Pottery Works

1898–1917 San Francisco,
 California

This firm was founded by members of the City Street Improvement Company. Walter E. Dennison acted as president and invented the company's 'thru-an-thru' terracotta. The plant was burnt in 1917 and never rebuilt.

Southern Terra Cotta Works

1875 Atlanta, Georgia

P. Pelligrini started making flowerpots, chimney-pots and architectural terracotta on a small

scale in 1872. From 1875 the firm traded either as Pelligrini and Castelberry, or as the Southern Terracotta Works.

Stephens and Leach

1886–7 Philadelphia,
 Pennsylvania

Stephens, Leach and Conkling

1887–8

Stephens, Armstrong and Conkling

1888–94

A firm that underwent rapid changes in title before becoming a branch of the New York Company in 1893. Armstrong and Conkling left to form the Conkling–Armstrong Company in 1896.

True, Brunkhorst and Company

1877–86 Chicago, Illinois

True, Hottinger and Company

1886–7

Northwestern Terra Cotta Company

1888–1956

This works was first established by John R. True, John Brunkhorst, Gustav Hottinger and Henry Rohkam, all employees of the Chicago Terra Cotta Company. The company became one of the largest in the country, dominating the market in Chicago and the Midwest. During the inter-war period branch factories were in operation in Denver, St Louis and Chicago Heights, the last being purchased from the Advance Terra Cotta Company in 1928.

Winkle Terra Cotta Company

1889–c.1950 St. Louis,
 Missouri

Formed by Joseph Winkle, to run a works which he had founded in 1883. The firm supplied some major contracts in the Midwest and in San Francisco and Seattle.

REFERENCES

The references below show page number followed by line number, and are marked in the text by a star symbol.

CHAPTER 1

11.13 J. Sproule (ed.), *Catalogue of the Irish International Exhibition of 1853* (J. McGlashan, Dublin, 1854), pp. 93–4.

11.24 S. Chappell, 'As if the Lights were Always Shining: Graham, Anderson, Probst and White's Wrigley Building at the Boulevard Link', in J. Zukowsky (ed.), *Chicago Architecture 1872–1922* (Prestel-Verlag, Munich, 1987), pp. 291–301 (p. 298).

12.3 *Building News*, 51, 1886, p. 528; Letter by P. G. Konody originally published in the *Daily Mail*, 3 November 1908, reprinted in *British Clayworker*, 17, 1908, pp. 260–1.

12.23 A. Ure, *Dictionary of Arts, Manufactures, and Mines* (London, 1839), p. 1229.

13.7 *Builder* 50, 1886, pp. 537–40 (p. 537).

13.30 For a fuller consideration of terracotta terminology see F. Celoria, 'Contributions towards Working Definitions of the Word "Terracotta", *Journal of the Tiles and Architectural Ceramics Society*, 2, 1987, pp. 10–20.

14.11 J. Miller Carr, 'Architectural Ceramics', *British Clayworker*, 14, 1906, pp. xc–xcv (p. xc).

14.17 For further discussion on the role of meaning and association see J. A. Schmiechen, 'The Victorians, the Historians, and the Idea of Modernism', *American History Review*, 93, 1988, pp. 287–316.

14.30 *British Architect*, 29, 1888, pp. 243–4 (p. 243).

15.13 *Builder*, 23, 1866, pp. 847–8 (p. 847).

15.23 *American Architecture and Building News*, 31, 1880, pp. 35–6.

16.4 O. Jones, *The Grammar of Ornament* (Day, London, 1856), p. 6.

16.13 *Builder* 66, 1894, p. 28.

17.8 G. G. Hoskins in *British Clayworker*, 11, pp. lxvi–lxvii (p. lxvi). L. Stokes, paper following Ingress Bell's contribution under the title 'Terracotta: its Manufacture, Uses, and Abuses', *Builder* (1893), op. cit., p. 322.

18.2 Quoted in *British Clayworker*, 31, 1923, p. xlv.

18.10 Quoted in F. Toker, *Pittsburgh: An Urban Portrait* (Pennsylvania State University Press, Pittsburgh, 1986), p. 11.

19.20 R. Sturgis, 'The Warehouse and the Factory in Architecture', *Architectural Record*, 15, 1904, pp. 1–17 (p. 10).

CHAPTER 2

20.30 *British Clayworker*, 7, 1898, pp. 6–7.

21.4 *British Clayworker*, 43, 1935, p. 317.

21.16 W. Geer, *The Story of Terracotta* (Tobias A. Wright, New York, 1920), pp. 268–99.

21.23 See R. Porter, 'The Industrial Revolution and the Rise of the Science of Geology', in M. Teich and R. Young, *Changing Perspectives in the History of Science* (Heinemann, London, 1973), pp. 321–43).

21.28 See M. C. Rabbitt, *Minerals, Lands and Geology for the Common Defence and General Welfare*, vols. 1–3

(United States Government Printing Office, Washington, 1979).

22.2 J. Taylor, 'Architectural Terracotta No. 7', *Clay-Worker* 8, 1887, pp. 1–4 (p. 2).

22.11 Ibid.

22.19 Ibid.

23.8 J. M. Blashfield contributing to discussion paper by C. Barry, 'Memoranda on the Works Executed in Terracotta at New Alleyn's College, Dulwich', *Trans. RIBA*, 1868–9, pp. 15–29 (p. 19).

23.14 *American Architect and Building News*, 1, 1876, pp. 420–1 (p. 421).

24.1 Letter from James Taylor, New York, to Messrs Gladding McBean, 25 September 1888.

24.6 Letter from J. DeGolyer, Lincoln, California, to Mr McBean, 21 March 1896.

24.28 W. Geer (1920), op. cit., p. 56.

25.2 Letter from J. DeGolyer to P. McGill McBean, San Francisco, 22 February 1896.

25.32 W. Geer (1920), op. cit., p. 215.

27.23 *Claycraft*, 2, 1929, pp. 340–2.

29.4 *Clay-worker*, 10, 1888, p. 271.

29.27 Ibid.

32.2 This section on the manufacturing process draws upon M. J. Stratton, 'The Terracotta Industry: its Distribution, Manufacturing Processes and Products', *Industrial Archaeology Review*, 8, no. 2, 1986, pp. 194–214.

37.31 P. Lucas, *Heathfield Memorials* (A. L. Humphreys, London, 1910), p. 107.

38.13 *American Architect and Building News*, 1, 1876, pp. 420–1 (p. 421).

38.40 *Clay-Worker* 76, 1921, pp. 233–4.

40.4 *Daily Mail*, 17 December 1904, Supplement: the Coliseum.

42.8 *Clay-Worker* 9, 1888, pp. 272–4.

43.2 E. Gosse (ed. D. Eyles), *Sir Henry Doulton* (Hutchinson, London, 1970), p. 78.

44.2 Letter from B. Danforth to New York Architectural Terra Cotta Company, 11 February 1913.

44.10 For a consideration of the role of the Terra Cotta Association see M. J. Stratton, *The Manufacture and Utilisation of Architectural Terracotta and Faience* (Ph.D. thesis, University of Aston, 1983), vol. 2, pp. 341–56.

CHAPTER 3

46.31 J. A. Wight, *Brick Building in England* (J. Baker, London, 1972), p. 181.

46.34 R. Holt, *A Short Treatise of Artificial Stone* (S. Austen, London, 1730).

47.2 D. Pincot, *An Essay on the Origin, Nature, Uses and Properties of Artificial Stone* (R. Hett, London, 1770), p. 47.

47.8 A. Kelly, *Mrs Coade's Stone* (SPA, Upton-upon-Severn, 1990), pp. 37–43. Alison Kelly has provided the definitive work on Coade, ground that can be covered only briefly in this book.

47.16 E. Coade, *Etchings of Coade's Artificial Stone Manufacture* (E. Coade, London, 1777).

48.3 J. E. Ruch, 'Regency Coade: a Study of the Coade Record Books, 1813–21', *Architectural History*, 11, 1968, pp. 34–56.

48.8 E. Meteyard, *Life of Josiah Wedgwood* (Hurst and Blackett, London, 1866), vol. 2, pp. 70–1.

48.12 E. Meteyard (1866), op. cit., vol. 2, p. 375; A. Kelly, *Decorative Wedgwood in Architecture and Furniture* (Country Life, London, 1965), p. 68; see also R. Reilly, *Wedgwood* (Macmillan, London, 1989), vol. 1, pp. 482–9.

48.22 G. L. Remnant, 'Jonathan Harmer's Terracottas', *Transactions of the Sussex Archaeological Society*, 100, 1962, pp. 142–8.

48.38 Kelly (1990), op. cit., p. 313.

48.40 R. Hunt, 'Artificial Stone', *Art Journal*, 11, 1849, pp. 128–9.

49.5 *Architectural Magazine*, 1, 1834, pp. 159–63.

49.7 The history of the brick taxes is covered by E. Dobson (ed. F. Celoria), *A Rudimentary Treatise on the Manufacture of Bricks and Tiles*, 1850 (George Street Press, Stafford, 1971), vol. 1, pp. 6–8, and vol. 2, pp. 79–85.

49.13 C. Barry, 'Terracotta', *Builder*, 26, 1868, pp. 546–7.

49.17 J. M. Blashfield, *An Account of the History and Manufacture of Ancient and Modern Terracotta* (J. Weale, London, 1855), p. 20.

49.24 J. M. Blashfield, *A selection of Vases, Statues, Busts, &c. from Terracottas* (J. Weale, London, 1857), unpaged; *Building News*, 5, 1859, p. 1032; *Builder* 18, 1860, p. 783.

49.28 *Building News*, 5, 1859, p. 260.

50.6 *Art Journal*, 2, 1863, supplement, p. 260.

50.12 S. A. Smith, *Alfred Waterhouse* (Ph.D. thesis, Courtauld Institute of Art, 1970). Smith briefly considers the application of terracotta to secular Gothic architecture.

51.8 *Illustrated London News*, 5, 1844, p. 188.

52.7 *Ecclesiologist*, 3, 1844, p. 87.

52.11 *Builder*, 3, 1845, pp. 571–2; R. Jolley, 'Edmund Sharpe and the "pot" churches', *Architectural Review*, 146, 1969, pp. 427–431 (p. 431).

52.19 E. Sharpe, 'On the adaptability of terracotta to modern church work', *Builder*, 34, 1876, pp. 553–4.

53.32 M. Diamond, *1850–1875 Art and Industry in Sheffield: Alfred Stevens and his School* (Sheffield City Art Galleries, 1975), p. 11.

54.11 V. Ottolini, Introduction to L. Gruner (ed.), *The Terracotta Architecture of North Italy* (J. Murray, London, 1867), pp. 1–9 (p. 4).

54.23 H. Cole, *Fifty Years of Public Work* (G. Bell, London, 1884), vol. 1, p. 98.

54.30 Cole Diary, 6 August 1864. The major examples of Tudor terracotta in Norfolk are the monuments at Bracon Ash, Oxborough, Norwich Cathedral and Wymondham Abbey. There are further tombs at Layer Marney in Essex where the gatehouse also has window-frames of terracotta. The Tudor use of terracotta is described in J. A. Wight (1972), op. cit., pp. 178–97.

54.35 *Builder* 26, 1868, pp. 137–8.

55.16 D. Watkin and T. Mellinghoff, *German Architecture and the Classical Ideal* (Thames and Hudson, London, 1987), p. 112.

56.24 Vienna gained a major series of public buildings with terracotta decorations in the *Rundbogenstil* during the 1860s and 70s. On the development of the most important buildings lining the Ringstrasse see F. R. Farrow, 'The Recent Development of Vienna', *Trans. RIBA*, new series, 4, 1888, pp. 27–42.

57.8 H. Cole (1884), op. cit., vol. 1, p. 332.

57.16 Cole Diary, 23 January 1857.

59.14 *Athenaeum*, 8 June 1861, p. 766.

59.36 All the terracotta for the Residences was supplied by Blanchard.

59.39 F. H. W. Sheppard (ed.), *Survey of London*, vol. 38: The Museums Area of South Kensington (Athlone Press, London, 1975), p. 107.

60.15 F. H. W. Sheppard (1975), op. cit., p. 145.

62.2 *Building News*, 19, 1870, p. 55.

62.28 Cole Diary, 2 April 1866.

63.18 H. Scott, 'On the Construction of the Albert Hall', *Trans. RIBA*, 22, 1871–2, pp. 99–100. It is now impossible to appreciate fully the intended combination of repetition and sculptural variety. Grit-cleaning undertaken in the 1970s has blasted away the sharp arrises and finer detailing.

64.3 *Burslem Minute Book* (1861–73), 18 February 1863.

65.6 For further details of the evolution of the design see A. Swale, 'The Terracotta of the Wedgwood Institute, Burslem', *Journal of the Tiles and Architectural Ceramics Society*, 2, 1987, pp. 21–7 (pp. 22–3).

65.19 *Burslem Minute Book* (1861–73), 16 March and 4 January 1869.

65.41 Among later provincial art schools to be given terracotta decorations the following are probably the most noteworthy: Derby Free Library and Museum by R. K. Freeman, 1876–9 (Coalville Brick and Tile Company with panels of stylized vegetation), Birmingham School of Art by Martin and Chamberlain, 1881–5 (lily and lattice panel modelled by S. Barfield and made by King), and the extension to Manchester School of Art by Woodhouse and Willoughby, 1894 (Doulton, with angels by W. J. Neatby).

CHAPTER 4

66.17 A paper by Charles Barry, junior, on terracotta was read to the Royal Institute of British Architects and printed in both the *Transactions of the RIBA* and the *Builder*: *Trans. RIBA*, 18, 1867–8, pp. 259–79, and *Builder* 26, pp. 546–7.

66.30 *Builder* 26, 1868, pp. 44–5 (p. 44).

66.38 *Builder* 22, 1864, pp. 62–3.

67.10 E. M. Barry, *Lectures on Architecture* (J. Murray, London, 1881, pp. 171–2, 363–4. E. M. Barry may have inherited some interest in terracotta from his father's experiments with the material in the 1830s.

67.23 *Building News*, 11, 1864, p. 955.

68.4 *Builder*, 27, 1869, pp. 925, 927.

68.16 C. Barry (*Trans. RIBA*, 1868), op. cit., p. 260.

69.5 Experiments undertaken at Kirkaldy's Testing and Experimenting Works showed filled blocks and columns to have a strength exceeding common brick and Bath stone and almost matching Portland stone. (C. Barry (*Trans. RIBA*, 1868), op. cit., Appendix: Results of Experiments by David Kirkaldy, 17 June 1868.

69.12 Drawings showing the detailed design and disposition of the terracotta are held by Dulwich College.

69.17 C. Barry (*Trans. RIBA*, 1868), op. cit., pp. 265, 268–9.

69.21 *Building News*, 16, 1869, pp. 520–1.
69.24 Cole Diary, 20 March 1870.
70.2 J. Piggott, *Charles Barry (Junior) and the Dulwich College Estate* (Dulwich Picture Gallery, London, 1986), p. 28.
71.3 Andrew Saint has demonstrated the relevance of the Oxford Museum as a precedent for Waterhouse's design.
71.13 St Mark, Silvertown, East London, by S. S. Teulon (1861–2), is lined with interlocking blocks of pale grey terracotta.
72.16 The contracts for the superstructure and interior of Manchester Town Hall were signed in October 1870, by which time the use of terracotta had presumably been decided; W. E. Axon (ed.), *An Architectural and General Description of the Town Hall, Manchester* (A. Heywood and Son, Manchester and London, 1878), pp. 8, 34. The first certificate for the supply of terracotta for the Town Hall is dated 1 April 1872; A. Waterhouse, Long Ledger, Entries for Manchester Town Hall, 1864–1880, p. 104.
74.6 In a report to the trustees, it was claimed that virtually none of the lithographed drawings had been adhered to and that a total remeasurement was necessary to determine the extent of the alterations; Works 17–17/1 Charles Trollope to Trustees of Geo. Baker and Son, 20 December 1880.
74.15 F. H. W. Sheppard (1975), op. cit., p. 212.
74.28 *Magazine of Art*, 4, 1881, pp. 258–62, 463–5. Quoted in F. H. W. Sheppard (1975), op. cit., p. 213.
76.4 M. Girouard, Alfred Waterhouse and the Natural History Museum (British Museum: Natural History, London 1981), p. 56.
76.6 *Nature*, 24, 1882, pp. 54–6 (p. 55).

CHAPTER 5
78.4 Hardy gained a RIBA prize in 1863 for his now lost essay, 'On the Application of Coloured Bricks and Terracotta to Modern Architecture'. See *The Architectural Notebook of Thomas Hardy* (Dorset Natural History and Archaeological Society, Dorchester, 1966), p. 2.
78.7 *Building News*, 51, 1886, pp. 552–3.
78.15 Robert Kerr, quoted in J. M. Crook, *The Dilemma of Style* (John Murray, London, 1987) p. 176.
79.3 On the influence of the Picturesque see Crook (1987), op. cit., pp. 13–41, 190–1.
79.17 *Building News*, 46, 1884, p. 580.
79.22 *Builder* 30, 1872, pp. 298–9 (p. 298).
79.25 *Building News*, 46, 1884, p. 580.
79.31 *Building News*, 40, 1881, p. 253.
79.38 A. Waterhouse, Lecture to Birmingham Art Students, *Building News*, 44, 1883, p. 245.
80.1 *Building News*, 20, 1871, p. 154.
80.11 *Builder*, 62, 1892, p. 18.
80.17 *Builder*, 54, 1888, pp. 117–18.
80.21 H. J. Grainger, *The Architecture of Sir Ernest George and his Partners* (Ph.D. thesis, University of Leeds, 1985), pp. 78–9.
81.9 For an example of such denigration see *Architects' Journal*, 72, 1932, pp. 718–22.
81.14 *Builder* 36, 1878, pp. 905–7.
81.20 Waterhouse used neither terracotta nor the Gothic style exclusively. Stone and plain brick predominate for his Cambridge commissions; a terracotta Parrot House at Eaton Hall, Cheshire

(1881), is in the form of a classical rotunda.
82.10 Letter from A. Waterhouse to chairman of CGLI, 28 March 1883.
84.17 S. A. Smith, 'Alfred Waterhouse', in J. Fawcett (ed.), *Seven Victorian Architects* (Thames and Hudson, London, 1976), p. 104.
84.20 *Builder*, 50, 1886, p. 703.
85.6 Prudential Assurance Company, Board Minutes, vol. 20, p. 232, 23 June 1892. Information provided by Colin Cunningham.
85.15 The original Prudential head-office building of 1878 was in turn refaced in the 1930s by Hathern to achieve a red uniformity with the Furnival's Inn Building. J. C. Edwards supplied at least eight of the Prudential buildings where red terracotta and bricks were carefully matched. Another Ruabon firm, Clark and Rea, claimed to have supplied several other branches. Wilcock, later Leeds Fireclay, of Burmantofts were responsible for supplying most of the frontages of buff terracotta and virtually all of the interior faience.
85.33 The Victorian Society (West Midlands Group), *The Best Buildings in the Neighbourhood? Martin and Chamberlain and the Birmingham Board Schools*, May 1968, unpaged.
86.4 *Daily Gazette*, 5 April 1878. Several commissions were supplied by Clark and Rea of Ruabon, from their evocatively named Wilderness Works.
87.2 *Builder*, 50, 1886, p. 301; 51, 1886, pp. 151–3; 51, 1886, p. 649.
87.25 *Builder* 57, 1889, p. 442.
88.11 *Builder* 59, 1890, pp. 338–9.
90.7 *British Architect*, 43, 1895, pp. 94, 96.
91.4 *Builder*, 37, 1879, p. 1050.
92.12 *Builder*, 52, 1887, p. 897.
92.30 S. Beattie, *The New Sculpture* (Yale University Press, New Haven and London, 1983), pp. 14–22, 49–51.
93.25 D. J. Olsen, *The Growth of Victorian London* (Penguin, Harmondsworth, 1979), pp. 142–56.
94.5 G. Huxley, *Victorian Duke* (Oxford University Press, London, 1967), pp. 134, 148.
94.8 Grainger (1985), op. cit., p. 44.
94.20 F. H. W. Sheppard (ed.), *Survey of London*, vol. 40: The Grosvenor Estate in Mayfair, part 2 (Athlone Press, London, 1980), p. 328.
96.11 Susan Beattie has attributed the modelling of the sculpture at 52 Cadogan Square to Harry Bates on stylistic grounds.
96.26 *Builder*, 56, 1889, p. 389.
97.12 D. Linstrum, *West Yorkshire: Architects and Architecture* (Lund Humphries, London, 1978), p. 325.

CHAPTER 6
99.6 *Daily Mail*, 3 November 1908, reprinted in *British Clayworker*, 17, 1908, pp. 260–1.
100.23 A theme developed in R. W. Edis, *The Decoration and Furniture of Town Houses* (Kegan Paul, London, 1881).
102.6 Bradford Art Galleries and Museums, *Burmantofts Pottery* (Bradford Art Galleries and Museums, 1983), p. 9.
102.10 R. Thorne, 'Places of Refreshment in the Nineteenth Century City', in A. D. King (ed.), *Buildings and Society* (Routledge and Kegan Paul, London, Boston and Henley, 1980), pp. 228–53.
102.20 *Brick, Tile and Potteries Journal*, 6, 1891, p. 233.
104.4 *British Clayworker*, 14, 1905, pp. liii–liv; *Architectural Review*, 138, 1965, pp. 338–41.

104.25 Their meetings considered terracotta in 1887 and majolica, faience and Delft ware in 1899. H. J. L. Massé, *The Art Workers' Guild, 1884–1934* (Art Workers' Guild, London, 1935).

104.43 *Country Life*, 166, 1979, pp. 888–90.

106.19 Della Robbia Pottery Limited, Catalogue (1896); *Della Robbia Pottery, Birkenhead, 1894–1906* (Williamson Art Gallery and Museum, Birkenhead, undated interim report *c*.1980).

106.21 *British Clayworker*, 2, 1894, p. 238.

108.11 H. Ricardo, 'Of Colour in the Architectural Cities', published in *Art and Life, and the Building and Decoration of Cities* (Arts and Crafts Exhibition Society, in association with Rivington, Percival and Co., London, 1897), pp. 221–2, 248.

108.16 Debenham and Freebody's store was designed by Wallace and Gibson and built in 1907; *Architectural Review*, 23, 1908, pp. 362–9.

109.6 Skipper's life and work is described in D. Jolley, *Architect Exuberant: George Skipper 1856–1948* (Norwich School of Art, 1975).

109.22 D. Jolley (1975), op. cit., p. 14.

110.14 *British Clayworker*, 14, 1906, pp. xc–xcv (p. xc).

111.29 J. Hawkins, *The Poole Potteries* (Barrie and Jenkins, London, 1980), pp. 41–4.

111.36 *British Clayworker*, 36, 1927, pp. 199–201.

112.15 *British Clayworker*, 19, 1910, p. lxxiv.

113.7 A. Crawford, M. Dunn and R. Thorne, *Birmingham Pubs 1880–1939* (A. Sutton, Gloucester, 1986), pp. 5–8, 10, 36.

114.7 Hathern Archive, held by the Ironbridge Gorge Museum.

115.7 Faience made by Carter was used for the façades of many of Portsmouth's public houses dating to the 1890s, A. E. Cogswell creating a distinctive ceramic style for each of the brewery companies. See R. L. Elwall, *Bricks and Beer, English Pub Architecture 1830–1939* (RIBA, London, 1983), pp. 23–4.

116.17 *Hackney and Kingsland Gazette*, 9 December 1901.

117.15 L. Stokes, 'A Tilt at Terracotta', *British Clayworker*, 11, 1902, pp. iv–v.

117.29 Dr Kay, *The Moral and Physical Condition of the Working Classes* (2nd ed., J. Ridgway, London, 1832), pp. 28–30, and F. Engels, *The Condition of the Working Class in England* (orig. pub. 1844; Basil Blackwell, Oxford, 1958).

118.5 *Manchester City News*, 24 April 1909, p. 5.

118.29 Report of the opening in *Manchester Guardian*, 23 May 1911.

118.39 *Builder*, 96, 1909, p. 705. See also *Builder*, 100, 1911, pp. 177–80: The architectural treatment for the YMCA evolved through several stages, and it may be that the details of the method of construction differed from those described in 1909.

119.13 *British Clayworker*, 15, 1907, p. lxxxi.

120.11 A detailed description of the form of these stations is given in *Tramway and Railway World*, 8 June 1905, pp. 499–500.

CHAPTER 7

121.27 H. Robertson, *Architecture Explained* (E. Benn, London, 1927), pp. 18–19, 27, 74–5.

122.2 E. Hampton, 'The Architect of Adventure', *Producer*, August 1930, pp. 221–3 (p. 223).

122.18 G. N. Hodson, 'Architectural Terracotta and Faience', *Transactions of the Ceramic Society*, 35, 1935–6, pp. 43–51 (p. 44).

123.8 J. Hawkins, *The Poole Potteries* (Barrie and Jenkins, London, 1980), pp. 71–3.

124.5 The panel was for the Children's House Nursery School, Eagling Street, London E3, the architect being C. Cowles-Voysey. It was illustrated in Architectural Review, 59, 1926, pp. 188–90.

125.7 *British Clayworker*, 40, 1932, pp. 94–102 (p. 102).

127.13 *Blackpool Gazette and Herald*, 7 May 1932, p. 7.

128.11 C. G. Holme (ed.), *Industrial Architecture* (Studio Limited, London, 1935), pp. 9, 11.

129.24 C. E. Reynolds, *Concrete Construction* (Concrete Publications Limited, London, 1945), pp. 1–10, 143.

130.9 There is a useful section on 'External Wall Finishes to Concrete and Steel Structures' in P. E. Thomas (ed.), *Modern Building Practice* (G. Newnes, London, *c*.1935), vol. 2, pp. 337–52.

130.31 R. Cochrane, *Landmark of London, The Story of Battersea Power Station* (CEGB, London, 1983), p. 27.

131.7 T. Wallis, 'Factories', *RIBA Journal*, 3rd series, 40, 1933, pp. 301–12, (p. 307).

131.13 J. J. Snowden and R. W. Platts, 'Great West Road Style', *Architectural Review*, 156, 1974, pp. 21–7 (p. 22).

131.27 *West Middlesex Gazette*, 6 May 1933.

132.17 *Kentish Independent*, 23 October 1903; W. T. Davis, *The History of the Royal Arsenal Co-operative Society* (RACS, London, 1921), p. 94.

132.27 *Kentish Independent*, 23 October 1903.

132.33 *Producer*, 13, 1929, p. 109.

132.37 T. Ellison and G. W. Ramsden, *The Management of Foodstuffs and Allied Departments* (Co-operative Union, Manchester, 1925), pp. 32, 100–1.

134.24 R. Redmayne, *Ideals in Industry* (Burton, Leeds, 1951), p. 445.

135.8 Information provided by E. Fairfoot, Burton Group, Leeds.

135.18 F. Towndrow, 'The Creed of a Modernist', *Architectural Design and Construction*, 2, 1932, pp. 348–54 (p. 353).

138.3 *Sheffield Daily Telegraph*, 10 February 1911.

138.25 For an overview of cinema design and Coles's work see D. Atwell, *Cathedrals of the Movies* (Architectural Press, London, 1980).

139.19 G. Coles, 'Architectural Design in the Theatre', *Cinema Construction*, 1, no. 11, 1930, pp. 14–15 (p. 15).

140.20 *Cinema Construction*, 7, no. 6, 1935, pp. 10–11.

141.9 *West Sussex County Times and Standard*, 4 September 1936.

141.31 Letter from G. A. Hodson to H. J. C. Johnston, Leeds, 1 December 1928.

141.34 *Design and Construction*, 8, 1938, pp. 88–9 (p. 88).

CHAPTER 8

143.2 The two main accounts of the introduction of terracotta into the United States are by leading figures in the industry: J. Taylor, 'Architectural Terracotta', which consists of a series of articles commencing with *Clay-Worker*, 8, 1887, pp. 57–60; and W. Geer, *The Story of Terracotta* (1920), op. cit.

143.11 J. E. Mitchell, *Terracotta Ornaments for Cottages, Villas, Pleasure Grounds Etc.* (Philadelphia, *c*.1855).

144.23 The Massachusetts Normal School of Art was established in 1874, but Smith returned to Bradford in 1883. See D. Korzenik, *Drawn to Art: A Nineteenth Century American Dream* (University

Press of New England, Hanover and London, 1985), p. 154; J. Rocke, 'Walter Smith: a Pioneer of Art Education', *Yorkshire Illustrated*, June 1952, p. 15.

144.27 W. Smith, *Art Education: Scholastic and Industrial* (J. R. Osgood, Boston, 1872), pp. 86–7, 239–43).

144.34 M. H. Floyd, 'A Terracotta Cornerstone for Copley Square: Museum of Fine Arts, Boston, 1870–76 by Sturgis and Brigham', *Journal of the Society of Architectural Historians*, 32, 1973, p. 90.

144.39 J. Blashfield to J. Sturgis and C. Brigham, 10 April 1873. A series of letters from Blashfield to Sturgis, and less frequently to Brigham or Colling, dated between August 1869 and August 1878, provides a most valuable account of the supply of terracotta from Stamford to Boston for the Museum of Fine Arts. I am most grateful to Margaret Henderson Floyd for having enabled me to examine them.

145.8 J. Blashfield to J. Sturgis, 8 April 1872.

145.15 Memorandum of Agreement, 3 July 1872, between J. Blashfield and J. Colling; and J. Blashfield to J. Sturgis, 27 May 1870 and 29 June 1872.

145.21 J. Blashfield to J. Sturgis, 5 December 1873; and J. Blashfield to C. Brigham, 4 February 1874.

146.5 J. Blashfield to J. Sturgis and C. Brigham, 4 July 1874.

146.10 J. Blashfield to C. Brigham, 1 December 1874; J. Blashfield to J. Sturgis and C. Brigham, 2 April 1875; and J. Blashfield to J. Sturgis, 15 June and 26 August 1875.

146.13 Note of Bankruptcy, sent by Michael Barnes, trustee to J. Sturgis and C. Brigham, undated.

146.16 Letter from J. Blashfield to J. Sturgis, 7 January 1871.

146.19 J. Blashfield to J. Sturgis, 13 November 1872.

146.23 J. Blashfield to Sturgis and Brigham, 1 April 1874.

147.10 *Clay-Worker*, 9, 1888, pp. 144–5 (p. 145).

148.7 *Clay-Worker* 8, 1887, pp. 113–15 (p. 113).

148.18 Ibid.

148.32 *Clay-Worker*, 9, 1888, pp. 135–6.

149.14 S. Darling, *Chicago Ceramics and Glass* (Chicago Historical Society, Chicago, 1979), p. 170; C. Condit, *The Chicago School of Architecture* (University of Chicago, Chicago, 1964), p. 24. The first use of hollow-tile flat arches in New York is virtually contemporary with the Kendall Building. They were built into the US Post Office Building of 1872–3. See Anon., *A History of Real Estate, Building and Architecture in New York City* (orig. pub. 1898; reprinted by Arno Press, New York, 1967), p. 474.

150.2 S. B. Landau, *P. B. Wight: Architect, Contractor and Critic 1838–1925* (Burnham Library of Architecture, Chicago, 1981), p. 46.

151.1 *Clay-Worker*, 9, 1888, pp. 135–6.

151.5 *Clay-Worker*, 8, 1887, pp. 113–16 (p. 115).

151.16 *Clay-Worker*, 8, 1887, pp. 169–73 (p. 170).

152.9 B. Bunting, *Houses of Boston's Back Bay* (Harvard University, Cambridge, Mass., 1967), pp. 194–5.

152.28 *Clay-Worker*, 8, 1887, pp. 169–73 (p. 170).

154.35 *American Architect and Building News*, 1, 1876, pp. 244–5; F. A. Walker (ed.), *International Exhibition 1876: Reports and Awards*, vol. 3 (United States Centennial Commission, Washington, 1880), p. 279.

155.13 *Clay-Worker*, 27, 1897, pp. 529–30; 25, 1896, pp. 40–2 (p. 40).

156.5 *Clay-Worker*, 8, 1887, pp. 233–6.

159.6 'Long Island Historical Society', *Atlantic Terracotta*, 8, 1926, unpaged.

159.13 W. Weisman, 'The Commercial Architecture of George B. Post', *Journal of the Society of Architectural Historians*, 31, 1972, pp. 176–203.

160.11 *Clay-Worker*, 30, 1898, p. 356.

160.15 *American Architect and Building News*, 26, 1889, p. 297.

161.17 A report stated that two factories at Perth Amboy supplied 60 per cent of national output, only 25 per cent being made in Boston and 15 per cent in Baltimore and Chicago. See *Clay-Worker*, 10, 1888, p. 271.

161.35 *American Architect and Building News*, 18, 1885, p. 150.

162.17 National Building Museum, *Archival Summary Sheet: Exterior Cornice* (National Building Museum, Washington, 1983), p. 9.

162.37 C. Buberl to M. Meigs, 24 May, 14 July and 18 September 1883.

163.2 J. Taylor to M. Meigs, 10 December 1882; letter from M. Meigs to C. Buberl quoted in J. McDaniel, 'Caspar Buberl: The Pension Building Civil War Frieze and Other Washington, D.C. Sculpture', *Records of the Columbia Historical Society*, 50, 1980, pp. 309–44 (p. 328).

163.7 In the same year that the Pension Building was completed, Buberl modelled another terracotta frieze, for the Soldiers' and Sailors' Memorial Arch in Bushnell Park, Hartford, Connecticut.

163.14 *Clay-Worker*, 10, 1888, p. 271. New York architects were responsible for both buildings.

163.29 *Clay-Worker* 19, 1893, pp. 486–7. The firm set up by the native Americans was Messrs Fiske, Holmes and Company, of Boston.

163.29 W. Geer (1920), op. cit., pp. 92–3 and 302. These attitudes are confirmed by Taylor's obituaries in *Clay-Worker*, 31, 1899, p. 15.

CHAPTER 9

164.3 *Brick-Builder*, 3, 1894, p. 31.

164.14 T. Dreiser, *The Titan* (New York, 1914), quoted in M. and L. White, *The Intellectual versus the City* (Harvard University Press, Cambridge, Mass., 1962), p. 89.

164.36 *Brick-Builder*, 3, 1894, p. 31.

165.13 His philosophy is presented in H. Croly, *The Promise of American Life* (orig. pub. 1909; Belknap Press, Cambridge, Mass., 1965).

166.11 *Industrial Chicago: the Building Interests* (Goodspeed Publishing, Chicago, 1891), vol. 1, p. 169.

166.24 *Brick-Builder* 6, 1897, pp. 173–5. Most of the porous lightweight terracotta used for fireproofing was made by specialist firms. Some contemporary producers of decorative 'dense' terracotta also made porous tiles and blocks, so gaining an additional and profitable source of business.

166.26 *Brick-Builder* 6, 1897, pp. 144–5.

167.7 *Brick-Builder* 6, 1897, pp. 98–9 (p. 98). On Wight see S. B. Landau (1981), op. cit.

167.14 H. Ries, *Building Stones and Clay Products* (John Wiley and Sons, New York, 1912), pp. 334–7.

167.21 *Brick-Builder*, 7, 1898, pp. 144–5 (p. 145).

168.6 *Brick-Builder*, 5, 1896, p. 212.

168.16 *Brick-Builder*, 5, 1896, p. 230.

168.36 *Brick-Builder*, 6, 1897, p. 9; *A History of Real Estate, Building and Architecture in New York* (1898) op. cit., pp. 465–6.

169.2 *Brick-Builder*, 7, 1898, p. 190.

169.5 *Brick-Builder*, 7, 1898, pp. 103–4 (p. 104).
169.7 *Brick-Builder*, 16, 1907, p. 609.
169.12 *Brick-Builder*, 13, 1904, pp. 191–2.
169.31 H. Ries, op. cit., pp. 328–32.
169.37 *Brick-Builder*, 7, 1898, pp. 123–4 (p. 124).
170.18 *Industrial Chicago* (1891), op. cit., vol. 1, p. 67.
170.27 H. Monroe, *John Wellborn Root* (orig. pub. 1896; Prairie School Press, Park Forest, Illinois, 1966), pp. 62, 247.
171.18 *American Architecture and Building News*, 12, 1882, p. 242. The most significant architects had intertwined careers. Daniel Burnham was apprenticed to Jenney and met his partner John Wellborn Root while working with Wight. Holabird worked briefly with Burnham and Root before forming a partnership with Martin Roche.
171.28 Darling (1979), op. cit., p. 172.
171.31 Monroe (1966), op. cit., p. 247.
172.20 *Brick-Builder*, 3, 1894, pp. 1–5.
173.10 *Industrial Chicago* (1891), op. cit., vol. 2, p. 621.
173.22 *American Architecture and Building News*, 25, 1889, p. 294.
175.19 S. B. Landau, 'The Tall Office Building Artistically Reconsidered: Arcaded Buildings of the New York School, c.1870–1890', in H. Searing (ed.), *In Search of Modern Architecture* (MIT, Cambridge, Mass., and London, 1982), pp. 148, 152–3.
175.27 *Architectural Record* 5, 1895–6, pp. 411–35.
178.16 On Furness see *Architectural Review*, 110, 1951, pp. 311–15.
178.33 L. S. Weingarden, 'Louis H. Sullivan's Ornament and the Poetics of Architecture' in J. Zukowsky (ed.), *Chicago Architecture 1872–1922* (Prestel-Verlag, Munich, 1987), p. 238.
181.9 G. Twose, 'Steel and Terracotta Buildings in Chicago, and Some Deductions', *Brick-Builder*, 3, 1894, pp. 1–5.
181.23 Rental brochure for the Bayard Building attributed to Louis Sullivan and quoted in W. H. Jordy, 'The Tall Buildings', in W. de Wit (ed.), *Louis Sullivan: The Function of Ornament* (Norton, New York, and London, 1986), p. 104.
182.9 W. H. Jordy, *American Buildings and their Architects* (Anchor Books, New York, 1976), p. 122.
183.2 W. de Wit, 'The Banks and the Image of Progressive Banking', in de Wit (1986), op. cit., p. 159.
183.24 *Architectural Record*, 63, 1928, pp. 555–61.
184.27 M. W. Reinhart, 'Norwegian-Born Sculptor, Kristian Schneider, his Essential Contribution to the Development of Louis Sullivan's Ornamental Style' (paper at Norwegian American Life of Chicago Symposium, October 1982), p. 14; R. Twombly, *Louis Sullivan: His Life and Work* (University of Chicago Press, 1987), p. 387.
184.33 Notes by Purcell, Feick and Elmslie sent to P. B. Wight, Chicago, November 1915.
185.7 *Brick-Builder*, 3, 1894, p. 106.
185.9 See L. M. Roth, *McKim, Mead and White Architects* (Thames and Hudson, London, 1984), pp. 157–61.
187.6 *Economist* 7, 1894, p. 206, quoted in *Sites*, 18, 1986, p. 4.
187.10 *Clay-Worker*, 22, 1894, pp. 427–8. See also C. E. Jenkins, 'A White Enamelled Building', *Architectural Record*, 4, 1895, pp. 299–316.
189.32 *Brick-Builder*, 3, 1894, p. 31.
189.37 Reproduced in *Sites*, 18, 1986, p. 14.
190.14 Report of R. T. Eyck to New York Architectural

Terra Cotta Company, 9 December 1914.
190.25 *New York Times*, 27 January 1907, quoted in S. Tunick, 'American Decorative Tiles' (pamphlet of Italian Tile Center, New York, n.d.), p. 7.
190.28 H. Peck, *The Book of Rookwood Pottery* (Herbert Peck, Tucson, 1986), pp. 161–8.
190.39 *Connoisseur*, 184, 1973, pp. 47–53.
191.22 M. V. Bernstein, *Art and Design at Alfred: A Chronicle of a Ceramics College* (Art Alliance Press, Philadelphia, 1986), pp. 19, 48, 70.
192.2 *Brick-Builder*, 3, 1894, pp. 195–6.
192.13 K. T. Gibbs, *Business Architectural Imagery in America 1870–1930* (UMI Research Press, Ann Arbor, Michigan, 1984), p. 143.
192.17 W. H. Jordy and R. Coe, *American Architecture and Other Writings by Montgomery Schuyler* (Harvard University Press, Cambridge, Mass., 1961), Vol. 2, p. 620.
192.23 *British Clayworker*, 21, 1912, p. xxxvii.

CHAPTER 10
193.24 *Clay-Worker*, 70, 1918, p. 506. The number of orders undertaken by Northwestern peaked at 865 in 1912 and dropped to 149 in 1918. See Northwestern Archives, National Building Museum.
193.27 *Clay-Worker*, 82, 1924, p. 59; 84, 1925, p. 205; 85, 1926, p. 241; 87, 1927, p. 560.
194.3 See National Terra Cotta Society, *12th–17th Reports Relating to the Technical Work* (National Terra Cotta Society, New York, 1926–8).
194.14 G. Kurutz, *Architectural Terracotta of Gladding McBean* (Windgate Press, Sausalito, 1989), p. 112.
194.27 Gladding McBean memo, Firestone Building, undated. Many of the memoranda in the Gladding McBean Archive do not give full details concerning the writer and recipient and some are even undated. The box-files containing such correspondence run from order no. 451 to no. 7068, dating to 1957.
194.32 Gladding McBean memo, 27 January 1927.
195.1 Gladding McBean memo, 12 August 1924.
195.6 Gladding McBean often defended themselves by complaining that drawings gave inadequate information. Gladding McBean memo, 13 August 1919.
195.8 Gladding McBean memo from A. McBean to J. DeGolyer, 12 August 1914.
195.11 Letter from O. Speir to Gladding McBean, Lincoln, California, 8 October 1919.
196.2 Gladding McBean memo to J. DeGolyer, 22 June 1914.
196.6 Kurutz (1989), op. cit., p. 129.
197.8 Letter from A. McBean, San Francisco, to L. Lentelli, New York, 26 March 1926.
197.13 Standard Specification for the Manufacture, Furnishing and Setting of Terracotta (National Terra Cotta Society, 1923); *Common Clay*, 4, 1922, p. 14.
197.21 C. E. White, *Architectural Terracotta* (C. E. Siercks, Scranton, 1938), pp. 46–51.
197.24 *Terracotta Standard Construction* (National Terra Cotta Society, New York), 1914 and 1927; National Terra Cotta Society, *Summary of Technical Work* (National Terra Cotta Society, New York, April 1927), pp. 16–19.
197.32 Report of H. F. Murchie to New York Architectural Terra Cotta Company, 26 November 1913.

199.7 *Common Clay*, 3, 1921, p. 8; Gladding McBean memo, 13 August 1919.
199.19 *San Francisco Examiner*, 8 March 1908.
201.3 Memo from San Francisco office to J. DeGolyer, Gladding McBean, 26 February 1912.
201.12 Memo from Atholl McBean to J. DeGolyer, Gladding McBean, 11 June 1914.
202.8 Letter from W. J. Winkle, Seattle, to J. DeGolyer, Gladding McBean, 15 July 1913.
202.11 See V. G. Ferriday, *Last of the Handmade Buildings: Glazed Terracotta in Downtown Portland* (Mark, Portland, 1984), pp. 99–119.
202.30 *Atlantic Terra Cotta*, 10, 1929; *Buildings and Building Management*, 24 February 1930, reprinted by National Terra Cotta Society, New York).
203.3 *Clay-Worker*, 77, 1922, pp. 437–8.
203.18 *Colour in Architecture* (National Terra Cotta Society, New York, 1924); *Terra Cotta of the Italian Renaissance* (English edition, Terra Cotta Association, Derby, 1928).
203.27 *Architectural Record*, 60, 1926, pp. 88–9.
204.7 Letter from Charles Brown, Atlantic Terra Cotta Company, to Perth Amboy Public Library, 17 October 1932.
204.11 *Architectural Record*, 60, 1926, pp. 97–111 (p. 105).
204.16 Letter from A. McBean to J. DeGolyer, Gladding McBean, 1 August 1910.
204.32 Gladding McBean memo to J. DeGolyer, 28 December 1910.
205.5 Kurutz (1989), op. cit., p. 95.
205.23 *Architectural Record*, 58, 1925, pp. 365–85.
205.34 R. A. M. Stern, *New York 1930* (Rizzoli, New York, 1987), p. 555.
206.8 On the aesthetics of the city's tower blocks see N. Messler, *The Art Deco Skyscraper* (Peter Lang, New York, 1986).
207.10 Darling (1979), op. cit., pp. 194–5.
208.9 M. I. Ingle, *The Mayan Revival Style* (Peregrine Smith, Salt Lake City, 1984), pp. 43–9.
208.17 T. E. Sanford, *The Story of Architecture in Mexico* (W. W. Norton, New York, 1947), pp. 235–41.
209.12 Stern (1987), op. cit., p. 263.
209.20 Darling (1979), op. cit., p. 191.
210.16 *Atlantic Terra Cotta*, February 1928, p. 1.
212.7 F. C. Davis, 'Method Used for Installation of Machine-Made Terracotta on the Breuner Building', August 1931.
212.14 *Clay-Worker*, 36, 1931, p. 298.
212.18 R. C. Mack, 'The Manufacture and Use of Architectural Terracotta in the United States', in H. Ward Jandl (ed.), *The Technology of Historic American Buildings* (Association for Preservation Technology, Washington, DC, 1983), pp. 117–151 (p. 138).
213.14 Gladding McBean memo to M. F. Johansen, 27 January 1926.
213.25 C. Breeze, *Pueblo Deco* (Rizzoli, New York, 1990), pp. 95–7.
214.10 *Works Progress Administration, Tulsa: A Guide to the Oil Capital* (Mid-West Printing, Tulsa, 1938), p. 58.
215.6 *Clay-Worker*, 100, 1933, p. 164.
215.9 The decline of the American terracotta industry is charted by Susan Tunick in *Sites*, 18, 1986, pp. 35–7.
215.27 Quoted in W. H. Kilham, *Raymond Hood, Architect* (Architectural Book Publishing, New York, 1973), p. 174.

CHAPTER 11

216.31 The most widely available introduction to the conservation of British terracotta is provided by J. and N. Ashurst, *Practical Building Conservation*, vol. 2: *Brick, Terracotta and Earth* (Gower, Aldershot, 1988). On the conservation of the Hackney Empire see *Refurbishment*, 9 September 1988, pp. 18–21.
219.36 J. G. Stockbridge, 'Analysis of In-Service Architectural Terracotta: Support for Technical Investigations', *Journal of the Association for Preservation Technology*, 8, no. 4, 1986, pp. 41–5. S. E. Thomasen and C. S. Ewart, 'Techniques for Testing, Analysing and Rehabilitation of Terracotta', IABSE (International Association for Bridge and Structural Engineering) Symposium, Venice, 1983: final report, pp. 139–46; S. M. Tindall, 'How to Prepare Project-Specific Terracotta Specifications', *APT Journal*, 21, no. 1, 1989.
220.31 Ashurst (1988), op. cit., pp. 76–8.
220.33 R. C. Mack, *The Cleaning and Waterproof Coating of Masonry Buildings* (Office of Archaeology and Historic Preservation/Heritage Conservation and Recreation Service, Washington, DC, 1979).
222.4 See T. Ducato and K. L. Sarring, 'Timeless Terracotta', *Inland Architect*, 28, 1984, pp. 14–19 (p. 18).
227.14 Catalogue, *Firing the Imagination: Artists and Architects Use Clay* (Lumen, New York, 1988).
228.12 V. Geibel, 'Clay in Context', *Metropolis Magazine* April 1988, pp. 70–3.

GLOSSARY

ARABESQUE: ornate decoration combining geometrical patterns, sphinxes and classical vases.

ARTIFICIAL CEMENT: cements whose raw materials, usually lime and clay, were mixed by a manufacturer, in contrast to Roman cements which were obtained simply by burning nodules of clay containing calcareous matter.

ARTIFICIAL STONE: a confusing term applied during the eighteenth and early nineteenth centuries to blocks moulded in forms and colours imitating fine carved stone, whether composed of aggregated stone or of fired clay.

BALL CLAY: a clay of high plasticity resulting from the decomposition of granite and widely worked in the west of England.

BEAUX-ARTS: a style of Edwardian architecture reflecting the influence of the École des Beaux-Arts in Paris, which promoted a pure interpretation of the classical orders, in contrast to Victorian eclecticism.

BISCUIT: unglazed and incomplete ceramic articles.

BLUNGER: a mixing tank with a rotating paddle used in the preparation of liquid slips of clay.

CARRARAWARE: a glazed stoneware, single-fired to a matt finish, developed by Doulton of Lambeth during the late 1880s.

CARYATID: a sculptured female figure used as a column.

CHINA CLAY: a highly refractory clay, also called kaolin and an essential ingredient of porcelain.

CHURRIGUERESQUE: a heavily decorated late Baroque style found in latin America, and Mexico in particular.

COADE STONE: a high-quality terracotta made in Lambeth, London, by Eleanor Coade from 1769, and closely imitating stone in its colour and texture.

COAL-MEASURES: a series of coal-bearing rocks formed in the upper Carboniferous period, and usually interbedded with valuable clays.

CONSOLE: an ornamental bracket.

CORBEL: a projecting block supporting a horizontal member.

CUPOLA KILN: a domed kiln with a down-draught flue system.

DADO: the finished surface of the lower part of an interior wall, from floor to waist height.

DOWN-DRAUGHT KILN: a type of single kiln of circular or rectangular shape, with holes in the floor communicating with a flue and chimney.

EARTHENWARE: a term applied to ware having porous bodies which may or may not be covered by a glaze.

EXTRUSION MACHINE: a powered appliance in which clay is forced through a mouthpiece to give a desired shape.

FAIENCE: originating as a name for tin-glazed earthenware, but in the context of architectural ceramics referring to large blocks or slabs of glazed ware. Faience is usually called glazed terracotta in north America.

FILTER SIEVE: an appliance used for separating water from a fluid slip, and hence converting the slip into a paste, and consisting of a frame and cloth bags, the latter retaining solid matter.

FINIAL: an ornamental feature set on the apex of a roof.

FIRECLAY: a clay that does not show signs of fusion when heated to about 1500°C. The term is largely restricted to the refractory clays and shales occurring in the Coal Measures.

FLUX: an element or compound which acts on others, causing them to melt when heated.

GELATINE: a viscous, water-soluble material used for moulding forms with undercut detailing.

GLAZE: any impervious (usually glassy) material used to cover a ceramic article to prevent it from absorbing liquids or to give it a more attractive appearance.

GRIT: the American term for grog.

GROG: ground, burned clay which when mixed into a ceramic mixture reduces shrinkage and increases the strength of the burnt material.

HOLLOW-TILE: extruded tile, hollow in section, used primarily for fireproof floors or partitions.

HORSE: a wooden frame which holds a metal template as it is moved through semi-liquid plaster during model-making.

HYDRAULIC CEMENT: a cement that will set under water.

I BEAM: a horizontal girder or joist of wrought-iron or steel with a cross section in the form of a capital I.

LION SÉJANT: a statue of a lion in an upright, seated position.

LUMBER: see POROUS TERRACOTTA

MAJOLICA: a term for decorated tin-glazed earthenware that became applied to a range of highly-coloured wares made by different techniques, but typically with raised, hand-glazed decoration.

MARL: friable earths, which often incorporate a proportion of chalk.

MUFFLE KILN: a kiln in which the contents are protected from the fire, usually by a lining of refractory bricks or tiles.

ORIEL: a window projecting from an upper storey.

PAN-MILL: a mill for grinding clays with a pair of edge-runners set over a pan.

POROUS TERRACOTTA: a light terracotta with an open texture, sometimes achieved by incorporating sawdust into the clay mixture, and used for curtain and partition walls as well as for protecting columns and beams from fire. May be referred to as lumber in north America.

PUG-MILL: a type of clay mixer in the form of a closed cylinder with a tapered exit, and mixing blades set on a vertically or horizontally mounted axle.

RUNDBOGENSTIL: a round-arched style of architecture developed in Germany during the 1830s–40s and taken up in Britain during subsequent decades.

SEMI-GLAZE: a term used in north America in the last two decades of the nineteenth century to refer to coatings applied to terracotta more akin to a clay slip than a true glaze.

SHALE: a mud which has been hardened after deposition giving it a laminated texture. Shales must be carefully ground before being used.

SKELETON CONSTRUCTION: a form of building construction consisting of an iron, steel or concrete frame and an outer shell which takes no load.

SLIP: a suspension of fine solid particles in water, used in casting ceramics in moulds or to coat pressed ware.

STANCHION: a vertical member of iron or steel.

STONEWARE: a variety of clayware which has a hard and glassy or vitrified body, impervious to water, and capable of being moulded into large articles.

TERRACOTTA: large blocks of pressed clay, typically buff or red in colour, and usually in the form of statues, garden ornaments or building materials.

TIE-ROD: a round bar designed to prevent walls or beams spreading apart.

TUNNEL KILN: a type of kiln in which the goods are placed in wagons and are burned as they travel through a heated tunnel.

VITREOUS FAIENCE: a form of glazed ceramic made in Britain in the early twentieth century with a clear glaze being applied to a buff or orange-coloured body.

INDEX

The figures printed in bold type refer to illustration numbers, not page numbers.